Whe

Wheels of Her Own

*American Women
and the Automobile,
1893–1929*

Carla R. Lesh

McFarland & Company, Inc., Publishers
Jefferson, North Carolina

ISBN (print) 978-1-4766-7277-9
ISBN (ebook) 978-1-4766-5237-5

LIBRARY OF CONGRESS AND BRITISH LIBRARY
CATALOGUING DATA ARE AVAILABLE

Library of Congress Control Number 2023057368

Front cover images, *clockwise from left:*
Entrepreneur and philanthropist Madam C.J. Walker at the wheel
of her Model T Ford in front of her Indianapolis home in 1912
(Madam C.J. Walker Collection, Indiana Historical Society, P0391);

Alice Ramsey and passengers in Maxwell automobile, 1909
(Lazamick Collection, Detroit Public Library, Resource ID: na032240);

Philip and Eugenia Wildshoe (Coeur D'Alene) and family
in their Chalmers automobile, 1916
(photograph by Frank Palmer, Library of Congress);
Background © LeManna/Shutterstock.

Printed in the United States of America

*McFarland & Company, Inc., Publishers
Box 611, Jefferson, North Carolina 28640
www.mcfarlandpub.com*

For
MARY ELIZABETH HENDEE PLANK
1897–1984
Historian, Traveler, Storyteller
Who always had a story ready for her little granddaughter

Table of Contents

Acknowledgments

This journey began with my grandmother's stories of the early automotive era and of the love of travel that is deep in our family lore. Growing up in the vast distances of the American West, we were well aware of the importance of having access to our own wheels. That sense of the automobile as a partner in working toward an improved quality of life never left me. Years after those first stories were handed down to me by my grandmother, my graduate school journey opened up new roads of research, including into the history and experiences of Black and Indigenous women. I can see now that the journey into the question of women and transportation still has many turns and miles left to explore.

Thank you to my graduate school advisor, Dr. Ivan Steen, for his valuable guidance throughout my University at Albany, State University of New York experience. Thanks also to the dissertation committee: Dr. David Hochfelder, for sharing his understanding of the relationship between technology and social change; Dr. Amy Murrell Taylor, for her enthusiasm and clear revisions; Dr. Nadieszda Kizenko, for reminding me to keep an ever-expanding world view.

Thanks to the many friends and family who have shared ideas, book suggestions and patiently listened to and encouraged me. Karen Horton provided just the right books at just the right time. Dr. Chris Lezotte, fellow board member of the Society of Automotive Historians, shared her publishing journey and encouragement.

Thanks to the fine archivists, curators and researchers who helped guide my way: Geoffrey Stein, Dr. Penelope Drooker, Toni Cooke and Pamela Dickinson at the New York State Museum; Chris Ritter and Cathy Alexander at the Antique Automobile Club of America Library in Hershey, Pennsylvania; David Mitchell, Curator, Miriam Snow Mathes Historical Children's Literature Collection, SUNY Albany; Bill Bell of the Society of Automotive Historians for generously sharing his personal collection of automobile registrations; George A. Thompson, for sharing his formidable newspaper research skills; Mary Frances Ronan at National

Archives I, Washington, D.C.; Ken House at National Archives, Seattle and Dr. Kristina Reuille who incorporated gathering research materials into her vacation. Jennifer O'Neal at the National Museum of the American Indian; Gina Rappaport at the National Anthropological Archives; Nicolette Bromberg at the University of Washington; Kay Frazer at the Elwood Haynes Museum, Kokomo, Indiana; Jan Grenci and Marilyn Ibach at the Library of Congress Prints and Photographs Reading Room; David Freburg at the Mashantucket Pequot Museum and Research Center Archives and Special Collection; Susan Sutton at the William H. Smith Memorial Library, Indiana Historical Society; Lynn Laffey at Fosterfields, Morristown, New Jersey; the librarians at the New York State Library and New York State Historical Association.

To those who got me started on this topic: at Lindenwald, Martin Van Buren National Historic Site, Dr. Patricia West first validated the idea and Judy Harris introduced me to the Native American Institute of the Hudson River Valley. There I met Indigenous scholars, including Dr. Margaret Bruchac (Nulhegan Abenaki), whose scholarship serves as a continuing inspiration; Dr. Lucianne Lavin of the Institute of American Indian Studies, Washington, Connecticut, who in turn introduced me to Faith Davison, Mohegan Tribal Archivist. Ms. Davison generously shared her family photographs. My thanks also go to Jim Yellowhawk (Itazipco Band of the Cheyenne River Sioux Tribe and the Onondaga/Iroquois) and the Rev. Duncan Burns (Muscogee Creek) for sharing their family stories. The scholarship of Heather Bruegl (Oneida Nation of Wisconsin and a first-line descendant Stockbridge Munsee) is a valuable asset.

My thanks go to the on-line writing group, at times spanning three countries and nine time zones, our camaraderie makes life very enjoyable and fulfilling. Dr. Deborah Coe has been there from the beginning encouraging each accomplishment. Sarah Wassberg Johnson brought a valued fresh burst of enthusiasm and research navigational skills. Thank you, Sarah, for making the seemingly impossible achievable and for showing the way to book publication. Thank you also for introducing me to Tenereh Idia. Thank you, Tereneh, for sharing your deep insight into travel as experienced by Black women.

Thanks to Dr. Robin Campbell, Paul Schneider and Dr. Gretchen Sullivan Sorin for their friendship, advice and generous sharing of scholarship. Gratitude to copy editors Mary Koniz Arnold and MK O'Donnell, who read multiple drafts. Thank you to Dave Prout for the fine work creating the index. Thanks also to the editorial team at McFarland for their patience, guidance and interest in this project.

Deepest thanks go to the vast numbers of volunteers and professionals who digitize countless images and documents making them available

through the internet. Reading about automobile parties and the Black social network of decades past from my home office at all hours of the day and night is a technological miracle for which I continue to be thankful.

Final thanks go to my husband, Glenn Knickerbocker, whose support, encouragement and belief in my ability has made the achievement of this dream possible.

Preface

"Travel is more than the seeing of sights; it is a change that goes on, deep and permanent, in the ideas of living."—MIRIAM BEARD[1]

A 1910 article entitled "What a Woman Can Do with an Auto" made an early observation of the freedom women found when they took the wheel of a automobile, or when they held the lever on a horseless carriage. "It gives her immediately a larger interest and takes her out of the monotonous round of household duties quickly and conveniently, whenever she requires respite."[2] While the article was written with a White audience in mind, women of color also used automobiles in this era to improve their lives, while meeting different challenges and being motivated for a wide variety of reasons. *Wheels of Her Own* looks back at the topic of this original article after more than a century of perspective since it first went to press.

This book digs deep into the years spanning roughly 1893–1929, the period which brought the automobile to the United States. It explores ways in which women interacted with, mobilized, and responded to developments in automotive technology, access, infrastructure development, as well as legal quandaries regarding who could drive where, when, and how. Necessarily, these explorations intersect with questions of racial and class disparities, in which exposure to driving was met with a complex and volatile network of experiences. Wherever possible, investigations into nonwhite contexts for the intersection of women and the automobile are undertaken. However, this study, being explorative in nature on a very broad theme, limits itself to creating a kind of map for further study in each of these areas, deserving as they are of comprehensive analyses of their own.

Overwhelmingly, when it was both accessible and affordable, the automobile offered new freedoms: freedom for Black women from the insult and danger they encountered on public transportation in the era of increasing segregation; freedom for Indigenous women to rebuild cultural,

1

kinship-based, and economic networks shattered by Federal government policies; and freedom for White women from the restrictions of the sheltered, home-centered life of the Victorian era. These women all shared unique concerns and common aims as they negotiated their way through a time when advocacy for social change was undergoing a resurgence. In the 1890s legal and social restrictions based on racism and gender stereotypes were on the rise in the United States. For women the automobile was a useful tool as they worked to improve their quality of life. The automobile provided a means for Black, Indigenous, and White women to pull away from those limitations and claim their individual freedom. In the 19th century, these were some of the obstacles that faced these three groups of women. The independent mobility of the automobile enabled them to continue to work to change things for the better. And yet, as we will see, 20th-century oppressions also loomed large in the areas of travel and transportation.

The terms Black, Indigenous, and White will be used as proper nouns to identify the socially constructed groups. When an individual's tribal affiliation is known, it will be incorporated with the proper name, e.g., Zitkala-Sa (Dakota Sioux). The terms used to describe a group of people are reflective of the prevailing political and social environment and change over time. Direct quotations will retain original spelling, capitalization, and terminology of the original source. To preserve the authentic voice of the historically under-represented Black and Indigenous authors, extensive quotations are utilized.

Research for this project followed a path similar to the way people learned about automobiles in the 1890s. Beginning with scientific journals, then automobile specialty journals, followed by how-to books, and finally moving into popular magazines, the "horseless carriage" came to public attention and eventually acceptance. Newspapers reported on the earliest proof-of-concept races and long-distance journeys held by inventors and manufacturers. Women, primarily White women, are found amidst the abundance of information about early automobile development and use, both as readers and participants. Social columns were a standard feature in both the Black and White early 20th-century newspapers. These reports of the comings and goings of their readers provide glimpses of early automobile use and the public transportation on trains and streetcars that automobiles replaced. Articles and advertisements give personalized details of travel on trains, streetcars and later, automobiles, to visit friends, family, scenic and historic sites. Black churches offered excursions to picnic grounds and groves where Black visitors could relax in a safer environment from the segregation that was increasing in the 1890s. Further, close attention to White-focused histories also reveal indications of those whose histories have been pushed to the background.

In the years since this research began, many more histories by Black and Indigenous authors have been published broadening the available research. Books made available at Indigenous museum stores offer a wealth of information. While the navigation of the extant sources took me to unique places and exposed my thinking to important historical moments, this book ends its journey some "place" quite different from any road trip's final destination. While there are societal and political limitations to a full realization of the phrase "Wheels Equal Freedom," independent mobility is a key component to living a more independent and rewarding life. Given the unique concerns and backgrounds of Black, Indigenous, and White women in the United States, I explore the path to the common aim of living a rich, full life, and how automobiles aided that journey. I am a non–Indigenous, White woman whose ancestors have been interacting with Black and Indigenous communities during the 400 years since my ancestors arrived in North America. It was a chance encounter with two women, one Indigenous, the other Black, at the beginning of this research that got me thinking about how it came to be that given the very different histories, we each were able to drive our own vehicles to the same location in the present day. That led to working on tracing out the paths that brought the three groups of women to automobile-use on the same roads.

This work puts readers in a position for readers to think about a crucial question that reaches beyond the scope of this work: given the complex terrain created by the dawn of the "auto," in which liberating benefits coincided with the reality of oppressive tactics, what has changed? In the era of climate change, will a move to cycling, walking, and good public transit (and the ability to do without a car) become the mark of class status and high quality of life? Do the newest technologies of our wireless era bring about the same combination of extreme benefits, and extreme dangers? Black, Indigenous, and White women have been traversing the American landscape and interacting for hundreds of years starting from diverse points in the past to sharing the road today. This book examines the journey women took from the age of segregated public transportation to the early years of the popular use of automobiles as they learned about and acquired automobiles and used their vehicles to improve their quality of life.

Perhaps this look back on a once-new technology—the automobile—and its interplay with a specific facet of human experience, will enrich our own self-reflection on the technological innovations that confront us in the modern age, and provide the opportunity to develop responsible, equitable transportation for all to improve their quality of life.

Introduction: Our Itinerary

At the dawn of the automobile era, Black, Indigenous, and White women in the United States were separated from each other, either by custom or law. The journey begins in Chapter 1 with an overview of the community and travel situations provided by public transportation. Here the groundwork is laid for understanding the context that predated the introduction of the "horseless carriage." We look at the various modes of transportation with which women were familiar, and observe both their limitations and their capacity for movement. In Chapter 2, independent motion arrives on the scene, with the lure of being at the wheel and making decisions about where to go. As opposed to being merely a passenger, the idea is as exciting as it is fraught with safety concerns, interactions with horses, and questions about roads themselves. After those initial (and literal) "bumps in the road" are increasingly met with solutions, it becomes apparent that the education of would-be drivers must be fully and carefully considered.

Chapter 3 dives deep into early instances of getting underway with instructional materials and ideas, especially as they reflect women's experiences with learning the intricacies of their machines, travel etiquette, and rules of the road. Chapter 4 draws upon the findings in Chapter 3, as women automobilists begin to venture farther from home and tackle some of the pleasures, and problems, on the road that vary with race and class. Chapter 5 treats of the earliest iterations of the iconic American "road trip," leading to the transcontinental drive between the Atlantic and the Pacific Oceans to be discussed in Chapter 6, as well as examples of the use of the automobile for practical purposes. Chapter 6 shows how a half a century before the legendary road trips of the 1950s, women were traveling by automobile from coast to coast, spanning ever-longer and more storied journeys. We will see, among other things, how this trip was reflected in the popular press and travelogues.

Black travelers planned their trips differently than White motorists, traveling at specific times and between specific destinations to avoid

dangers of racism and White supremacy. Indigenous families, encouraged by the Bureau of Indian Affairs to take advantage of promised, but not delivered, economic urban opportunities, returned to homelands and reservations to reconnect with relatives and maintain traditions. The automobile remained a useful tool as Black, Indigenous, and White women moved through the unique concerns of restrictions of the early 20th century and toward the common aims of an improved quality of life.

Finally, we arrive at our destination: an opportunity to reflect on where we've been, and raise questions about how new technologies, especially in transportation, are incorporated in our everyday lives, especially as women.

CHAPTER 1

Women *En Route*

"There is nothing new about women travelling the highways of the world and from the early centuries, the Christian Church has offered a useful umbrella to women who had the will and the money to travel the pilgrim route to Rome and Jerusalem."—MARY RUSSELL[1]

Women have always traveled. As Mary Russell notes, even prior to the development of the automobile, women traveled on the available routes via the modes of transportation of their time, whether by foot, cart, chariot, wagon, or any number of the various beasts of burden. By the 19th century, their options included trains, stagecoaches, omnibuses, and steamboats. They were also enthusiastic about the introduction of the safety bicycle in the 1890s. Thus, there was already a tradition of women's independent travel in the 1800s, even prior to the horseless carriage. In this chapter, the complex tension between the mobility offered by public transit, and the political and cultural forms of oppression that pervaded early public transportation systems will be considered in order to contextualize the era in which the automobile first appeared. The use of the bicycle and its relationship to women's changing views on fashion, physical exercise, and freedom of mobility will add another perspective to this context, thus further setting the stage for women's relationship to transportation at the dawn of the automobile age.

While curtailed by the social expectation that women stayed in the home, some White women with money, and the time that comes with money, had the means to travel for pleasure, education, escape from the monotony of daily life, and to seek improved economic opportunities. Black women traveled to work as teaching jobs were created in the South during Reconstruction in the 1870s. Church conferences and out-of-town social visits were recorded in the Social News sections of newspapers for both Black and White audiences.

In the rapidly transforming landscape, culture, and economy of the

19th century, middle- and upper-class women, primarily White women, began to write and speak about traveling independently, thus popularizing the idea with the general public. Lady travelers—the popular term of the time for these mostly White women (men were referred to as travelers)— often hired large retinues of local people as guides, cooks and porters. The backgrounds of these lady travelers fell into several broad categories. There were unmarried women who had come into an inheritance to fund their first journey, and who often wrote about their trip and found a publisher that led to book sales to fund their next trip. Then there were missionaries who were able to access remote regions of the world under the sponsorship of missionary societies. Wealthy women who had the financial means to travel alone or with their husbands comprised a third category. A final group included women who had to finance their own travels by other means, sometimes securing support from their male counterparts, who found funding from such places as museums or scholarly societies.

American and European men of the same era more easily found motivation and funding from research institutions and private individuals for exploration and adventure expeditions. For women, travel writing, painting, botanizing, and missionary work were socially acceptable reasons for the travel that gave them individual satisfaction. As Dea Birkett points out, "Often, women attempted to excuse their desire for travel by claiming it was being undertaken for motives of duty and service to others, seeking to alleviate their sense of guilt for enjoying themselves 'skylarking,' 'rambling' and 'puddling around.'"[2]

Lady Travelers

The definition of a White woman traveling "alone," particularly in Africa, Asia and the Middle East, meant that she was the only White person in the party. In these circumstances, the White woman had the ability to give the orders and set the journey's course. In keeping with the times, racism set the tone for her interactions. The precedent for this complex situation was set early; as Dea Birkett notes, "In non–European terrain, the sense of achievement they had privately experienced was soon matched by public acknowledgment of their powers and skills. Their welcome into the heart of foreign landscapes differed greatly from those they had received when stepping down from the ships and carriages into the colonial domain." Thus, as White women traveled farther from the centers of colonial power after landing in the port cities, the social advantages of being European or American increased.[3]

Isabella Bird Bishop, an English Victorian vicar's daughter under physician's orders to travel for her health at age 20, was among the more intrepid of this group, willing to travel with fewer guides and take greater chances than others. Isabella Bird Bishop noted that "Travelers are privileged to do the most improper things with perfect propriety, that is one charm of travelling." Bishop biographer Pat Barr writes that Isabella Bird Bishop had a dignity about her that enabled her to travel safely in masculine circles. Isabella Bird Bishop traveled alone with male companions "with whom she would share the inevitable proximities of camp life. For, once she had fixed on some particular goal, she quite ruthlessly made use of men and animals in order to reach it. But she must have gone about it in such a straightforward, single-minded, matter-of-fact way that not an eyebrow was raised."

Other White lady travelers behaved one way at home and a very different way while traveling. Mary Kingsley traveled as a trader and anthropologist in West Africa between 1893 and 1895. Mary Kingsley, daring while traveling, behaved far more decorously at home in England. While she scorned other people's refusal to eat meat with members of a tribal community who had a reputation for cannibalism, she refused for modesty's sake to ride a bus in London and had no use for the bicycle.[4]

While curtailed by the social expectation that women stayed in the home, some White women with money and time had the means to travel for pleasure, education, escape from the monotony of daily life, and to seek improved economic opportunities. Black women traveled to work as teaching jobs were created in the South during Reconstruction in the 1870s. Church conferences and out-of-town social visits were recorded in the Social News sections of newspapers for both Black and White audiences.

Differences Along Racial Divides

Travel, even under the auspices of a missionary society, was very dangerous for the 19th-century Black woman traveling alone in areas where slavery was still legal; any Black person could be claimed by slave catchers and sold into slavery. In her narrative *A Black Woman's Odyssey through Russia and Jamaica*, Nancy Garner Prince, a free Black woman born in 1799 in Massachusetts, describes a sea journey from Jamaica to New York City in the 1840s. The captain steered the ship off the stated course to Key West, Florida, apparently to pick up cargo. During the unscheduled four-day layover in a slave state, she refused to get off the ship. This was despite the fact that

every inducement was made to persuade me to go ashore or set my feet on the wharf. A law had just been passed there that every free colored person coming there, should be put in custody on their going ashore; there were five colored persons on board; none dared to go ashore, however uncomfortable we might be in the vessel, or however we might desire to refresh ourselves by a change of scene.[5]

After leaving Key West, a gale struck, blew them off course and damaged the ship which was towed by steamer to New Orleans, Louisiana, for repairs. During the four days of repairs in New Orleans "the Whites went on shore and made themselves comfortable, while we poor blacks were obliged to remain on that broken, wet vessel." Prince describes seeing a drove of Black men and women chained together. The prisoners included free Blacks from northern ships, arrested for being onshore. Prince tells of the captain's explanation that there was a $100 bet going amongst the White passengers in Key West that she could be persuaded to get off the ship.[6]

While waiting on the boat docked in New Orleans, the rude treatment Prince received from a crew member changed abruptly once that crew member realized he knew her father from Newburyport, Massachusetts. She refused his offers to arrange her safe passage to New York, opting to stay on the boat in support of her fellow Black passengers. She writes that her attitude toward the Whites was so stern and unflinching that the White crew forbade her to speak to the Black, probably enslaved, workers while the boat was docked. Meanwhile, Black passengers were expected to pay the same full ticket price as Whites no matter what they experienced during the journey.[7]

Nancy Garner Prince's experience is in sharp contrast to the cheery picture painted by David Lear Buckman in *Old Steamboat Days on the Hudson River* writing at the same time as Prince. Buckman writes, "…it is an honor to this country that an unprotected woman of any age may travel through its length and breadth from Boston to New Orleans, from New York to farthest west without insult or the slightest attempt to take advantage of her youth or inexperience." And yet, the myth of safe travel for all women had another side: it placed the blame for danger while traveling squarely on women, not the men who were doing the harassing. If a woman was harassed or harmed while traveling, then she was not a "lady" and therefore deserving of whatever treatment she received. Further underscoring that women of color were not considered "ladies" or deserving of treatment with respect by mainstream White society. Sheltering women from the travails of the working world and the urban centers where the businessmen spent their days became a 19th-century mythic standard that, while set as the goal for all women, was primarily applicable

to White women. Protecting women from the world of men served as an excuse for withholding the vote, excluding women from the paid work-force, and limiting the ability of women to travel without a male escort.[8]

Indeed, traveling alone was a dangerous necessity for many Black, Indigenous, and White women. The constant threat of insult and phys-ical and sexual attacks pervaded railroad travel for Black women. The outcome of the incidents depended on the individual circumstances, the place, attitude of the people involved, and the atmosphere of the onlook-ers. Dr. Bessie and Miss Sadie Delany describe the situation succinctly in their memoir *Having Our Say*:

> All little girls and young women were chaperoned in those days. That's because things hadn't improved much since slavery days as far as the right of colored women and girls to be unmolested. If something bad had been done to us, and our Papa had complained, they'd have hung *him*. That's the way it was.[9]

As the danger of travelling alone during the era of legal slavery gave way to a new version of independent travel, Black women in the South began traveling to find more satisfying work and to reunite families sepa-rated during slavery. Pleasure travel was also popular. Black churches and social organizations arranged chartered railroad excursions for Sunday School picnics and celebrations. Evelyn Brooks Higginbotham writes that the yearly gatherings of the Black Baptist Church provided an opportunity for Black women to travel to new cities, meet new people, gather and share information and "to establish an agenda for racial progress and to renew their strength of the struggle against the debilitating intent and effects of Jim Crow."[10]

The social and personals columns of the *Baltimore AfroAmerican* newspaper in the late 1890s and early 1900s carried entries of railroad and trolley car excursions to specific celebrations as well as summer pic-nics sponsored by churches. The Colored Citizens of Maryland hosted a Labor Day Demonstration at Fairy Grove Inlet with boating, bathing, fish-ing, swimming, music and "plenty of fresh fried fish and chicken," as well as speeches by local dignitaries and Civil War veterans.[11] Picnic grounds and pleasure groves such as Round Bay outside of Baltimore, Maryland, advertised in the September 7, 1901, *Baltimore AfroAmerican* newspaper. At Round Bay, excursionists were able to rent bathing suits for swimming, listen to free concerts and go for part of the day rather than dedicating an entire day to the venture, "Because you need not lose a whole day's work." Round Bay appears to have been associated with a railroad or trolley line, as they advertise in their list of reasons to go to Round Bay, "Because the company has paid more to the churches and other organizations than any other road. Also gives more ads to colored newspapers."

Prior to the decision of the United States Supreme Court in 1896 of *Plessy v. Ferguson,* which legalized segregation in public accommodations, the American rail car, with its central aisle, rows of seats, and passenger ability to move from car to car, provided the opportunity for passengers to meet a wide variety of people. Amy Richter writes:

> Respectable ladies might travel beside women and men of a different class, race, or region. In a smoking car, businessmen from New York City could rub shoulders with country doctors or farmers … everyone—northern and southern, urban and rural, immigrant and native-born, black and white—seemed to be aboard the trains.[12]

The 1896 United States Supreme Court decision *Plessy v. Ferguson* gave "constitutional sanction to laws designed to achieve racial segregation by means of separate and supposedly equal public facilities and services for African Americans and Whites. It served as a controlling judicial precedent until it was overturned by the Supreme Court in *Brown v. Board of Education of Topeka* (1954)." *Plessy v. Ferguson* was the case in which the United States Supreme Court, on May 18, 1896, by a seven-to-one majority (one justice did not participate), advanced the controversial "separate but equal" doctrine for assessing the constitutionality of racial segregation laws. Making the racial segregation laws of individual states legal solidified the racial divide.[13] After 1896, there was no guarantee, even with a first-class rail ticket, that Black passengers would not be put in the smoking car, baggage car, or divided section of a sleeper car. As described by Dr. Mary Church Terrell, "There are few ordeals more nerve-racking than the one which confronts a colored woman when she tries to secure a Pullman reservation in the South and even in some parts of the North."[14]

Etiquette books written for a White audience from the 1870s through the 1890s emphasize the ability of women to travel alone by rail and steam ship. Etiquette authors urged older women travelers to look after younger women and encourage women to converse with fellow travelers—while maintaining proper decorum and ending the acquaintance at the end of the journey. Richard Wells, author of an 1891 etiquette manual wrote, "Who would care about sitting and moping for a dozen of hours on board a steamer [steam ship] without exchanging a word with anybody?" while making clear that "The friendship which has subsisted between travelers terminates with the journey. When you get out, a word, a bow, and the acquaintance formed is finished and forgotten."[15]

Repeatedly, 19th-century etiquette authors remind women travelers not to take up more than the seat they have paid for, not bring an excessive amount of luggage, have their tickets purchased in advance, anticipate train changes and "Read notices; they are put up on purpose to be read,"

exhorted Mrs. M.F. Armstrong. If even the discreet and well-prepared woman traveler still had questions, she was urged by Mrs. M.W. Baines to "inquire in advance of the conductor. The conductors on our trains are always polite and willing to be of service, especially to women traveling alone."[16]

Mrs. M.W. Baines' reassurance of a safe and comfortable trip did not apply to Black women travelers. The 1888 etiquette book written for a Black audience, Mrs. M.F. Armstrong's *Habits and Manners: Written originally for the students of Hampton N[ormal] and A[gricultural] Institute* joined the books written for White audiences in perpetuating the myth that demure, ladylike behavior would elicit respectful treatment while traveling. The "Jim Crow" laws were named after a 1820s blackface character portrayed by White minstrel show performer Thomas Rice as an old Black man with an exaggerated dialect. The number of individual states and cities enforcing segregation laws had been increasing since the 1870s. Mrs. Armstrong is probably the wife of Hampton Institute founder Civil War Brigadier General Samuel Armstrong. Her use of the phrase "your people" later on page 80 makes it clear she is a White woman writing for Black students. The closest Mrs. M.F. Armstrong came to addressing the dangers Black women faced while traveling is this passage:

> I do not forget that to colored people in America the question of manners on the road may involve at times peculiarly difficult and trying positions, and cases where the courtesy will seem very one-sided. But while I understand and deplore this, and while I admit that there may be circumstances when it will be right and necessary to make a stand, in a proper and lawful way, for one's lawful rights, I believe that, especially in these cases, propriety of deportment on your own part will do more than anything else towards securing for you fair and proper treatment from others.[17]

Black educator and activist Dr. Anna Julia Cooper found White conductors to be the opposite of "polite and willing to be of service" in her travels by railroad as an unaccompanied Black woman in the early 1890s. In her 1892 volume *A Voice from the South*, she writes of the insult delivered by White conductors who, after carefully assisting White women passengers in the steep descent from the rail car, "deliberately fold their arms and turn round when the Black Woman's [Cooper's reference to herself throughout the book] turn came to alight." Cooper continues: "The feeling of slighted womanhood is unlike every other emotion of the soul." The feeling of slighted womanhood was more than hurt feelings—Black women were in physical danger each time they embarked on a journey.[18]

Cooper's comment is put in perspective by an August 31, 1895, article written by Black newspaper publisher and editor T. Thomas Fortune

reprinted in the *Baltimore AfroAmerican* from the *New York Sun,* a White-owned newspaper. Titled "Southern Chivalry," it describes the sharp differences in the ways Black and White women were treated when traveling on streetcars. T. Thomas Fortune writes:

> On the street cars of this city conductors are expected to help women on and off the cars. It is a very absurd regulation. It entails upon the conductor an enormous amount of unnecessary work and worry.... But here it is a rule. I have ridden on every streetcar line in the city, and while I have never seen a White woman get on or off a car without the assistance of the conductor, if he could reach her, I have yet to see a conductor who extended the courtesy of a black or colored woman even if accompanied by children.

The treatment that Dr. Anna Julia Cooper described was a deliberate insult. T. Thomas Fortune goes on to write, "white men and women appear to strive to show how offensive they can make themselves. In theaters, and churches, and public resorts, as on railroads and steamboats." What he calls "the persistent but futile effort" to keep Black citizens "in their place."[19]

In 1902, as the Separate Car Law was proposed in Maryland and petitions and protests were raised against it, the *Baltimore AfroAmerican* wrote, "The law commonly called the 'Jim Crow' car law has for its real purpose the humiliation of our people. It is a wicked and shameful measure and should be defeated." Defeated in 1902, the Separate Car Law was passed by the 1904 Maryland state legislature and signed into law.[20]

The White conductor's behavior Dr. Anna Julia Cooper describes is an example of just how dependent women were, especially when traveling alone as Black women traveling to jobs often had to do; they were dependent upon the good behavior of the people they encountered. The underlying premise of etiquette books was that all well-behaved women would be treated with respect and never encounter the hazards such as those John Kasson describes in *Rudeness and Civility*:

> Possibilities for intrusion and symbolic violation abounded. From an impertinent glance, an unwelcome compliment, the scale of improprieties rose through a series of gradations to the ultimate violation in rape. The premise of ladylike behavior rewarded with respect implied: "Any disrespect a woman did encounter she must have deserved" and left Black women in the infuriating and untenable situation of having to prove they were ladies and thereby worthy of respect.[21]

As the Separate Car Law was reintroduced in Maryland in the 1904 legislative session, having been voted down two years earlier, newspaper articles brought up the danger to Black women travelers on railroad and street cars: "but if this iniquitous law prevails there will be no protection

on boat or cars [street and railroad] in this state for our women."[22] In the summer of 1904, as the Separate Car Law was about to be put into effect, the *Baltimore AfroAmerican* carried articles describing protests, boycotts, and techniques used by Black passengers to resist. Readers were encouraged to walk, churches canceled excursions rather than use segregated rail and street cars, and those who could afford it hired entire sleeping cars to ensure safe travel. Section 4 of the Separate Car Law enacted on July 1, 1904, gave railroad and street car conductors total authority to implement the Separate Car Laws. Section 5 carried the provision to fine conductors who did not enforce the law.[23]

The *Baltimore AfroAmerican* June 25, 1904, issue provided the basis of the legal actions brought following the passage of the Separate Car Laws:

We do not desire to bring on any kind of trouble between our people and the authorities, we must positively insist that the law, while it stands shall be construed literally and that every colored person shall insist on all that the law gives them. If the law says the cars must be as good for one as for the other, then we must insist that we get it. If the railroad furnishes a smoker and a ladies' car for the white people then it must furnish the same for the colored people, and that is all there is to it. We must be satisfied with nothing less than that furnished to the whites. Again the law does not apply to express trains. [Those crossing state lines.] This must also be taken literally. Going or coming from Washington, Philadelphia, or any other city in any other state we are not compelled to take a "Jim Crow" car, and we ought never to do it. In going to those cities, the railroad cannot compel us to ride in one of them, and they have no right to place such a car on the train. In all let us insist, like gentlemen and ladies, without offensive language of any kind, but none the less most positive that while we are to have these obnoxious cars, we are not reconciled to them, and the railroads must live up to the strict letter of the law.[24]

When menaced at a Waycross, Georgia, train station, Dr. Annie Elizabeth "Bessie" Delany decided her best tactic was to maintain her ladylike demeanor and ignore the growing crowd. A drunken White man invaded the Colored waiting room and began leering at and threatening her. After she told him to "shut up and go wait with your own kind in the white waiting room" he responded by shouting to the White passengers that she had insulted him. The two other Black women in the waiting room left to hide in the woods, and the Black porter also left the room after praising her courage. Delany wrote, "I realized that my best chance was to act like nothing was happening. You see, if you acted real scared, sometimes that spurred them on." The situation was resolved when "That glorious, blessed train rounded the bend, breaking up the crowd and giving me my way to get on out of there. And it helped that the white man was drunk as a skunk, and that turned off some of

the white people."[25] The White onlookers showed no inclination to assist Delany or stop the drunken White man, as if the encounter were a diversion to observe until the train arrived.

A segregated coach car described by Dr. Mary Church Terrell was used as the smoking section for White men in the front half and as the coach accommodations for Black men and women in the back half. While a student at Oberlin College in Ohio, Terrell was directed to this car by a White porter, when she had to change trains on her trip home to Memphis, Tennessee. Although she had purchased a first-class ticket and had been riding in the first-class car until the train change in Bowling Green, Kentucky, the White conductor refused to allow her back into the first-class car, telling her, "This is first class enough for you, and you stay just where you are."[26]

Terrell's discomfort turned to realization of danger when the other Black passengers reached their destinations and got off the train, leaving her alone in the car. She writes: "I had to travel all night, and when I thought that during the whole night or even a part of it I might be in that car alone at the mercy of the conductor or any man who entered I was frightened and horrified. As young as I was, I had heard about awful tragedies which had overtaken colored girls who had been obliged to travel alone on these cars at night." She confronted the conductor again, he again refused to allow her in the first-class car.

His manner, as he assured her that he would stay in the empty car with her, made it clear that her fears of attack were justified. At that point Terrell decided to leave the train at the next stop, even though getting off the train in a strange town where she knew no one was also very dangerous. When she tried to leave, the conductor stopped her and asked what she intended to do.

She replied, "I am getting off here to wire my father that you are forcing me to ride all night in a Jim Crow car. He will sue the railroad for compelling his daughter who has a first-class ticket to ride in a second class car." The conductor tried to force her to stay on the train, letting her sit in the first-class car only when the White passengers began to take notice. When the train pulled into Memphis the next morning the conductor was careful to point out to Terrell's father that she was in the first-class car. Black women made every effort not to travel at night, but as Terrell writes, when suddenly called home due to an emergency, it was a risk that had to be taken.[27]

Sometimes Black women fought back physically when conductors forcibly removed them from a first-class Ladies Car to a segregated car. Ida Wells Barnett bit a conductor on the hand as he dragged her from her seat, and, with the aid of other White passengers, carried her to the segregated

car. Legal action was another method of fighting segregated accommodations. Dr. Mary Church Terrell's threat of a lawsuit was very real, as the conductor acknowledged when he pointed out her first-class seat to her father. Ida Wells Barnett and other Black women sued railroads for refusing them the accommodations they had purchased. The success rate of the lawsuits depended on a variety of factors, including the political leanings of the judge hearing the case.[28]

Interstate railroad travel in areas where the state boundaries are close together, such as Frostberg in western Maryland, could be especially difficult. "The only time that the law can be enforced is when one is traveling within the state limits. The moment he crosses the line in Pennsylvania or West Virginia he can ride where he pleases." Black passengers arranged train schedules to cross state lines and thereby avoid the Separate Car Laws, even when it added miles to the journey.[29]

Lawsuits were brought against railroads by Black passengers who had paid full price for a first-class ticket and were removed to a smoking car. The difference between travel within state boundaries where that state's Separate Car Law prevailed and railroad trips that crossed state boundaries where the law prohibited segregated rail, was a basis for many of these lawsuits. "Mrs. Elizabeth Crump has entered suit in the United States court at Cincinnati, for $25,000 damages against the C&O (Chesapeake & Ohio) Railway for being forced to ride in a 'Jim Crow' car under the Separate Coach Law of Kentucky."[30]

Violation of the separate-but-equal requirements was another basis for lawsuits. Passengers brought suit against railroads that required them to move from a clean first-class car to a dirty car without sanitary facilities or water. Railroads countered with arguments that the cars were clean at the start of the trip and were dirtied by the passengers.[31] White passengers could also move freely between cars, while Black passengers could not.

> The respectable black man who pays as much railroad fare as the white man not only receives far inferior accommodations, but is subjected to the smoking nuisance and other evils from which the white traveler is exempt. White men can familiarly invade the black men's car when they want to enjoy a cigar, but the black men, in their turn, cannot cross the race line of demarcation.[32]

For a Black woman traveling alone, the indignities and dangers included this situation, but were greatly heightened.

Indigenous Women's Travel

The United States' mystique of the freedom of the open road predates the automobile. The lure of the open road as a path to adventure and a new

life is steeped in the American mythos. And yet, that "open road" traverses stolen land, often obstructing original and ancient passageways and patterns of trade and movement.[33] As Indigenous lands were stolen through a succession of treaties, land-theft took on different forms. The goal, as is now increasingly being realized, motivated Whites regardless of the method; that goal was not only to push Indigenous people off their traditional homelands and take the land for the settler colonialists, but in many cases, to erase their presence altogether.[34]

As the 19th century progressed, the complexities of travel for women intensified, and Indigenous women dealt with increasing constrictions on travel and the ability to move about independently. During the period when White and Black women were gaining more, though deeply unequal, mobility, Indigenous women were forced onto confined spaces with increased federal surveillance.

Indigenous women's travel was sharply restricted in the later decades of the 1800s. Federal policy enforced removal from traditional homelands. Bureau of Indian Affairs officials exerted ever tighter control over tribal finances and daily life. Children were taken from their homes and forced to go to church and federally run residential boarding schools far from their families. The intent of those schools was to eradicate their Indigenous heritage by any means. Despite this, travel and the pursuit of economic opportunity continued as Indigenous families worked, sometimes in popular, White-led Wild West traveling shows, which could include international travel. Travel also included presenting and selling arts and crafts in tourist centers and World's Fairs. Federal policies aimed at disrupting Indigenous traditions and lifeways, while simultaneously advertising economic opportunity, led families to move from traditional homelands to urban areas. The majority of these promises were unfulfilled, leaving individuals without financial resources in unfamiliar environments. Returning home for gatherings and festivals maintained ties to home communities and kin networks, but relied heavily on having the means to travel back and forth.[35]

Indigenous families, many of them matrilineal with a tradition of cooperative work for the benefit of all, were removed from traditional homelands and lifeways that incorporated travel into the seasonal yearly cycle. Cooperative living and working was forbidden by federal agents who forced a false ideal that a 160-acre farm would feed a male-headed family working on their own, a myth that even White farmers were rejecting, though they did so largely because of the inadequacy of the apportioned lot, not because of a sense of moral justice or desire for cooperative work. As Whites expanded Western ranch holdings to cover thousands of acres, they took over Indigenous lands while Indigenous families were

forced onto small patches of land unsuitable for farming, making it impossible for families to eke out a living.

As the 1800s drew to a close, the Federal government's military and social tactics of violence, starvation, and epidemic illnesses continued to decimate Indigenous populations and disrupt the sharing of spiritual and cultural lifeways and traditions. Disrupt, but not eliminate, despite the constant efforts of the Federal government, and the crush of settler colonialism. At the risk of putting it too briefly, settler colonialism, as the establishment of White culture and government in the United States, was built on the theft of land from Indigenous communities and the theft and exploitation of Black labor; it incorporated cultural and physical genocide to drive Indigenous people off the land. Most relevant to the present study, this history contributed to the *lack* of mobility that faces Indigenous and non–White cultures in the United States to this day.[36]

Following the theft of land, came the theft of Indigenous children by withholding the federal food rations to Indigenous families and communities until they agreed to send their children to the residential boarding schools. Indigenous people, as forced onto reservations and no longer allowed to hunt and gather food in traditional ways, relied on those rations to prevent starvation. The children were then forcibly removed from their communities and sent to far away residential boarding schools where they were cut off from their culture and language and severely punished for their resistance to the efforts to cut them off from their traditions with mandates to wear Western clothing, cut their hair, adopt Christianity, and speak only English.[37]

In contrast to restrictions on Black education, Indigenous children were forced to receive a Western education and forbidden to live in a traditional manner. Residential boarding schools were established in 1879 with the goal to assimilate Indigenous children into White society. These schools, some run by the Bureau of Indian Affairs, others by Christian missionary societies, were all federally funded and shared the goal of removing children from their families and traditions, thus further decimating Indigenous traditions and lifeways. Cut off from their families, children suffered physical abuse and emotional trauma. They were forbidden to practice their religion or speak their own languages, their traditionally long hair was cut off and traditional clothing taken away. The education they received was inadequate to function in either the White or Indigenous worlds. Albert White Hat, Sr. (Lakota Sioux), writes,

> Take a child of four or five out of the home and put him in a boarding school, forbid him to speak his language, and after twelve or fifteen years he will have lost it altogether. He will no longer know who he really is. Not only did we come close to losing our native language altogether, but our educational

system was so inadequate that we were given severely limited education as well. [...] A person living in and educated under that system simply couldn't function without outside consent or permission.[38]

This attempted destruction of traditional Indigenous life made it easier for White dominant society to steal their land. In the last decades of the 1800s, Indigenous land was greatly reduced via the Dawes Allotment Act. The purpose of the 1887 Act was to break up communal living and land management and reassign tribal land into 160-acre, male-head-of-household farm lots. These farm allotments accounted for a small percentage of the tribal land. The "excess" tribal land was then sold to White settlers and developers. The individual allotments, particularly in the arid West, were too small for anyone to sustain a viable living. Further, the 1890s brought droughts and grasshopper infestations to already unfertile land with resultant crop failures, thus the interest by the Whites to acquire as much land as possible for themselves to create 1000+ acre ranches.

> What historian David Chang has written about the land that became Oklahoma applies to the whole United States: "Nation, race, and class converged in land." [Color of the Land] Everything in US history is about the land—who oversaw and cultivated it, fished its waters, maintained its wildlife; who invaded and stole it; how it became a commodity ("real estate") broken into pieces to be bought and sold on the market.[39]

The return of the Republicans to the White House with the 1889 election of President Benjamin Harrison led to renewed efforts to turn Western territories into states with their associated Congressional representation to increase Republican party power. Newly installed agents overseeing distribution of food and supplies had little interest in the welfare of the Indigenous people. The Benjamin Harrison Administration further reduced the size of the Indigenous reservations, making it impossible for communities to grow enough food to feed themselves.[40]

This land was redistributed to White ranchers and farmers who knew larger acreages were needed to make a living off the land. Rations were distributed twice a month at the Indian Agencies, these rations had been cut since the 1870s despite the Treaty agreements. The hot, dry growing seasons of the late 1880s increased the tensions. Historian Dr. Heather Cox Richardson writes:

> Now, having signed away their hunting lands but still far from seeing any profit from the deal, Indians found their rations reduced at a time when they had no stores to fall back on. South Dakota settlers whose crops had failed could cut their losses and move back East, but the Indians had no similar option." "While not deliberately launching a program of extermination, the administration certainly did nothing to stop the crisis on the reservations.

Benjamin Harrison Republicans made it clear that they would not be sad to see the end of the Sioux.

Children of the Dakota, Lakota, and Nakota tribes were sent to the Carlisle Indian School as part of the retribution for the resistance against the forced land removals.[41]

Following the Wounded Knee Massacre and the Drexel Mission Fight in December 1890, Indigenous people were further subjected to forced cultural assimilation into White society. The brief period after the Wounded Knee Massacre, when the U.S. Army took over from the Benjamin Harrison Administration, saw "success" by the Sioux in ranging cattle. "But this sensible solution to Indian poverty fell victim to the American drive to seize Indian lands for development, a drive encouraged and aided by Republican policies. Local residents wanted the Sioux range and also their livelihood." Through taxes that applied only to herds owned by Indigenous people, they were forced to sell their land to White cattlemen.[42]

Traditional Indigenous language, culture, and land use were derided, discouraged, and often, forbidden. Nineteenth- and early 20th-century federal policy was based on the idea of assimilating Indigenous people into White society. A principal part of the assimilation program involved removing Indigenous people from their traditional homelands onto reservations. The traditional homelands were then sold to White settlers.[43]

Reservation land was frequently in harsh landscapes ill-suited for farming, and beyond the ever-expanding line of White settlement. Indigenous people were expected to adapt to a European agricultural lifestyle where men were the farmers rather than the traditional Indigenous women's role in agriculture, give up their traditional customs, adopt an American lifestyle including Christianity. Further evidence that the rules were about control rather than genuine concern for Indigenous well-being were the rules that forbade Indigenous communities to work communally when growing and harvesting food.[44]

To this day, cultural adaptation and transformation continues to affect Indigenous interaction with Europeans as it did beginning with the earliest European arrivals. Indigenous women, while expected to adopt the subservient societal roles of White women, adapted and maintained cultural traditions and leadership roles in their family and tribe. As Nancy Shoemaker writes, "They also, on other occasions, advocated change. They were, in short, crucial participants in the ongoing struggle for the survival of Indian cultures and communities." Removing Indigenous people from their traditional homelands and separating children from their families and culture had a devastating effect on traditional Indigenous culture.

In *The Land Looks After Us: A History of Native American Religion*, Joel Martin summarized the difference between the portable world religions

of Christianity, Buddhism, and Islam—which can be practiced any-where—and the Indigenous religious view, with this explanation given by a Hopi man in 1951: "Our land, our religion, and our life are one." Christianity's emphasis on proselytizing and converting non–Christians was completely alien to the Native religious view, where conversion was not possible. Joel Martin explains: "Koyukon religion … cannot be exported from central Alaska. It belongs there just as surely as Hopi religion belongs in northern Arizona. Koyukon missionaries will never knock on your door. Traditional Hopis will not try to convert you." The link of religion to sacred lands was equally alien to Whites, who saw the land as a resource to exploit for financial gain.[45]

Even when movement across geographical space was induced by the rapid changes in transportation, it was coerced by White power and its attendant desires. As an example, for an eight-year-old Dakota Sioux girl named Zitkala-Sa, the lure of the unknown Eastern United States with the promise of all the red apples she could eat and the excitement of a rail-road train ride was as strong as the lure of the Western United States was for Eastern travelers. The anticipation of the train ride and of the "nice red apples" promised by the boarding school recruiters were a powerful lure in Zitkala-Sa's excitement to leave the West to "roam among" the orchards of the East—strong enough for her to beg her mother to allow her to go East to boarding school. Her mother, convinced that Zitkala-Sa needed a White education to survive in a world where there would be fewer "real Dakotas," considered boarding school necessary, and agreed, despite her knowledge that "my daughter must suffer keenly in this experiment."[46]

Zitkala-Sa describes how her excitement at her first train ride faded to dismay when she and other children being taken to boarding school were stared at by the White passengers: Zitkala-Sa was dressed up for the occasion wearing new moccasins and her best blanket over her new dress—clothing more modest than the close-fitting European styles the White girls were wearing. "Directly in front of me, children who were no larger than I hung themselves upon the backs of their seats, with their bold white faces toward me. Their mothers, instead of reproving such rude curiosity, looked closely at me…. This embarrassed me, and kept me constantly on the verge of tears."[47]

The treatment she received on the train was the beginning of the indoctrination into White culture for which the boarding school experience was created. Her embarrassment worsened when she saw that she would be required to wear tightly fitting clothes at the boarding school and would have to cut and wear her long Native-style hair to conform to White styles, major aspects of boarding school indoctrination: "Our mothers had taught us that only unskilled warriors who were captured had their hair shingled by the enemy. Among our people, short hair was worn by

mourners, and shingled hair by cowards!" Perhaps harshest of all, through all the changes that left Native children caught between two cultures, Zitka-la-Sa writes: "Not a soul reasoned quietly with me, as my own mother used to do; for now I was only one of many little animals driven by a herder."[48]

This theme Zitkala-Sa raises, namely, experiencing travel in such a way that one calls to mind their own parentage, their mother, or other strong feelings of having their roots and their heritage threatened, reso-nates with a description from Beulah Hester in 1924. Had Beulah Hester and her minister husband, a Black couple, been able to take their trip that year from Greensboro, North Carolina, to his new church job and their new home in Roxbury, Massachusetts, by automobile rather than railroad car, they could have been spared the insulting and painful encounter they were subjected to when a racist family boarded their railroad car. Beulah Hester remembered that her joy and excitement at moving to a Northern city was crushed by the comments of other passengers. It is a long excerpt but very much crucial to showing the depth of the harm and its attendant feelings as Beulah Hester experienced them *en route*:

> And when we started for Boston from New York, going to Boston, and there were some people who got on in Providence, Rhode Island. And I remember distinctly. I think my husband was reading the *Saturday Evening Post*, and I had the *Ladies Home Journal*, and we were sitting next to, almost to the rear com-partment of the club car. And there were some people behind us, and the con-versation went like this, "I wonder what they're doing in here. Think about it, I just can't stand it. In the South, they have their own churches and their own schools and their own everything to themselves. Here they are, in the car with us. I can't stand it. I don't see what they're doing here." We weren't speaking. Oh, and my heart was hurting anyway [...] He didn't speak, neither did I. But we were, you know, ridiculed to the point where [...] It looked like my heart was breaking anyway, leaving my home, my mother, for the first time. And then to be subjected to something like that, I can't describe it. Neither one of us spoke. Sometimes I'd raise my eyes from the *Ladies Home Journal* and look at him; and he'd look at me. I know he wasn't reading much, but he had the *Saturday Evening Post*. And I had the *Ladies Home Journal*. And they were talking back and forth. These people sitting directly behind us. There was a comment, "Mas-sachusetts, cradle of liberty." Dear Lord, you don't know how it hurt.[49]

After that encounter, Hester had to regain her composure to make a good impression on the welcoming party from her husband's new church who met them at the Boston train station. The insulting behavior of the rac-ist family on the train had nearly extinguished the joy and excitement of starting a new phase of life with her husband, but then, to her relief, the welcoming party were indeed warm and welcoming[.][50]

The level of scrutiny Zitkala-Sa and the hostility Beulah Hester endured had the potential to ruin the transportation experience that

White women could regularly look forward to. Indeed, the confluence of "good" and "bad" experiences in Indigenous and Black women's uses of, innovations with, and responses to automobiles will continue to be complex as we continue the exploration.

Steamboat Travel

Excursion steamboats provided day trips along the Hudson River in New York State, providing passengers an escape from the heat and humidity of the cities, New York City in particular. Passengers in period photographs are primarily White. The Hudson River Day Line began in 1863 and was in operation for decades. It was noted for fast, elegant steamboats that carried thousands of passengers. The steamboats featured fine food, stately surroundings, orchestras, beautiful scenery, and fresh air. During the 19th century, the Hudson River steamboats brought passengers from around the world to Catskill Mountain resort hotels. Travel guides read by Europeans featured the overall beauty of the Hudson River Valley, the Hudson Highlands, and the United States Military Academy at West Point. Hudson River steamboats brought visitors to riverside parks for a day in the country.[51] The *Baltimore AfroAmerican* reported that segregated seating was more lax on steamboats of the Chesapeake Steamship Company. "The officers do not seem to care where the white folks sit, and the colored folks do not sit very long on the port side. One who travels there can hardly tell which is his side of the boat."[52]

A single conclusion about the benefits or drawbacks of public transit for women, whether by stage, train, or boat—especially without attention to differences in class and race in this era—is unreachable. Especially in places where reliable train or other services were prominent, the political and cultural oppressions that characterized American life in this era encroached upon public infrastructure in deeply palpable ways. Not only that, but as noted above, public transit was not equally available or equally maintained. Mass transit would not be the only pre-automotive wheels available to women, however.

The Whirl of the Bicycle Wheel— The steed that never tires

"What enjoyment to a ... woman's life is the whirl of the wheel ... it gives a woman for one brief while the chance to rejoice in the feeling of liberty and delight in her own strength."[53]—WHEELWOMAN MAGAZINE

Women's athletic activities considered appropriate in the 1880s and 1890s were those that enabled her to strive against herself. Competing against others in team sports such as baseball, football, boxing, was reserved for men. Women swam and played tennis, badminton, croquet, golf, basketball, and participated in some track and field events. Women's cycling was accepted for its health benefits. Exercise made for healthy women who could bear large numbers of children easily, so the theory went. Although their patriotic duty to bear children was probably not on the minds of the middle-class White women who took to their bicycles, the nativists' racial fears that immigrant families were having larger families than American born White families may have benefited the women cyclists, by lessening the social disapproval of the healthy outdoor activity that led to greater freedom of movement and dress.[54]

As soon as the cycles were available, women began to use the new, equal-size wheel bicycles that replaced the previous high wheel models. Women's rights advocate Susan B. Anthony said of bicycling, "I think it has done more to emancipate women than anything else in the world. It gives women a feeling of freedom and self-reliance." Maria E. Ward emphasized the independence of the bicycle in *Bicycling for Ladies,* when she insisted that women bicyclists be able to maintain and repair their bicycles without assistance. "I hold that any woman who is able to use a needle or scissors can use other tools equally well," said Ward. "It is a very important matter for a bicyclist to be acquainted with all parts of the bicycle, their uses and adjustment. Many a weary hour would be spared were a little proper adjustment given at the right time to your machine."[55]

Between the peak of the bicycle craze in 1895 and the end of the decade, there were tremendous changes in women's individual independence. Dress became less restrictive, individual freedom of movement increased, and attitudes and expectations of women's physical strength and abilities changed. Women had the opportunity to go on day trips and explore new places with their bicycles. A writer in *Wheelwoman,* a weekly British bicycle magazine with an international readership, proclaimed, "What enjoyment to a [...] woman's life is the whirl of the wheel [...] it gives a woman for one brief while the chance to rejoice in the feeling of liberty and delight in her own strength."[56]

The chances for women to enjoy bicycle rides took a leap forward with the development of the safety bicycle in the 1890s. This new mode of transport enabled people of all ages to experience the thrill and satisfaction of venturing forth on their own, going where they wished, when they wished, for as long as they wished—and faster, under their own power, than ever before. Prior to the bicycle, people traveling on their own either rode or drove horses or walked. As Frances Willard complained, long

skirts impeded walking, driving was not real exercise, and horseback riding was expensive, but "the steed that never tires" was both affordable and enjoyable. The bicycle brought women greater opportunity to get out of the house and visit new places on day and overnight trips without the expense and advance planning required by public transportation.[57]

The high wheel bicycle, precursor to the equal-sized-wheels safety version, had been available since the 1870s but was almost exclusively a young man's machine. The high wheel bicycles were difficult to mount and awkward to ride, even in pants. They were also expensive and dangerous. Prior to the safety bicycle, the tricycle was considered the only machine suitable for ladies. It was used primarily for wheeling decorously along park lanes and private drives. With the advent of the safety bicycle, women were urged to abandon the tricycle and take up bicycling as mounting and dismounting was more graceful, women could steer their way around obstacles safely, and accidents were fewer. In the case of an accident on a tricycle, it was nearly impossible for a woman to avoid getting trapped between the two large wheels on either side of her, but on the bicycle she had a greater chance to jump free and land on her feet. If she could manage her ankle-length skirt and petticoats, that is.[58]

The safety bicycle, a new import from England, was described in the July 16, 1887, edition of the Washington, D.C. *Evening Star* newspaper:

> The saddle is placed between the two wheels. The pedals, which are directly beneath the saddle and near the ground, turn a cogged wheel around, which plays on an endless chain that passes around another cogged wheel on the axle of the rear wheel. These bicycles are so constructed, the cogged wheels being so proportioned, that one complete revolution of the pedal propels the machine as far as a revolution of the pedal on a high wheel.

The many miles of smooth concrete roads of Washington, D.C., made it conducive to cycling and there were newspaper articles carried in a variety of national newspapers about the popularity, and social acceptance of women bicycling in Washington, D.C.

Dress

The bicycle aided the loosening of restrictive dress styles, a loosening begun by the more adventurous of the Victorian lady travelers mentioned earlier, such as Isabella Bird Bishop. Women could not ride bicycles when hampered by long skirts and tightly laced corsets. Cycling was dangerous and almost impossible in tightly laced corsets that hampered breathing, or in long, full skirts and petticoats that caught in the spokes and chains. Not

surprisingly, the major causes of women's bicycle accidents were clothing related. Women's riding was made more tiring by the wind catching the skirts and causing drag. Proper dress had been a concern even in the days of the more sedate tricycle when the skirt would ride up over the knees with the pedaling motion. Some women sewed lead shot into the hems of their dresses to hold them down, others secured their hems to the tops of their shoes; both methods made pedaling very difficult and tired the rider quickly. Cycling dress design drew from the idea of the riding habit, special costumes for special activities. The traditional walking dress, which hampered each step and was not conducive to walking, was quickly discarded as an option for bicycling.

Knickerbockers were another cycling costume option. The Rational Dress was a modification of the 1850s-style baggy pantaloons worn with a knee-length overskirt that had been popularized by Amelia Bloomer. The 1890s bicycling version was less baggy. It consisted of knee length pantaloons, long leggings, and a coat long enough to act as an overskirt but short enough not to interfere with the bicycle mechanism. Women's bicycles came equipped with safety guards covering the chains and the spokes of the wheels, in order to try to prevent accidents from entangled clothing.

The May 30, 1896, issue of *Wheelwoman* reported on the creation of the New Woman's Rational Dress Association, "the object of which is to popularize the Rational Costume for women while cycling." The Rational Dress Association organized "shopping expeditions in Rational Dress every Wednesday." There was also a Rational Dress League, perhaps the same organization, whose members pledged to wear the Rational Dress when cycling in public, much to the shock of the members of said public. Having the support of fellow cyclists in similar dress emboldened women unwilling to face public disapproval when going out alone.[59, 60]

Corsets of any kind were contrary to the touted health benefits of cycling, which included "expansion of the lungs." It became acceptable to replace the corset with a flannel bodice while exercising. Corsets did not disappear immediately but gradually became less restrictive and were worn less often, presumably as women cyclists who initially disapproved of the Rational Dress began to follow the fashion as it became more generally accepted.

A choice, selected by Frances Willard, leader of the Women's Christian Temperance Union (WCTU) who learned to ride at age 53, was "a skirt and blouse of tweed, with belt, rolling collar, and loose cravat, the skirt three inches from the ground; a round straw hat, and walking-shoes with gaiters." She declared it to be "a simple, modest suit, to which no person of common sense could take exception."[61]

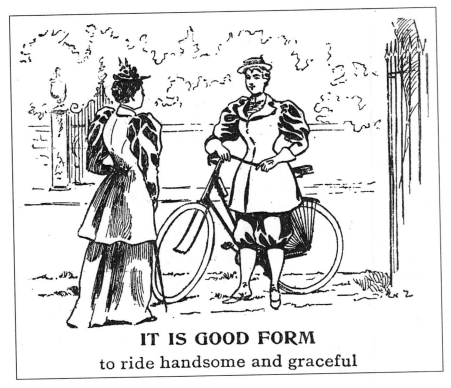

IT IS GOOD FORM
to ride handsome and graceful

"It is good form to ride handsome and graceful," says this cartoon from the magazine *Life* showing the contrast in the styles of dress. *Life,* New York, Vol. 25, p. 268, April 18, 1895 (Fenimore Art Museum Library, Cooperstown, New York, Butterfield Collection).

Learning to Ride

Once a proper cycling outfit had been chosen, the next task was learning to ride a bicycle. Bicycle academies sprang up in conjunction with bicycle sales. Some were run by bicycle manufacturers and sales agents, others by private individuals.

The media attitude toward women cyclists changed quickly from condemnation and ridicule in the early 1890s to acceptance and cover stories by the mid–1890s. Authors Judith Crown and Glenn Coleman suggest that the advertisement dollars the bicycle industry brought to the newspapers and magazines may have contributed to this change in attitude, especially during the financial panics and depressions of the 1890s.[62]

The bicycle was used for practical reasons as well as pleasure. The bicycle brought women greater opportunity to get out of the house and

visit new places on day and overnight trips without the expense and advance planning required by public transportation. Philip G. Hubert, Jr., wrote in the June 1895 *Scribner's Magazine* article "The Wheel of To-Day":

> A bicycle is better than a horse to ninety-nine men and women out of a hundred, because it costs almost nothing to keep, and it is never tired. It will take one three times as far as a horse in the same number of days or weeks. [...] The exercise is as invigorating as walking, or more so, with the great advantage that you can get over uninteresting tracts of country twice as fast as on foot. In fact, as any bicyclist knows, walking seems intolerably slow after the wheel [.]

Another advantage of the bicycle was the ability to ride in weather that would be too hot for a horse. A piece in the conservative British publication *The Girls' Own Paper* described a 55-year-old country woman who found learning to ride very difficult but was determined to continue. Her motivation to learn came from witnessing a girl cycle five miles into town to alert the fire engine when a neighboring house caught fire. The country woman thought that a wonderful thing and wanted to acquire the skill herself.[63]

Another avid cyclist, temperance reformer and president of the Woman's Christian Temperance Union Frances Willard, led a very active life of speaking tours and writing, and talked of the "nerve-wear" of having her "mental and physical life out of balance." She welcomed the advent of "Gladys," her bicycle, into her life at age fifty-three, as a return to the carefree days of her childhood. Her days of "running wild" had ended at age 16 when she was required to wear long skirts, corsets, and pin her hair up. Her two "major reasons" for learning to ride in her fifties were her doctor's mandate to exercise and her desire to be a role model for other women. Her three "minor reasons" were her love of adventure, her love of "acquiring this new implement of power and literally putting it underfoot" and because "a good many people thought I could not do it at my age."[64]

Maria E. Ward's *Bicycling for Ladies*, published in 1896, is an example of several bicycling handbooks for those who wanted to augment their formal lessons, or to learn on their own or with the help of friends. Ward suggests at least two people serve as instructors. In the introduction, she stresses the importance of women doing a new sport correctly in order to limit censure. Her book gives detailed instructions on every aspect of bicycle riding: mounting, dismounting, picking up a bicycle, pedaling, hill-climbing, proper inclination of the bicycle when mounting, mounting and dismounting over the back wheel. Ward stressed the importance of women maintaining and repairing their own bicycles. She devoted several chapters of her book to detailed instructions on the care and maintenance of all aspects of the bicycle including

mathematical formulas to explain gear ratios. Ward even included instructions on setting up a home workshop.[65]

Two ways to mount a bicycle are described as the English and the American. "The one is to get on from the curbstone, while the other is to jump on, giving the machine a push at the same time so as to start it." How the "jumping on" method was accomplished in long skirts is hard to imagine, even with the bicycle chain fully enclosed in a safety guard.[66]

Care of the bicycle shared elements of caring for a horse after a ride. It was presented with instructions given in magazines and instruction manuals to carefully wipe down one's ride and keep it in a clean and dry place. Love of the machine—whether bicycle or automobile—a carryover from the love of the horse, is seen in this advertisement in *Wheelwoman:* "All wheelwomen who love their machines enough to clean them themselves, cannot do better than give 'Garlio' a trial." In the feature, "In Moments of Emergency," instructions on how to recognize and repair a punctured tire are given: "In the tool-bag at the back of the saddle there is—or should be, if she has thus wisely taken thought for the morrow—a repair outfit."[67]

Annie Londonderry

For 15 months between June 1894 and September 1895 Annie Londonderry kept women bicyclists in the spotlight as she circumnavigated the globe on (and with) her Sterling bicycle. Annie Cohen Kopchovsky in her early 20s, a Latvian-born Jewish wife and mother of three young children living in Boston, transformed herself into athlete adventurer Annie Londonderry. Her highly publicized journey, widely followed in the international press, brought women cyclists to a wide audience. It was an era of wagered long-distance races. In 1890, journalist Nellie Bly traveled around the world in 72 days, inspired by the 1872 Jules Verne novel *Around the World in 80 Days.*[68]

Annie Londonderry's adventure was said to be a wager between two Boston businessmen with a $10,000 reward for traveling the world by bicycle in 15 months starting and ending in Boston. Rules of the wager were said to include earning her travel expenses along the way and sending home $5000 in addition. Travel by steamboat and railroad was allowed as part of the journey. She earned money by selling advertising space on her bicycle and her outfit through placards on her bicycle—first a Pope, then a Sterling—and attaching advertising streamers to her bicycle costume. The pseudonym "Londonderry" came from the paid agreement with New Hampshire's Londonderry Lithia Spring Water Company. Annie Londonderry excelled in public relations and established newspaper contacts

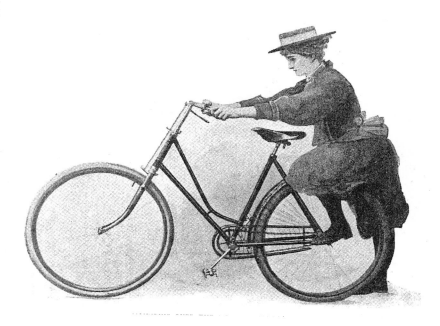

"Mounting over the wheel from the peg." Ward's model is wearing knicker-bockers, not a long skirt, but this still seems to require a great deal of ath-leticism. *Bicycling for Ladies* by M.E. Ward, p. 94. Brentano's: New York, 1896 (Fenimore Art Museum Library, Cooperstown, New York, Butterfield Collection).

at every stop. She was greeted by local cycling clubs and gave lectures about her adventures.

A master storyteller with an abundance of charm and engaging wit, Annie Londonderry knew how to deliver what her audiences wanted and told her exciting stories accordingly. She gave paid lectures at per-formance halls, made paid appearances at stores and cycling events. Her cycling costume evolved from a heavy skirt to the more sensible, albeit shocking to some, men's bicycling outfit. She started out on a heavy, Pope drop-frame "women's" bicycle, and changed to a lighter diamond-frame Sterling men's bicycle. Sterling bicycle dealers assisted with travel arrange-ments and speaking engagements. Annie Londonderry's well-publicized 15 months "awheel" helped authenticate the idea of the independent, ath-letic, free-thinking "New Woman" breaking free of the staid, corseted Vic-torian mode.[69]

The bicycle craze of the 1890s reached its peak around 1895, spurred by a dramatic fall in purchase price. Even by 1893, factories turned out hundreds of bicycles and accessories, such as brakes, bells, lights, and

locks. Profits from the sale of accessories closely rivaled those from the bicycles themselves. The bicycle price wars began in 1893 when the War-wick Company dropped its price from $150 to $85. From the beginning, there had been charges of price inflation on the part of the bicycle manu-facturers. As the bicycle's popularity increased, so did manufacturer's out-put, creating a glut on the market that further lowered the price of a new bicycle.[70]

To appeal to women buyers, who made up 25 to 30 percent of the market, showrooms were cleaned up, painted bright colors, and chang-ing rooms were provided. Planned obsolescence, a part of the marketing strategy from the beginning of the 1890s, created a market in used bicy-cles, widening their availability to the middle and working class. Barter-ing for bicycles was an active business, with people willing to trade violins, cats, dogs, or cigars for a bicycle. Bicycles were also available through auc-tion houses.[71]

Rentals were available with a steady business on weekends. Even during the week, women often rented a bicycle for a ride in the park. Rebecca Gibson Johnson remembers that young Black men would rent bicycles in Coconut Grove, Florida, and ride to visit the young Black women working as waitresses at the White tourist resort of Camp Bis-cayne, Florida, in the early 1900s. In addition, Johnson remembered that Black men and women rented bicycles from the local bicycle shop as the transportation to work: "There were bicycles everywhere, all the way into Miami. Getting around on bicycles was the livelihood of all the black boys and girls." Her cousin Joe Major was a Black man who owned one of the bicycle rental shops. This shop was outside the main business streets of Miami as Blacks were not allowed to operate businesses on the main streets in Miami.

When Miami was a small town in the 1890s, Black and White families took boat trips to Ocean Beach—an earlier name for Miami Beach—for picnics and baseball games. After the arrival of White real estate developer Henry Flagler, Carl Fisher, and the development of the Florida East Coast Railway and Miami Beach respectively, segregated spaces were established and Blacks were limited in their ability to travel to the former recreation areas.[72]

By the end of the 1890s, nearly every major British and American national magazine had devoted cover stories to bicycling, and there were several magazines devoted exclusively to cycling, both men's and women's. The British *Wheelwoman* claimed an international readership of 70,000. Others, including *The Wheelman*, were American in origin and advocated road improvement, founding the Good Roads Movement, which worked at the national and local level for the transformation of rutted, dusty or

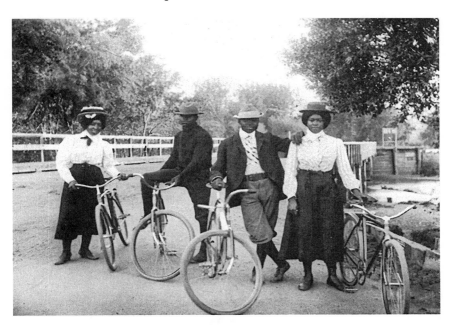

Four cyclists stop for a photograph on the Alameda Avenue Bridge, Denver, Colorado, circa 1905 (History Colorado—Denver).

muddy roads into smooth roads. The mucky roads of the Midwest were featured prominently in the travails of early automobilists who continued the advocacy of road maintenance. Early automobile registrations and driver's license fees were instituted ostensibly for that reason, namely, to pay for road improvement and maintenance.[73]

In addition to magazines and instruction books, many cycling clubs for both men and women encouraged group rides, and published road guides with recommendations of places to eat, lodge, and have bicycles repaired. These cycling road trips led to a resurgence in the use of the old stagecoach inns and wayside stops that had languished after railroads became popular in the latter quarter of the 1800s, diminishing stagecoach travel. *Wheelwoman* ran notices of women looking for bicycling companions for both day and overnight bicycle tours, stories of recommended tours with suggested rest stops and sites to see. The publication also ran a series called "Snacks for the Satchel," that recommended fruit as the healthiest bicycling snack, as well as easy-to-carry sandwiches. Enterprising farmers set up roadside stands to sell food and drink to the touring bicyclists. Roadside stands continued to economic and nutritional advantage in the automobile age as John D. Long and J.C. Long wrote in 1926 of the motor camping week-enders. "The tendency more and more will be for

the week-ender to take occasion on his outing to stock up with fresh vegetables, eggs and fruit, thus giving the farmer a more profitable market for his products and giving the city and town dweller fresher and more wholesome food."[74]

The bicycle craze peaked around 1895. As we will see, it soon gave way by 1900 to the next new thing, the automobile. But in the last decade of the 19th century, the bicycle was a catalyst for transformations in women's dress, social and individual attitudes towards women's physical strength and abilities, and women's view of their own individual independence. What Maria E. Ward wrote of the "absolute freedom of the cyclist"—including the cyclist's sense of independence, her ability to travel beyond the end of the railroad line, and her ability to explore new areas beyond walking distance—would soon apply to the automobilist, but predictably, not with equal advancement for all races and classes.

Black, Indigenous, and White women all utilized travel, tourism, and related businesses as they worked to gain greater freedom to improve their quality of life. Travel involves three sets of participants: the tourists, the tourism industry, and the local residents. The tourists are those who travel from one point to another to gather new experiences; the tourism industry develops to provide food, shelter, necessities, and mementos to the tourists; the local residents become part of the tourist experience by design or by chance, photos of local residents become mementos, local art purchased by tourists provides economic benefits to local communities, the tourists and the locals form

Woman bicycle messenger. No more messenger boys for the National Woman's Party—from president to messenger, all the members of the staff are feminine. This is in accordance with the stipulation of Mrs. Belmont when she donated the National Woman's Party headquarters. Photo of Julia Obear, messenger (Library of Congress).

opinions of the other in the tourist environment and those opinions are seen as an accurate representation of a different aspect of society. The political and social restrictions of the early 1900s shaped the ways Black, Indigenous, and White women utilized travel, tourism, and related businesses as they worked to gain greater freedom and improve their quality of life.[75]

Mainstream magazines featured articles and entire issues giving women the information they needed to plan trips to different parts of the country. Travel as a means of becoming an educated person developed alongside the fitness movement emphasizing the need for urban-dwelling men and women to spend time on exercise and in the fresh air. Black educator Dr. Anna Julia Cooper wrote in 1892 that "There can be no true test of national courtesy without travel. Impressions and conclusions based on provincial traits and characteristics can thus be modified and generalized."[76]

CHAPTER 2

The Dawn
of Independent Mobility

Harvey Houses

Restaurateur Fred Harvey's partnership with the Atchison, Topeka & Santa Fe Railway in the 1870s elevated the rail travel dining experience from unpalatable food to, primarily for White railroad passengers, reliably tasty meals served quickly to get passengers back on the trains headed West without delay. Over the years, Harvey Houses expanded from dining stops to hotels such as those Emily Post and other automobilists mention in upcoming chapters.[1]

In an era when waitressing was not considered a respectable form of employment, the standards maintained by the 100,000 women who came West between 1883 and 1940 to work as Harvey Girls helped change that perception. Author Lesley Poling-Kempes writes: "Harvey Girls knew they made Harvey Houses what they were: the finest eating establishments in the West, even in the United States. They were proud of their jobs, their skills, their professionalism."[2]

Restaurateur Fred Harvey worked with the Atchison, Topeka & Santa Fe Railway to establish fine dining along the railway. Harvey Houses and the Harvey Girl waitresses set a new, high standard for railroad dining and became: "...islands of American culture, linked to the 'homeland' by the Santa Fe rails." In the 1880s when Harvey Houses were started, Harvey set strict guidelines for his waitresses. The employment office in Chicago primarily hired White women (no Black women, a few Hispanic and Indian women) with high school or eighth grade educations between the ages of 18 and 30 with good manners, clear speech, neat appearance, and no vulgarity, for twelve, nine, or six month waitressing contracts. Women of color were hired as maids and dishwashers and for pantry work. The women left for training 24 hours after they were hired. Harvey Girls had strict curfews with a mandatory residence in the dormitory where the

rooms were immaculately kept, cleaned by maids. They received good pay and good tips. The standard uniform at all Harvey Houses set the waitresses apart. Fred Harvey's corporate paternalism and strict standards elevated the reputation of waitresses.[3]

Single White women of rural backgrounds had the opportunity to move up economically and socially by working as a Harvey Girl. Fred Harvey offered an educational opportunity for White women who couldn't afford college. Women were able to send money home as they had very few living expenses, room and board being provided. A seasonal work schedule allowed farm girls to return home for harvest, with schoolteachers replacing them during school vacation. Work as a Harvey Girl provided working-class White women an opportunity for travel, adventure, independence, self-esteem, a new life in the West and for those who didn't need to send money home, the opportunity to build up a savings account.[4]

Fred Harvey's paternalistic management style prohibited waitresses from dating male Harvey employees, but allowed socializing with railroad workers and the local men. In the early 1900s, permission from the house manager of the dormitory where the women lived was required before they were allowed to go out on a date. The respectability of being a Harvey Girl overcame the potential stigma of being a woman away from her family, working for a living and traveling independently. In the words of Santa Fe Railroad employee Lenore Dill, quoted in Beverly West's *More Than Petticoats: Remarkable New Mexico Women*, "Anybody could ride in a covered wagon, but only a lady could become a Harvey Girl."

Women had the opportunity to choose where they wanted to work and could change every six months if they wished. The eastern terminus of Atchison, Topeka & Santa Fe Railway was Chicago and the line extended across the southern Midwest of Missouri, Kansas, Oklahoma, throughout Texas and across the Southwest of New Mexico, Arizona, and through California to the Pacific Ocean. For a young, rural White woman of limited economic means, the opportunity to travel the western United States safely and independently while earning a living wage, provided an educational opportunity unavailable elsewhere. Further, their connections with the Santa Fe railroad employees enabled the women to recommend their male family members for jobs on the railroad.[5]

Rail travel across the Western United States was in sharp contrast to the comfortable and well provisioned dining cars of rail travel in the Eastern United States. The early days of the transcontinental railroads allowed for twenty-minute meal stops. Those meals, for which the passengers paid extra, were described as greasy fried meat, canned beans, stale coffee, hard biscuits served in dirty dining rooms. Those passengers who brought their own food found the long train ride in the heat made the food unappealing.

The Harvey House restaurants in contrast provided clean surroundings, pleasant service and appetizing meals served within the stop. "It may be on the desert of Arizona, a hundred miles from water, but if it is a Fred Harvey place, you get filtered spring water, ice, fresh fruit and every other good thing...."[6]

The approaching train telegraphed the Harvey House of the number of people onboard. When the passengers disembarked, they were ushered to their seats where the fresh, hot plated meal was ready to eat. The food at each stop on the transcontinental route was coordinated so passengers were served different meals at each stop. The menus rotated every four days and could include Blue Point oysters on the half shell, roast sirloin of beef, ice cream, fruit, cheeses, a special blend of coffee made with fresh water free of alkali bitterness. And pie, generous slices of pie cut into four pieces rather than the traditional six pieces. Male customers were required to wear a jacket, provided by the restaurant if needed. The jacket rule was not a welcome one amongst the cowboy customers. While good food and attractive waitresses were welcome, fancy clothes were not.[7] We will see how automobilists venturing across the western United States also enjoyed Harvey House meals. But first, a look at the earliest days of automobile development and travel.

Women During the Experimental Era of Automobile Development

In ways that have been vastly understudied, women helped popularize automobiles from the very beginning of the experimental stage in the 1880s and 1890s. Even when self-propelled vehicles were in the prototype phase, they were driven by women. The October 1899 issue of *Automobile* magazine wrote an article about an experimental vehicle created 32 years earlier, a steam-carriage built and run by Frank Curtis of Newburyport, Massachusetts, in 1867, and included an image of his aunt, Miss Betsy Carr, operating the vehicle.[8]

White inventor Frank Curtis made the machine to order for a Boston man and reclaimed it when the purchase fee was not forthcoming. He ran the vehicle for 11 years. His first passenger was the Reverend Dr. Seymour, a minister who needed to make an out-of-town visit to a parishioner and return to town in time for the evening worship service. Frank Curtis's machine, with a top speed of 25 miles per hour, made the trip easily and was the topic of the minister's sermon that evening. Frank Curtis took the vehicle off the road after an encounter with the sheriff responding to a complaint by a local coachman. He evaded arrest by outrunning the

sheriff who was in a horse-drawn carriage, and then made it over the town line to where he hid his steam carriage in a barn.[9]

Women, mostly White women related to inventors with access to motor vehicles in their homes, learned to operate the new technology early. Karl Benz patented the first practical motorcar in 1886, after Nicholas Otto's 1876 patent on a four-stroke internal combustion engine was invalidated by German courts. In 1888, Bertha Benz, Karl's wife and financial backer, along with their two teenage sons, drove the prototype Model 3 more than sixty miles from Mannheim to Pforzheim. This first long-distance trip, taken without Karl Benz's knowledge, demonstrated the practical uses of the Benz motor wagon by cutting the travel time by horse-and-buggy in half. The trip avoided violating local Mannheim law, which prohibited Karl Benz from taking long drives but permitted him to take short drives on specified streets; the law also held Karl Benz responsible for any accidents. Bertha Benz wasn't included in the law. Thus the plausible deniability of not telling Karl Benz about the drive.[10]

There were no accidents on the 1888 Mannheim-to-Pforzheim trip. They refilled with water to cool the engine at every opportunity along the route, as there was no radiator in the first vehicle. Ligroin, the dry-cleaning fluid used as fuel, was available in small quantities at pharmacies, so they stopped at each pharmacy to purchase the fuel needed to keep the vehicle running. Bertha Benz's hat pin cleared the clogged fuel line. The need for additional gears, more horsepower, and stronger brakes was made evident as they traveled up and down hills. The stripped leather brake-lining from the downhill trek was replaced by a shoemaker. The broken spring cable was replaced by Bertha Benz's rubber garter belt.

As darkness fell on the final mile to their destination, the way was lit by curious townspeople who had heard of the approaching vehicle. The townspeople were carrying lanterns to light the way as the vehicle had no headlights. During the stay in Pforzheim, Bertha Benz and her two sons drove her mother around to neighboring towns and villages gathering crowds along the way. Bertha Benz talked about the potential of the vehicle and demonstrated its use. Bertha Benz's drive established both a practical use for the "motor wagon" and provided evidence that it was worth putting into production. The repairs she made along the way also set the example for the improvement of future vehicles.[11]

Fairs and expositions were popular and effective venues for displaying and sharing new automotive technology. In 1889, future European automakers André Citroën and Louis Renault, then schoolboys, were introduced to automobiles at the Exposition Universelle in Paris. In 1888, Benz motor wagons were displayed at a Munich, Germany exposition. Continuous European automobile production began in 1885 with the work

Miss Betsy Carr operating a steam-powered vehicle in 1867. *The Automobile Magazine*, October 1899, 133 (courtesy New York State Library, Albany, New York).

of automakers in Germany and France. French automobile production, aided by the high quality of the roads in France, was underway by the late 1880s and early 1890s. French automaker Panhard et Levassor was issuing regular catalogs of available models by the early 1890s. By 1893 there were enough automobiles on the streets of Paris that the Parisian police required driving tests and issued the first registration plates and driver's licenses.[12]

The painting by American expatriate Julius Stewart shows the Goldsmith sisters, fellow American expatriates, driving an 1897 gasoline-powered Peugeot in the Bois de Boulogne just outside the Paris city limits. The Peugeot automobile manufacturer introduced a steam-powered automobile at the 1889 Exposition Universelle in Paris. Steam-powered automobiles required a long warm-up time and were bulkier than the gasoline-powered engines that the Peugeot automobile manufacturer began producing shortly after the steam-powered engines.[13]

American-made automobiles were exhibited for the first time at the 1893 World's Columbian Exposition (Chicago World's Fair) in Chicago, Illinois. Three years earlier, the fair organizers announced a prize for the best mechanical road vehicle exhibited at the fair. Elwood Haynes

of Indiana and brothers Charles F. and J. Frank Duryea of Massachusetts were among the inventors to attend the 1893 fair. The Duryea brothers displayed a gasoline-powered automobile developed in their Chicopee, Massachusetts, bicycle shop. A single-cylinder, four-horsepower engine was mounted underneath a carriage body and featured friction drive. Charles Duryea said the exposition encouraged American automobile inventors "who had been discouraged by ridicule and pity 'to take a fresh hitch at their trousers.'" The Duryea brothers designed their automobile based on descriptions of the Benz vehicle in an 1889 copy of *Scientific American*.

Horsepower—the common unit of power; i.e., the rate at which work is done. In the British Imperial System, one horsepower equals 33,000 foot-pounds of work per minute—that is, the power necessary to lift a total mass of 33,000 pounds one foot in one minute. This value was adopted by the Scottish engineer James Watt in the late 18th century, after experiments with strong dray horses, and is actually about 50 percent more than the rate that an average horse can sustain for a working day.[14]

Safety was a primary concern of the early inventors. By February 1895, Charles and Frank Duryea were confident enough in the safety of their latest horseless carriage to take their wives for a ride. Elwood Haynes, experimenting with a gasoline engine in the kitchen of his Kokomo, Indiana, home, nearly set the kitchen on fire when the vibrating engine broke free of its support and bounced around the kitchen. Elwood Haynes' wife banished him from using the kitchen for his experiments. He built a workshop where he developed a two-piston, horizontal-stroke engine that ran much more smoothly.[15]

Early automobile manufacturers on both sides of the Atlantic were interested in proving the durability and ease of use of their vehicles and promoting the new technology as viable. Automobiles participating in the 732-mile Paris–Bordeaux–Paris reliability race held in June 1895 achieved notable sustained speeds, quick servicing stops and the first finish accomplished in 48 hours. Gasoline-powered engines performed better than steam and electric-powered engines and turned in times unimaginable for horse-drawn vehicles. The French reliability race was closely watched by American auto-enthusiasts, and it was an inspiration for the first American race, held in Chicago on Thanksgiving Day, November 28, 1895.[16]

Distance and speed races were sponsored by local businesses, including newspapers, to publicize and promote the new technology. Herman H. Kohlsaat, publisher of the *Chicago Times-Herald* and an official of the 1893 Chicago World's Columbian Exposition, sponsored the 92-mile round-trip run from Chicago to Waukegan, Illinois. The original plan of a run from Milwaukee, Wisconsin, to Chicago, Illinois, was abandoned due to

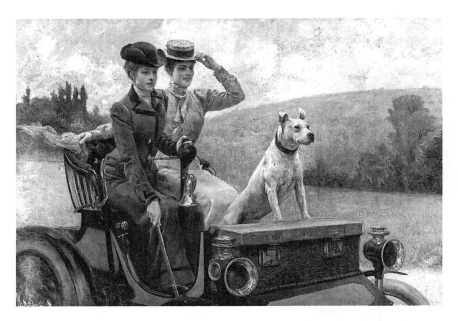

Julius LeBlanc Stewart (French, 1855–1919), *The Goldsmith Ladies in the Bois de Boulogne* in a Peugeot in 1897. The dog is enjoying the breeze; the arrival of windshields would prove a disappointment. 1901, oil on canvas, 59¹⁄₁₆ × 68⅞ in. (150 × 175 cm.) (Musée National du Château, Compiègner via WikiArt).

the poor condition of the Wisconsin roads. Herman H. Kohlsaat, who had read European automobile publications and had seen automobiles first-hand on a trip to Paris, was a believer in the potential benefits the horseless carriage would bring to the public. A well-publicized contest could also boost his newspaper's circulation—if it was successful. If the automobile race failed, Herman H. Kohlsaat and the race participants risked humiliation from the negative publicity of rival newspapers, who ridiculed the race as soon as it was announced.[17]

The $5,000 prize and national publicity for the winner were powerful incentives to potential race participants. The four-month preparation time from the July announcement to the October qualifying trials proved a challenge to new automakers, and gave an advantage to those with operational machines already on the road. To enter the race, vehicles had to have three or more wheels, an independent motive power source, and be proven safe and superior to a horse and wagon. For those interested in putting the automobile into commercial production, the Chicago race was an excellent opportunity to prove the superiority of their particular vehicle. Or the end of their plans if the vehicles failed to complete the race. The day of the race, the original field of 35 interested participants was down to six

with automobiles that had been built by the deadline. The drivers faced the challenge of driving through 12 inches of heavy, wet snow. The gasoline-powered vehicles were the best equipped to operate in wet, snowy weather.

Frank Duryea was the driver of the first of the two vehicles to finish the race with an average speed of less than eight miles per hour. The wagon pulled by two horses following the racers was unable to make the 54 mile run, proving that the gasoline-powered automobile could go where a horse-drawn vehicle could not. The national publicity generated by the race helped launch the Duryea Motor Wagon Company. The race also increased the inventors' awareness of each other—many more individuals were working on automobile production than most of them realized. An article in the August 17, 1901, issue of the *Baltimore AfroAmerican* reported that five additional special examiners had been hired at the automobile section of the Washington, D.C. Patent Office. The division was made up of four sections: electro motors, steam motors, gas and acetylene motors, and compressed-air motors.[18]

The Black-owned C.R. Patterson & Sons Company of Greenfield, Ohio, transitioned from the wagon-making company founded by Charles Richard "C.R." Patterson to producing Patterson-Greenfield automobiles and later trucks and buses. C.R. Patterson, settled in Greenfield, Ohio, after freeing himself from a Virginia plantation in 1861. C.R. Patterson built up a horse-drawn vehicle making company and realized the importance of expanding into the manufacture of automobiles. His son, Frederick Douglass Patterson, founded the automobile branch of the business in 1910 offering repair service with the first automobile available in 1915.[19]

The Black newspaper *Chicago Defender* published an announcement on October 2, 1915: "'Patterson-Greenfield' is the name of the new automobile made by the famous firm of buggy makers, C.R. Patterson & Sons of Greenfield, O. The car is said to embody many distinctive features and to in every way measure up to the Patterson standard of excellence." The company continued to repair and produce "Everything a Motor Drives—Everything a Horse Pulls" until closing in 1939.[20]

Horses

In the first decade of the 1900s, the reactions of horses to automobiles were the focus of humor, annoyance, and restrictive automobile driving laws. As automobiles moved beyond being the experiments of their builders and became the playthings of the wealthy, resentments began to build between the automobilists and the not-yet-automobilists. Automobile

magazines advocated automobiles as safer, quieter, healthier, and cheaper than horses. These arguments were stated years before the automobile was an option, in an 1881 *New York Times* editorial. The author realized horses were necessary for the movement of goods, people, and fire protection equipment, but he pronounced horses as animals prone to skittishness and disease, who were expensive to maintain, "he munches greenbacks when he eats," and whose hooves tore up the pavement and created "stone powder," which, when mixed with horse droppings, produced "especially disgusting" street filth. The writer conceded that "some motive power beyond our own muscles is of course indispensable" but advocated that the horse be considered indispensable only "until some better instrument enables us to dispense with him."[21]

The 1881 *Times* editorial cited the 1872 epizootic of equine influenza that crippled Canada and the United States. The epidemic was first tracked to infected horses imported from Canada through Detroit in September 1872. According to the editorial writer: "A general cold in their heads, as was the case in 1872, disorganizes everything, would reduce the population to walking, and would cut off their food supplies." By early December 1872, the epizootic had swept across the eastern half of the United States and as far south as Havana, Cuba. Individual animals were sick from five to 45 days, but were too weak to work for a much longer time. The Report of the Commission of Agriculture attributed the majority of equine deaths to overwork before the horses had fully recovered from the disease and were back to full strength.[22]

An 1899 editorial in *The Automobile Magazine* titled "The Transition" remembered the 1872 epizootic and how the vast majority of horses were affected, bringing transportation of goods and passengers via canal boat, wagon, horsecar, and omnibus traffic to a standstill. In a few cases, employees of the horsecar and omnibus companies hauled the cars by hand, offering passengers a ride at a per rider cost much higher than usual. The lack of healthy horses to bring fire engines to the scene resulted in a devastating fire in Boston. The possibility of another epizootic—potentially even more devastating given the westward expansion of the intervening years—led the editorial writer to praise the "transition to the era of mechanical traction" then underway.[23]

The concern over diseases spread from horses to humans was another argument used in favor of the automobile. The "stone powder" mixture of horse droppings and street filth mentioned in the 1881 *New York Times* editorial contributed to the spread of tetanus, known also as lockjaw. Dr. James J. Walsh, in his article "The Automobile and Public Health" traced annual increases in tetanus cases—fatal in 60 to 90 percent of patients— to shortly after the Fourth of July. Celebrants shooting off fireworks in the

street could get a slight burn which would be infected by street dirt and tetanus could set in. Dr. Walsh also traced summer increases in cases of cholera and dysentery to street dirt.

Flies were the most prevalent summer nuisance and disease carrier associated with stables and horses. Flies used stables as breeding grounds and horses as a food source. Proponents argued that as automobiles did not appeal to flies, replacing horses with cars in the crowded city environment would benefit public health. Stable fires that killed horses and spread to nearby buildings were another common hazard that automobile use would alleviate.[24]

Another advantage of a horseless city would be a decrease in the number of cases of cruelty to horses. The American Society for the Prevention of Cruelty to Animals was founded in 1866 with a primary focus on the humane treatment of horses. Forced to haul heavy loads on the public streets in all kinds of difficult weather—sleet, ice, snow, heat—exhausted horses suffered from beatings as the drivers attempted to keep to strict delivery deadlines. The carcasses of dead horses were sometimes left on the sides of the streets. These were usually soon claimed for the money they could bring when sold to tanners and renderers. Horse carcasses were used for a wide variety of products including pet food, soap, upholstery, oils, and bone handles for cutlery. As much as, or more than, an average week's wage could be realized from a single horse carcass.[25]

Noise was second only to filth in the argument against horse-drawn vehicles—at least during the years before the popularity of the gasoline engine, considerably noisier than steam or electric vehicles. "A horseless city means a clean city, a quiet city, a wholesome city, a more odorless and beautiful city." This idealized image of a horseless city attributed the "vast and overwhelming din" of the modern city to the clopping of hooves and the dragging "bumpingly, poundingly, crashingly, with unceasing rattlety-bang, the endless procession of clamoring carriages, wagons, carts, and drays."[26]

The author of the 1881 *New York Times* article continued, "His [the horse's] perpetual cowardice, considering that he is provided with defensive weapons at each end, and also with fleetness to escape danger, makes him the cry-baby among animals. Even the helpless sheep should shame him, for it does not start [react] at scraps of paper and banks of dirt." The skittishness of horses was an over-arching concern of the early automotive era. Educating horses and their drivers as to the ways of automobiles was a topic of concern to writers and readers of the early automobile magazines. Opinion was divided over whether the horse, driver, or automobilist was the most at fault in the early encounters between horse-powered and horseless carriages.[27]

In the spring of 1900, the beginning of motoring season, the White-owned publication *Horseless Age* reported approvingly of a motorist who advertised in his local newspaper that he would bring his automobile to the stables of any interested horse owner. It was thought that by introducing horses to automobiles under controlled conditions, horses would not be frightened when encountering them on the road. This method would also introduce horse drivers to the automobile at the same time. There were repeated complaints by automobilists that horses got out of control at the sight of an automobile because the horse driver was distracted by the sight of the automobile and lost control of the horses.[28]

Education of the people, as well as the horses, was the aim of the "Lessons of the Road" department in *The Horseless Age*. It was agreed by both sides that the worst way to handle a horse-automobile encounter was for the automobilist to stop the "shaking, thumping machine within twenty feet of the horse's nose," thus adding to the horse's fear. Far better, agreed an automobilist in 1899 and a horse driver in 1905, was for the automobilist to move as quickly and quietly past the horse as possible, especially when operating a gasoline vehicle which were the noisiest of all the automobiles. "The unpleasant moment (and by watching the faces of automobilists I have learned that it is usually unpleasant even to them) is thus much shortened," wrote Allen French in a letter to *Country Life in America*. French wrote to *Country Life* as he felt it was the general interest magazine that reached more automobilists than any other publication at that time.[29]

Another suggestion to calm a frightened horse was to speak reassuringly to it. "Very often the driver of the horse is too much absorbed in looking at the motor to speak to his animal himself, or has lost his presence of mind altogether at the strange spectacle," wrote Sylvester Baxter in *The Automobile Magazine*. The idea that the new machine was human-driven was thought to be comforting to the horse, according to Baxter. He compiled a six-week survey of newspaper accounts of runaway horses—startled by non-automobile causes—to build the case that horses had a history of causing accidents long before the advent of the automobile. In another article, Baxter proposed creating horse-automobile training schools because "The greatest drawback to a much more rapid introduction of the latter for domestic purposes, both of pleasure and general utility, is the fear of frightening horses." Baxter pointed out that horses were trained to work in hazardous conditions as both war and as fire engine horses, thus they could be trained out of their fear of automobiles.[30]

The Black-owned and operated newspaper *Chicago Defender* carried a story from Somerville, New Jersey, headlined "Daring Rescue by Woman in An Auto. Dashes after Runaway Horse and Grabs Child from

a Flying Milk Wagon" in November 1912. Mrs. Rogers spotted a runaway horse pulling a milk wagon owned by S.P. Nevius. Also in the wagon was a six-year-old girl. The horse sprang away from Mr. Nevius just after he had untied it. Working together with streetcorner policeman Edward Ramsey, Rogers accelerated her car as the pursuit began, then sped up to close the half-mile gap to get around the horse to slow it down, while calling to the little girl to stay in the wagon and not try to jump. John Logan, a farmer, heard the loudly tooting horn as they approached, pulled his buggy to the side, grabbed a horse blanket, stepped into the path of the horse and with a lucky throw tossed the blanket over the horse's head as it approached.

> The blinded animal slackened its speed to such an extent that Mrs. Rogers was able to run her automobile alongside the milk wagon while Policeman Ramsey leaned out and caught the child safely in his arms as she jumped from the door. The horse brought up head on against a fence and was captured. Mrs. Rogers is known as one of the most daring women automobile drivers in this section.[31]

The *Chicago Defender* newspaper carried a similar story in the May 25, 1912, issue of a runaway horse pulling an express wagon running full speed through a crowd of pedestrians. A Black chauffeur driving a "large, magnificent automobile" sized up the situation and sped up to get in front of the runaway horse. He slowed the automobile down gradually, forcing the horse to slow down to a stop and bringing the situation under control.[32]

First Encounters

Early copies of White-owned automobile enthusiast magazines such as *The Automobile Magazine* carried articles by and for women automobilists encouraging them to take up the new sport in the late 1890s. An *Automobile Magazine* article entitled "The Oldest Chauffeuse" described White Philadelphia resident Mrs. Sarah Terry celebrating her 108th birthday by taking her first automobile ride—in an electric hansom cab in Philadelphia. It is a delightful example of women's eagerness to travel faster than walking speed as soon as the technology was available, no matter their age. The hansom cab Mrs. Terry rode in was a modification of the two-wheeled horse-drawn covered carriage with the driver's seat above and behind the passengers. Mrs. Terry said, "It's so exhilarating, I don't see why people use horses when they can go like this. I am not nearly so uneasy as behind a skittish pair of horses."[33]

A few years earlier, bicycle enthusiast magazines carried similar articles that emphasized the freedom of movement and ability to travel under their own power farther than they had been able to previously, and with a

newfound spontaneity. Mrs. Terry's driver started the vehicle slowly "that she might not be startled" and the electric vehicle on the paved Philadelphia streets rolled along noiselessly, gradually picking up speed.

> The wind blew the old lady's bonnet strings till they fluttered out behind, but she sat up like a major, enjoying the novelty to the fullest extent. The faster the automobile went the better she liked it. The evident amazement of other old ladies she passed afforded her the greatest amusement.[34]

During her two-hour ride she asked that the automobile stop at the houses of her friends so they could see her with the automobile. At the end of the two hours, she insisted she was not tired, saying, "it did not shake me up as ordinary driving does, and I do not see why I cannot stay out the rest of the afternoon."[35]

It took until 1923 and lots of encouragement by her son, grandson and friends for Mrs. Martha Beckley, an 87-year-old Black Washington, D.C., resident, to be persuaded to take her first automobile ride. Where the son and grandson had been unable to get her into an automobile, her friends Mr. and Mrs. Fortuna prevailed. The Black newspaper *Chicago Defender* reported that they "drove up to the Beckley home, entered, dressed Mrs. Martha in her best, picked her up bodily, put her into their gas buggy and started this 87-year-'young' lady off on a new phase in her young life." Mrs. Beckley particularly enjoyed the drive past the White House where her husband, Edgar Beckley, Sr., had worked as special messenger (on horseback) of the presidents beginning with the administration of Ulysses S. Grant in 1869.[36]

Excitement over the ability to travel without any visible motive power and the attention drawn by the new technology permeate early automotive literature. The perception that motorists were vain as well as excited about their new purchases is seen in the feature from the comic magazine *Life* "The Automobile Face." The passenger's joy of an automobile ride being "very like that of sailing through the air on wings," and "skimming along, dodging hither and thither like a swallow, and enjoying a buoyant exhilaration" is contrasted with her listener's response that she was getting the "automobile face [...] proud and puffed up, as if she were somebody better 'n' any other woman. That's the way they all look."[37]

As early as April 1896, speed was identified as a primary factor in the appeal of the automobile. M.H. Daley wrote in *Horseless Age* that the desire for speed had led to sacrificing the strength of the ox for the speed of the horse in hauling freight and passengers, and even then horses were abused to move faster. Daley wrote that the bicycle was faster than a horse-drawn carriage and concluded: "There would be no call for the motor vehicle if greater speed was not desired."[38]

Clouds of dust began to be associated with an approaching automobile as Pearl Snider, a White girl of Ripley County, Indiana, remembered: "We looked up and saw a dust storm, it was about a mile from where we were. We could see it was an automobile coming, and I started to run; and believe it or not, I was back in time to see the automobile [go by]. We didn't see too many at that time, so this was quite a thrill."[39] It was in this context that the first encounter with an automobile inspired some memorable reactions. The first time Esther Mae Scott saw a car, as a young Black girl going to fetch water in rural Mississippi around the year 1900, she thought the cloud of dust approaching signaled a herd of cattle being driven to market. As her mother had taught her:

> [...] "if you see a cloud of dust coming, make it to some place, a house or shack, and get under it, to be safe, because those animals, three and four hundred of those things, will stamp your child and kill him." Course there was plenty of children out there had been killed like that. And we didn't forget that. So I looked down the road that morning and saw that dust coming, I thought it was cattle. And I didn't hear no man hollering, "AAAuuugggh! AAAuuugggh!" Cause they used to make a noise and popping they whip. And this thing is coming closer and closer. Now I look and saw this black thing coming. And no mules or horses, and nothing hitched to it. I took off like a jet. I thought the world was coming to an end. It scared me out of my wits.[40]

Esther Mae Scott and her brother hid in the marsh until their mother came to find them. Based on their description of "something black going down the road, and people in it and honking, blowing horns," she explained that they had seen their first automobile. The car passed them again on the way home and startled the mules into bolting with the wagon filled with people and bags of cotton. Scott's mother understood how her children had been frightened.[41]

A few years later when Esther Mae Scott was traveling as a musician, the band used an automobile for travel. They could make better time in the truck than with a mule-drawn wagon, and despite the need for gasoline being a constant, it was more convenient to buy gas for the truck than to feed the mules. During this period of legalized segregation, the uncertainty of finding safe accommodation and the ever-present threat of violence against Black communities meant that automobiles, in many ways, provided a more secure form of travel. Decades later singer Harry Belafonte wrote of not being allowed to stay at the White-owned hotels and resorts where he was performing. To avoid the dirty and inadequate accommodations offered, which could be several miles from the performance venue, adding to the inconvenience, Belafonte arranged to stay in private homes of friends and acquaintances.

Black travelers who had one could use an automobile to avoid the

"sundown towns" that forbade them within the municipal limits after sundown or a specific time of day. In the days before the published Black travel guidebooks, word of mouth and advertisements in Black newspapers gave Black travelers information about safe places to stay and stop for supplies. Mrs. Dora P. Campbell ran this ad for her Boarding & Lodging House at the corner of Mary and Nassau Streets in the Charleston, South Carolina, *Afro American Citizen* in January 1900: "Anyone desiring first class boarding and lodging by the day, week, or month, Persons seeking a fine place of retreat will do well to call at this house. Everything in first class order."[42]

While advantages of the auto were making themselves known, memories of certain perks of horse travel remained. The horse's ability to find its own way along a familiar route had long meant, in many places, that small children could travel by themselves. Beulah Mardis remembered riding a pony when she was four years old, with her three-year-old cousin riding behind her to a birthday party two miles away. It was considered safe because the only car in the rural Indiana vicinity belonged to the doctor. It was this lax attitude about driving horses that would soon infuriate the early automobilists.[43]

Masa Scheerer remembered the first automobile in her Indiana town, driven by a man who drove fast, tooting the horn to scare the animals. Though she thought the big red car was beautiful, the buggy drivers who had to control and calm their horses as he passed were of a different opinion about reckless automobile drivers. Automobilists who gave children their first ride in an automobile provided lasting memories to the new automobile enthusiasts. Even just sitting in an automobile was a thrill: "I didn't get to ride in it [the Ford], but the little girl whose Daddy had the car invited me over to set in the car with her one day, and I thought I was really doing something to set in that car." One of the drawbacks of a first automobile ride was the walk back: "A Doctor Hess, the veterinarian, came to doctor the cows. That was the first automobile I had rode in. It didn't have a top in it, and just one seat. You know, he took me up the road for a whole mile and let out to walk home. That was the longest mile I ever walked in my life, because we went so fast, and then I came home so slow."[44]

Not everyone made the transition from horse and buggy to automobile. For some, replacing the buggy horse with an automobile sharply curtailed their independent travel. Robert Lienert remembered his mother's experience in Nebraska; married in 1906, she had her own buggy horse and was free to come and go independently. Lienert writes, "When she wanted to visit a neighbor or go to town, she'd whistle for her horse and he'd come to the barn. She could harness him and hitch him to the buggy and be on her way. As a result, she was more independent than

were many farm wives." In the 1920s, the buggy horse was displaced by an automobile, which his mother never learned to drive. After that, she was dependent on others for transportation and as Lienert's father preferred to stay home, she was more homebound than when she had her own horse and buggy.[45]

Physician Automobile Use

Physicians were early users of the automobile as they found it useful while making house calls in all sorts of weather. As leaders in their communities, the adoption of automobiles for practical purposes by physicians helped the new technology gain wider acceptance. Physician Dr. Carlos Booth of Youngstown, Ohio, designed his own motor carriage in December 1895, after he and his wife were in an accident caused by a runaway horse. His wife nearly died, and his horse was killed in the accident. By spring of the following year, he was using the vehicle on his regular physician's rounds. Ten years later, in 1905, Dr. Kate Campbell Mead wrote a piece for *Horseless Age* describing her experience as a horse-lover learning to drive a gasoline automobile. The answer to the question posed by the title of her article: "Should a Woman Doctor Use an Automobile or a Horse?" was an automobile. Dr. Mead concluded that "an automobile is more practicable for a woman doctor than a horse I have no doubt."[46]

The 1903 Ford sales brochure "The Ford High Grade on any Grade" featured a cover illustration of a woman driving the 1903 Ford model. The brochure included this enticement: "The busy physician has no business undergoing the fatigue and excitement so often attendant on driving by turns a weary or spirited horse to the houses of his patients. He needs quiet nerves, calm self-possession in his business, and the Ford is the ideal carriage for his purpose."[47]

Anne Rainsford French's father, a physician in Washington, D.C., solved the problem of needing to fire up the boiler to restart his steam carriage while he was making house calls by having his daughter—who received her steam engineer's license in March 1900—serve as his chauffeur. She kept the automobile running while he was in the house caring for the patient. Anne Rainsford French's driving career ended in 1903 when she married and her husband told her to stop driving, as he was of the opinion that "Driving is a man's business. Women shouldn't get soiled by machinery." For physician Dr. Frank L. McKee of Plymouth, Pennsylvania, the annoyance of maintaining a steam carriage's water and air tanks while making medical house calls, as well as having to "hear the safety

valve on his steam wagon go blowing away like a locomotive, to the terror and consternation of pedestrians and horses," converted him to the use of an "explosive motor carriage" (gasoline-powered) which, when housed in a warm carriage house, was much more reliable and less annoying for him to use in all types of weather. Edwin C. Chamberlin, author, agreed that the automobile was "pre-eminently suited to the physician" as it cost about the same as a good pair of horses and equipment, cost less to maintain after the initial purchase, and could be left standing while on a house call and be ready for immediate use.[48]

Black newspapers reported on many Black physicians purchasing automobiles. In 1903, the *Baltimore AfroAmerican* reported that a Black doctor in Richmond, Virginia, "rides in an automobile." By November 11, 1910, the newspaper wrote of the purchase of an automobile by a physician employed by the Mutual Benefit Society as being "the third automobile that has been purchased by our people [in Baltimore] within the last month." The June 24, 1911, *Chicago Defender* reported that Black physician Dr. J.A.C. Lattimore of Louisville, Kentucky, had purchased a "handsome automobile."[49] Dr. George W. Kennard of Baltimore purchased a four-cylinder Ford for $2000. The *Baltimore AfroAmerican* listed the automobile purchased by Dr. Charles Fowler in November 1910 as the third automobile purchased by a Black customer in the past month. In addition, Mrs. William Emanuel is listed as one of the first Black Chicagoans to own an automobile. While Dr. Roberts, a Black Chicago physician utilized his automobile to cover his large practice, Dr. Williams, also of Chicago, purchased a racecar for the thrill of high-speed driving.[50]

In 1911, the booklet "What the Motor Car Means to the Doctor," was created by the Ford Motor Company as an advertisement for the Model T. Arguments in favor of the Ford over a horse included the need for the horse to rest versus the automobile being ready to go, with a tank of gas, at any time. Testimonial letters spoke of the distance covered in less time, the increase in the number of house calls and the ability to reach emergency situations more efficiently. An appeal to the country doctor emphasized the comfort and efficiency of the automobile as well as the increased number of medical visits he can make in a day "which not only means more money for him but greatly increases his capacity to minister to the sick who need him."[51]

Early Roads

Greater speed was hard to attain on the poorly maintained American roads. The lack of a national road system meant that road maintenance

Automobile stuck in ditch on road in New York, 1909 (Library of Congress).

was left up to the individual communities. Landowners could work on the roads in lieu of paying property taxes. Unskilled laborers working under an untrained road supervisor did a lot of socializing and what road improvements were accomplished did not last long. These annual work parties did little to improve the roads, which were often trails cleared of vegetation, as seen in the above photograph of a New York State road. In wet and cold weather, the roads turned into muddy quagmires or deep frozen ruts, depending on the season.[52]

European automobile development and popular use was directly tied to the well-maintained European roads, particularly in Germany and France, and taking an automobile for a spin is much more enjoyable on smooth roads. As a writer in *Good Roads* put it: "America is the home of the shockingly bad road, hence it is not surprising that this country has been slow to become affected with the germs of automobilism."[53]

The abysmal condition of American roads was due to the sectionalism of early 19th-century politics that prevented the creation of a national road system. Certain regions such as New England developed good roads but were unwilling to support roads accelerating emigration to the Ohio Valley and the Western territories. Voters and government officials in New York and Pennsylvania were supportive of a federal road system to augment the established canal system and develop railroad lines bringing

farm goods to market centers. New York and Pennsylvania concentrated on state road improvements when the increasing sectionalism and defense of slavery that culminated in the Civil War forestalled the federal road building effort.[54]

The Western territories, in contrast to the Eastern states, were strong advocates of federally funded roads. Author W. Turrentine Jackson, in *Wagon Roads West*, describes the dichotomy of the rugged individualist's desire for federal aid: "The American frontiersman expressed his individualism by seeking an untrod path into the wilderness for a new home. Yet the pioneers' individualism and adaptability did not preclude their willingness to call upon the government for practical help in solving problems of migration and transportation."

Congress had power over territorial governments that it did not have over states and supplied funding for military operations. Time was of the essence in obtaining federal assistance, because once statehood was attained road construction was no longer the financial responsibility of the Federal government. Territorial delegates to Congress rushed to push through military road requests before statehood votes turned road construction over to the newly created states and federal funding was no longer readily available.[55]

The definition of a military road in the interests of national defense was broad. Federal money went to individual contractors to forward supplies to Army posts, delivery of mail, and telegraph dispatches, making communication and transportation in the West possible. In the territories that would become the states of Michigan, Wisconsin, and Minnesota, federally funded and constructed military roads opened up heavily forested regions to settlers coming in from the Eastern states. In the 1830s, the rapidly growing population in Arkansas and Iowa made statehood imminent with a resultant push by local residents to have roads paid for by the Federal government while they were still territories. Territorial governments gave arguments of protection from so-called "Indian attacks" for scattered settlements by connecting them with roads.[56]

Commercial interests led some communities to plan roads without waiting for the military. W. Turrentine Jackson describes the difficulties of a Texas road survey expedition in 1848, three years after statehood, charged with laying out a road from San Antonio, Texas, to Chihuahua, Mexico, via El Paso, Texas, in an attempt to move the eastern terminus of the New Mexico trade route from St. Louis, Missouri, to San Antonio, Texas. The survey party followed the lead of "incompetent Indian guides" on a circuitous route hundreds of miles out of the way through the harsh trans–Pecos country. The delay used up the resources of the survey party, and the exhausted party returned to San Antonio, Texas, by a more direct route.

The concerns of the Indigenous guides were not of particular note to mainstream historians when W. Turrentine Jackson wrote *Wagon Roads West* in 1965, and of even less concern in the 1840s when they were hired. Jackson's phrase "incompetent Indian guides" above raises the question of whether the Indigenous guides were leading the engineering party away from Indigenous settlements or hunting grounds. It is also possible that they were unfamiliar with the area and lost, but agreed to be hired by the Whites who assumed that as Indigenous people they would know the territory. The influence of the Indigenous guides on the layout of Western roads is worthy of further study.[57]

Federally funded military roads were followed by transcontinental railroads with generous federal land-grant allotments. The allotments were sold to land speculators for township development. The railroads often followed the same route as the wagon roads. These in turn often appropriated, destroyed, or overtook Indigenous trails. As historian Dr. Heather Cox Richardson writes, "There was special urgency to the Indian Wars in 1865, for post [Civil] war Americans were eager to push their way into the west and Indians were stopping them."[58] The 19th-century precedent was for the Federal government, not individual towns, counties, or even states, to build roads that carried goods to market centers. Because there was more commercial incentive to maintain the roads in the cities and towns, those received greater attention than the roads leading out of the city and town centers.[59]

Smooth road surfaces were found in cities and stopped at the edge of the city. Asphalt, concrete, and macadam were the three most popular road-surfacing materials in the early automotive era. Each had its advocates and detractors, and most significantly, no matter what the surface material was, roads cost a significant amount of money to maintain. Revenue raised from automobile license fees helped resolve the long-running debate between bicyclists and farmers over which should be taxed to pay for road improvement. The state license fees added to federal revenue provided the long-term solution for road building and maintenance.[60]

Macadam required broken stone with sharp angular surfaces that would hold together firmly, as opposed to rounded stones. The cost of breaking up the stone to the required three-quarters to one inch size was considerable and very labor intensive; convict labor to break rock was used in New York, California, and North Carolina as well as other states. *Good Roads* magazine suggested in an 1899 article quoting from *Municipal World* that "There are few who desire to see in public anything resembling chain-gangs, guarded by armed keepers," and recommended bringing the rock to the prisons to be broken up behind the prison walls.

The June 1, 1929, issue of the *Chicago Defender* carried a story about

prison labor used to build roads. By then the ball and chain were no longer used in Georgia and Florida, authorities being in agreement with the 1899 observation that it didn't present a positive image for tourists. And the reporter added "the Negroes couldn't pull their chains about on the food they get." The graft of shorting the prisoners on food while the authorities pocketed half the food-allowance money continued. Two meals a day, breakfast and supper, consisting of coffee, cornbread, syrup and beans, did not provide enough calories for the hard labor of breaking rock.[61]

Ratified on December 6, 1865, section 1 of the 13th Amendment to the Constitution of the United States provided the loophole that enabled states to assemble chain-gangs. "Neither slavery nor involuntary servitude, except as a punishment for crime whereof the party shall have been duly convicted, shall exist within the United States, or any place subject to their jurisdiction."[62] The phrase "except as a punishment for crime whereof the party shall have been duly convicted" was open to interpretation that varied from state to state and county to county particularly when applied to the broadly defined vagrancy laws against which there was little recourse. White supremacists, particularly those of the former Confederate States of America, utilized this as an opportunity to reassert racial control over the Black population.[63]

Denial of Black rights by local governments increased as a result of the presidential election of 1876. The compromise that ended the deadlock between Republicans and Democrats and put Rutherford B. Hayes in the White House resulted in the end of Reconstruction and the withdrawal of the federal troops. The federal troops had provided some protection of Black rights between 1865 and 1877. Once the troops were removed, the former Confederate states put in place laws ensuring a return to the oppression of the Black population, including convict labor and chain gangs. The 1929 *Chicago Defender* article quoted a Jacksonville, Florida, lawyer saying, "When a county down here starts a road building program there is a general round-up of loafing and vagrant Negroes and pretty soon the roads are in tip-top shape." The article continued, "The Negro, however, isn't always in such a good state of repair when he gets off the road gang." A sentence of 90 days "spreading gravel" was reported for a drunk and disorderly charge. The racist, very broad interpretation of what Black loafing and vagrancy entailed left little recourse for Black men to counter.[64]

These laws restricting the movements of Black men, women, and children included segregated and inferior quality public transportation at the dawn of the automobile era. And at the same time, as the following chapters show, Black and Indigenous as well as White women often benefited from individual control over transportation, although in different ways.

These observations combine to make both the complexity and the urgency of the topic of the early automobile all the more apparent.

Learning to Drive

Cleveland Moffett, in his article "Automobiles for the Average Man" was outlining "Safety, simplicity, and efficiency!" in his review of the "several advantages and disadvantages" of electric, steam, and gasoline horseless carriages written for the general interest publication *The American Monthly Review of Reviews in 1900*. Moffett recommended the electric carriage for city use: "It is the handsomest automobile, the easiest to drive, the pleasantest to ride in; but it is not adapted for general use—say, in rural districts, nor for touring."

Steam carriages, while faster at top speeds of forty miles per hour and able to handle rough roads and climb hills, were more complicated to operate than gasoline, and they required stops every twenty miles or so to refill both gasoline and clean water: "What harm a little mud can do, to be sure, or a bit of grit in the feed-pipe!" said Moffett. "While one is enjoying some lovely panorama, the water-flow into the boiler has been cut off, and presently there are burned-out tubes to be reckoned with, and a dead carriage by the wayside."[65]

The gasoline carriage was noisier than the steam engine, smellier—especially for those traveling behind the vehicle—and produced greater vibration, which shook the occupants, but it won Moffett's approval as the most convenient for use in rural driving. "Perhaps the chief advantage of the gasoline carriage over its steam rival is that on a long run it needs but one kind of replenishing—gasoline for its engine; while the steam carriage needs two kinds of replenishing—gasoline for its burner-fire and water for its boiler." Gasoline was readily available—common stove gasoline was sold at most general stores—and gasoline vehicles could go up to 70 miles before needing refueling. Moreover, rural mechanics familiar with stationary gasoline engines were able to work on automobile engines in case of a breakdown.[66]

The advantages of simplicity in operating a horseless carriage were the subject of one of the few jokes run in *The Horseless Age* quoted from the *Chicago News*:

HE: "Did you ever ride in a horseless carriage?"
SHE: "Yes; once."
HE: "How did you like it?"
SHE: "Not at all. The fellow had to use both hands to work the levers."[67]

Charles Duryea developed a solution to this dilemma: the single lever control rudder requiring only one hand to drive. *Good Roads* magazine also noted that as automobiles became easier to operate and understand, more people—men and women—would take to operating their own automobiles: "As a matter of course there will be a lot to learn, but as the motor mechanism is simplified and people become more or less familiar with the workings of it, it goes without saying that a goodly number of ladies will be too independent to admit that they must stay at home because there happens to be no gentleman available to act as driver."[68]

For the wealthiest automobilists the problem of where to take their automobiles was resolved with runs and automobile parades on their private estates. These parades of flower-bedecked vehicles began in Newport, Rhode Island, in 1899. City parks were another early popular place for the elite to go motoring, popular with automobilists that is. Non-motoring park goers and park officials were not as enthusiastic. New York City's Central Park had been known for horse-drawn carriage parades of the social elite since the mid–1800s, and automobiles were not welcomed when automobilists first tried to enter Central Park in the late 1890s. Fear of the automobiles startling the horses was a common argument given for keeping automobiles out of public parks in such cities as Chicago, Boston, San Francisco, Philadelphia, as well as New York City, which by 1899 included Brooklyn. Mrs. Jules Junker was fined $5 for driving her automobile in Philadelphia's Fairmount Park. Fines, and the registration and licensing fees that followed as automobiles gained acceptance, were utilized by communities to raise money.[69]

The authorities at Brooklyn's Prospect Park were persuaded to allow electric vehicles into the park without a permit, once "...a little experience with the new conveyance proved to the custodians of the parks that horses are taking their new competitors more philosophically than they anticipated...." Inviting automobile opponents for a ride was a strategy encouraged by the writers of *Horseless Age*, and it worked when New York Park Board President Clausen was persuaded to take a ride in an automobile along the paths of Central Park.[70]

The reports of that excursion vary from *Automobile* magazine's excerpt from the *Press Dispatch* that "When he consented to enter Central Park in an automobile he was surrounded by an escort of mounted policemen, two riding in front, one on either side of the carriage, and three bringing up the rear ..." to *Horseless Age*'s report that once he had operated the vehicle himself he was convinced of the safety of the vehicle, and was "...soon brought under the spell of the machine." A third version of Commissioner Clausen's automobile ride was that the automobile broke down and Commissioner Clausen had to walk home.

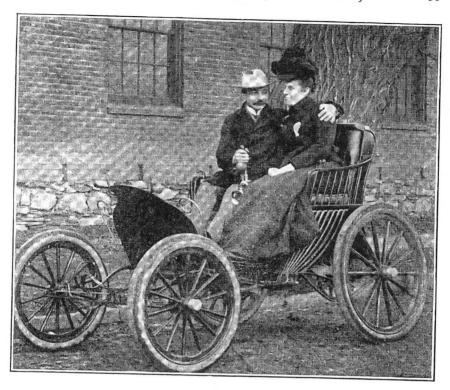

C.E. Duryea's latest argument in favor of single lever control. *The Horseless Age*, December 19, 1900, p. 32 (courtesy New York State Library, Albany, New York).

This ride took place shortly after members of the Automobile Club of America, who were denied permits to drive in the park, purposely got themselves arrested for entering the park. They brought their case to court where the judge ruled that automobiles were pleasure vehicles and thereby allowed to operate in the park. Revenue from licensing fees was an advantage to allowing motorized vehicles into city parks. Florence Woods, age 17 and daughter of an electric-car builder, was issued one of the first licenses by the New York City Park Board in 1899 after she demonstrated her ability to operate her automobile skillfully.[71]

Familiarity with the automobile, both by officials and horses, was seen by automobile advocates as the surest way to gain acceptance for the new technology. Motor vehicle owners interested in developing good roads in the Minneapolis, Minnesota, region took county commissioners for a pleasure ride from Minneapolis to Wayzeta on the shore of Lake Minnetonka, approximately 15 miles away, and treated them to dinner at the

Lafayette Club in Minneapolis "...after which came an informal discussion on the subject of good roads and the need of them in the country around Minneapolis."[72]

An early account of a woman learning to drive appeared in the April 1898 edition of the automotive journal *Horseless Age*. The author and inventor Hiram Percy Maxim describes taking a "young lady from the South" out for her first ride in a Columbia electric "motor carriage." After an hour's drive on a winter evening on "choice roads with long swift coasts, and the lonely places, where the moon shone down through the leafless trees on the frozen road, giving the much sought 'spookey' effect," the author offered his passenger the opportunity to run the motor carriage herself. Once she was in the driver's seat, "steering handle in the right hand, speed controller in the left, and foot regularly in place on the brake pad, all in regulation form," her driving lesson was as follows:

> A few trial motions were then made with the speed controller, with the "running plug" out, in order to get the "feel of the different speed notches," and then the injunction given to "point the steering lever the way you want to go until your hands gets so that it doesn't require any thinking." The "running plug" was then replaced, and we were ready[.][73]

With this brief driving lesson she started off, at the first notch, a three-mile per hour speed, gradually increasing to the second notch, a six-mile per hour speed, and reaching the plaza at the end of the parkway, and "at this interesting juncture rushed the inevitable trolley car." She swerved back and forth, applied the brake and brought the vehicle safely to a stop. Hiram Percy Maxim continues, "If she went slowly enough and stopped quickly enough it was all there was to it. This little incident of a moment, all without a word, proved more than hours of logic could have done. She saw the point of the whole game."[74]

Her second encounter with a trolley was more successful and with each pass up and down the road she gained confidence and increased her speed to the third notch at twelve miles per hour. After just a short time at the controls she had enough confidence to accept Hiram Percy Maxim's challenge to drive through the busy city center to the end of the asphalt on the other side of the city. Although most likely not the same city—Hiram Percy Maxim does not give the name of the city in his article—this Indianapolis street scene fits Hiram Percy Maxim's description: "Crowds of people occupied the sidewalks, and numbers were continuously crossing. Carriages, wagons, and cars were everywhere." The term "car" at this time referred to trolley cars and streetcars rather than automobiles. Several articles were published in the early automotive literature discussing possible names for the self-propelled motorized vehicles including: motor

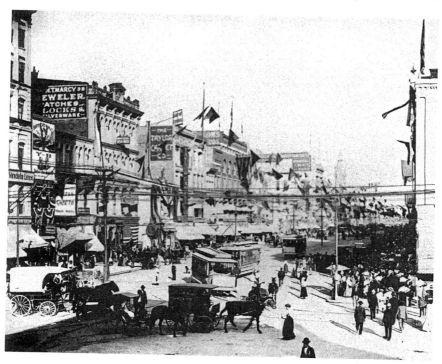

This Indianapolis street scene from 1901 shows the uncontrolled congestions of the turn-of-the-century street with pedestrians, horse-drawn carts, and wagons, as well as trolley cars all converging together at intersections. Illinois and Washington streets, Indianapolis, Indiana, 1901 (Indiana Historical Society, P0391).

wagon, horseless carriage, automobile, voiturette, gasoline carriage, gas buggy.[75]

A motor carriage driver venturing into this congested traffic would need to proceed with caution, especially when dealing with the type of trolley car driver Hiram Percy Maxim described:

> Everything went smoothly, until she was surprised by a trolley car, whose driver I think was trying to "rattle" her, and which ran unexpectedly close in crossing the main street. Fearing a scene, I put my hand on the steering lever and pulled it quickly over enough to clear the car, which highly amused the trolley driver, and greatly relieved my companion.

Learning new technology, in heavy street traffic, was daunting enough without being rattled by trolley car drivers. The trolley driver may have sped up to get to the intersection first to scare her. She recovered her composure, finished off the drive with a confident flourish, passing her

neighbors' houses "with the electric bell going steadily," and "pulled up with the carriage step almost squarely opposite the stepping block, and close to the curb, so that stepping out was easy."[76]

This driving experience, despite the traffic congestion and unhelpful trolley car driver, was under the very favorable circumstances of a smooth asphalt road and the easy-to-operate electric car. At the time he wrote this article Hiram Percy Maxim was working with Colonel Albert Pope, a prominent bicycle manufacturer who moved into electric automobile production. Hiram Percy Maxim had designed the Columbia electric he taught the young woman to drive.[77]

Given the right circumstances, some women taught themselves to drive. Marie Hjelle Torgrim, a young Iowa farm woman whose older brothers, who owned a Model T Ford, took advantage of a quiet afternoon when the rest of the family was away. The full excerpt merits our attention, in that the narrative of Marie Hjelle Torgrim's experience captures an important aspect of a women's first experiences behind the wheel:

> Marie wanted to do this alone. She released the hand brake, then pushed the low-gear pedal to the floor. The car chugged, jerked, and died. She yanked the hand brake back, her jaw thrust forward, and started over.
>
> Ignition on, battery on, spark off, hand brake on (the sequence in her mind for starting a car too often included her brothers chasing lurching vehicles across the yard), choke, crank, throttle, deep breath, crank, throttle, spark, magneto, hand brake, low-gear pedal.
>
> At last she lurched from the lawn onto the dirt drive. Low gear in a Model T was designed just to get the car rolling, and high gear wasn't much faster, but to Marie it felt like flying. The play in the large black steering wheel and the chuckholes in the driveway made aiming straight for the narrow home-made bridge frightening. Back stiff, hands tight, face thrust forward, for the first time she felt the terrain of the road with her hands.[78]

Learning to drive included learning how to get a feel for the exposed, highly responsive machinery of early automobiles. The experience required sensory attention, and in Marie's case, the experience also rewarded that attentiveness with the feel of an open road. Driving to a favorite fishing spot helped Marie Hjelle Torgrim develop her driving skills prior to the cross-country drive with her seven friends in 1924. We will see in later chapters that a few years later, Marie Hjelle Torgrim put together a traveling party from Iowa to Yosemite, California, of eight young women in two Model T's. Marie Hjelle Torgrim drove her grandfather out to fishing holes: "I drove slowly on the gravel, neck craned, sucking in the rich smell of earth, content with the evening star, the drone of the motor, and Grandpa."[79]

In another anecdote, Caroline Foster, a woman who lived with her

very strict, automobile-hating father in Morristown, New Jersey, received a Model T Ford as a Christmas gift from her friends in the early 1920s when she was in her forties. The automobile enabled her to visit her beloved aunts in West Hartford, Connecticut. Foster's first trip, the day after receiving the automobile, was the 150-mile, 12-hour drive to visit her aunts. As the automobile covered the miles more quickly than her horse and buggy had, Foster was able to spend more time at her beloved fishing spot, Skunk's Misery, and she thoroughly enjoyed the greater independence her automobile provided her.[80]

While many articles were written detailing how to start cars and how to repair automobiles, "The Confessions of an Anti-Motorist" in the magazine *Country Life in America* describes the experience of frequent breakdowns from a passenger's point of view. D. Enville writes that his dislike of the automobile was hardened by an early automobile experience which consisted more of standing by the side of the road watching the automobile be unloaded to get at the engine under the seat cushions than actually sitting in the automobile. This led him to conclude: "I began to think that the chief fun in automobiling must be in becoming proficient in unloading and unbuckling things with a minimum of time and effort."[81]

Purchasing an Automobile

Buying an automobile has always had, and continues to have, elements of the era of horse-trading. And those elements, writes author Dr. Steven Gelber, "...continued the lead of the preindustrial marketplace haggling that characterized almost all retail but that had been refined into a dark art by the men who engaged in horse trading." Even though the early automobile was called the horseless carriage, buying an automobile was closer to the methods used in buying horses rather than the straightforward method of buying a carriage or wagon. The motive power—the ability of the automobile to carry people farther and faster than ever before—equated the automobile more with the motive power of the horse than with the carriage that it physically resembled.[82]

Horse trading was among the last of the purely haggling purchases by the early 20th century. Department stores and mail order catalogs offered established, clearly marked prices beginning in the mid-19th century. Gelber writes that the one-price policy was touted as more democratic by the retailers who followed it, as everyone paid the same price, even if the treatment by sales staff was different based on social status or race. Automobiles, like horses and bicycles before them, were traded in for newer models while there was still use left in them. So the price of even a

factory-new automobile would be negotiated as part of the culture carried over from horse trading.

Early automobile buyers were told that if the vehicle was well-maintained, it would bring in a high price when it was resold. Used car buyers, similarly, were told that the vehicle had been well-maintained by the previous owners. Female ownership of horses and automobiles were used as selling points as women were purported to use their horses, and automobiles, more gently than men. The saying, "this car was only driven to church on Sundays by a little old lady" dates back to horse trading to indicate a horse had not been over-used by the previous owner.[83]

Victor Lougheed, a self-taught automobile and aeronautical engineer, advised new owners in his 1908 book "How to Drive an Automobile" that customers who lived nearby could either have the vehicle delivered to their homes or pick it up at the dealership. In that situation, the new owner had the reassurance that the new vehicle was operational. However, Lougheed continued, purchasers far from dealerships could have the new automobile shipped to them in a crate by rail or boat. In those cases:

> it probably will need to be uncrated and perhaps to some extent set up, since certain parts of it probably will be taken off to facilitate crating, or to be specially packed, to lessen the danger of injury. Before attempting to manipulate a new car in any way, every part of it should be thoroughly studied, with the literature of the manufacturer at hand to explain points that may not be immediately clear otherwise.

This included checking to be sure all-important nuts, screws, bolts, and other connections were tight, including those holding the muffler and carburetor in place. Lougheed continued:

> Most careful attention of all should be paid to the brakes, steering gear, running gear, and to all other parts upon which the safety of the user depends. The next step is to make sure that the car has sufficient lubricant in the oil cups, oil reservoirs, or other lubricating devices. With a new car, lubrication is especially important, because the bearings have not had the smoothing that comes from wear, and that is the best insurance against overheating.[84]

Before the advent of the electric or self-starter in 1912, a primary chore of driving a gasoline-powered automobile was the need to turn the crank to start the engine. Automobile instruction books, both those written for a female audience and those written for a general male audience, emphasized that crank-starting the automobile was a skill and not dependent on brute force. Dorothy Levitt gave clear instruction:

> In front of the car you will notice a handle. Push it inwards until you feel it fit into a notch, then pull it up sharply, releasing your hold of the handle the moment you feel you have pulled it over the resisting (compression) point.

Unless starting a car fitted with magneto ignition, on no account press down the handle—always pull it upwards, smartly and sharply. If it is pressed down the possibility of a backfire is greater—and a broken arm may result. This, however, it not a common occurrence, and is one that is brought about entirely through carelessness on the part of the would-be driver.[85]

Victor Lougheed also stressed that crank starting was an art. He wrote, "The novice will realize this better after he has seen some one physically much weaker than himself start an engine that he is totally unable to throw over by main force." Lougheed's male audience would presumably be inspired to learn the art of crank-starting after seeing women drivers successfully crank-start their own automobiles. Waldon Fawcett would seem to be writing for the male members of *Toot Toot*'s audience in his description of teaching a woman how to crank-start an automobile. "The suave instructor always encourages his fair pupil with the explanation that 'cranking' requires a knack rather than mere strength, but it is a detail which in the case of the average car the feminine operator prefers to leave to masculine brawn."[86] His ignorance on this point would have been well-challenged by Marie Hjelle Torgrim, the young Iowa farm woman we encountered above.

As automobile technology advanced and automobiles became more reliable and easier to operate, even previously self-described "anti-motorist" D. Enville began to see the advantages of an automobile. He wrote in "The Confessions of an Anti-Motorist" that his attitude toward automobiles had begun to change as he realized that he was seeing fewer breakdowns by the side of the road. A turning point for Enville was a particularly rainy morning drive to the railroad station in his horse and buggy when he was passed by a neighbor who stayed dry in his enclosed automobile while he was "soaked and miserable all day in the city." That evening, after being reassured that automobiles were no longer "always out of order" or "complicated," he accepted his neighbor's invitation to go for an automobile ride the following Sunday. Enville wrote:

I suppose the trip we had would have been only an incident to a motorist. To me it was a revelation. Here I was carried along on wings of air forty miles from home in two hours. We had dinner in a little road-house I hadn't seen since I was a boy, and the return trip was made in the glorious coolness of a September afternoon, the motor purring all the way like a contented cat.[87]

That automobile ride changed Enville's opinions about automobiles. He was happy to purchase his own automobile and be able to go on exploring day trips of 50–60 miles rather than his previous limitations of "the ten- or twelve-mile circle that my horses could go in a day and get back in good shape." He visited friends 30 miles away, and saved an hour

on his daily commute to the railroad station. Both horse and automobile had a place in Enville's life as "No automobile can ever take the place of horseback rides." While Enville kept the horse for pleasure rides and used the automobile for work, Thelma Nixon, a woman from Union County, Indiana, remembered that the automobile replaced the buggy horse on Indiana farms, and the work horses were kept for farm work.[88]

CHAPTER 3

Getting Underway

In the early 1900s, learning to drive automobiles was simultaneous with learning to repair them. Many books and magazine articles were written advising new automobile owners on the repair and operation of their machines. Drawing on materials written in the 1900s and 1910s, this chapter examines some of the instructions written for the early automobilist as they ventured farther from home and considers the context in which early drivers learned their craft: an era defined by experimentation in fuels, debates about public health, and controversies about who is best suited to drive what, where, and how.

Breakdowns and Repairs

The issue of breakdowns almost always raised the concurrent debate about types of fuel. D. Enville's first experience riding in an automobile was so unpleasant that he walked the six miles home after yet another breakdown—this one beyond the repair capabilities of the driver—at which point there was "Another rapid exit and removal of cushions, floor and impedimenta [...] and I made one big resolve—'Never again for me.'" Enville also objected to the smell that automobiles, especially gasoline-powered ones, emitted. The smell the early gasoline engines were noted for was in part due to dirty spark plugs. Waldon Fawcett wrote, in "Teaching a Woman to Operate an Automobile" in the automobile enthusiast magazine *Toot-Toot*, that by "laying especial stress upon the method of cleaning the spark plug—the best remedy for that irritating, irregular exhaust which betokens a sick engine," gasoline automobiles would run more smoothly with less of the smell that inspired the rhyme:

> Mary, Mary, Quite Contrary
> How Does Your Auto Go?
> With Toots and Yells and Nasty Smells
> It's a Gasoline, You Know.[1]

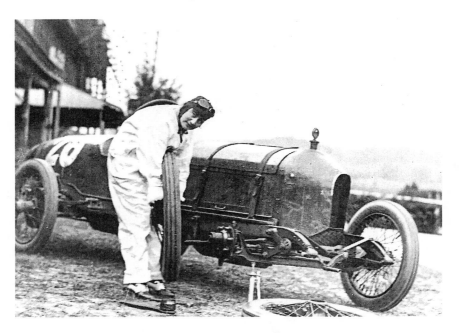

Woman changing tire of Stutz Weightman Special no. 26 on Benning race track, Washington, D.C., area, circa 1910s (Library of Congress).

Both Waldon Fawcett and English automobilist and race car driver Dorothy Levitt encouraged women to learn to operate and repair gasoline-powered automobiles. In his 1906 article Fawcett wrote that women were driving: "not merely the natty little electrics that spin noiselessly up and down the city streets, proving a God-send for shopping and calling, but also the big gasoline touring cars that go bowling along country roads at express train speed."

In her 1909 book, *The Woman and the Car,* Dorothy Levitt recommended the single-cylinder gasoline powered DeDion which "combines simplicity with reliability—two very important items to the automobiliste." Levitt stressed that "Motoring is a pastime for women[…]. There may be pleasure in being whirled around the country by your friends and relatives […] but the real, the intense pleasure, the actual realization of the pastime comes only when you drive your own car." She was writing for women who were already enjoying motoring and, "for those who would like to, but either dare not because of nervousness, or who imagine it is too difficult to understand the necessary details."[2]

Levitt and Fawcett also advised their readers to purchase a single-cylinder gasoline-powered vehicle for everyday driving. These were recommended as being the easiest and most economical to run and

maintain—"more cylinders mean more work, and also more expense as regards tyres, petrol, oil, &c."—while providing ample power for speed and hill-climbing. Even when a lighter-weight vehicle put less weight on the tires, which gave them a longer life, changing tires was a constant part of early motor trips.[3]

The 1902 British book *Motors and Motor-Driving* recommended 14 items in a list of spare parts to be taken along on every motor excursion. Spare exhaust-valve and spring; Spare inlet-valve complete; Three spare sparking plugs; Spare inner tubes and repair outfit; A large screw wrench; Small pocket wrench; Long screwdriver; Small screwdriver; Pair of cutting pliers; Pair of gas pliers; Two files, medium size; Coil of copper and steel wire; Oil-can with long nozzle; Small cold chisel. The book also recommended filling up with petrol at every suitable opportunity, making sure the water tanks were full, ensuring that working and spare accumulators were fully charged, and lubricators and grease cups full.[4]

Types of Motive Power

The Horseless Age

Petroleum or compressed air,
Ingenious spring-power or benzene,
Helped the wheels to speed us there.
Carbonic acid, kerosene,
Naptha, ether, gasoline,
Carcoal, coke, acetylene,
Storage batteries or steam;—
With such rivals it is plain
Dobbin will not reign again.
—Carol M. Lewerenz, San Clemente, California[5]

This poem, inspired by an undated indexing session of *The Horseless Age*, Vol. 1, No. 1, November 1895, sums up the variety of fuels used in the early days of automobile experimentation. Of the 14 types of motive power listed in Carol Lewerenz's poem, three—electricity petroleum, and steam—emerged as the front-runners in early commercial automobile production.

Each form had its advantages and disadvantages. Electric cars were the easiest to operate of the early automobiles. While they were easy to start, odorless, and silent while running, the storage battery made them heavier than gasoline-powered vehicles, which limited their hill-climbing ability and top speeds. The battery storage life limited their range as they needed to be recharged frequently. For city driving, particularly with frequent stops, the easy starting capability of electrics was very convenient. Electric cars traditionally—though this is unsubstantiated by

sales figures—have been referred to by automobile historians as a ladies' car. Gijs Mom suggests this view was promoted in electric car advertisements of the 1910s when gasoline-powered vehicles were gaining popularity in the market. There were those who agreed with the designation of the electric car as a ladies' car earlier in the century. In Chicago, where licenses to operate motor vehicles were required as early as 1900, those in charge of issuing licenses were of the opinion that steam or gasoline-powered vehicles were not "considered safe in the unmechanical hands of feminine drivers." Licenses were issued to women only for electric vehicles. *Horseless Age* objected to this restriction stating, "As gasoline voiturettes (a small automobile) are all the rage among Parisian women, it seems inevitable that the ban will ere long be removed in this country."[6]

Women automobilists in Chicago also objected to restrictions and licensing. An article in the September 12, 1900, issue of *Horseless Age* reported the warning by the city engineer that he intended to have women operating vehicles without licenses arrested. According to the article, both "leading society women" and women employed by companies selling automobiles were the chief offenders. One of the women who did receive a Chicago license was Miss Emeline S. Blye, a woman who planned on "earning her living by teaching her sex how to manage the new machines." While the *Horseless Age* article does not identify the type of machine, it was likely an electric-powered vehicle.[7]

An engineer's license to operate the steam-boiler was required to drive a steam-powered vehicle by some cities and states but not others. Mrs. Frank E. Norton, a woman who drove a steam surrey, was listed in the August 1900 edition of *Horseless Age* as the first woman automobilist in Syracuse, New York. Different laws in neighboring areas made driving from one state into another very confusing; the resultant fines were expensive for the driver and lucrative for the local government. Licenses were not required in New Jersey; "hence the owner of a steam vehicle might roam with perfect freedom over that neighboring State and find himself in the clutches of the law the moment he crossed the ferry and undertook to operate his machine on New York soil."

Steam-powered vehicles had a long start-up time until the invention of the flash boiler, which enabled immediate starts if the pilot light had been left on. Steamers, while heavy, had more hill-climbing power than electrics, and the water needed to fill the boilers was readily available at town horse-watering troughs. Steamers required gasoline in addition to water to operate. As improvements were made to increase the power of gasoline-powered engines, the steamer, as well as electric vehicles, faded in popularity, despite the fact that steamers were easier to start, did not stall, and were easier to operate.[8]

Until the technology of the gasoline-powered automobiles caught up to the steamers, the Locomobile was one of the most popular makes of automobile in 1900 and 1901. Publicity and visibility also helped with the Locomobile's popularity. In an article with the headline, "The President Is Initiated," *Horseless Age* praised Locomobile founder F.O. Stanley for inviting President McKinley for a ride in his steam carriage. The writers were of the opinion, "Now that the horseless carriage has won the approval of the Chief Magistrate, its popularity will gain a decided impetus." Locomobile was one of the first automakers to set up a sales division in Washington, D.C., a "splendid market" (smooth roads made for a more receptive market), according to the writers of *Horseless Age,* where interested buyers could see the vehicles in person instead of ordering by mail. "Washington teems with wealthy people who are seeking some healthful diversion or amusement, and who would willingly invest in automobiles if they could see them."[9]

Chauffeur Opportunities

Exposing the cars to passing would-be shoppers, or offering rides, became a popular way to advertise beyond the confines of mail-order catalogues. Indeed, taking a ride in an automobile was a frequent first introduction. Wealthy automobile owners hired chauffeurs to drive the cars for them. The Black community recognized the new employment opportunity and driving classes were offered at community institutions, including the Young Men's Christian Association (YMCA) locations—the ones that allowed Blacks to register for classes—as well as private driving schools. Chicago's Charles L. Reese rose from chauffeur to YMCA automobile-expert instructor, to opening the Charles L. Reese Automobile School.

In 1909, the *Baltimore AfroAmerican* wrote of the need for Black coachmen to learn the use of automobiles as wealthy White families favored automobiles over the horse and carriage;

> An Afro-American who has been driving in one family for the past ten or twelve years has been notified that his job as a coachman is nearly at an end, and unless he can, in a very short time master the intricacies of a "buz wagon," he will in all probability be looking for another job. It is up to us to keep step with the march of improvements. It is true that there are a number of Afro-American chauffeurs, but not near so many of them as there are of the other fellow. And it is in this as it is in all other walks of life the fellow that is prepared is the fellow that gets the job.

Chicago's Greer College of Motoring was featured in the October 29, 1910, issue of the *Chicago Defender.* Following the description of the tour of the

school, the article encouraged "Ladies, go and visit the school, then send your sons to learn a useful trade."[10]

The *Pittsburgh Courier* ran an advertisement from the Imperial Employment Repair and Auto School in 1911. Black men were encouraged to attend the Black-owned school even though a White-owned school had begun accepting Black students; "...but don't be Jim Crowed. Come where you can exercise your race pride and be a gentleman." The school also bought and sold first- and second-hand cars, ran an auto repair shop, and hired automobiles by the hour or day. Black newspaper *Chicago Defender* reported in August 1911 that Earle Ewing had gone to the only Black-owned-and-operated school for chauffeurs and machine shops in the state of Ohio. The three-year course would teach him "the automobile business from A to Z."[11]

In 1911, the *Chicago Defender* carried a story headlined "3,752 Miles by Automobile Without a Breakdown," describing the trip of "Mr. Charles L. Reese, Expert Chauffeur." The subhead explains that Mr. Charles L. Reese "Successfully Motors Mr. and Mrs. E.L. Kuhns Through the Principal Cities of the East on a Trip Lasting Six Weeks."[12] This style of reporting was a contrast to the newspapers catering to White readers, which focused on the automobile owners with a side mention of the chauffeurs who did the actual driving. In this era of frequent automobile breakdowns and poorly maintained roads, the trip through 12 states and 143 cities and towns with only two punctured tires was noteworthy. The article reported that New Hampshire Governor Duneen wanted to hire Charles Reese as his chauffeur to the objections of Mr. and Mrs. E.L. Kuhns, owners of the Studebaker used on the trip. Mr. Reese declined the governor's offer.

By 1917, the Charles L. Reese Automobile School in Chicago, Illinois, gave his credentials as "former director and chief instructor of the big YMCA auto school, and fourteen years as chief mechanic, demonstrator and instructor for the Studebaker Corporation." The advertisement featured not only "special classes for ladies" but also that "There is a great demand also for lady chauffeurs and mechanics."[13] Throughout 1917 and 1918 the *Chicago Defender* reported on the increase in the number of cars owned by the Charles L. Reese Automobile School to keep up with the growing number of students.

A July 6, 1918, *Chicago Defender* story headlined "Women Secure Licenses to Act as Chauffeurs" reported that "The Charles L. Reese Automobile School is the only school that has ever turned out licensed women drivers and mechanics. The first two being Miss Anna Lynch, 3745 Indiana Avenue, and Mrs. Sally Hairston, wife of the proprietor of the Tonsorial Shop, 3436 S. State street. These two women are the only women of our Race that have passed the state examination. When interviewed by a

Defender representative, Mr. Reese said that he is at present preparing 22 women for the state examination." A July 27, 1918, feature read:

> It is estimated that there are over 100 women of the Race who are chauffeurs in the city of Chicago, and with this number it is thought that Chicago leads all other cities. Of the 100 there are 38 that are expert mechanics, able to take machines apart and repair them. Sixty percent of the 100 are graduates of the Charles Reese Automobile School, which is now making a world's record for efficiency. Students are now coming from all parts of the country to matriculate at this school.[14]

Driving Around the Countryside

Another suggestion for a practical application for the automobile came from Frances S. Carlin, a landscape artist who detailed her requirements for an "Artists' Automobile" that would combine transport to scenic sites and comfortable places to sit and paint once there. In an 1899 article in *The Automobile Magazine* she envisioned an inexpensive, low speed vehicle; "Low and open in front like an invalid's chair, but with the seat wide enough for two for an occasional friendly spin. A parasol suspended from a hook, like a baby carriage. An easel adjustable to the brake. Places under the seat for color box and canvases." Carlin suggested further that the carriage be "very light and simple in construction, so that it could be easily trundled home in case of a breakdown." She added that, since "as a rule, artists are not practical mechanics, as are many of the present owners of automobiles," artist-drivers ought to choose a simple gasoline or kerosene engine.[15]

Publicity for the automobile was often generated by aesthetic means. In the age of wide-spread popularization of the auto, fiction followed suit and became to incorporate cars into their main storylines, often with female readers in mind. Automobile use was popularized by the publicity generated by the races and cross-country runs undertaken by women. In addition, fiction written for a White audience of young adults also popularized and helped make automobile use by young women acceptable and encouraged them to dream about owning an automobile even if they could not afford to purchase one. In the first two decades of the 1900s, young adult novels were published in series form, and the Edward Stratemeyer syndicate was among the largest and best known. The *Motor Girls*, the *Motor Maids* and the *Automobile Girls* all carried a story line of poor but virtuous and well-mannered girls befriended by a kind-hearted wealthy girl who takes her friends for jaunts in her automobile.

The *Automobile Girls* was a six-book series published between 1910

and 1913. The *Motor Girls* was a ten-book series published between 1910 and 1917 and the *Motor Maids* was a six-book series published between 1911 and 1913; like their successor Nancy Drew, they used their automobile along with their driving and automobile repair skills to aid them in solving mysteries. While the heroes in boys' books solved mysteries, they also had adventure for adventure's sake such as gold mining or cross-country racing. The heroines in girls' books used their automobiles as a tool to accomplish a goal, while enjoying the increased freedom automobile rides bring.

In the first two decades of the 1900s, American children's books gained popularity, evolving out of children's literary magazines of the period. Prior to that, children's books were imported to America from Great Britain where children's literature was a well-established and respected genre.[16]

Publisher Edward Stratemeyer was one of the most successful of the young adult series publishers of the era. He refined a popular story-line formula and employed authors writing under multiple pseudonyms. The Edward Stratemeyer heroines were hard-working, educated, upper middle class White teenagers who socialized with a tight-knit group of three to four female friends and an equal number of minor-character male friends. The main characters were frequently either orphaned and being cared for by a kindly relative or else a child of a widowed parent.

In addition to popularizing new technology, the series books reinforced the idea of the social and moral superiority of Whites of Northern European descent. This was in keeping with what Dr. Nell Irvin Painter identifies as the "Second Enlargement of American Whiteness," when Irish and German families who had been discriminated against in the mid–1800s were accepted as White in the late–1800s as immigration from Southern and Eastern Europe increased. As the heroines, who drove and repaired their own vehicles, had their adventures under the watchful eye of a chaperone who learned to love automobiling, the villains were described as "dark," "swarthy," and spoke with an uneducated accent. The hero or heroine who is rescued, restored to their true identity, reunited with estranged or lost family, is identified as being well-spoken, beautiful, refined, and having modest qualities that shine through despite the unfortunate circumstances of the moment.[17]

The Motor Boys series of 22 books was first published in 1906 followed by *The Speedwell Boys*. The vehicles in the boys' technology series progressed in complexity from motorcycles, motorboats, automobiles, airplanes, to vehicles of their own creation. The boys' books featured a recurring foe who was usually wealthier, and morally and physically weaker than the heroes. While the boys did not require a chaperone, they had

a mentor, knowledgeable if absent-minded, who helped them on their adventures. An important character in the girls' series was the chaperone, who fit Emily Post's description: "It goes without saying that a chaperone is always a lady.... Above all, a chaperone must have dignity, and if she is to be of any actual service, she must be kind of heart and have intelligent sympathy and tact."[18]

There was a continual undercurrent of White superiority running through the technology and outdoor series. The emphasis was on travel, with the outdoors and adventure shown as a complement to urban life, not a long-term lifestyle. The girls' series began with adventures and jaunts set around their suburban New York City hometowns, including camping trips to the Berkshire Mountains in Massachusetts and Adirondack Mountains in New York. There, the heroines met up with Indigenous "herb women" and healers—usually kindly and well-meaning—who were doing their best to care for a White girl whose natural refinement inevitably shone through her rough surroundings. After the true identity had been revealed (she was often found to be a long-lost heiress), the girl was taken from her Indigenous home in the mountains to live in "proper" suburban surroundings.

Described as "The romantic rescue of a little girl whose birth had been concealed from her rich white relatives by her Indian grandmother...," in *The Automobile Girls in the Berkshires* an exception is made for the Indigenous grandmother who is allowed to see her granddaughter during school holidays after having hidden her from the White father's family for fear "...they would be unkind to her baby." In addition to the series dedicated to automobiles, other series dedicated volumes to the acquisition of an automobile (*Patty's Motor Car*) or a cross-country automobile trip (*Across the Continent with Paul and Peggy*). The heroes and heroines always returned home to sophisticated suburban life to pursue their education and place as leaders in society enriched by their experiences in the wild.[19]

Travel Etiquette

Etiquette books kept pace with the new technology. The association of the privacy of automobiles with unchaperoned romance was of less concern than assuring the comfort of passengers on automobile trips. Beth Bailey writes that the automobile contributed to the popularity of dating over the former practice of a young man calling upon a young woman at her home. The social practice of "calling" was already giving way to socializing outside the home. Florence Howe Hall in her 1914 etiquette book *Good Form for All Occasions* gave detailed instructions about planning

ahead to find picnic sites that were free from "...any danger of an incursion by cattle ... driving so as not to alarm the passengers, and how to provide for the chauffeur when the automobile party stops for meals."

Emily Post stressed that while a young woman "...may motor around the country alone with a man, with her father's consent ... she must not ... go on a journey that can by any possibility last overnight," or "...to the end of time her reputation will suffer for the experience." Miriam Matthews remembered a situation where a college age couple drove from Los Angeles to Berkeley to attend a football game without a chaperone and the young woman found herself to be "...the talk of the town." The Black newspaper *Portland New Age* printed this warning that could apply to horse and buggy or automobile rides: "When a man takes a girl out riding on a country road, and puts his arm around her, someone passes and tells, though they are riding in the wilderness."[20]

Excursions, Tours and Parties

Learning about cars through exposure to them was a common first step on the way to learning more about their operation. That exposure often occurred through automobile excursions, tours, and even parties advertised through the newspapers. American papers began automobile news coverage with reports of European automobile use in the 1890s. By the first years of the 1900s, newspaper articles moved to generalized reports of automobile use. Livery stables began expanding from horse and carriage rental to including automobiles, and presumably drivers, available for hire.

In 1903 the *Baltimore AfroAmerican* described Jordan C. Jackson in Lexington, Kentucky, a Black man with a well-established business: "The stable that he is the owner of stands second to none in the city of Lexington and he owns some of the best horses, best carriages and buggies and even one of the latest improved automobiles."[21] Establishments with automobiles for hire varied in size. A Black Chicago businessman added a second vehicle for hire in 1911. Larger sightseeing buses offered tours of tourist destination cities. The Black-owned Sight Seeing Automobile and Investment Company located in Washington, D.C., operated a line of automobiles. Their motivations were reflected in a report in the *Baltimore AfroAmerican* in 1909; "The white sight-seeing concerns do not serve colored patrons."[22]

Automobile rides included in entertainment events were listed in the August 8, 1908, *Baltimore AfroAmerican*. In addition to a musical concert, the Block Carnival and Automobile Ride in Baltimore offered a ride in

an automobile for ten cents a ticket. In 1911, the Young Men's Christian Association offered a five-mile ride for 25 cents and a two-mile ride for ten cents, leaving hourly on Tuesdays and Wednesdays from 7:00 p.m. to 11:00 p.m. Churches also offered automobile rides for their fundraising events, including the Bethel A.M.E. Church in Hagerstown, Maryland, which raised $109 in 1911.[23]

"Automobile parties" were featured in the social columns of Black newspapers, and were hosted by individuals, social clubs, and church excursions. The touring cars could hold seven or eight passengers. In June 1911, the Phyllis Wheatley Club in Chicago announced, "The date of the automobile party will be announced soon. Just get ready for it. It is something new and very enjoyable. Mrs. Fischer will make it a success and all the committees will work to that end." The event featured a large, roomy car, and traveled from the home of one club member along Chicago boulevards to the destination home, where music and refreshments were served.[24]

Other Black women's automobile-related club activities included a South Bend, Indiana, "after dinner automobile joy ride" and a successful automobile party in Chicago. Visitors were offered automobile rides and tours of the area. A visitor from Beaver Falls, Pennsylvania, to Sewickley, Pennsylvania, reported "an excellent time" on her automobile trip to Allegheny, Pennsylvania.[25]

An automobile trip reported in the October 11, 1913, Black newspaper *Philadelphia Tribune* showed the ability to take day trips by automobile rather than needing to plan ahead for a train trip. A Sunday drive, at the time three hours driving time each way, was taken by a group of motorists who drove from Philadelphia, Pennsylvania, to Atlantic City, New Jersey, to spend the day with friends and have dinner. The July 10, 1915, *Baltimore AfroAmerican* reported a summer trip to Sea Isle, New Jersey, to the Ocean House hotel, described as "the mecca of the race" located right on the boardwalk with an orchestra and a dining room overlooking the ocean. A group of physicians and their wives were driven by automobile to Ocean House for the weekend and described it as "one of the best on the Atlantic Ocean run by colored people."[26]

Auto Tours

Columns featuring the social and travel activities of local residents were a staple in late 19th and early 20th-century newspapers for Black and White readerships, respectively. Correspondents from area towns submitted weekly updates listing names and addresses. Seeing one's name in the

paper was a potential incentive for increased subscriptions. The travels were reported year-round with an increase of longer trips in the peak vacation months of July, August and into September. Black women traveled from cities such as Baltimore to visit relatives in the country and in other cities. Former residents who had moved away returned for annual visits to family and friends. Cape May and Atlantic City, New Jersey, were featured destinations in the *Baltimore AfroAmerican* with visitors staying for weeks at a time. Located on the Maryland seaside, Round Bay camp advertised in 1893: "The Hotel and tents at the Round Bay camp are in good shape and a good many boarders are taking advantage of the opportunity."[27]

Vacation listings in the social columns of Black newspapers in the 1890s referred to travel by railroad. The 1895 Cotton States and International Exposition ran from September 18 to December 31 in Atlanta, Georgia. Advertisements by Southern Railway in the *Baltimore AfroAmerican* in the years just prior to the implementation of Separate Car Laws featured descriptions of comfortable day coaches, Pullman sleepers and dining cars with direct service between Washington, D.C., and Atlanta without changing trains. The advertisements seem to be directed equally at Black and White passengers. The 1896 *Baltimore AfroAmerican* listed the summer vacation season as opening by June 15 and wrote of the employment bureaus as "doing a good business in getting places in the numerous cottages and hotels for those seeking employment." For those off duty or on vacation luxurious bath houses on the beach were listed that welcomed Black vacationers. However, the newspaper also wrote of boardwalk amusements that were not open to Black customers.[28]

Auto tours remained a very popular use of automobiles. Suggested routes were listed in automobile enthusiast magazines and national and local automobile clubs sponsored cross country runs and published reports of the excursions. Local newspapers ran items in the local news column as well as feature-length stories about local residents taking automobile trips. The White newspaper *Albany (NY) Argus* reported the activities of Albany, New York, automobilists in the column, "Automobile News of Albany Motorists—Pleasure Tours and Test Trips of Local Interest—Machines That Are Making Records." The *Argus* proudly pointed to the "...over half a dozen well-equipped and, in some cases, handsomely fitted garages for the accommodation of the motoring public" as proof that Albany was the "headquarters of automobile interest in this part of the state."[29]

Comings, goings, and passings-through like these were reported in the White owned newspaper *Albany (NY) Argus:*

> Miss Irma Steefel was "...one of the youngest automobilists in this city..." who drove her Columbia Electric runabout around the city;
> Mrs. Howard Martin "...one of the most expert women autoists..." who

drove the more powerful 17.5 horsepower "Doctor" Maxwell—"This machine is as complicated to manage as a larger car which is ordinarily driven by a man."

Driving into the city of Albany from a country house as Mr. F.C. Huyck did from Rensselaerville with his 87 round trips since early spring 1906.

Mrs. Louis S. Greenleaf who drove her Steamer runabout into the city of Albany from their summer place in Loudonville on an almost daily basis.[30]

Longer distance trips were also reported in the *Argus*. Miss Edith Armstrong took her mother on an automobile trip through the Berkshires in her Locomobile runabout, which, according to the *Argus*, "…was a very ambitious undertaking for a woman, and accords her the honors of having been the first one in this vicinity to make the tour alone." "Alone" presumably meant that her mother was a passenger and not a fellow driver. Edith Armstrong was one of the first women automobilists in Albany, the *Argus* reported, having been driving for two seasons: the pleasant weather of late spring through fall.

Separate Railroad Car Laws

The intersections between race, class, gender, and the new technology of the automobile are, as we have seen, vastly complex. As noted from the outset, this study only begins to point to some of those relationships and hopes to invite further study into these areas. While examining newspapers that described the new drivers' approach to learning about their machines and discussed exposure to automobiles through leisure or touring excursions, it at least becomes clear that understanding cars in the context of early-20th-century laws governing the use of *trains* is essential. But to get to trains, we must begin at church.

The annual sessions of the National Baptist Convention and Woman's Convention provided an opportunity—for some Black women the only opportunity—to travel outside their state. Individual churches raised money throughout the year to pay the transportation costs for women attending the conventions. Under segregation, when the majority of public buildings were closed to Blacks, churches served as the primary public meeting place and "housed a diversity of programs including schools, circulating libraries, concerts, restaurants, insurance companies, vocational training, athletic clubs—all catering to a population much broader than the membership of individual churches."

These annual conventions provided Black women from a variety of socio-economic backgrounds the opportunity to learn and share new ideas, information, and experiences and to speak openly in a safe environment. As Dr. Evelyn Brooks Higginbotham writes: "The vast crowds who

flocked to the Woman's Convention's annual assemblies stirred feelings of
freedom and security. In these assemblies black Baptist women expressed
themselves openly and without fear of reprisal." These ideas were brought
back to the home churches and thus spread throughout the country.[31]

The churches in the host cities provided meals, accommodations, and
travel all within the network of private homes and Black-owned boarding
houses for the thousands who attended the National Convention. Black
Baptist women's emphasis on good manners and moral behavior coun-
tered the prevailing White attitude of Black women's loose morals and
rude behavior. In 1896, the *Baltimore AfroAmerican* gave this report of the
strategy used by delegates on their way to the General Conference of the
African Methodist Episcopal Church in Wilmington, North Carolina:

> At the different stations along the A.C.L. [Atlantic Coast Line Railroad] the
> delegates would drop out on the platform to become the "show" for both white
> and colored, for many of them had never seen so many good-looking, well-
> dressed Negroes before in their lives. We bore the scrutiny well and tried to
> look as dignified as possible.[32]

While much critical research has been done to think through these
displays for the White onlooker, they did much to expose the hypocrisy of
the segregation laws. While opposed to segregation in all its forms, mem-
bers of the Woman's Convention in 1904, 1908, and again in 1910 put forth
a petition for equal—if still separate—toilet facilities on railroad cars.
Educator Nannie H. Burroughs, a leader of the Woman's Convention,
declared at the 1908 convention:

> The women of this Convention will never be reconciled to the toilet arrange-
> ments in the [railroad] cars. Everybody else may get tired of talking about it,
> but we are at least going to say that we don't like it, because it is indecent. We
> want a separate toilet for colored women, just as they have a separate toilet for
> white women. We want basins, soap and towels. We pay the same fare and are
> entitled to the same treatment.[33]

Inspired by her speech, members of the Woman's Convention wrote
and signed a petition which was taken to Washington, D.C., and presented
to the Interstate Commerce Commission. There was no change in seg-
regated accommodations. In 1910, another petition was presented to the
Interstate Commerce Commission, with the same lack of response on the
part of the Federal government. In 1918, the Woman's Convention took
the next logical step and called for elimination of segregated rail cars alto-
gether writing:

> Nothing short of a repeal of the separate laws is going to bring a permanent
> and satisfactory change in travel in those states where the law is in operation.
> The very fact that the railroads are allowed to operate separate cars for people

who pay the same fares is a temptation to make a difference in accommodations for and treatment of those people. The very purpose of the "Jim Crow" car law is to make such striking differences in accommodation and treatment as will suggest the inferiority of one race to the other and humiliate the race thus discriminated against.[34]

Travel in the period of tightening segregation, whether across town or across the country, became increasingly dangerous for Black women using public transportation. They fought for their right to travel with dignity and safety. Segregated public transportation was resisted in a variety of additional ways. Lucy Rucker Aiken remembered that her father did not allow her family to ride the segregated trolley in Atlanta, Georgia. They walked to school rather than suffer the insult of segregated seating. "Papa did not allow us to ride the trolley. He bought us good raincoats, good umbrellas, and good rubbers, and we walked a mile and a half to school every day, and a mile and a half from school every afternoon." Dr. Ruth Janetta Temple spoke of the "perfect freedom" she felt living in Natchez, Mississippi, as a little girl. The feeling of freedom ended when the segregated streetcars were introduced into the city. "Then from that time on, my parents had us walk to school if they couldn't carry us in their buggy or in their dray or something. We had to walk because we were never supposed to get on the streetcars."[35]

Susie W. Jones' family traveled the 120-plus miles from Cincinnati, Ohio, to Danville, Kentucky, by train to spend their summers. "We always went on the train from Cincinnati, Ohio, because my mother insisted that we were interstate travelers, and this meant we did not have to use the segregated coaches. I did not understand this at that time, but I can remember that she would often have arguments with the conductor as to where we would sit."[36]

Lawsuits

The Separate Car Laws passed by the individual states were in violation of the federal mandates of the Interstate Commerce Commission. Created in 1887, the Interstate Commerce Commission was a regulatory agency created by the Interstate Commerce Act of 1887. The purpose of the act was to regulate the railroad, and later trucking, industry to ensure fair rates, eliminate rate discrimination and regulate other aspects of common carriers. In the "other aspects of common carriers," Black railroad passengers who had purchased a first-class ticket and then been removed to a segregated car when the train entered a state with a Separate Car Law were able to file lawsuits against the railroads for unequal treatment. Under the

Supremacy Clause of the United States Constitution, federal law supersedes state law. The 1896 Supreme Court Case *Plessy v. Ferguson* upheld the constitutionality of racial segregation laws for public facilities that were equal in quality and legitimized state segregation laws. The "unequal but separate" accommodations for which Black passengers had been charged full fare had been the subject of complaint and the basis of lawsuits from the beginning.[37]

The January 19, 1907, issue of the *Baltimore AfroAmerican* newspaper reported:

> Sues the B&O Railroad. Rev. Dr. Harvey Johnson, pastor of Union Baptist Church, through his attorney, Mr. W. Ashbie Hawkins, has entered suit in the Circuit Court claiming $1,000 from the Baltimore & Ohio Railroad for alleged unlawful ejectment from a car on August 15th last. Dr. Johnson took a car at Camden Station (Maryland) for Harpers Ferry (West Virginia) to attend the meeting of the Niagara Movement, and was ordered to go in the Jim Crow compartment. He refused to do so and was ejected. Under the interpretation made by the Court of Appeals in the Hart case, interstate passengers are not affected by the Maryland separate car law.[38]

A January 29, 1916, letter to the editor of the *Chicago Defender* from a Black woman reader in the all–Black community of Mound Bayou, Mississippi, began: "I would make my protest to the Interstate Commerce Commission if I were sure of some good purpose it would serve, except find its way into the waste basket." Traveling from Chicago, Illinois, to New Orleans, Louisiana, on the Illinois Central Railroad, she and her party were forced to move to the segregated (Jim Crow) rail car at Cairo, Illinois. This was despite the federal law that overrode the state separate car laws. The author describes the conditions—for which they had to pay to full ticket price in the following powerful testimony:

> At Cairo, Ill., we were forced to ride in a Jim Crow car and aside from humiliation and disgrace afforded by this legalized rule of slavery: filth, dirt and unfair treatment made up for the rest. Half the car was a smoker [the smoking car was where White men went to smoke cigars, pipes and cigarettes—they would return to the white cars to use the toilets and wash], at one end swinging doors between, one toilet at the far end of the car. The toilet filled with vermin and filth which found its way into the aisle. The car was ill smelling because of no ventilation. There was no place to wash your face or hands. Men and women had to use the same toilet. Those who were compelled to use this terrible hole were nearly overcome with sickness. Aside from this women going to the toilet were subject to the slurs of men who were occupants of the car.[...] One poor woman with a sick child, who was frail and weak herself, suffered terrible agony, because of no accommodations. Some of those who suffered with me: Sarah Hall, Rosedale, Miss.; Mrs. Louise H. Bibb and three-year-old baby; James Williams, Parkin, Ark.; Dewitte Gullage, East St. Louis, Ill.; Della

Hardy, Dearborn, Ky. The above is an incomplete list of the passengers who were on the car with me, but are sufficient to vouch for my statement of the truth. That the race must suffer such indignity, disgrace and shame is hardly conceivable. These conditions are unbearable, unlawful, unAmerican and are an indictment of every law-abiding citizen of the nation. A woman's voice is weak, but would it to God, that I had the voice of Thor and could speak from the skies. I would cast thunderbolts from Heaven and shake the mighty earth; I would condemn before God and man this terrible sin, unequaled in any other part of the known world, expect in the South. Justice, Liberty and Law, we must have it; if through peace, perhaps, if not war and bloodshed. If men of the race will not fight, the women must. Yours truly—A Subscriber.[39]

Letters of complaint are reported in contemporary Black newspapers to have been sent to the Interstate Commerce Commission. A page-by-page inspection of the Interstate Commerce Commission collection during a research trip by the author to the National Archives and Records Administration in 2013 failed to reveal any of the letters of complaint regarding railroad travel discrimination referred to in Black newspapers of the 1890s–1920s. There is strong secondary evidence that letters were written to the Interstate Commerce Commission. The author of the letter to the *Chicago Defender* raises an interesting question as to what happened to those letters and how they were received when written. If they had been kept, those letters would shed further light on the experience of Black travelers. Perhaps the writer above was correct, and the Interstate Commerce Commission did not keep the letters at the time they were received.

Dr. Mary Church Terrell described the extreme frustration of having to wait to buy a train ticket in the South until all the passengers in the White waiting room had purchased their tickets, no matter how early she arrived at the ticket counter:

> When I first filled lecture engagements in the South, I traveled with a trunk, and several times I barely secured my ticket in time to have it checked. Once I had to leave it, although I had reached the station early. Many white people were going to some special meeting and the ticket agent paid no attention to me whatever, as I stood waiting what seemed to me an interminable time at the window of the colored people's room.[40]

The insulting practice of making Black customers wait until all the White customers had been served continued into the days of full-service gasoline stations, the only kind available before the invention of self-service gasoline pumps. White-owned gas stations that did serve Black customers—many did not—could allow the gasoline pump attendants to fill the gas tanks of every White customer before Black customers were served. In some cases, Black customers who attempted to leave before being

served could be threatened with gun violence. In such cases, the full tank of gasoline could be accompanied by damage to the car's paint finish.[41]

As automobile use became more accessible, and as Black drivers, doctors, tour-guides, and other professionals gained traction with the expansion of automobile use, segregationists responded in kind. In 1913, a White automobile dealer in Springfield, Illinois, revoked the sale of an automobile to a Black physician after Whites threatened to boycott the dealer if the sale was completed. The *Chicago Defender* wrote, "so this chicken-hearted dealer refused the sale, thereby cutting off his nose to spite his face. It is hard to conceive of a man being such a fool. This is a great big world, and it isn't hard to find people who think the colored man's money as negotiable as the white man's. There seem to be races other than our own that lack business ability."

Fifteen years later, the Black newspaper *Pittsburgh Courier* reported on the refusal of White-owned insurance companies to insure Black motorists in Pennsylvania. The article reported on the letter of complaint written to the Insurance Commissioner outlining among others the extra cost to White drivers when Black motorists were unable to carry automobile insurance. The article continued with a discussion of the benefits of Black-run Motor Clubs to provide a network of 24-hour garages where Black motorists could safely get their autos repaired. In the segregated and frequently hostile environment of the road, this reassurance was very important.[42]

Indigenous Experiences, and Resilience, in the Early Automotive Era

In Miami, Florida, where Blacks were forbidden to work as chauffeurs, or to drive an automobile within the city limits, White photographers requested that Indigenous people pose in automobiles wearing feathered headdresses, long hair, and traditional clothing as these were popular postcard images. Meanwhile, Indigenous people who purchased and utilized automobiles for their own purposes were ridiculed. In both cases, use of the new technology by Blacks and Indigenous people represented a challenge to the White-preferred social hierarchy.[43]

The Sac and Fox Tribe of the Mississippi in Iowa/Meskwaki Nation is a settlement, not a reservation. The land is owned by the tribe on the settlement. This land was purchased in the late 1850s in their traditional homeland. In contrast, the land of a reservation is set aside by the Federal government for tribal use. From the original purchase of 80 acres, the settlement has been continually expanded to the present size of 8000 acres.

This 1850s land purchase was unique and far-sighted on the part of the tribal elders.[44]

In 1913, the Meskwaki Nation Sac & Fox Tribe of the Mississippi in Iowa hosted their first annual powwow open to Indigenous and non-Indigenous visitors. The four-day event held in August, originally associated with the harvesting of crops from the communal field and called the Green Corn Dance, celebrates the end of summer and serves as a time of "reaffirmation and hope, of kinship and friendship, and of celebration." Meskwaki shared the tasks of the harvest during a two-to-three-week celebration of harvesting, feasting, and social festivities. After the festival, the Meskwaki moved from the summer village to the fall and winter settlements as part of the seasonal lifeway.[45]

After a smallpox epidemic in the winter of 1901–1902 killed 45 members of the community, the Federal government burned down the summer homes. The government built replacement homes that were more permanent structures distributed around the Meskwaki Settlement. In the new structures, families planted and harvested individually. Without the common growing and harvesting area to bring them together from 1902 to 1912, the tribe held Field Days near the old village site. Neighboring Whites attended these Field Days that featured a week of traditional dancing, games, and horse racing.[46]

The Lincoln Highway, running from New York City to San Francisco, was the first transcontinental route and was dedicated in 1913. It passed right by the Meskwaki Settlement at Tama, Iowa. Bead stands were set up to sell to the tourist trade. Realizing the commercial opportunities the increase in tourist traffic presented, a committee of 15 men was appointed to establish a powwow that charged admission to visitors, while aiming to maintain the shared atmosphere of kinship, celebration, reaffirmation, hope and ties to the traditional homeland.[47]

The August 23, 1917, issue of the *Ackley (Iowa) World Journal* reported on the arrival of Indigenous people by automobile from Nebraska and Oklahoma to the Meskwaki Powwow. At the end of the Iowa Powwow they traveled on to La Crosse, Wisconsin, to visit with Indigenous communities. "The days of Indians using ponies for long journeys, as are still pictured in the wild west shows, is past. The automobile has succeeded the Indian pony." Later that week the *Esterville Democrat* carried the same story. The *Milford Mail,* dated later that year, expanded the description identifying the Nebraska and Oklahoma Indigenous visitors as driving "good cars" and as a part of the Iowa Sac and Fox tribe related to the Meskwaki Settlement.[48]

White-owned and operated newspapers in the 1920s often listed White automobilists who included the Meskwaki Powwow on their auto

tours. Papers also measured the increased automobile traffic on the Lincoln Highway, reporting "an average of ninety-three cars an hour or a little more than a car and a half every minute" with 1,551 automobiles, 13 motorcycles and 12 teams passing through the town of LeGrand, Iowa, between 6 a.m. and 10:30 p.m. In 1922, 6,000 automobiles were said to be in attendance. The White newspapers praised the well-organized parking arrangements for these vehicles. Fees were charged for entrance, and for taking pictures of the festivities. The White newspaper Burlington (Iowa) *Hawkeye* predicted that the traditional dances would soon become "only legendary" as the "American Indian is fast becoming civilized." That prediction proved false as Indigenous communities around the country continue to celebrate and carry on their traditions and protect their cultural representation despite the efforts of the Federal government to "civilize" them and erase their Indigenous identity.[49]

During the same time that the Meskwaki Powwows were drawing thousands of spectators, White and Indigenous, and participants from around Indian Country, the Bureau of Indian Affairs conducted surveys to evaluate the socio-economic status "industry," in Bureau of Indian Affairs parlance, of tribal communities. The term "industry" refers to being an "industrious farmer" according to the White based standards put forth by the Bureau of Indian Affairs survey takers. Those occupations considered industrious were farming, working at a trade learned in boarding school, or working for the Milwaukee Road (the nickname for the Chicago, Milwaukee, St. Paul and Pacific Railroad). Occupations not considered industrious were hunting, trapping, and "trying to live in the old ways."[50]

Other Bureau of Indian Affairs approved occupations included working for a Smithsonian Institution anthropologist and silver-smithing. The surveys show the variety of lifestyles of families living in the Meskwaki Settlement of Tama, Iowa. The records include information on family member age, tribal status, property ownership, living conditions, economic and educational accomplishments (as defined by the Bureau of Indian Affairs), and attitudes, again, as interpreted by the Bureau of Indian Affairs employees taking the surveys. Included are photographs of homes which range from traditional wickiups to 1920s frame dwellings. According to *Encyclopædia Britannica* the wickiup is constructed of tall saplings driven into the ground, bent over, and tied together near the top. This dome-shaped framework was covered with large overlapping mats of woven rushes or of bark that were tied to the saplings. Relatively easy to construct and maintain, a typical wickiup was some 15–20 feet in diameter. The term wickiup is derived from the Fox language and means "dwelling." These were the summer homes burned by the Federal government

after the smallpox epidemic and replaced with frame houses. The surveys provide a snapshot of life experiences and skills ranging from traditional lifeways to the incorporation of modern technology.[51]

During the first decade of the 1900s, there was continued discussion of the "old" and "new" ways. Most relevant to the current study, debates about the advantages of the automobile versus the horse took precedence in Indigenous communities. As we have also seen, the early uses of the automobile by physicians, ideas about drivers' education, fuel types and fuel mechanics, and even entertainment and leisure constituted the preoccupation of early car users. The positive outcomes in this complex era were reflected in newspaper and magazine stories featuring women drivers and encouraging female distance- and speed-racers to write articles and books encouraging women to drive. Physicians advocated for the speed of the automobile, and as automobile use became more accessible, automobile tourism increased, providing opportunities for certain Indigenous groups to incorporate the economic benefits of tourism, and providing many African Americans an alternative to traveling on segregated public transportation.

As Dr. Philip Deloria (Standing Rock Sioux) wrote of Indigenous automobilists, automobiles were incorporated into Indigenous everyday life just as other non–Indigenous technologies, including the horse, had been in the centuries before. The automobile, as well as public transportation, enabled Pequot, Narragansett, Nipmuc, Wampanoag and other southeastern New England Indigenous families who had moved away to find jobs in the nearby cities to stay connected to their families, culture, and ancestral homelands.[52]

Although it is far from the complete story, to an important extent automobile travel helped Indigenous people to connect with each other, both on the reservations and between reservations, enabling them to strengthen their tribal identity and to make connections with other tribes. Deloria writes: "long-distance travel—and especially such travel between reservations—allowed Indigenous people to imagine an even broader vision of Indian country[...]. It is no coincidence that the rise of an intertribal powwow circuit began at the same moment as Indian people were acquiring and using automobiles." The automobile enabled transportation for visiting and gatherings that were an important part of Native life and kept Native peoples connected to each other and to cultural traditions.

The practical aspects of being able to sleep and camp in the car, reprised "...the older functions of both horse and tipi," and the headlights were useful to light the dance circle after sundown. Tribal dances were never successfully eliminated, despite the attempts of federal officials. A

section of the Annual Narrative and Statistical Reports submitted by tribal agency superintendents dealt specifically with the subject of traditional Indigenous dances and whether or not they should be allowed despite their association with Indigenous religions that ran contrary to ongoing White efforts to convert Indigenous people to Christianity; the tourism aspect of Indigenous dances complicated the issue for federal authorities.[53]

Lucian Spencer, superintendent of the Seminole Agency, wrote to reassure his superiors that the "Annual Seminole Sun Dance" was entirely a White affair put on by the Palm Beach, Florida, tourism promoters where White tourists dressed up in "Indian costume" enacted "Indian dramas" and "[had] a general good time." Spencer gave an indication of what the Seminole thought of the annual event when he wrote, "It is an affair of the white people and so far as they are concerned, the Florida Seminoles care nothing for it and do not attend unless paid for their services." Lucian Spencer enclosed newspaper clippings from the *Jacksonville Times-Union* with the headline "Genuine Seminoles Will Take Part in Great Sun Dance at Palm Beach March 9." White usurpation of traditional dances was an inheritance of the wild west shows of earlier decades; Indigenous people sometimes reluctantly accepted financial benefits while also striving to protect the genuine nature of the dance as part of their cultural traditions.

Clyde Ellis quotes Harry Tofpi, Sr. (Kiowa): "We're a dancing people, always have been. God gave us these ways. He gave us lots of ways to express ourselves. One of them is these dances. When I go to them […] I'm right where those old people were. Singing those songs, dancing *where they danced*. And my children and grandchildren, they've learned these ways, too, because it's good, it's powerful." The automobile had a significant role in providing transportation for visits and gatherings that were an important part of Indigenous life, and in this sense, played a part in maintaining connections among Indigenous peoples and their cultural traditions. The practical aspects of being able to sleep and camp in the car, reprised "the older functions of both horse and tipi," and the headlights were useful to light the dance circle after sundown.[54]

The automobile was useful to Indigenous families in the early 20th century as they traveled home to visit family, reconnect with traditional homelands, and participate in traditional cultural activities. In the 1950s and 1960s, Albert White Hat, Sr. (Lakota Sioux), writes, "There was a time when we had songs called Cankusapa olowan, 'black-top songs' or 'black-road songs.' We'd be driving down the road, singing in Lakota, beating on the seats and dashboard for drumming, and really getting into it." Adolf Hungry Wolf writes, "Now that so many traditional tribal customs have been lost, inter-tribal powwows offer some of the best opportunities for cultural expression. They are the prime evidence that American Indian

culture is still very much alive. The constantly changing dance and costume styles help make powwows a living art form in which anyone can learn to take part as a dancer, drummer or spectator." The young adult novel *Son Who Returns* summarizes: "Powwows are based on things that Native Americans think are important. Honor, respect, tradition, and generosity."[55]

At the same time that White authorities worked to ban the sacred rituals, other aspects of White society celebrated the growing popularity of Wild West open air theater shows, including the well-publicized "Buffalo Bill's Wild West Show" that traveled around the United States and had eight European tours. Wild West shows were traveling vaudeville performances popular from 1870 until 1920 when the movie western took their place. Acting as a crossover between the American West that came to a close with the end of the Federal government's armed conflict against Indigenous communities in the 1890s, Wild West shows portrayed a stylized, romanticized version of the American West.

While Buffalo Bill's Wild West Show was among the bigger names, there were a variety of other Wild West shows during the period. Wild West shows featured skills associated with the Cowboys and Indians mythology begun with the post–Civil War inexpensive adventure novels known colloquially as dime novels. Horses, buffaloes, cattle and other western animals were included in the rodeo performances, cowboys and cowgirls performed horseback riding and roping tricks. Men and women performed sharpshooting demonstrations. And "Indian Wars" were re-enacted as well as demonstrations of "Indian life." World's fairs also featured re-enactments of Indigenous life.[56]

Performing in these shows gave Indigenous people the opportunity to keep traditional dances and regalia alive while earning more money than they could on the reservations. The westerns featured in the early movie era were the successors to the Wild West shows, with similar stereotypes. Bureau of Indian Affairs superintendents tried to discourage work in the western themed shows. Adolf Hungry Wolf writes

> After Indian tribes got settled on reservations the people found themselves with a lot of spare time. Gone were the buffalo hunts, war raids, and daily camp life. There was much time for leisure activity, so dancing became very popular. With a change to modern clothing, dances became the main occasions when Indian people could wear traditional costumes and practice old social customs. Thus, although modern powwows have their roots in ancient times, their real development only began in the late 1800s.

As non-native automobilists began touring the country on newly opened transcontinental roads, those tribes who opened their celebrations

to outsiders benefited from tourism money. As mentioned previously, the passage of the Lincoln Highway right next to the Meskwaki Nation Sac & Fox Tribe of the Mississippi in Iowa provided a market for the sale of traditional crafts in conjunction with the Powwows that began in 1913.[57]

Dr. Philip Deloria (Standing Rock Sioux) writes:

> Mobility, speed, power, progress: these things matter, and Americans of every race, class, gender, and origin have found ways to express them in automotive terms. Cars serve a utilitarian function of course—and, thus, access to automobility matters critically to those outside the few transportations systems in the United States. As important as the moving of people from point A to point B, however, is the fact that automobiles express a driver's sense of self and of the nature of his or her power.

Federal Control Over Indigenous Funds

The members of the Confederated Tribes and Bands of the Yakima Nation in south-central Washington State adapted to ranching and farming when the Yakima Reservation was allotted into individually owned plots of land in 1892 as part of the Dawes Act of 1887. The act divided communally held land into farm plots in an effort to force Indigenous families to adopt a White-style ranching and farming economy. In addition to farming and ranching, the Yakima community members worked to preserve rights to the root-gathering and fishing spots that were part of their traditional seasonal round of fishing and gathering roots from their permanent villages on the Yakima River. Members of several tribes (among others Yakima, Palouse, Wenatchee, Wanapum, Wishram) with three language families were placed on the Yakima Reservation—also known as an Agency—and referred to collectively as "Yakima" by state and Federal government officials.[58]

Yakima women had traditionally been important food providers and continued that role as they began western-style farming and ranching. Clifford Trafzer's study of the Yakima Reservation *Bills of Sale for Personal Property* maintained between 1909 and 1912 by the Department of the Interior's Office of Indian Affairs (which recorded business transactions by all Indigenous people under federal jurisdiction) shows that Yakima women made more purchases of wagons, horses, cattle, buggies, and other transportation equipment than did men. Since the introduction of the horse to the region in the 1750s, horses were an important factor in Yakima culture. Although Yakima men and women earned their own money through farming, leasing farm and grazing land to Whites, and through the complicated, paternalistic federal oversight system, individual purchases had

to be approved by federal officials who judged the "worthiness" of the individual to make the purchase.[59]

In the October 29, 1909, Office of Indian Affairs "circular no. 359," entitled "Privileges to be granted by graded steps," agency superintendents were instructed that it was left to the superintendent's discretion to approve funds disbursement in the following steps:

> It (the first request) may be less than $100 but not more than $500, according to the ability and opportunities of the applicant. When the first test has been successfully applied, a second may be given involving a larger amount, either within the $500 limit or above it, according to the best judgment of the Superintendent. In most cases the privileges exceeding $500 should be reserved for the third step toward ultimate independence. When application is made for sums in excess of that amount, the applicant will be required to base his claim of competency on the use he has made of special privileges previously granted him.[60]

As Clifford Trafzer points out, this was money the Yakima community members earned, "through land-leasing, farm labor, ranch work, freighting, government employment, and domestic labor." Trafzer writes, "The federal government did not give the people cash for merely being Indian, as is often believed, but men, women, and children worked and leased their lands. Since the Yakima made their own money, they decided for themselves how they would spend it." But having to go through the federal bureaucracy to access that money would make it difficult to make purchases such as an automobile which agency superintendents would consider unnecessary for "an industrious and worthy Indian," particularly at a time when agency employees were sending their own requests and justifications for automobiles to their superiors at the Washington, D.C. Office of Indian Affairs. Records of Yakima purchasing automobiles are listed in 1927.[61]

Dr. Philip Deloria (Standing Rock Sioux), writing about the Rosebud reservation in South Dakota, quotes Inspector McConihe's 1910 letter requesting an automobile for the agency, saying, "The roads around here are admirably adapted for automobiles and with the stupendous amount of traveling that is absolutely required of an agent if he is to do any real good here, a machine is almost indispensable." *The Oglala Light* monthly magazine of the Pine Ridge Reservation in South Dakota regularly listed automobile purchases made primarily by the White employees of the Oglala Indian Training School.

Allotting Surveyor Charles Ash Bates is the proud and happy possessor of an International touring car, which he purchased about the first of September. October 1911

There are now seven automobiles in our midst, all different, and, as we heard it expressed, they run all the way from a "Brush" to a "Reo." March 1912

Mrs. J.J. Duncan went out to Kyle in her Buick touring car and brought Mr. Duncan and his Hupmobile which had been put out of commission back to the Agency. December 1912

Mr. Will Kiger recently purchased a "King" automobile and is now eligible for admission into the society of the "Auto Bums." June 1915[62]

While the White agency employees may have considered automobiles an unnecessary purchase for Indigenous individuals, Indigenous people were able to buy automobiles because "An economic window of opportunity and a clear realization of the usefulness of automobiles happened to coincide with sporadic infusions of cash on many reservations in the form of payments from claims cases, land and cattle sales, leasing, allotment sales, and Wild West income," according to Deloria. Family cattle wealth enabled Annie Yellowhawk (Lakota) from Green Grass, Old Agency, South Dakota, to purchase a Model T. According to her grandson, artist Jim Yellowhawk (Lakota), she was stopped for speeding while driving 20 miles an hour. The Rev. Duncan Burns (Muscogee Creek) remembers stories from his grandmother, Isabelle Strouville (Muscogee Creek), about being driven to school by a chauffeur in Tulsa, Oklahoma.[63]

Black Travelers' Strategies for Safety

Black travelers continued to strive to travel safely and be treated with respect despite the inferior, dangerous, segregated public transportation and accommodations. The August 1912 issue of the magazine *The Crisis*, the publication of the National Association for the Advancement of Colored People (NAACP), featured the story "Vacation Days," which summarized information gathered from readers about where they spent their vacations. The majority responded that they were not able to take very much time away from work as they were "...too busy trying to earn a living to think about summer resorts." The article continued:

To this large body of people, the picnic, the evening car ride, the excursion to some neighboring part is the only escape from the city's toil and heat. "How are you welcomed when visiting picnic grounds and parks?" we have asked. "You are tolerated if you are very careful," is one answer to this question, and it seems to cover a large number of cities. You may go to the beach, but you may not hire a bathing suit; you may walk about under the trees, but you may not dance in the newly erected hall; you may ride in the trolleys, but you may not take the sightseeing automobiles; these are some of the ways in which you are "tolerated."[64]

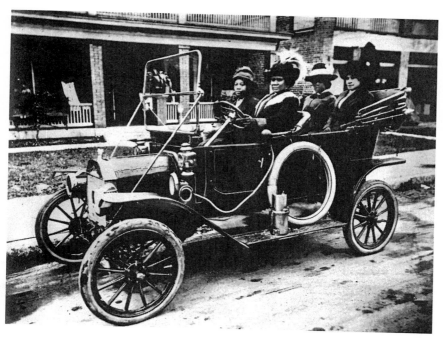

Entrepreneur and philanthropist C.J. Walker at the wheel of her Model T Ford in front of her Indianapolis home in 1912 (Madam C.J. Walker Collection, Indiana Historical Society, P0391).

Finding safe places to visit, eat and stay overnight—all while paying full price for the accommodations, no matter what the conditions—was a primary concern for Black travelers. According to the author of *The Crisis* article, the only way to avoid discrimination "is to board an ocean liner, preferably a French or German one, and make your pilgrimage abroad." However, even travel in Europe, which was very expensive and not an option for the general traveling public, did not guarantee freedom from discrimination, as Dr. Mary Church Terrell reported of her experience while studying in Berlin, Germany, in the 1880s in her book, *A Colored Woman in a White World*. When two American medical students from Washington, D.C., and Baltimore, Maryland, moved into the small boarding house where she was living, they tried to persuade the German landlady to ask her to leave—explaining that Blacks were socially ostracized in the United States and not allowed to stay in the same lodgings with Whites. The landlady refused to ask Dr. Terrell to leave and asked her to explain the American social custom to her. Dr. Terrell left the boarding house anyway, over the landlady's protests.

I felt I could not retain my self-respect if I stayed another second in the same boarding house with two young men who were so full of prejudice against my race that they would drive from comfortable quarters a young colored girl who was alone in a foreign land three thousand miles from home.[65]

Black writer Claude McKay, musician E. Azalia Hackley, and even Dr. Terrell—despite the above experience—all wrote about the relative freedom from American racism that they experienced while traveling in Europe. Historian Mark Foster writes: "Some blacks who went overseas sought at least temporary relief from the suffocating racism affecting the United States late in the nineteenth and early twentieth centuries. A few even found their dreams fulfilled." Other Black travelers recount difficulties when they were treated as curiosities by Europeans meeting a Black person for the first time or felt unable to relax as they were regarded as spokesmen for all Black Americans.[66]

In the western United States, *The Crisis* reported that "...things seem better, and we hear of the best of good fellowship in some western towns..." but the welcome Blacks received varied from one location to another. Dr. Ruth Flowers described the difference between Cripple Creek, Colorado—which was a "wide-open, tolerant" town where they had never been refused service—and Boulder, Colorado, which had a prominent population of wealthy White families from Texas and Oklahoma who owned the majority of the businesses and where Blacks were refused service. As Dr. Flowers put it: "Consequently, when they bought out everything, they said—O.K.—no Negroes in any theaters, no Negroes in any restaurants—no Negroes anywhere."[67]

CHAPTER 4

Venturing Farther from Home: Problem-Solving on the Road

Accounts of early automobile excursions have two major themes: breakdowns and the reactions of the people and animals they drove past. The early automobiles were in frequent need of rescue from a farmer and team of horses, even as motorists were passing through new territory often to the dismay of farmers and the farm animals who regarded the dusty roads as their territory. Automobilist Mrs. J.C.C. found the reaction of cows to her automobile to be the opposite of that of skittish horses. "They [cows] will stand and chew their cud, turn their lazy eyes around to look at you, and nothing can induce them to move." The cows they were trying to pass were standing and lying in the road ignoring the tooting auto horn and waving handkerchiefs. Eventually, "one of us had to get out of the car to make one gentle old thing that was lying down get up so we could pass." They concluded that "if people would only drive cows in carriages instead of horses there would be no danger of frightening them."[1]

Running out of gasoline was one of the main hazards of early automobile trips. Mrs. J.C.C. and her friends had that problem when they found that the connection from the gasoline tank to the carburetor was loose and almost all of the gasoline had dripped out. The first store they tried had no gasoline, but the proprietor was willing to rent them a team to drive the six miles to the next town, after they helped his children catch the horses. After checking with the two stores that carried gas but were out of it, they went door to door asking families if they had any spare gasoline. That effort failing, they were sent to a mill that used a gasoline-powered engine. After considerable persuasion—for the miller needed the gasoline to complete his own tasks—the mill's assistant sold them a gallon-and-a-half of gasoline.[2]

Automobilist C.H. Claudy describes the difficulties in *Country Life in America,* one of the early general interest magazines to carry articles about automobiles. Two motorists ran out of gasoline 12 miles from the

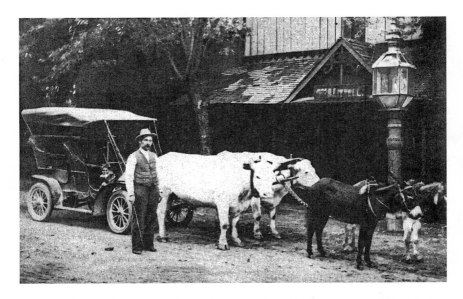

Hunting for gasoline, Greensburg, Indiana, circa 1905. The automobile is being towed by a team of oxen and mules (Indiana Historical Society, P0391).

nearest town and stopped at a farmhouse to buy stove gasoline. Claudy describes the scene: "The hour was five in the evening and a storm coming." Claudy was convinced that the farmer, when he eventually agreed to sell, put water in the gasoline so they would be forced to come back for help. They ended up spending 14 dollars for a tow first back to the house, then to Bridgeport, Connecticut, the next morning, and food and lodging for the night.[3]

Claudy may well have been correct in thinking the farmer was interested in extracting as much money as he could from the automobile party, it is also possible that the hour being five in the evening, the storm coming, and distance to the town, were factors in the life of the farm family who needed the stove gasoline to prepare their evening meal and would have to replenish the fuel for their own needs. As Michael Berger points out, "Because rural and urban areas had long been isolated from each other, a 'culture gap' had developed." In their book about motor camping in 1926, John D. Long and J.C. Long address the separation of town and country. "Week-end camping will tend to bring the town and country into closer acquaintance and sympathy to the mutual advantage of both."[4]

City dwelling automobilists did not know how to handle rural resources that were vital to farm life. Something as seemingly simple as stopping for a drink of water at a farmer's well caused complications. There was an etiquette to be followed to keep the well water clean. Wells

functioned as refrigerators, and the intricate system of ropes with buckets holding cream and food to be kept cool could easily be spilled into the well, ruining the water supply. As the farm wife in Michael Berger's story said, "The rope on the southeast corner carries a pail containing any meat or fish we have on hand. The rope on the northeast supports the cream. It requires a certain amount of skill to steer a bucket without putting our precious water supply out of commission altogether."[5]

Automobilist Joel Smith from Poughkeepsie, New York, wrote in *The Automobile Magazine* encouraging fellow automobilists to come to his native Dutchess County for auto tours within close reach of New York City. He pointed out that the hilly section of the county ran from east-to-west and the north-south routes were more level. The routes he recommended—Poughkeepsie to Tivoli and on to "The Wood Road," which led to Germantown—were north-south routes along the Hudson River. Joel Smith wrote, "The roads are well kept, and let it be said, to the credit of many of the farmers, there is more of a kindly disposition on their part to maintain them in good condition than is found usually." Joel Smith was writing specifically to draw people's attention away from the other established auto routes around New York City, Long Island, New Jersey, and Staten Island.[6]

The roads on Long Island were among the earliest to be adopted by automobilists. Beginning in the 1890s and continuing through the end of World War I, the North Shore of Long Island became a favorite haunt of America's newly rich families during the spring and fall seasons and winter weekends. The proximity to New York City made what became known as the Gold Coast ideal for establishing huge, secluded estates reminiscent of European nobility—nearly 600 estates had been built by 1920. To build these huge estates with private access to forests, beaches and lakes, the incoming wealthy White elite bought up Long Island resident-owned ancestral farms to convert to estate lands, bought and tore down large resort hotels and small houses that were obstructing the ocean view and cut off all public access to the oceanfront on the North Shore.[7]

While some White Long Island residents sold their property willingly, others protested the estate building methods. In 1898, Greater New York City was created by combining Brooklyn, Manhattan, Queens, Staten Island and the Bronx. The White wealthy elite used this to their political advantage by leaving Nassau County out of the new Greater New York City and establishing it as a Republican stronghold with close ties to state leadership in Albany. By arranging to have the legal limit of town incorporation changed from 250 residents to 50, estate owners with their large staff of on-site servants were able to incorporate their private estates, elect the landowner as mayor and

thus be free to make their own laws, thus ensuring private access to the previously public resources.[8]

Racing

Racing was an activity that continued to evolve to establish automobile durability among the different automobile makers and drivers. As the sport professionalized and became a predominantly White male activity, women were excluded from participation. Black newspapers reported on the racing events that included Black women race drivers for several years after White women were no longer allowed to participate in the racing events sponsored by White organizations.

The September 22, 1903, *Baltimore AfroAmerican* reported on plans (unfulfilled) to construct a 112 mile long automobile speedway the length of Long Island from Blackwell Island Bridge to Montauk Point. The plans called for the track to be 40 feet wide and enclosed by hedges and wire fences. The potential cost was great but "the automobilists can well afford it, and other people might profitably contribute for the sake of getting the racing machines off the public highways." While that racetrack wasn't created, the following year saw the first of the Vanderbilt Cup automobile races. The new rich—including automobile enthusiast William K. Vanderbilt II—were fascinated with automobiles and soon turned Long Island roads into racetracks.[9]

The Vanderbilt Cup, 1904 to 1910, a speed race that covered 300 miles on Nassau County public roads, drew international attention in the automobile and general interest press, over 100,000 spectators and the protests of local farmers. To prepare for the race, William K. Vanderbilt II proposed spreading 90,000 gallons of oil on the unpaved roads to keep down the dust and provide a firmer surface to attain higher speeds. The farmers objected that such an amount of oil would pollute their produce, harm their livestock and make it impossible to get their goods to market while the race was going on. But Vanderbilt prevailed. The roads were prepared to his specifications, and the race was held on Long Island for the next six years, drawing hundreds of thousands of spectators each year. Those spectators needed places to park their cars for the dawn race start and food to eat during the day-long race. According to *The New York Herald,* local residents charged up to ten dollars for parking spots along the race route and made similar profits in food sales.[10]

The first decades of auto racing took on two main categories, speed races and reliability runs. These were run on public roads and the smooth beaches at Daytona and Ormond Beach, Florida. Speed races were used

by manufacturers to demonstrate the power of their machines and by the wealthiest automobilists using their automobiles as playthings. Reliability runs tested the ability of automobiles to traverse rugged terrain in all sorts of weather and road conditions, making it more interesting to a wider group of potential automobilists. A 1902 article in the White publication *Munsey's Magazine* was subtitled "The automobile, so recently an innovation and a wonder, has today become familiar on our streets and roads as the costly plaything of the rich—tomorrow it may be the popular conveyance of the great middle class."[11]

Eustace Clavering described the October 1902, 488-mile reliability run from New York to Boston and back as a good test of the practicality of the automobile: "The road is a trying one, very hilly in places, and rough and sandy in others; and the run was made in unfavorable weather. Yet of the seventy-five motor cars which started, sixty-seven finished successfully." Clavering went on to write that the reliability runs would prove that the automobile was useful to the "ordinary citizen" who wanted: "…something that will travel at a speed greater than that of a horse, yet less than that of a railroad train … that will not blow up when he uses it, that will not break down when he leaves the streets of the city."[12]

The newly formed, predominantly White American Automobile Association sponsored a tour from New York City to St. Louis, Missouri, to visit the 1904 Louisiana Purchase Exhibition. Mrs. Laura Lillibridge, driving a White Steamer, was among the 18 drivers who started the tour. The White Motor Company produced automobiles from 1898 to the end of World War I in 1919. The road was marked with a trail of confetti tossed from a car traveling ahead of the procession. Author Bellamy Partridge writes that this worked well until the confetti car broke down, was passed by the faster moving tour cars, or ran out of confetti and substituted beans and corn. The last solution attracted flocks of barnyard fowl to the middle of the road where they were in the way of the cars on the tour. Running over the farm flocks would increase the anti-automobile sentiment of local residents.

The Glidden tours, held each year from 1905 to 1913, were cross-country courses of about 300 miles through the East or Midwest. Begun by telephone pioneer and millionaire Charles Glidden, under the auspices of the American Automobile Association, for members of the AAA and affiliated clubs, the tours were to promote cross-country motoring and draw attention to the automobilists' need for good roads. Participants drove their own automobiles and the winner was the vehicle that needed the fewest repairs, not necessarily the first to finish. Reliability runs had been sponsored since 1900 by automobile clubs and civic organizations interesting in promoting and legitimizing automobile travel. The

Glidden tours were grueling trips covering hundreds of miles in the days before well-maintained roads. They tested the mettle of both automobile and driver.[13]

The first Glidden tour in July 1905 followed a route from New York City to Bretton Woods, New Hampshire, and back to New York City. New Hampshire was an early state in building good roads for automobile travel. A corporation had been established in New Hampshire in 1900 to provide 500 miles of scenic roadway and New Hampshire was also home to the scenic Mt. Washington and the Mt. Washington Hill Climb held in 1905 to coincide with the Glidden tour. The American Automobile Association, founded in 1902, allowed women to join and Joan Newton Cuneo, a successful White woman race car driver, participated in the 1905 Glidden tour but was not allowed to participate in the "Climb to the Clouds" up Mt Washington.[14]

Joanna (Joan) Newton was born in 1876 in Holyoke, Massachusetts. She was the youngest of five daughters. Her family were successful and wealthy business entrepreneurs. The family took regular trips to California and Vermont during her girlhood. She attended finishing schools and was an adventurous and athletic tomboy. At the age of 22, in 1898, Joan married Andrew Cuneo of New York City. Andrew Cuneo was a millionaire banker and businessman. Andrew Cuneo had inherited his uncle Antonio Cuneo's banking, banana importing, pasta manufacturing and tenement rental housing businesses.[15]

In 1902 at age 26, the former tomboy Joan Cuneo purchased her first auto, a used Locomobile Steam Car. She was interested in mechanics. She was a skilled horsewoman and carriage driver. She loved the outdoors. Automobiles allowed her to combine her love of the outdoors, adventure and working on machinery. Joan Cuneo's interest in automobiles had increased during her trip to Paris. Paris at that time was the center of the automotive world. Cars were increasingly popular with Joan and Andrew Cuneo's wealthy social set in New York City and Long Island as they were introduced on trips to Europe to European cars and European smooth roads. Newspapers and magazines carried more and more articles about automobile driving exhibitions.[16]

Joan Cuneo learned to maintain her automobiles from a skilled mechanic hired by her husband when she bought her first automobile. Louis Disbrow served as her "riding mechanic" throughout her racing career. Riding mechanics rode with the drivers on the racecourse to help balance the speeding vehicle and in some cases holding the drivers down to keep them from flying out of the car on tight turns.[17]

It seems that women were not expressly banned from participating in the Glidden tours because Charles Glidden never expected a woman to

enter the tour. When Joan Cuneo submitted her application to drive in the 1905 Glidden tour it was rejected. She successfully made the case that the rules did not explicitly forbid women drivers. As Dr. Elsa Nystrom puts it: "Female participation in automobile races, endurance runs and hill climbs was regarded as an interesting novelty in 1905, but by 1908 there was growing resistance to letting women take part in any of these potentially dangerous competitions."[18]

The only woman to enter the Glidden tour as a driver, Cuneo drove a White Steamer. On the first day of the 1905 tour, the leg from New York City to Hartford, Connecticut, she swerved quickly to avoid hitting the car in front of her that was stopped on a bridge. The driver of the stopped car had been warned by bridge workers that a blast was about to be set off, but the warning did not get to Cuneo. She steered around the stopped car but struck the bridge rail and plunged off the nine-foot bridge into the creek. Cuneo and her three passengers were able to get out from under the car, the car righted and pulled from the creek. After repairs were made to the condenser and drip pan of her vehicle, Cuneo and her passengers were underway within an hour. As she told a reporter: "The fastest driving I ever did in my life was from Bridgeport to Hartford after that accident." Upon her arrival at the evening banquet in Hartford, Connecticut, that night, she and the other women passengers from a variety of tour cars were "...entertained by a special committee of Hartford ladies." Meanwhile the 32 male drivers of the tour were in the grand ballroom for the formal banquet.[19]

Descriptions of Joan Cuneo's accident have varied through time, the variations reflecting the societal expectations of the writers as the automobile became more accepted and ridicule of women drivers increased. The 1905 report in *The Horseless Age* clearly stated that Harlan W. Whipple's car was stopped in the road and "Mrs. Cuneo was driving up behind and had no time to turn around but attempted to pass Mr. Whipple's car and continue on to the bridge." The account in "What a Woman Can Do with an Auto" from *The Outing Magazine* in 1910 reported on the accident in more detail:

> ...on the narrow Put's Hill, the automobile just ahead of her, being warned of a blast, began to back rapidly, the driver not even looking behind. Mrs. Cuneo had to choose between letting this car smash into her own, or backing down against the temporary wooden railing on a narrow bridge. She took the latter chance; the railing broke and her machine went upside down into the creek below. By some miracle she and her three friends escaped without serious injury.[20]

Bellamy Partridge, writing in 1952, reported the accident with a very different tone:

She [Cuneo] had not gone far, however, before she had the misfortune to crash the rail of a bridge and drop into a small stream some 10 feet below, just as she was entering Greenwich. Luckily she was unhurt and was soon fished out. Her car was righted and, though somewhat battered, continued on its way, followed by cheers of the onlookers who even then were making remarks about "those woman drivers."[21]

The derisive "woman driver" joke prevalent in the mid- to late-1900s was not the dominant theme in automobile jokes of the early automotive era. Jokes of the 1890s and 1900s focused on the frequent mechanical breakdowns and frightened animals. Bellamy Partridge's description of Joan Cuneo's being "fished out" is much less respectful than his term "...rescued by friendly onlookers..." which he used to describe an incident involving a male driver whose accident was caused by speeding and passing in low visibility. Partridge also neglects to mention the circumstances of Joan Cuneo's accident, which *The Horseless Age* article described in detail. The article "Woman Gliddenite," published in the fall 1955 edition of *The Antique Automobile,* adopts a rather patronizing tone when relating the accident: "...she ran into a creek at Greenwich, Connecticut, and capsized her fifteen horsepower White..." and goes on to detail the mechanical "mishaps" that "dogged" her on the 1905 tour.[22]

The "Woman Gliddenite" article failed to mention that Mr. Hutchinson did not complete the tour either, thus giving the impression that the only woman driver was also the only Gliddenite not to complete the tour. Further, the line "Unfortunately for Mrs. Cuneo and the history of women, she never won the Glidden Trophy, but she did win the honest praise and sincere admiration from her fellow Gliddenites" shows the unrealistic expectation that the success or failure of individual pioneers represents the potential for an entire section of society. Joan Cuneo, the article continues, "...won their admiration and respect as a woman capable of competing as an equal with men..." with the reward that "On subsequent tours she was known as the mascot of the Gliddenites and was always placed in a seat of honor."[23]

The terms "dogged," "mascot," and "placed in a seat" all serve to undercut Cuneo's driving ability and reflect the attitude toward woman drivers of the 1950s which were not necessarily those in 1905. Beverly Rae Kimes describes the incident succinctly, in her 2005 book *Pioneers, Engineers and Scoundrels.* "Swerving to avoid his [Harlan Whipple] Peerless on a bridge in Connecticut, she [Cuneo] drove into a river bed and was pinned underneath her White steamer, but got both herself and the car out and back on the road."[24]

Following the 1905 Glidden tour, Cuneo entered an oval track race on the beach at Atlantic City. There were oval dirt horse racing tracks at the

hundreds of fairgrounds built across the country beginning in 1850. From 1900 to 1950 both horse and auto races were held; since the autos damaged the tracks, they were held after the horse races. The Hudson River Driving Park in Poughkeepsie, New York, was a one-mile dirt oval track that hosted both horse and auto races. In 1905 Joan Cuneo ran her first oval dirt track race at the Poughkeepsie track. Dirt track speeds reached 60 mph—a thrilling sight at a time when the majority of the spectators had never gone faster than 10 to 15 mph. While driving a practice run on the Poughkeepsie, New York, track with nationally admired professional race car driver Barney Oldfield as a passenger, Cuneo's quick responses prevented an accident, reinforcing her reputation as a skilled driver. As Cuneo excelled at the racing events she participated in, she became a celebrity whose endorsements were sought after in the automotive world.[25]

The Automobile Club of America—which did not allow women members—and the American Automobile Association—which did—were two White organizations that officially sponsored auto races.[26] Beginning in 1908, racing officials began rejecting Cuneo's applications to participate in races. Once the novelty of seeing an auto race wore off, auto racing was on the fringe of respectability. Accidents were a regular occurrence, race organizers professed to fear public outcry and the possible banning of racing if a woman was hurt during a race. That Cuneo was never injured during her racing career is a testament to her superior driving ability. In 1909, the American Automobile Association Contest Board formally changed the rules to explicitly ban women from entering automobile races. Despite Cuneo's ability to draw large audiences to the racing events, she was refused entry or, in the case of an event hosted by the Fort George Auto Carnival Committee, she was turned away at the starting line. At the time of her banishment from racing Joan Cuneo had participated in the majority of the major racing events of the time. Those she did not participate in had refused her applications.[27]

The first generation of racing moved from public spaces to specially built tracks. In 1909 the first competitive race took place at the Indianapolis Motor Speedway. Circular wood plank and dirt tracks were installed around the country beginning in 1913. County fairs and professional tracks gave rise to racing as a spectator sport. The early years of racing saw little regulation and ample opportunity for cheating and fixing events. Races were sanctioned by a number of White organizations and individuals, including the upper-class membership Automobile Club of America (ACA); the middle-class-oriented American Automobile Association (AAA), and the American Motor Car Manufacturers Association (AAMA).[28]

The world heavyweight boxing champion and first Black man to hold that title, Jack Johnson's 1910 race against White auto racing professional

Barney Oldfield was closely followed in the Black newspapers. The race was at the Sheepshead Bay (New York) racetrack. Black newspapers in the 1910s reported trips to racing events in the social events sections.[29]

Automobile manufacturers also sponsored races and racers. Winning races provided excellent advertising and helped a manufacturer stand out in the crowded market. Joan Cuneo drove Knox cars in competitions. As automobiles became faster and more powerful racing fatalities increased. This led to calls to ban auto racing. While women racers were not involved in fatal accidents, the sponsors feared that the death or injury of a woman driver would kill the emerging sport. An increasing number of women were entering, and winning, races. Out of the discussions in 1908 and 1909 between the auto enthusiast clubs and the automobile manufacturers to regulate and codify racing came the effective banning of women from racing by inserting the word "male" in the entry qualifications.[30]

After being forced out of racing in 1909, Joan Cuneo continued her work with children's charities that she had begun in 1903. Joan supported Orphan's Day in New York City and worked with charities whose mission was to better the lives of children. She took children on automobile rides as part of her work with the Woman's Motoring Club of New York Women's Brigade, which ferried orphans to and from the amusement parks as part of Orphan's Day. One of her last formal public automobile events was participating in the 1909 Good Roads Tour held to publicize the need for road improvement.[31]

In 1919 the *Baltimore AfroAmerican* carried the headline "Negroes Drive Cars in Automobile Race" reporting on an automobile race held in Birmingham, Alabama. All the race drivers were Black; there were thousands of spectators. While the White sponsored races forbade women entrants, the race sponsored by the Afro-American Automobile Association held at the Ho-Ho-Kus, New Jersey, racetrack in 1924 offered races open to women drivers as one of the six separate events. Mrs. Mattie Hunter of Harlem was a featured entrant. Winners received a cash prize well above the average annual income. The Indianapolis Colored Speedway Racing Association held a fourth annual automobile race at the Indiana State Fair Grounds in Indianapolis first held in 1923, the July 4, 1927, race held on a holiday allowed more fans to attend the event.[32]

The later 1920s saw Black racing organizations partnering with the White American Automobile Racing Association. Those race results were universally recognized in the racing world. In 1928 the Tri-State Racing Association (Black) and the American Automobile Racing Association co-sponsored a "mixed" race where Black and White drivers competed against each other at Arden Downs in Pennsylvania. An article in the *Pittsburgh Courier,* a Black newspaper, offered reassurance that the Black

drivers would be judged and treated fairly despite the involvement of a White racing organization with this statement:

> The Tri-State Amusement Co., Inc. takes pride in announcing that they have secured the services of the greatest array of Negro automobile race drivers obtainable in this district to uphold the honor of our race and wish to assure our people that they need have no fear of our colored drivers not making a creditable showing against the nationally known white drivers, with whom they will be associated in the first mixed race ever to be run in the state of Pennsylvania.
>
> The Tri-State Amusement Co., Inc., all colored, further wishes to assure our people that no white corporation or individual has any authority whatsoever in the promotion of this automobile race. Mr. Burgess E. Lewis, representative of the American Automobile Racing Association, with whom the Tri State Amusement Co., Inc., has affiliated itself, in order that our colored drivers may enjoy the privilege of riding in a sanctioned race in which the records will be approved and recognized by the American Automobile Racing Association is only taking charge of the entries of the white race drivers.
>
> Out of courtesy to the American Automobile Racing Association and Mr. Burgess E. Lewis of Indianapolis, Ind., the Tri-State Amusement Co., Inc., announce that the officials for the Labor Day classic will be composed of members of both races, something that is unique in the annals of major sporting events in the United States. This will assure all drivers competing in this Labor Day derby of an absolutely even break and square deal by the officials and absolutely eliminate the possibility of either the colored drivers or the white drivers being "framed" by anyone in charge of the 100-mile auto race.[33]

In the 1929 racing season, Black racing events were held at the Milwaukee Fair Grounds and the Akron–Cleveland Board Speedway. The Akron, Ohio, event was held on July 14, 1929, and called the "Emancipation Derby," drawing drivers from around the United States. An event held in September 1929 as a feature of the Emancipation Day festivities at the Ohio State Fair Grounds in Columbus was open to Black and White racers and was attended by the Ohio governor among other celebrities.[34]

Managing the Tourists

The Adirondack Mountains of northern New York State provided White tourists with a wilderness experience that was within reach of the cosmopolitan areas of the Northeast. Wilderness vacations became popular in the late 1800s for middle-class nature lovers and the wealthy who built lavish camps and hunted and fished for sport. A seasonal activity, the tourists who came to the private camps and the middle-class resorts and hotels put Algonquian and Iroquoian residents, for whom the mountains

had long been home, in the position of having to supplement their incomes by working as guides, utilizing their deep knowledge of the Adirondacks. While the White tourists may have considered this arrangement to stand in contrast to the federal policies attempting to erase Indigenous culture by cultural and physical genocide, the White wilderness tourists wrote about their guides in the "last of" trope, or sometimes spoke of them as coming from Canada.

As Dr. Melissa Otis writes in *Rural Indigenousness,* guiding and working in rural settings during the rise of the automobile touring era provided a living while utilizing and preserving their traditional skills, including hunting, fishing, tracking and woodcraft. This survivance, while still owed to a long history of attempted erasure, was in contrast with the federal efforts of the early 1900s to build on the boarding school atrocities that tried to literally beat the "Indian-ness" out of the students taken from their families by moving Indigenous peoples from their reservations into unfamiliar urban settings. "Gerald Vizenor (Anishinaabe) defines survivance as '…more than the ordinary act of survival.' Survivance is an active sense of native presence over absence, or sense of presence in native stories over absence of natives in histories. Survivance is a renunciation, or rejection, of the political and cultural dominance, and the unbearable sentiments of tragedy and victimry. Survivance is native courage, spirit, and native traditions."[35]

The Wisconsin River Dells has had a long connection with the Ho-Chunk people who returned to the traditional homeland repeatedly each time they were removed from their homes by the U.S. Army in the mid–1800s. They were treated as trespassers by the White settlers until legislation was passed in the 1870s and 1880s that allowed the Ho-Chunk to take up homesteads, by which time only the poorest quality farmland was available for settlement. Ho-Chunk families turned to seasonal agricultural wage labor to supplement the hunting, trapping, and subsistence gardening their homesteads were able to produce.

The Wisconsin River Dells, a popular tourist destination since the 1870s, were noted for scenic boat-rides through the narrow passages of the Wisconsin River, which was lined with dramatic cliffs, canyons, and rock overhangs. Reached from the upper Midwest cities via the Chicago, Milwaukee & St. Paul Railway, the natural beauty of the area was appealing to city vacationers. Legacies of racism persisted; purporting to add to the "natural wilderness" of the region were postcards and photographs of the Ho-Chunk people taken by local Wisconsin River Dells White photographers interested in promoting the tourism industry. As in other parts of the United States, once the local Indigenous population was no longer a threat, they began to be romanticized as part of a nostalgic view of the industrializing landscape.[36]

The tourism industry of the Wisconsin River Dells provided an opportunity for the Ho-Chunk people, widely scattered throughout the state of Wisconsin, to gather together to work in the tourist trade selling baskets and handmade artifacts, and participating in living village and ceremonial displays. The Wisconsin River Dells required dedicated development to become a popular tourism destination, beginning with railroad visitors and then automobile tourists who came from the upper Midwest urban centers. Photographer H.H. Bennett sold landscape scenes that included Ho-Chunk people in print and postcard form to the Wisconsin Railroad and the Chicago, Milwaukee & St Paul Railway to promote the Wisconsin River Dells as a tourist destination.[37]

Posing for photographers gave the Ho-Chunk more control over their employment options. To the dismay of the White farmers, they had the option to not work during the harvest season in the cranberry bogs when they were able to earn money, and maintain a more independent life, posing for photographers. Both studio portraits and landscape images were made by the local photography studios. H.H. Bennett complained that the Ho-Chunk insisted on wearing their choice of clothing and accessories, refusing to wear the Western Plains head-dresses and Navajo blankets that he kept in the studio for portrait shots. The Western Plains dress was most easily recognizable to White audiences as "Indian" and was frequently used to portray Indigenous groups that had no connection to the Western Plains.

Dr. Steven Hoeschler writes that the Ho-Chunk's controlling the way their images were portrayed by photographers was one of the ways they were making "…survivance their first order of business." Indigenous communities utilized survivance to shape their cultures and societies to keep them alive. As defined at the National Museum of the American Indian,

> Survivance: Native societies that survived the firestorm of Contact faced unique challenges. No two situations were the same, even for Native groups in the same area at the same time. But in nearly every case, Native people faced a contest for power and possessions that involved three forces: guns, churches, and governments. These forces shaped the lives of Indians who survived the massive rupture of the first century of Contact. By adopting the very tools that were used to change, control, and dispossess them.[38]

Indigenous communities on Long Island had been dealing with European colonizers for 300 years when the automobile increased development in the early 1900s. Seasonal ceremonies such as June Meeting, Mid–Winter Fest, and the Shinnecock Powwow offer opportunities for those who have left the area for economic reasons to return and reconnect. Despite the repeated attempts by White developers, the Shinnecock and Unkechaug

maintain a land base in their traditional homelands and culture. As John A. Strong wrote in 1998:

> the communal ownership of land, the renewal of family and tribal ties at seasonal gatherings and funerals, and the identification as Native American, as elders assert, have remained intact in spite of pressures from the outside world to conform to the mainstream culture. The most obvious and persistent cultural value for most Native American people is their relationship with the land, which all of the Indians view as a sacred trust linking them to their aboriginal ancestors. Communal ownership of land is part of their identity as Native American, because residence on the reservation preserves a cultural boundary between the Indians and outside ethnic groups.[39]

The Shinnecock Indian Powwow, now one of the largest on the East Coast of the United States, grew out of the traditional gatherings stretching back generations. June Meeting, Mid–Winter Feast, and the harvest ceremony, *Nunnawa,* included participation by tribal members and outside guests. An advantage of the large Powwow such as that held by the Shinnecock, who are surrounded by high-priced real estate in the Hamptons of Long Island, is the clear evidence that Indigenous peoples are still very much present and using their own land. Their presence proves false any White claim that this land has been abandoned. The Shinnecock Powwow welcomes 100 Native American vendors from all over the Americas sharing cultural education and enrichment. Today, just as in the era with which the present study is concerned, as non–Indigenous automobile tourists traveled out to Long Island, they interacted with the Indigenous cultures and purchased items made for the rising tourism trade.[40]

The early 20th-century Federal government and Christian missionary attempts, in the 500-year campaign to completely wipe out Indigenous lifeways, did enormous damage, and did not succeed. One example is the Powwow. It can also be demonstrated that although modern powwows are grounded in ancient practices and traditions, what we have come to know and recognize as a powwow was developed in the late 1800s, in relation to the development of the automobile. Evolving from sacred dances, banned by White authorities in the 1870s and 1880s, these annual dances and celebrations took various forms as they grew and spread. When the Ponca tribe was moved to Oklahoma, they were surrounded by tribes with whom they had no history. Around 1879, the Ponca hosted an intertribal powwow in a cultural exchange with members of the neighboring Omaha, Kaw, Osage, Pawnee and Otoe-Missouria tribes.[41]

The increased use of the automobile and autocamping led to the decrease in popularity of long stays at resort camps by the 1920s.[42] Long drives began to take precedence. Gallup, New Mexico, transitioned from a railroad town to automobile tourism in the 1920s and 1930s aided by its

location on United States Route 66, connecting Chicago to Los Angeles. Founded in 1922, the Gallup Intertribal Ceremonial draws an international audience and celebrates Indigenous life. Lack of economic opportunity and drought conditions that further damaged the already poor farming conditions on the reservations prompted Indigenous young people and families to move to metropolitan areas, such as Albuquerque, New Mexico, and Kingman, Arizona. There, during the rapid urban growth of the early 20th century around the United States, they sought wage labor and participated in farm labor, all in an effort to provide for their families on the economically harsh reservations. Returning to the reservations and tribal homelands for annual powwows and ceremonial events provided a cultural and spiritual connection. In the 1920s, Indigenous actors in Hollywood helped to nurture and support the Indigenous community in Los Angeles by "holding regular 'powwows,' or large parties attended by people from throughout the city."[43]

Wealthy Indigenous people, including the Osage of oil-rich Oklahoma, also embraced the automobile. Historian Terry Wilson is quoted in Dr. Philip Deloria's (Standing Rock Sioux), *Indians in Unexpected Places,* saying that it was believed there were more of the expensive luxury Pierce-Arrows in Oklahoma's oil-rich rural Osage County than in any other county in the United States. Driven from their traditional homelands in Kansas in the 1870s, the Osage were removed by the White authorities to land in northeastern Oklahoma presumed to be worthless. As the oil age dawned, the rich oil fields under that land proved to be worth millions of dollars. To access the oil, prospectors had to pay the Osage tribe for leases and royalties. This money was put into a fund that was divided quarterly among registered members of the tribe. As the fund grew to millions of dollars in the 1920s the Osage were considered among the wealthiest people per capita in the world.

The opulent lifestyle of some Osage was a subject of fascination to the White public and regularly reported on by the White press. The Bureau of Indian Affairs was not pleased with the Osage families who adopted the lifestyles of wealthy Whites. Just before the rise in oil lease payments in the 1890s a Bureau of Indian Affairs commissioner said, "The Indian must conform to the White man's ways, peacefully if they will, forcibly if they must." Indigenous families were warned that if they did not send their children to the White boarding school, the government would withhold the annuity payments. Families, deprived of the ability to provide for themselves in the traditional ways, would starve without the annuity payments. The oil lease payments enabled Osage families to live with more independence for a time.[44]

At the time of the breaking up of tribally shared reservation land

into individual allotments whereby Indigenous families were allowed plots of land too small to eke out a living, the Osage were able to negotiate favorably. The Osage were able to prevail upon the Federal government "to divide the land solely among members of the tribe, thereby increasing each individual's allotment from 160 acres to 657 acres." "The Osage also added into the agreement what seemed, at the time, like a curious provision: 'That the oil, gas, coal, or other minerals covered by the lands ... are hereby reserved to the Osage Tribe.'" At the time of the allotment, some small wells had begun operating and the Osage leadership was aware of the rich potential of the mineral rights. Further, by keeping the land division within the control of the tribe, the Osage were able to prevent the selling off of the "excess" land to Whites that cheated other Indigenous communities.[45]

The discovery of oil on Osage and other Oklahoma reservation lands which were then leased to White-owned oil companies produced a great deal of wealth which was shared among tribal members. This wealth was viewed with resentment by Whites who sought to deny Blacks and Indigenous people economic and social gain. Independent mobility was the opposite of keeping social underlings in their place. Dr. Philip Deloria (Standing Rock Sioux) writes: "Mobility served as a form of empowerment, and it made Indians, African Americans, Latinos, Asians, workers and all manner of women just a little more threatening. Automobility seemed an undeserved benefit that those lower down on the social ladder had no right to exercise." As is demonstrated throughout this study, Blacks and women were also often seen as not deserving improvements in their quality of life.[46]

The Osage agency superintendent wrote despairingly in his 1911 annual report that:

> The curse of the average Osage Indian is his wealth.... A [young man] was asked why he did not farm some part of his allotments, he having previously admitted that he knew how to farm. His answer was that he had too much money and did not have to. The Osage Indian has what the average white person is striving for, namely, an income sufficient to keep him from performing labor of any kind.[47]

And again in 1912:

> With a very few exceptions Osage lessors do little or no work, notwithstanding that as a class they are in good physical condition. This condition exists because of reasons before given, namely: the large income from their leases, annuities, and royalties on the oil and gas produced on this reservation.[48]

While this description could just as well apply to the wealthy White Vanderbilt Cup participants, it is difficult to imagine White millionaire

William K. Vanderbilt II being asked why he preferred racing his automobile to farming.[49]

To keep the mineral rights and land under Osage control, a provision was made that no one could buy or sell headrights, they could only be inherited. The funds, however, still had to get to the individual Osage via the United States government. The government, falling back on the "uncivilized Indian" myth, declared that many Osage were unable to manage their own money. The Office of Indian Affairs was charged with determining which members of the tribe were considered capable of managing their trust funds. Those that were deemed incompetent were "forced to have a local white guardian overseeing and authorizing all of their spending, down to the toothpaste they purchased at the corner store." As David Grann points out, the guardians were usually drawn from the prominent white (male) citizens in Osage County.[50]

Despite the limited access the Osage had to their money, the exaggerated White press reporting of Indigenous people living like rich Whites outraged the same White citizenry that celebrated the Roaring Twenties tales of wild extravagance in F. Scott Fitzgerald's writing. This outrage took the form of predatory price gouging by the White merchants, accountants, lawyers. "An Osage, speaking to a reporter about the guardians, stated, 'Your money draws 'em and you're absolutely helpless. They have all the law and all the machinery on their side. Tell everybody, when you write your story, that they're scalping our souls out here.'"

The predatory practices and exploitive guardians took a deadly turn when Osage, including those married to their guardians, began dying under suspicious circumstances or by undisguised murder. Direct "headrights," rather than the funds gained by guardianships, could be accessed by Whites through inheritances. Eventually, the Osage were able to persuade Congress to pass a new law barring anyone who was not at least half Osage from inheriting headrights from an Osage tribal member. As the price of oil fell drastically with the Great Depression of the 1930s, the annual headright payments dropped from thousands to a few hundred dollars per year, further diminishing the Osage finances.[51]

White Resentment of Black and Indigenous Automobile Use

While the automobile ownership and use by William K. Vanderbilt and other wealthy White automobile enthusiasts was embraced and set a new social standard, White mainstream society viewed Indigenous and Black automobile owners with disapproval and overt jealousy. Black

newspapers regularly reported violence against Black automobilists. The May 25, 1912, *Philadelphia Tribune* reported the following of the regular insults hurled at Blacks:

> In this country if a colored man happens to be driving in his own carriage or automobile, his ears are apt to be assailed with an insult from some envious white ruffian along the highways. And if the colored man stops and attempts to resent the insult every white man within reach will join in an assault upon him until an officer appears on the scene and drags him to the station house. This condition prevails even in Philadelphia.

Hanging a chauffeur's cap on a hook in the back seat was a method used to try to mitigate White jealousy and harassment. Black drivers were sometimes seen as less of a threat if they were driving a White owner's vehicle, at least in areas where Black chauffeurs were permitted to work in peace.[52]

Automobile ownership was a new aspect of the status struggle underway in the United States since the dawn of European colonization. In America, White men sought opportunities to gain greater wealth and social prominence than they found in Europe. Wealth and social standing in the New World depended on land and the labor to extract goods for material gain from that land. The land was taken from the Indigenous population already here and the labor was extracted from the Africans forcibly brought here. To justify both, the White population had to maintain the fiction that Whites were more worthy of the land and the wealth from the extracted labor than the Indigenous and Blacks from whom it was taken. Throughout United States history Whites have pushed back against gains made by people of color—automobile ownership was no exception.[53]

The Black newspaper *Baltimore Afro-American* reported in 1911 of the systematic harassment by White chauffeurs against Black chauffeurs in New York City. This harassment included the vandalism of automobiles driven by Black chauffeurs when the White-owned automobiles were parked overnight in White-owned public garages. Parking in New York City has evidently always been hard to find, and Black-owned garages were an effort to provide safe, respectful options. The article went on to report that even when the automobiles were owned by Whites, if the chauffeurs were Black, the rates for parking and gasoline were raised.[54]

The following year the Black newspaper *Chicago Defender* reported that Chicago had more Black automobilists than any other city in the United States. The article went on to say "Chicago also takes the lead" in the number of Black expert chauffeurs and mechanics.

> Among the employed we have our largest representation. Every garage of note has its quota of expert chauffeurs and mechanics. Former coachmen and butlers

long ago mastered the intricacies of the business and the best families in Chicago ride behind a chauffeur of color. When it comes to a knowledge of the various parts of the automobile, and to tires and general repairs, the members of the race engaged in the business have no equal. At the recent meeting of the Negro Business league, Mr. Offord, manager of one of the largest garages in Chicago, gave an interesting and practical talk upon his success in the business.[55]

Longer Distance Runs

Poor road conditions continued to be a common theme in descriptions of automobile trips. The early long-distance runs that started or ended in New York City often came through Albany, including that of L.L. Whitman in his effort to set a new record driving between Chicago and New York City. Whitman's passage through Albany was reported in the September 2, 1906, edition of *The Albany Argus*. The piece described the difficulties Whitman experienced in his cross-country drive over muddy, rough roads, and fording streams. Automobile bodies were lower than buggies and wagons and were prone to being flooded out or stranded midstream in areas more easily crossed by horse-drawn vehicles.[56]

Quite different from Whitman's cross-country dash was the leisurely chauffeur-driven East Coast tour taken by Mr. and Mrs. Morgan Grass and their two children, ages four months and two years. Starting from their home in Jacksonville, Florida, on their arrival in Albany en route to Saratoga, New York, they had already covered 3,000 miles winding through New England: "Boston and the summer resorts in Massachusetts and Maine have been visited.... They have traveled leisurely stopping as often and long as they pleased on the road, and have had no delays. Their tour is to continue indefinitely."[57]

One of the "summer resorts in Maine" was Mount Desert Island, part of the original homeland of the Wabanaki people (Penobscot, Passamaquoddy, Maliseet, Mi'kmaq, and Abenaki tribes). Located at the border region of the historic tribal hunting territories of the Penobscot and Passamaquoddy, Mount Desert Island was a vital part of their traditional seasonal life and returning to the island remained a long-standing tradition throughout the changes brought by White settlement and development. Despite the devastating changes brought about from epidemic disease, White takeover of land, displacement onto ever-shrinking reservations, and attempts by White Bureau of Indian Affairs agents to acculturate the Wabanaki to a sedentary farming lifestyle, "...most Wabanakis preferred to hold on to their traditions and continued moving with the seasons through their ancestral territories, including the Mount Desert Island area."[58]

Indigenous groups along the Atlantic seaboard had been among the first to encounter European guns, diseases, treaty agreements that favored European settlers, high bounties paid by Europeans for Abenaki scalps and resultant devastation of traditional Indigenous culture. However, they found ways to struggle against the "vanishing" or "last of the" paradigm. The scholarship of Dr. Margaret Bruchac (Nulhegan Abenaki) highlights the ability of Indigenous individuals in the Northeastern United States to "hide in plain sight" and identifies the historical erasure of Native families from town histories published in the 19th century.

Dr. Jean M. O'Brien (White Earth Ojibwe) provides an in-depth study of the ways Indigenous peoples were written out of the histories of New England in her book *Firsting and Lasting: Writing Indians out of Existence in New England.* Her examination of more than 600 White authored local histories from 19th-century southern New England communities traces the erasure of Indigenous individuals from local histories. That erasure enabled White settler descendants to refute Indigenous treaties and land claims. Further, the idea of the "vanishing Indian" was used as justification for White seizure of Indigenous culture and physical objects. The power of the 19th-century White small town local historians to leave out Indigenous community members has had long-lasting implications in subsequent historical writings.[59]

Margaret Bruchac writes of the absurdity of the "last of the Indians" designation in local newspaper obituaries particularly when the surviving relatives and tribal members are listed. This cultural erasure, myth of the vanishing, or "last of the" Indians, as well as the White tradition of viewing Native families as wandering gypsies without permanent ties to specific plots of land, was used as justification in the 19th century for land takeover by Whites in the 17th and 18th centuries. Anne Wampy (Pequot) combined her established sales route through the White community on her annual spring basket selling trips in early 19th-century Eastern Connecticut with visits to her friends and kin in the area. Bruchac writes that, in 19th-century town histories, 17th-century Native encounters were rescripted with the emphasis on White triumph over adversity. Native cultural and skeletal remains were claimed as scientific specimens, and living Natives, even with large families and known tribal affiliations, were dismissed as being the "last of" their tribe. The idea of the "vanishing Indian" was used as justification for White seizure of Native cultural and physical objects. Bruchac summarizes the dilemma:

> If Native people persisted in maintaining traditions, they risked depiction
> as the "last of their kind"; if they adapted to modernity, they might appear to
> have ceased behaving like "real Indians," and perhaps stand a better chance at

gaining political recognition. In either case, White New Englanders have, as a whole, been reluctant to admit that Native nations had survived at all.[60]

As White settlers moved onto Mount Desert Island and the surrounding area, they created stories of their acquisition of Wabanaki land—stories that featured White cleverness and Wabanaki foolishness—to justify the questionable legal practices used to take over Wabanaki land. These stories hardened into folklore that included "the last Indian" stories common through the Eastern United States in the 19th century, folklore that helped sell the region to the tourists that began to flood the area in the mid-19th century.

The first summer visitors came to the area in the 1830s, followed by the Hudson River School artists, who popularized the natural beauty of the region in the 1850s with their paintings of Mount Desert Island.[61] The artists were followed by the "rusticators," city dwellers seeking respite from hectic city life by relaxing and tramping about in nature. The rusticators needed guides to take them hunting and canoeing, and also souvenirs of their rustic vacation. Handcrafted canoes were a high-end item for sale to Whites. Wood-splint and sweet-grass baskets and other handcrafted artifacts were popular items for sale at the Bar Harbor Indian encampment.

Tourists visited the encampment to hire guides for canoe outings and hunting trips and to purchase handmade items, special order birch bark canoes, and personalized hand-carved paddles. As the sawmills from the booming lumber industry were set up on the rivers near the Wabanaki reservations, the noise and pollution of the rivers were a constant intrusion into the daily life of the Penobscot and Passamaquoddy. The seasonal trips to Mount Desert Island provided them the opportunity to retreat to a quieter natural environment.[62]

Wabanaki families would make items to sell over the winter and transport them to the Indian encampment at Bar Harbor via a combination of steamship, railroad, wagon, and seafaring canoes. Canoes for personal use and for sale would be shipped as freight from interior towns along with the rest of the families' luggage and sale items. Wabanaki families could work multiple aspects of the tourist trade with the women running the sale tents while the men worked farther from town as guides. In addition, Wabanaki boys could earn money by shooting arrows at pennies and other small objects tossed in the air for the entertainment of the White tourists.[63]

The expansion of steamboat service to Deer Isle in 1880 brought White tourists to newly built hotels on Deer Isle and Stonington. This new tourist market enabled Passamaquoddy and Mi'kmaq artists to sell toys

and trinkets, small and portable to fit into luggage for the trip home—in addition to the bark, reed, cattails, sweetgrass, and other natural materials containers made over the previous centuries for storage, use in harvests and carrying. The opening of the "Indian Camps" was announced in the local White newspapers as the season began. Fancy baskets, developed in the early 1800s, were crafted to appeal to the tourist trade.[64]

By adapting their traditional skills to the seasonal tourist trade, Wabanaki families were able to maintain regular ties to their ancestral coastal land. As Bunny McBride and Harald E.L. Prins write:

> One can hardly overstate how important such seasonal coastal expeditions were for the emotional and financial well-being of Maine Indians bewildered and diminished by the brave new world forced upon them, and pressing in upon them. Moving in sync with nature's seasonal rhythm offered a sense of the familiar in what was becoming an alien environment.

While the Wabanaki were not necessarily among the early automobilists on Mount Desert Island, they were able to earn needed cash by providing guiding services and selling artifacts to the rusticators and the automobile tourists, while maintaining their cultural traditions and spiritual renewal from the increasingly harsh life on the reservations. In the coming years Indigenous communities incorporated their work in the tourism industry with their traditional lifestyle, as well as purchasing automobiles for themselves.[65]

Advantages of Automobiles

During the 1908–1913 period more and more people saw the advantages of automobile travel as cars became reliable, affordable, and easier to operate. The utilitarian Model T came on the market in 1908, priced at $850, and dropping in price to $298 by 1923. The development of the self-starter, first installed in Cadillacs in 1912, spread throughout the automobile industry, making automobile use even easier. As Christopher Wells writes of this period, the utility of the automobile, particularly the Model T, fused the interests of the mobility-minded (automobilists) and the horse-minded markets: "As the mobility-minded began to appreciate the appeal of everyday utility, and as the horse-minded began to appreciate easy mobility, the U.S. market for motor vehicles changed forever."[66]

Country Life in America was one of the first general interest magazines to popularize the automobile, regularly featuring automobile articles and columns as early as 1902. Marketed for the White suburbanite "gentleman farmer," *Country Life* ran regular columns about the care of horses,

farm animals, gardens, lawns, automobiles, and airplanes. A 1907 article titled "How to Keep Going: The Lessons of the Glidden Tour" begins,

A car that will go and keep going—that's what we all want[…]. We have a new standard for automobiles. Almost anything can happen to horse, wagon or harness, and yet we can make some kind of a repair and limp home, but the motor car must be somewhere near its 100 per cent, efficiency mark or there it will stand by the roadside, a mockery to its owner and a derision and scorn to the passer-by.[67]

Keeping the automobile going was the subject of a majority of the articles from the earliest of the automobile journals. The wealthiest automobile owners were able to hire chauffeurs who served as both drivers and mechanics, similar to the coachmen who both drove and cared for the horses and equipment. Most convenient was when a coachman was willing to learn about automobiles and make the transition to chauffeur-mechanic. Deferential behavior from servants was desired by the elite families. An independent contractor, such as machinist hiring on as a chauffeur, would be much less likely to have a deferential attitude toward the employer.[68]

Automobile maintenance was specialized, especially when dealing with electric, steam, and gasoline-powered vehicles. Early automobilists frequently owned multiple vehicle-types for different purposes, enough that there was a shortage of chauffeur-mechanics and employers had to deal with employee attitudes that were very different from the servant who knew his place. Some chauffeurs—without permission of the automobile owner—supplemented their income by using the automobile as an after-hours limousine service for downtown theater patrons in New York City, earning as much as $100 per night. Chauffeur training schools were an attempt to increase the number of available chauffeurs for hire and thus regain some advantage to employers.

The Cosmopolitan Automobile School in New York City advertised in *The Crisis* newspaper published by the National Association for the Advancement of Colored People. This would have been an option for Blacks to receive automobile instruction in New York City when the Young Men's Christian Association (YMCA) forbade Blacks to take part in the automobile classes they offered. The YMCA would offer segregated classes for Blacks, if enough Black students enrolled. This effectively prevented individual Black students from enrolling in the YMCA's automobile school.[69]

This is in contrast to Charles L. Reese's Automobile School in Chicago and to Mr. Reese's previous experience as a driving instructor for the YMCA. In addition to the chauffeuring and mechanic training mentioned

in the previous chapter, Mr. Reese expanded to include a taxi service and automobile repair shop, garage and sales by 1923. Further, he advertised that

> All automobile owners and their wives should know how to drive their cars. The Reese Automobile school is in full session now. Come in and prepare yourself for a good paying position. Calls are coming almost daily for competent automobile men. I am sure you have lost valuable time because you do not know how to properly drive and repair automobiles. Even with the scarcity of work, the chauffeur-mechanic succeeds in finding employment. The automobile profession is independent of all labor troubles and demands a good salary. Reese's graduates are given special consideration. Even if you are employed at present, I am sure you can spare a few hours to learn an independent profession.[70]

Chauffeuring was considered a desirable job—cleaner and better paying than farm work or common labor—with a certain amount of status associated with operating the shiny new automobiles. As such, in certain parts of the country, Blacks were not allowed to work as chauffeurs. The National Chauffeurs Association—as did the majority of the early automobile associations—did not allow Blacks to become members. It was suspected that cars driven by Black chauffeurs were sabotaged to hamper their business reputation. In addition to the women who worked as chauffeurs, the higher wages and social status would provide benefits to the families of men working as chauffeurs.

In Miami, in contrast to other parts of Florida and much of the rest of the country, Blacks were forbidden by law to work as chauffeurs. Marvin Dunn writes:

> In early Miami blacks could not operate businesses that catered to whites. This led to racial confrontations, the most serious of these being the bloody dispute between black and white drivers between 1915 and 1917. Chauffeuring was a highly prized job in those days. The pay was generally better than farm work or common labor, and it was a clean job that carried a certain amount of status in both white and black Miami. In Miami, unlike other areas of Florida and the country, it was considered a white job. White chauffeurs in Miami's quickly developing tourist industry were determined to keep blacks from working as chauffeurs.

The Miami tourist industry was booming just at the time automobiles were being adopted by the wealthy Northern tourists coming to the newly founded tourist destination. When wealthy Whites arrived at the Miami city limits in their automobiles driven by Black chauffeurs, they were required to turn the car keys over to a local White chauffeur. It is interesting to contemplate what the White automobile owners—as well as the Black chauffeurs—thought of being required to pay to allow a strange

man, who may well have had limited driving experience, to drive their family in the expensive machine.

One White tourist from Virginia made arrangements to have a police escort as his Black chauffeur drove his automobile from the Miami city line across the city to the beach front hotel. This would have been an unusual case, as the White police force generally did nothing to protect Black chauffeurs from being attacked by White mobs. Many in the early Miami police force were poorly trained recent arrivals from neighboring states with little experience in law enforcement and a suspicious and hostile attitude toward Blacks. Marvin Dunn writes: "Miami's police officers treated Miami blacks as blacks were generally treated in the South at that time: black people had no rights that white people were obliged to respect."[71]

Instructional articles about automobile repair were published in *The Horseless Age, The Automobile Magazine,* and *Country Life in America,* publications aimed at a special interest and economically privileged audience. A wider audience was reached by journals of other trades—*American Blacksmith, American Machinist, Bicycle World, Blacksmith and Wheelwright,* and *Hub*—which also published articles about automobiles and their repair. This would have been useful to local blacksmiths who were frequently asked to make repairs by automobilists stranded by breakdowns beyond their ability to fix.[72] Courses specializing in automobile repair by Ogden, Davis & Co. were featured in the December 22, 1923, issue of the Black newspaper *Chicago Defender.*

Help Wanted—Male. If you want to learn the automobile. How to drive it, how to repair it, how to make money out of the automobile business call on Ogden Davis & Co. Expert Instruction in Automobile Engineering 60 East 34th Street, Chicago, Ill. We give jobs to all students. Call in Person or Write for Booklet

Learn Auto Trade and Earn at Same Time. Oldest and best equipped auto school has opening for ten men in class now forming. If unemployed will get you a good job while learning. Reduced rate to complete class right away. Address Box 25, Chicago Defender.

Auto Instruction. Complete Course in automobile repairing. Personally taught by prominent factory engineers. You learn by clear demonstrations on the mechanism of 4, 6, 8 and 12-cylinder cars and by doing the work, under our guidance on the machines that come into our shop for repairs. Our method of teaching is quickest and easiest and the only one that does not require you to have a college education to learn. Entire course including Electric Lighting and Starting Battery Charging and Ample driving practice, $65, suitable terms. Day or evenings. A Good Position, repairing, demonstrating, or driving procured for every graduate. Our proposition is free of all misrepresentation and appeals to intelligent men.[73]

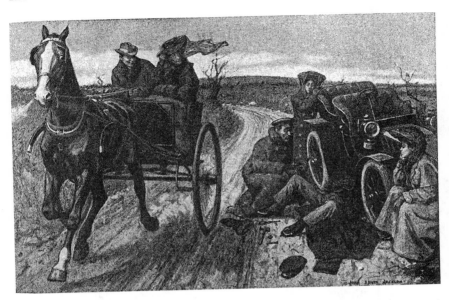

"The passing of the horse." This illustration from the comic magazine *Life* shows the frustration of early automobile runs and plays on the comments that the automobile was not likely to cause horse-drawn vehicles to pass out of common use. From *Life*, February 4, 1904, 109 (Fenimore Art Museum Library, Cooperstown, NY).

English author Dorothy Levitt, in *The Woman and the Car*, advised her readers to "pin your faith on the car with the reputation for reliability, the one that will not entail a big expenditure every few months for repairs." She warned that test-driving multiple automobiles inevitably led to the belief that whichever car was the last one tested seems to be the best, and that the faster car is always tempting to purchase. However, she said, a faster car broken down by the side of the road is not faster than the reliable car that keeps rolling down the road. As Levitt wrote, "One of the chief joys of motoring is to feel that you can rely upon your car." Levitt advised her readers not to allow anyone else to operate their automobile: "All cars have their individual idiosyncrasies, and if you alone drive, you get to understand every sound; but if you allow any one to drive you are ignorant of what strain the car has been put to. As a matter of fact, a strange hand on the wheel and levers seems to put the car out of tune."[74]

Hilda Ward, a 20-year-old artist living on Long Island, agreed with Levitt's philosophy of maintaining and operating your own machine. She wrote in the 1908 *The Girl and the Motor* that the salesman who sold her a gasoline motorboat—her first gasoline-powered engine—neglected to

include the customary instruction manuals with the purchase of the boat, which made its operation much more difficult than it needed to be. Ward bought all the gas engine books she could find, read them to the exclusion of all other literature, and ignored the advice of the "Mere Men" who advised her to "leave well enough alone" as long as the engine was running. She soon began to experiment to make the engine run even better. Her philosophy was "What is the use of having an engine if you can't be intimate with it? And why should I be satisfied with her going well if I think I can make her go better?"[75]

When Ward found herself without an engine to work on after "The Yacht" (her name for her 13 foot, 8 inch motorboat) had been put up for the winter, she bought a single-cylinder, six-horsepower, secondhand car. She learned a great deal about automobile gasoline engines while coaxing "The Kah" to run reliably. Next came the larger and more powerful "Borax," a 20-horsepower touring-car. The title of Ward's book *The Girl and the Motor* was very apt, as she was more interested in analyzing and repairing engine problems than when the automobile was running smoothly, although she did like to go for "picnics and gypsying in general." She worked with the "Master Mechanic" and learned as much as she could from watching him work and asking questions. She was dismayed when, while she was visiting friends, their chauffeur insisted on making "all necessary adjustments for me," adjustments she had just made herself and had to make again after the chauffeur was finished.

Ward wanted to learn about a variety of automobiles, but short of buying them for herself—which she could not afford—there was no outlet for her interest. She wrote, "It would do me lots of good to see what could be done with a hopelessly bad old engine and I could learn all about cutting gears and shaping cams and reboring cylinders and refacing brakes right here." As a woman, Ward did not have the outlet that "Master Mechanic" had, getting paid to work on a variety of automobiles in a shop setting. Nonetheless, she summed up her love of motors saying, "There's something in the personality of the motor[...]."[76]

Winifred Hawkridge Dixon, writing in 1921 of an automobile tour in her Cadillac Eight, described as having "a rakish hood and a matronly tonneau; its front was intimidating, its rear reassuring," of which she was half owner, also had a love of tinkering with engines. Her knowledge of the inner workings of engines came through practice: "What I knew of the bowels of a car had been gained, not from systematic research, but bitter experience with mutinous parts, in ten years' progress through two, four, six and finally eight-cylinder motors of widely varying temperaments." Carburetors, batteries, radiators, frozen steering-wheels, generators, springs, gears and clutches she was familiar with repairing,

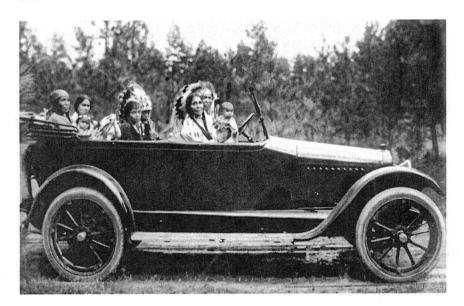

Philip and Eugenia Wildshoe (Coeur D'Alene) and family in their Chalmers automobile, 1916 (photograph by Frank Palmer, Library of Congress).

leaving "those parts which commonly behave themselves" alone. As had Berthe Benz in the 1880s, Dixon utilized hair-pins in her tool kit.[77]

As automobiles became more reliable, local auto club journals and national magazines regularly featured descriptions of places to go for longer day and overnight trips, sometimes with maps included. *Motor: The National Monthly Magazine of Motoring* published a regular column on touring. *Pacific Motoring: Only Weekly Automobile Publication West of Chicago* offered "All the Real, Reliable Motoring News No Fakes, Free, Fearless, Independent." Published in Los Angeles, California, *Pacific Motoring* featured a "Touring Department" and longer stories such as "Pathfinding on the Inland Route with a Pope-Hartford Car." These extended automobile trips benefited promoters of tourist attractions such as the Wisconsin River Dells in southeastern Wisconsin and the Adirondack Mountains of New York.[78]

Some of the Destinations That Welcomed Black Travelers

As author Alvin Hall writes in *Driving the Green Book*

Black Americans have always known it was their right to have equal participation in the American Dream. When denied it, they used their ingenuity,

cooperative spirit, hard work, and limited capital to find ways around those cruel barriers and establish places where such barriers didn't exist, if only temporarily.... Like many other Black people with entrepreneurial spirits who saw the growing but then segregated leisure travel industry, the creators of these Black resorts knew their only option was to build a world that was parallel to the white world in American, but also largely out of sight and out of mind of that world's gaze.

By the end of World War I in 1918, there were about two dozen resorts where Blacks were welcomed. Those who could afford the time and cost to stay at the Black resorts were generally middle- and upper-class Black professionals.[79]

The 1912 "Vacation Days" article in *The Crisis* continued with recommendations of summer resorts for those who had the time and money for a vacation getaway, since, due to discrimination, "our correspondents show us that the choice of a summer resort is limited[...]. The white New Yorker, for instance, may choose from a thousand different places the one to which he will go with his family[...]. But you, if you are colored, will knock in vain at the farmhouse door for board and lodging." The article recommended New Jersey Shore resorts, with Atlantic City as the most popular seaside resort, followed by resorts at Sea Isle and Cape May.[80]

Margaret Holmes, a Black woman, remembered that when the wealthy White Quakers living in Philadelphia "decided to make Atlantic City (New Jersey) their playground they wanted their hairdresser and their barber to come to Atlantic City," but as her grandmother pointed out, "'Negroes in Atlantic City live on the other side of the tracks; we're sure you don't want to come to the other side of the tracks.' And they said, 'Oh, we'll find you a place.' So they found her a place on Atlantic Avenue, which was the main avenue of Atlantic City, and there she and her husband established their shop and also lived above it." The Quakers in Philadelphia were liberal and wealthy, and the Blacks who worked for them, while they may not have received particularly high salaries, did receive investment advice. Margaret Holmes said, "That's how most of the Negroes got their money, on tips that they got from white people on the stock market, and how and when to invest and buy property." Elizabeth Barker also remembered Atlantic City as a popular resort with wealthy White families in the 1860–1910 period. She noted in the 1970s "Atlantic City isn't much of a town right now, but in those days, before there was Miami and such places, it was the most popular summer resort."[81]

The vacation industry brought Blacks, Whites, and Indigenous people together at tourist sites such as Cape Cod, Massachusetts. As mentioned previously, the Black minstrel show that Esther Mae Scott traveled with as a singer in the early 1900s traded their mule and wagon for an automobile.

Traveling by automobile, "we could make faster time than we could with mules. And we didn't have to feed them mules. Just buy gas for the cars." Esther Mae Scott traveled up and down the Atlantic Seaboard spending summers on Cape Cod and Martha's Vineyard, Massachusetts. Martha's Vineyard has a long history of tourism and of interaction between Blacks, Whites, and Wampanoag. As Helen Vanderhoop Manning (Wampanoag) remembered, "We've had tourists, it seems to me, forever, really. They used to come up by oxcart." Jack and Nellie Belain (Wampanoag) provided oxcart rides to the cliffs and lighthouse. They also supplemented their income by posing for tourist photographs in Wampanoag clothing.[82]

In the mid–1800s, the Methodist denomination established campgrounds at Wesleyan Grove and Oak Bluffs and elsewhere on the island, and welcomed Blacks as participants in the camp meetings. However, as Ann Tanneyhill remembered, Black families were not allowed to spend the night at the Methodist campground and stayed at Black-owned guesthouses nearby or built their own cottages. The Black leisure class also came to Martha's Vineyard beginning in the 1890s. Black working- and middle-class families established businesses that supported the tourist industry, including the Methodist ministers and their families. Regarding the popularity of Martha's Vineyard with Black tourists, Jill Nelson quotes Bob Hayden: "Blacks [...] came to Martha's Vineyard because it was a place away from the mainland, where they were still facing tremendous discrimination and lack of opportunity that they just wanted to get away geographically and physically."[83]

Other Black destinations included beaches along the northeast coast of Florida along the Atlantic Ocean. Segregation laws forbade Blacks access to the majority of the public beaches in Florida in the latter decades of the 19th century. Of the six public beaches in the Jacksonville, Florida, area, a portion of Pablo Beach—later known as Jacksonville Beach—was made available to Black visitors one day a week starting in 1884. Similarly to the beach excursions mentioned in earlier chapters, in the days before automobiles, group excursions organized by Black civic and religious organizations enabled hundreds of Black visitors to gain access to the beach for one day a week.[84]

Henry Flagler, White industrialist and one of the founders of Standard Oil as well as the Florida East Coast Railroad—which led to the development of the Atlantic Coast of Florida and the cities of Miami and Palm Beach, Florida, in the early 1900s—sold beachfront property to a group of Black railroad workers. This was part of Flagler's development plan; it involved establishing railroad villages and selling excess property to developers to build communities along the Florida East Coast Railroad line along the Atlantic Coast. More communities made for more users of

the new railroad. The Black-owned property became a Black resort and vacation area on Manhattan Beach, 22 miles one way by train from Jacksonville, Florida. The 44-mile round trip cost 60 cents for adults. The trains left Jacksonville early in the morning and returned after dark, to make the most of the daylight hours at the beach.[85]

The Separate Car Laws as enforced on railroad cars in Florida at the time put the Black passengers in the front cars, nearest the engine. The soot, cinders, and smoke from the engine settled heaviest through the windows of the cars nearest the engine, covering the Black passengers' clean traveling clothes with soot. Manhattan Beach had a variety of entertainment pavilions such as Mack Wilson's pavilion that provided entertainment, dining, lodging, and bathing facilities. Children wore their swimsuits under their traveling clothes, the quicker to get into the water and start swimming. After service stopped on the Mayport/Manhattan Beach railroad line in 1932, Black beachgoers came by car, truck and buses hired for the beach excursions. Beach erosion, the destruction of public pavilions by fire, the encroachment of White beach communities nearing Manhattan Beach, and finally the appropriation of part of the beach by the Federal government to build Mayport Naval Base during World War II, saw the demise of Manhattan Beach as a Black resort destination.[86]

A series of adverse personal and economic circumstances persuaded a White real-estate developer to go against the norm and sell 78 acres of oceanfront and riverfront property to a corporation formed by Black businessman Frank B. Butler in the mid–1920s. The tract of land was on Anastasia Island between the Atlantic Ocean coast and the Mantanzas River ten miles south of St. Augustine, Florida. Butler's Beach was developed as a Black seaside resort with home lots, hotels, and recreation areas and was active through the segregation years up to the mid–1960s. In the late 1950s Frank Butler sold portions of his beach property to the state of Florida to be used as a state park. Over the years, Black-owned property was sold to private interests and Butler's Beach as a Black resort area faded into memory.[87]

Another Black resort beach was begun in the 1930s with the purchase and development of beachfront property by the Pension Bureau of the Afro-American Life Insurance Company. What became known as the Black resort of American Beach was located on the southern tip of Amelia Island northeast of Jacksonville, Florida. In 1862, an independent community of Black families was established when the plantation on which they were enslaved came under Union control during the American Civil War and the Black families were emancipated. After the end of the Civil War the newly freed Blacks were able to acquire, and keep, land on Amelia Island. The ability to keep ownership of land through generations of Black

families did not always apply after the end of Reconstruction, when laws beneficial to Blacks were revoked by the White former Confederates who were once again in power and implementing segregation laws.[88]

Franklin Town, a forerunner of the Black resort of American Beach, was a predominantly Black town, named for Franklin E. Town, a black man who never owned property there. Town's land transaction to purchase four acres of property along the Nassau riverfront from White landowner Albert Cone never materialized. The name however, Franklin Town, remained and Black families made a living from fishing, shrimping, farming, and hosting Thursday summertime beach gatherings attended by Fernandina and Jacksonville Black churches. Beachgoers from nearby communities came on weekends for recreation including beach fish-fries. American Beach properties grew to encompass 216 acres with subsequent purchases by the Pension Bureau of the Afro-American Life Insurance Company. Beachfront homes, hotels, restaurants and nightclubs developed through the 1930s, 1940s, and 1950s and became known as a place for beach and ocean front recreation and relaxation without humiliation.[89]

Idlewild, Michigan, is located on the west side of Michigan's Lower Peninsula near the Manistee National Forest 200 miles northwest of Detroit. Prior to becoming a National Forest, much of the region was owned by regional railroad companies who leased or sold the land to private logging companies in the 1870s during the rebuilding boom following the 1871 Chicago fire. Once the lumber resources had been depleted the logging companies frequently left the area, allowing for the land to revert to the state of Michigan. The Michigan state government then made the land available for sale to private individuals and investors. By the early 20th century, Michigan was becoming a leisure and recreation destination for those interested in partaking of the extensive lake-front shorelines and forests.[90]

Among those investors was a White-owned, Chicago-based real estate firm. The firm formed the Idlewild Resort Company and began the process of acquiring property, which expanded to 2,700 acres, surrounding and including the newly renamed Idlewild Lake. The White-owned Idlewild Resort Company started an advertising campaign in Black newspapers and hired Black salespeople to market building lots to sell to Black families for vacation cottages. Fox Lake resort in Angola, Indiana, was another White-owned resort company that formed a resort community for Black families. A deep irony involving the Idlewild Resort Company was the membership of some of the company's leadership in the White Cloud, Michigan, chapter of the anti–Black, anti–Catholic, anti-immigrant hate group, the Ku Klux Klan.[91]

Idlewild sales agents attracted Black land purchasers from around the country with sales of more than 16,000 lots to Black families from Massachusetts and California as well as the cities of the Midwest who were able to afford the time away from work to enjoy extended vacation time. Lots were also sold on the island in the middle of the 105-acre Idlewild Lake. In an era when it was difficult for Blacks to find property to buy, the ability to purchase building lots was appealing. Hotels and rented rooms were available for visitors who did not own their own cottages. A train station was established at Idlewild for added convenience.[92]

Fishing, swimming, water-skiing, boating, and golf were among the many resort entertainment options. Cottages and hotel rooms were available for vacationers. Black entertainers were drawn to Idlewild to perform and relax in a welcoming, safe environment. Advertising campaigns featured the ability for Black visitors to "...find sweet, rest, enjoy clear blue skies, fragrant pure air and crystal-like waters." In the 1926 season, the first Idlewild Chautauqua assembly was held with a capacity crowd. Circuit Chautauquas brought entertainment and culture provided by notable speakers, educators, showmen and specialists of the day to rural areas. Ronald Stephens writes that the Idlewild Resort Company "...understood the significant role that the railroad, highway system, and automobiles would play in enticing their targeted audience, despite the distance of the resort from the larger cities. Idlewild was not only a vacation spot free from racism and segregation but also an investment opportunity and excellent moneymaking venture, free from the poverty, crime, and decay in the city."[93]

Other Black resort communities included locations at Sag Harbor, New York, on the eastern end of Long Island, and two Southern California locations: Val Verde, 45 miles northwest of Los Angeles and featuring a large swimming pool, and the privately owned Bruce's Beach, 25 miles south of Los Angeles. Bruce's Beach provided Pacific Ocean beach access to Black visitors from 1912 until it was seized by the White city council of Manhattan Beach in 1924 under the pretense of a planned, but not developed, public park. Highland Beach, 40 miles south of Baltimore and 40 miles east of Washington, D.C., on the Chesapeake Bay, was founded in 1893 by Major Charles Douglass, son of Black abolitionist, writer, and orator Frederick Douglass. After being denied service at a White-owned restaurant in the Chesapeake Bay area, Major Douglass began the process of purchasing land along the Chesapeake Bay beach front at Highland Beach to resell to Black families for use as safe vacation homes.[94]

The privacy of the automobile provided an alternative to segregated public transportation, even though Black travelers still had to plan automobile routes carefully to try to ensure safe, respectful accommodation.

While the automobile gave more control over their environment than they had while on public transportation, Black automobilists were still traveling through a segregated—either legally or by custom—unpredictable, and potentially hostile environment where a mechanical break-down could leave them stranded in a dangerous situation. The well-maintained, carefully packed automobile was an important part of the experience of a safer environment for Black travelers.[95]

Nearby Destinations

Tea rooms were a popular destination for women automobilists. As author Jan Whitaker writes "Put a woman in a car—often in the driver's seat—ban alcohol from public establishments, and voila! Dotted across the American landscape of cities and towns of the [nineteen] teens and twenties spring up little eating places serving light lunches, simple suppers, and dainty afternoon teas to her and her friends rambling about in small automobile touring parties." The Prohibition Era, from 1920 to 1933, provided the opportunity for women to operate and frequent alcohol-free eating establishments. The absence of alcohol made it respectable, and safer—no alcohol, no drunken men—for women to dine alone or in small groups. The passage of the 18th Amendment in 1919 banned the sale of alcohol in public establishments. Prior to that, restaurants were primarily male-owned and staffed. It was difficult for women to go to restaurants alone, much less own an eating establishment. Women unescorted by a man were subject to the widespread rule that they would not be served at hotels and dining rooms.[96]

Tea rooms were small restaurants with lunch and dinner offerings of sandwiches, tea, desserts and regional specialties. Tea rooms were located along the roadsides, away from the public transportation accessed city centers where restaurants were traditionally found. Women customers were welcomed at tea rooms, if they were considered socially acceptable by the predominantly White, Anglo-Saxon, middle-class tea room proprietor. Tea rooms also functioned as antique and curio shops selling items in the popular Colonial Revival style. Tea rooms were a seasonal business, coinciding with the spring, summer and early autumn automobiling season. Early tea rooms opened near resort towns, including Cape Cod, the Maine seacoast, the New Hampshire lake district, and along the coastal route to Florida. Advertisements in the early 1920s guidebooks featured tea rooms and accompanying businesses including small inns and gasoline stations to cater to the automobile traveler.

Some of the tea rooms were owned and operated by Black women,

welcoming Black customers. Two were located in the Chicago vicinity; others were in the Harlem neighborhood of New York City. Otherwise, during the era of segregation, Black automobilists would rely on word of mouth recommendations and advertisements in Black publications to learn of safe places that would welcome their patronage. Good roads leading out of the city centers and within a few hours' drive, about 25 miles, outside of resort areas were prime locations for tea rooms.[97]

CHAPTER 5

More Untrammeled Freedom

We find young and elderly women traveling across coun-
try for business purposes, for relaxation, and for pleasure.
[...], these women who travel are enjoying a much wider and
more untrammeled freedom than their grandmothers ever
enjoyed.—LILLIAN EICHLER[1]

As we have seen throughout this study, "untrammeled freedom" met
with different challenges, and took on different forms for women driv-
ing automobiles: for Black women—freedom, at least for a little while,
from insult and danger encountered on public transportation; for Indige-
nous women—freedom to reconnect with kin and cultural networks after
separations that the emergent highway system exacerbated; for White
women—freedom from a stifling domestic ideal.

Improvements in automobile technology and road surfaces made
automobile travel more accessible and appealing and made longer dis-
tance day and overnight journeys possible. Thus, what began as a pre-auto-
mobile-era enthusiasm for mobility and a willingness to take on exper-
imental technology unfolded into a wide-ranging field of sociopolitical,
aesthetic, and cultural reasons to maintain and increase women's par-
ticipation in the motoring life. A deeper look into the effects of highway
expansion will allow us to examine that favorite American pastime: the
road trip. Unsurprisingly, the revelations remain complex for each dis-
tinct group studied above. Exhibition coast-to-coast automobile trips pop-
ularized the automobile and emphasized the need for well-maintained
transcontinental highways. Once the Lincoln Highway opened in the nine-
teen-teens, cross-country travel became a popular vacation option. As the
automobile became more affordable, it was used to avoid the difficulties
of segregated public transportation, keep family and friends connected
and enabled Indigenous people to maintain and build inter-tribal cultural
ties.

Proving Their Worth

The automobile proved its practicality and won many admirers during the rescue and recovery efforts following the April 18, 1906, San Francisco earthquake and fire. Automobiles were able to get around the city when horse-drawn vehicles could not. Approximately 200 privately owned vehicles were put to use pulling fire engines after the exhausted horses collapsed, transporting the injured to medical care and covering the large distances to keep Army and city personnel in contact to coordinate the rescue effort.

The *San Francisco Call* wrote, "Horse flesh could never have withstood the high pressure and could not have covered the immense distances encompassed by the motor-driven machines." After tires ruptured from the fire-heated pavement, automobiles were run on the steel rims. The *San Francisco Call* used automobiles to distribute throughout the city free issues of their newspaper listing names and locations of survivors. In addition, the "length of the conflagration boundaries was determined yesterday by an automobile that puffed its way around the edge of the zone of ashes and debris. The register attached to this machine showed after the journey that twenty-six miles had been traveled."[2]

Robert Sloss writes in the 1910 publication *The Outing Magazine* that San Francisco automobilist Mrs. F.J. Linz, "with only a thin waist and petticoat over her underclothing [the earthquake struck just after 5:00 a.m.] ... drove steadily for two days carrying women and children and even exhausted soldiers to shelter." An editorial in the October 1906 issue of *Toot-Toot* (the official publication of the California Woman's Automobile Club, California Chauffeurs' Association No. 1, and the San Francisco Motorcycle Club) described the universal usefulness of the automobile during the aftermath of the earthquake. Automobiles were used against the Carmen's Union during the 11-day strike, August 27–September 6, 1906. The Union's strike against United Railroad brought electric streetcar service to a halt. Private automobiles were used in its place. "The old idea of the automobile being merely a toy for pleasure hunters, that they might ride luxuriously in spacious carriages, has ceased. The usefulness and really the necessity of the automobile has appealed to the mind, and all over the people are viewing the machine with the utilitarian idea." Presumably, members of the Carmen's Union did not have such a positive view of the automobiles used to undermine the effectiveness of the strike.[3]

An article in the January 1907 issue of *Pacific Motoring* attested to the increasing popularity of the automobile in San Francisco following the 1906 earthquake and fire when it reported that San Francisco had become

a close second to Los Angeles—the leading automobile sales market west of Chicago—in automobile sales.[4] As automobiles became more reliable, affordable, and easier to operate in the 1910s, more people saw advantages to automobile travel. The more affordable Model T came on the market in 1908 priced at $850, dropping in price to $298 by 1923.

The development of the self-starter, first installed in Cadillacs in 1912, spread throughout the automobile industry, making automobile use even easier. Christopher Wells writes of this period that the utility of the automobile, particularly the Model T, fused the interests of the mobility-minded (automobilists) and the horse-minded markets. "As the mobility-minded began to appreciate the appeal of everyday utility, and as the horse-minded began to appreciate easy mobility, the United States market for motor vehicles changed forever."[5]

Wartime Driving in France

The geographical limits of even the great cross-country trip were pushed beyond American shores by several women drivers. Wealthy American women shipped their automobiles to France to volunteer even before the United States entered the war by joining English and French volunteer motor corps. The requirements of women volunteers were much more stringent than the ones listed for the Young Men's Christian Association volunteers in the *Automobile Dealer and Repairer* article. The New York branch of the Women's Motor Corps working with the Red Cross required their volunteer ambulance drivers to have both a state chauffeur's and mechanic's licenses, receive emergency first aid training, learn to carry stretchers, perform infantry drills, learn army cooking, provide their own automobiles, and pay their own expenses. Historian Virginia Scharff points out that the young women from the leisure class who could speak French, drive automobiles, and were accustomed to volunteer philanthropic work were well suited to this work. Those requirements were listed in *The Khaki Girls* four-volume young adult fiction series written in the same style of the earlier automobile series.[6]

The heroines of *The Khaki Girls* made it clear that self-sufficiency is a feminine asset, particularly the ability to maintain and repair their own vehicles, with the opening sentence of the series: "There! Who says I can't be my own mechanician?" as the main character is introduced. In addition to rescuing wounded soldiers, repairing their vehicles and driving under heavy gunfire, the *Khaki Girls* demonstrate their patriotism by taking the lead in capturing a German spy. The highly patriotic tone of these books brought further validation to women driving and maintaining

automobiles, making the idea of automobile ownership even more accessible to the girls reading them.[7]

Established in conjunction with the Red Cross on January 27, 1917, shortly before and in preparation for the April 1917 entry of the United States into World War I, the National League for Woman's Services was divided into 13 national divisions. The Motor Driving Corps provided opportunities for women to drive and repair automobiles. As with the rest of the country at the time, the Corps was segregated by race. In New York State women Corps members had to have a state chauffeur's license and a mechanic's license, as well as pass a medical examination. The work done by the women further proved the practical applications of women automobilists as they transported supplies, patients and military personnel.

As with other wartime tasks the shortage of male automobile mechanics provided an opportunity for women to prove their worth as they learned to fix civilian and military automobiles and run garages. The Girl Scouts offered girls a driving badge, "The Order of the Winged Wheel," that required driving and auto mechanics ability as well as first aid. With the end of World War I many of these opportunities for women ceased as the men soldiers returned to home and their accustomed roles in the workplace. But the knowledge gained by women remained and developed further.[8]

Audley Moore remembers another aspect of Red Cross work during World War I. She and her sisters, then living in Louisiana, found out that "the Red Cross was giving coffee and doughnuts to the white soldiers and nothing to the black soldiers." The young Black teenagers organized the neighborhood women to make coffee and bring it to the Black soldiers who were being sent to Fort McClellan in Anniston, Alabama. Audley Moore and her sisters moved to Anniston, where they set up a welcome center in an old church building where the Black soldiers could relax and socialize.[9]

Automobiles Used on the Political Stage

Travel, transportation, and the ability to reach as many people as possible was an important part of the movement to gain the right to vote for women. Women suffragists incorporated each new mode of transportation as soon as they could, to spread the word about the need for women to have the ability to vote in federal, state, and local elections to help bring about a more equal quality of life. The opening of the Erie Canal across New York State in 1825, connecting the Hudson River and New York City with the Great Lakes and Western United States, allowed for the spread of new ideas, including women's right to vote. The Woman's Rights Convention

Woman driving Red Cross vehicle in France during World War I (Library of Congress).

held in July 1848 at the Wesleyan Chapel in Seneca Falls, New York, along the Erie Canal brought women together who had traveled by wagon and horseback from a 50-mile radius around the area to attend the convention. Eleanor Flexner writes: "[19-year-old Charlotte Woodward] and half a dozen of her friends planned to attend the convention, and set off early in the morning of the 19th in a wagon drawn by farm horses, fearful that they would be the only ladies present. But as they neared Seneca Falls, they met many other vehicles like theirs, headed for the same destination."[10]

Coming out of the 1848 Seneca Falls Convention, the resolution that "...it is the duty of the women of this country to secure for themselves their sacred right to the elective franchise" would take until 1920 to accomplish. During those 72 years, women's right activists traveled around the country utilizing the means of transportation they had access to as the years went on. As railroad lines expanded and linked the country together joining the efforts of women suffragists, the women were able to reach more varied parts of the country. Conventions were held annually as women worked for a variety of legal gains, including the right to own property, collect their own wages, to bring lawsuits and have similar property rights at the death of a husband as the husband had at the death of the wife.

To impress upon lawmakers that these demands were desired by their constituency required the collection of thousands of signatures on petitions. Each of those signatures required women to travel under difficult and hazardous conditions, at a time when travel by horse-drawn coach and later railroad cars was uncomfortable and women traveling alone were viewed with suspicion. And then there were the difficulties and dangers of holding rallies and meetings when they arrived at the destination. As we shall see, the automobile served as a mobile speaking platform, provided access to more women and men in communities off the main railroad routes and assisted in spreading the word and rallying support for women's rights.[11]

Writing in the July 1919 issue of *MoToR,* Margaret R. Burlingame commended the automobile's contribution to the passage of the Woman Suffrage Amendment by the United States Congress in June 1919. Margaret R. Burlingame was anticipating by more than a year the final ratification in August 1920 of the 19th Amendment that, in theory, guaranteed all women the right to vote. Burlingame wrote, "From the start of the industry woman has been the friend of the automobile. The automobile salesman has the woman in the home to thank for selling most of his cars for him. And now we find the automobile in a fair way to discharge its heavy obligation to her." The automobile was a prominent feature in the final push for passage of the 19th Amendment in the 1910s.

Midwestern suffragists organized some of the earliest massed automobile parades, and automobiles enabled suffragists to hold rallies in towns off the main railroad lines that they had not been able to reach before. Additionally, the ability of the automobile to "annihilate distance" enabled suffrage campaigners to cover more ground, reach and recruit more supporters and acquire tens of thousands of signatures on petitions that were brought to President Woodrow Wilson. The automobile served as a billboard and speaking platform in every town. Burlingame ended her article by concluding, "And so the score between the automobile and the woman bids fair to be settled, and the automobile salesman goes on his way rejoicing, knowing that while there are women there will be automobiles."

While Burlingame's salesman rejoiced over the immediate promise of future sales to women automobilists, the women making the purchases used their new automobiles to gain greater control over their lives and improve their quality of life. Indigenous women and men were granted United States citizenship in 1924 and allowed to vote in federal, but not all state, elections, in part as recognition of the service by Indigenous soldiers during World War I. Valor shown by Black American soldiers during World War I was recognized by the French Army who awarded them the

Suffragist speaker standing on automobile, ca. 1912 (Library of Congress).

high honors of the Croix de Guerre and Legion of Honor, but Black soldiers were not awarded the American Medal of Honor. Black women and men were prohibited from voting in many states in the American South until the passage and enforcement of the Civil Rights Act of 1964 and the Voting Rights Act of 1965.[12]

By 1916, the Woman Suffrage movement was regaining strength and, although it was not clear at the time, only four years remained before the passage of the 19th Amendment to the U.S. Constitution. In theory, the 19th Amendment guaranteed that "the right of citizens of the United States to vote shall not be denied or abridged by the United States or by any State on account of sex." In practice, this primarily applied to White women until decades and countless efforts later. The national political contests of 1916 provided the women voters of the 12 states that allowed them to vote in presidential elections, an unprecedented opportunity to wield political influence. The 1916 election saw the presidency, the entire House of Representatives and one third of the Senate with open seats. Maud Younger, keynote speaker at the woman suffrage Congressional Union meeting in June 1916, said: "For the first time in a presidential election, voting women are a factor to be reckoned with.... With enough women organized in each state to hold the balance of power, the women's votes may determine the presidency of the United States."[13]

The transcontinental suffrage tour from New York to San Francisco and back in the spring and summer of 1916, by two experienced White suffrage speakers, was one of the actions in the push to persuade White male party leaders to include woman suffrage platforms at both the Republican and Democratic national conventions. Alice Snitzer Burke and Nell

Richardson embarked on their tour from the Atlantic to the Pacific coasts and back on behalf of the National Woman Suffrage Association. They drove a bright yellow (the suffrage color), Saxon automobile that also served as their speaking platform. The two women, later joined by a small black cat named Saxon, left New York City on April 6, 1916, heading south. The automobile, nicknamed the "Golden Flyer," was a product of the Saxon Motor Car Company. Alice Burke also drove a Saxon vehicle in 1915 on her suffrage speaking tour across New York State. The *New York Tribune* provided regular coverage of the tour and Alice Burke provided updates describing their journey.[14]

Automobiles enabled women suffragists to reach towns off the railroad routes, make a notable entrance, serve as speaking platforms and, when needed, provide quick escapes from hostile crowds. In addition to spreading the word and encouraging voters, predominantly White men, to vote for woman suffrage, Alice Burke and Nell Richardson signed up local woman suffrage groups to send delegations to the St. Louis, Missouri, Democratic Convention and the Chicago Republican Convention set for the summer of 1916. Newspaper coverage included press releases announcing their arrival, and stories of the trip were carried by the *New York Tribune* and many other newspapers along the 15,000-mile route. The two women did the driving and maintenance of their vehicle and reportedly encountered few mechanical problems. They brought small trunks to carry tools, suffrage literature, and reception gowns. A small typewriter and portable sewing machine were brought and put to use along the way.[15]

At many of the stops they were escorted into town by an automobile cavalcade of vehicles driven by local woman suffragists. The "Yellow (Golden?) Flier" was "calculated to create a favorable impression wherever it goes." It was described as a gorgeous yellow with white slipcovers, doors of "campaign blue" and "pocket vases of flowers, yellow flag sticks and 'Votes for Women' banners and a chesty American eagle on the radiator."[16]

A feature of the 1916 St. Louis, Missouri Democratic convention was "The Golden Lane." A demonstration planned by the National American Woman Suffrage Association, which sought the passage of woman suffrage by individual state legislatures, it was seen as more acceptable to the White Southern Democrats than the parade planned for the Chicago Republican Convention. Stretching for the mile between the hotel housing the male conventioneers and the convention hall, women from every state (as well as a few men) stood silently on both sides of the street. The women wore long white dresses with a yellow "Votes for Women" sash and carried yellow parasols.[17]

Margot McMillen writes:

These women, with their dresses and parasols, changed everything. The men (delegations from each state) emerged from breakfast in marching ranks, wearing snappy suits, straw hats, and medals announcing their status in their clubs, and then found themselves embarrassed by a row of staring women. Their swaggers gone, the men faced a mile of mothers, grandmothers, aunts, and sisters. After the suffragists' years of marching and speaking out, the demonstration seemed to say that they were finished and were not going to move. And the delegates would have to travel between these two stony lines for a mile. There was no break where they might dive out and escape down a side street. And if they had, what shame they would have drawn to themselves.[18]

The Democrats passed an inconclusive plank as part of that year's goals in the party platform: "We recommend the extension of the franchise to the women of the country by the States upon the same terms as to men." Thus, they referred the granting of women's suffrage back to the individual states and evaded the question at the national level. The Republican National Convention in Chicago, site of a suffrage parade of 5000 women, incorporated a plank leaving woman suffrage up to the individual states.[19]

It was to gain support for these demonstrations that Alice Burke and Nell Richardson were on their cross-country tour. Organizers of the "Golden Lane" had figured out the quota of women participants needed from each state, and the number of parasols and sashes to be ordered. At the stops along the route of the Golden Flier women were signing up in support of women's suffrage and pledging to participate in the convention demonstrations. The tour began in New York City, went to California, and returned to New York City successfully.[20]

Both Alice Burke and Nell Richardson were experienced speakers and in addition to the seven prepared suffrage speeches, could switch topics as the situation required. At a mass meeting in Philadelphia the crowd was more interested in learning about the cross-country drive than hearing about suffrage. "So the speaker [Alice Burke] delivered a lecture on automobile mechanics and the science of packing much into little space." From Thomasville, Alabama, Alice Burke wrote "Our spark plugs won a few converts to suffrage this afternoon." A group of men gathered around the car to watch as she changed old spark plugs for new ones concluding that a "woman's hand in the machinery of politics might have the same helpful effect." That evening, in response to the flier Alice Burke and Nell Richardson put up in the post office, about 200 people gathered around the Golden Flier to hear them speak.[21]

Alice Burke's report of their travels through the old Confederate South highlights the deep racial divide intersecting in the woman suffrage

movement and early transportation. Her description of the Black picnic they encountered outside of Augusta, Georgia, makes it clear she did not consider Black men or women to be worthy of the vote. Her praise of the work of the United Daughters of the Confederacy to memorialize "some of the greatest Southern heroes" at Stone Mountain, Georgia, ignored the efforts of Southern politicians to deny Black men access to the vote and the violence Blacks encountered throughout the segregation and racism of the period.[22]

Black and White women's suffrage work separated as the 15th Amendment to the United States Constitution, ratified in 1870, while preventing the exclusion of voting rights on account of race, color, or previous condition of servitude, did not allow women the right to vote. As the racism of the post–Reconstruction era hardened in the 1890s and early 1900s, Northern White women acceded to Southern politicians' exclusion of Blacks from the voting process and did not advocate for Black women's voting rights. As time went on, Black women suffragists were not allowed to attend demonstrations, conventions and White-led suffrage work. Excluded from organizations led by Whites, Black women formed their own political and social reform movements.

Black women had worked and preached in Black churches honing their leadership skills. Black women's clubs came together as the National Association of Colored Women's Clubs in 1896 to fight racism, segregation and advocate for Black women's rights, social and economic improvement. The ratification of the 19th Amendment to the United States Constitution and the participation of women in the 1920 presidential election did not apply to Black women in the states where Blacks faced locally enforced obstacles and violence when they attempted to exercise their right to vote.[23]

Zora Neale Hurston

Black author, anthropologist, and folklorist Zora Neale Hurston had an early desire to see the world beyond the horizon of her hometown of Eatonville, Florida. Eatonville was a self-governing and self-determining all–Black town that provided her with an environment removed from the White-induced attitude that Blacks were inferior. Living in an all–Black town also gave a sense of privacy that enabled Eatonville families the opportunity to live their lives in a place where Black culture could thrive without being watched, judged, and punished by Whites. Hurston's parents encouraged education for their eight children and her mother encouraged her sense of curiosity and adventure.[24]

The porch of the local store provided rich material for Hurston's curious mind and love of a good story. The men of the town gathered on the porch and told stories "swapping lies," and while it was not socially acceptable for the young Hurston to sit and openly listen, she lingered as she passed by to catch what stories she could. After the death of her beloved and understanding mother when she was 13 her preacher father remarried, broke up the family and sent Zora away from Eatonville, Florida, to join two of her siblings at Florida Baptist Academy at Jacksonville, Florida. He only paid for part of the first year's tuition. To finish out the year Hurston scrubbed the school floors. Following that, she was on her own at the age of 14, wandering between the houses of family and friends and ever alert for the opportunity to continue her education.[25]

That opportunity came when she was 26 years old and living in Baltimore, Maryland. In order to qualify for the night-time high school, she needed to cut ten years off her stated age. So she did. Hurston worked a variety of jobs during the day and went to school in the evenings. After the evening high school, she moved on to the college preparatory schools of Morgan Academy in Baltimore, Maryland, and Howard Academy in Washington, D.C. Graduating in 1919, Hurston was admitted to the prestigious Black Howard University in Washington, D.C., attending as a part-time student. She majored in English and began her writing career in the 1920s. Encouraged to move to New York City to join the literary scene of the Harlem Renaissance, she left Howard University with an associate's degree. Her financial situation meant that she was only able to attend part-time during the five years she was a student there.[26]

Moving to Harlem, Hurston participated in and won awards at the *Opportunity* magazine literary competition. At the awards dinner she met two White women who offered her a job as a private secretary and admittance to Barnard College, the women's college associated with the all-male Columbia University. She went from the all–Black environment at Howard University to the all–White, elite environment of Barnard College as the only Black student. Her intellect and writing skill caught the attention of renowned Columbia University anthropology professor Dr. Franz Boas, when he read a paper she'd written for an anthropology class. Barnard College students were allowed to enroll in some Columbia University courses. As was seen at the World's Fair Midways, anthropology was used to justify racism and White European colonizer superiority over non–European White communities.

Hurston's intellect, writing skill, and interpretation of the stories she'd heard growing up in Eatonville, Florida, impressed Dr. Franz Boas, who rejected the racial hierarchy school of anthropology in favor of field-work and more respect for the cultures being studied. Hurston's ability to

connect with Black communities gave her the opportunity to successfully conduct fieldwork as a participant observer to gather folk lore and folk songs. The songs and stories derived from Africa and generations of Black life in the Deep South. She eventually succeeded where White anthropologists had not.[27]

Zora Neale Hurston's childhood desire—to "walk out to the horizon and see"—that she had put off until she "had something to ride on" was coming to fruition. The "something to ride on" was not the horse of her childhood imaginings but rather a $300 used two-seater Ford coupe bought on a monthly payment plan. To reach the Black communities that would be the source of folklore and folk songs, an individual, independent mode of transportation was vital, given the disrespectful, dirty and dangerous accommodations that railroad travel offered in the segregated era of the Separate Car Laws throughout the states Hurston would be traveling through. In addition, the communities that had the richest potential for folk stories and folk songs, practices and dances would not necessarily be near railroad stations. To provide backup for the safety of the automobile, she also carried a chrome plated pistol in a shoulder holster.[28]

Zora Neale Hurston's first trip back to Eatonville, Florida, to collect material was thwarted by her use of a Barnard-ese educated White manner of speaking, unintentionally setting her apart from her hometown. She had more success when she changed her approach and returned her manner of speech to the style from her time living in the South and dropped the Northern accent. During her fieldwork in 1927 and 1928 she drove "Sassy Susie," the name of her two-seater coupe, along the back roads of the South including Florida, Alabama, and Georgia. Valerie Boyd writes that Zora Neale Hurston's

...daring—and the potential danger of her mission—should not be underestimated. She was, of course, vulnerable to rape and the general misogynistic violence that any woman traveling alone might fear at any moment in American history. But there was more: This was 1927—a time when lynchings and other forms of racial barbarity were rampant in the South. She ...knew she had to be on constant guard.[29]

In addition to the danger, there was the insult and inconvenience that faced Black travelers in the 1920s. Hurston had to pull over by the side of road and go into the bushes when toilets were not available. She went to rooming houses and private homes in Black neighborhoods for food and lodging. When she could not find safe lodging, she slept in her car, not particularly comfortable in a two-seater, even though she was only five feet three inches tall. In the 1930s while traveling with two White workers on

the Florida Writers Project for the federal Works Project Administration, the Whites stayed in hotels while Hurston slept in her car. Not at all like the White autocamping experiences to be described later.

When Hurston and White author Fannie Hurst drove through New York, Vermont, and the Canadian province of Ontario, with Hurston as the driver, Hurst witnessed segregation for the first time and wanted to protest the discrimination. Valerie Boyd writes: "Zora viewed this kind of protest as an insipid waste of time." "Zora's attitude was swift and adamant," recalled Fannie, who was startled by Hurston's aloof lack of indignation. "If you are going to take that stand, it will be impossible for us to travel together," Fannie remembered Zora saying. "This is the way it is and I can take care of myself as I have all my life. I will find my own lodging and be around with the car in the morning."[30]

During the 1927 fieldwork expedition with "Sassy Susie," Black poet Langston Hughes joined Hurston after they unexpectedly met up in Mobile, Alabama. The Joplin, Missouri, born and Midwestern raised Hughes, who did not drive, was traveling by train on his own tour of the South as an extension of the invitation to read his poetry as part of commencement ceremonies at Fisk University, the historically Black college in Nashville, Tennessee. Together they explored the rural South that was entirely new to Hughes as was the language of the rural Black South that he heard from the guitar players, folk songs, tall tales and small-town juke joints. Juke joints were informal, Black-run establishments that provided music, dancing, gambling, food and drink for Black workers. The spirit of telling tall tales and improvising songs as the workers socialized contributed to the development of the Blues and Jazz that spread to the Northern cities.[31]

The trip through the rural South where Blacks were constantly under White surveillance was a different experience from the all–Black town of Eatonville, Florida, of Zora Neale Hurston's youth. During song and story collecting trips to the rough and dangerous turpentine camps, Hurston held "lying contests" and awarded prizes to encourage people to share their stories and songs. On a follow-up trip, this time driving a shiny, gray Chevrolet, Hurston found that she needed to explain her car to the suspicious turpentine camp workers whose trust she was trying to gain at the Everglades Cypress Lumber Company in Loughman, Florida. Turpentine camps were particularly difficult places to work in isolated locations, some with exploitive conditions harkening back to slavery. Laborers were hired with few questions asked and thus were good places for fugitives to hide out.

To explain the presence of her shiny car, and to prove she wasn't with law enforcement, Hurston made up the plausible cover story that

she was a bootlegger on the run from the law in Jacksonville, Florida, and Miami, Florida. Bootleggers were known to be able to afford, and to need, automobiles as part of their rum running activities. Past income from bootlegging also explained her dress that, while simple, was far more expensive than the dresses worn by the women at the lumber camp.[32]

Once Hurston had won the trust of the lumber camp workers the stories and songs began to flow. Valerie Boyd writes: "After that, Zora's car was everybody's car, and she was enjoined to sing 'John Henry' at every party she attended—and she attended every one." For her contribution at the lying contests, she read from Langston Hughes' 1927 poetry volume "Fine Clothes to the Jew." The poems, described by Hughes as "An interpretation of the 'lower classes,' the ones to whom life is least kind," were given poor reviews by Northern reviewers. The poems were welcomed by the southern blacks working in railroad camps, phosphate mines, turpentine stills, all places where life was least kind. Hurston was able to record and photograph the songs the workers spontaneously created putting the poems to music.[33]

In addition to winning the trust of the communities where she was collecting folk songs, stories, and games by providing rides in her car, her automobile provided Hurston with a means of a quick escape when necessary. The few women in the lumber, turpentine, and phosphorus mining camps were powerful and intimidating personalities who knew how to handle themselves in fights. Having killed a man increased credibility. Big Sweet, the powerful leader of the Loughman camp, allowed herself to be befriended by Hurston (and her automobile) and provided introductions and persuaded members to neighboring work camps to share their songs and stories. Big Sweet was asked by Hurston to be the judge of the Loughman camp lying contests—no one would dispute Big Sweet's rulings. While most of the camp workers got along with Hurston, not all did.[34]

Valerie Boyd writes: "Resenting the visitor's store-bought clothes, shiny car, and lighter skin, Lucy began threatening Zora in a way that made her especially glad she had befriended Big Sweet." When Lucy's threats turned to switchblade-backed violence at the jook joint, one of Zora Neale Hurston's allies yelled for her to run as Big Sweet counterattacked Lucy.

> And under the circumstances, running was about all Zora could do. "Curses, oaths, cries and the whole place was in motion," she noted. "Blood was on the floor." Zora fell out the door, ran to her room, flung her bags into her car, and promptly shoved the Chevy into high gear. "When the sun came up," she would remember, "I was a hundred miles up the road, headed for New Orleans."[35]

Following this dramatic exit from the Loughman, Florida, Everglades Cypress Lumber Company, Hurston traveled through lower Alabama collecting more stories and then to Eau Gallie, Florida. There she rented a small cabin and was able to spend some time sorting through the quantities of material she had collected. Access to automobiles provided her the ability to record and honor the rich folklore of the Black working-class communities in the 1920s and 1930s. This work provided a basis for the body of Hurston's literary work that followed.[36]

Autocamping

Autocamping began as a vacation alternative for the (primarily White) financially comfortable middle-class, while the lack of established auto infrastructure offered a major appeal to early autocampers, avoiding fixed rail schedules. World War I worsened rail schedule reliability, passengers had to be at the station on time, but passenger train schedules were preempted by freight and troop trains. The segregated ticket sales windows in stations where all White passengers were served before any Black passengers further complicated Black travel. For these and a variety of other reasons, as noted throughout this study, motoring was seen to allow complete control of schedule and route. It also was seen, and advertised, as a way to gain control over one's own sense of self and one's destiny. "Unless you really love to motor, take the Overland Limited. If you want to see your country, to get a little of the self-centered, self-satisfied Eastern hide rubbed off, to absorb a little of the fifty-seven (thousand) varieties of people and customs, and the alert, open-hearted, big atmosphere of the West, then try a motor trip," wrote Beatrice Larned Massey in advice that applied primarily to White automobilists.[37]

The "open-hearted" atmosphere of the West, however, is challenged by Florence Howe Hall's advice about preparing for camping as an extension of the auto picnic. In Hall's 1914 etiquette book *Good Form for All Occasions,* she advised getting the landowner's permission beforehand to stop for a picnic.

> It is very sad for a party of friends on pleasure bent to be warned off the grounds just as they have their whole luncheon unpacked and spread out on the grass. Yet this frequently happens at places in the neighborhood of summer resorts. The city visitor, misled by the uncultivated aspect of some beautiful spot, fails to realize that it is private property, and that the owners may find it extremely inconvenient to have their premises constantly invaded and their privacy destroyed. Some owners are willing to allow picknickers to come to their places, provided permission is obtained beforehand, the debris removed,

and no damage done to the trees and shrubs. The vandalism of certain summer visitors is hardly believable. They will calmly leave the unsightly and unwholesome remains of their repast lying about to offend the eyes and nostrils of later comers and to breed flies. Farmers and others sometimes make a regular charge for [use of] their grounds for the day.[38]

Automobilists venturing out from the cities for day trips and picnics in the country were not always welcomed by the farmers and roadside property owners. The litter, damage to property and animals was only partly alleviated by the money the motorists spent in the communities they drove through. To control the influx of motorists and help direct the tourism dollars to the downtown businesses, municipal officials and business owners began establishing free municipal campgrounds by the 1920s in central locations in towns along the touring routes.[39]

As autocamping became more popular in the 1920s, it became more institutionalized; farmers complained of garbage and campers complained of being charged for staying in fields without water access. Soon, early free public campgrounds in municipal parks were established. Large campgrounds had a central club house with a grocery, community kitchen, laundry, toilets, and often even showers. Municipalities hoped to draw tourist dollars from outlying farmers who were selling produce and charging for camping in fields. The 1926 guide *Motor Camping* devoted the second half of the volume to an alphabetized-by-state list of "Camp Sites in or near Cities and Town."[40]

While camping might have seemed an option to the segregated motels, being in the open with only a tent for protection was also dangerous for Black motorists, even if they had been able to find an integrated campsite. Candacy Taylor writes in "Overground Railroad" that Black visitor attendance in National Parks even in this new century is low; a 2008 survey showed that only 7 percent of total park visitors and 1 percent of visitors to Yosemite National Park identified as African American. The historical trauma of the violent actions against Blacks by hate groups Ku Klux Klan and other violent White supremacist group murders and violence occurring in the woods still presents a very different aspect of camping to Black travelers than to Whites.[41]

In specific areas where the circumstances had been thoroughly researched, some Black families' records indicate that felt they could camp safely. One Black family from Pennsylvania felt safe staying at National Park campgrounds during their two trips across country to California. Dr. Gretchen Sullivan Sorin writes, of her family's trips to New Jersey State Forest campgrounds during the middle decades of the 20th century, that her father always made friends with the Park Police, who would have been White during the segregation era, and who made regular patrols in the

State Forest and camping areas. Parking at the campsite close by swimming areas and well-traveled trails was safer than wilderness trails. Sorin writes, "We had no fear of the four-legged animals; it was the two-legged variety that were concerning." Among her father's precautions was the presence of his licensed rifle in the family station wagon. Sorin continues, "I recall it coming out of the case only once when we were on vacation, when my father wanted to teach me how to shoot targets. Years later, I wondered about that gun. Why did he really take it for a camping trip in New Jersey?"[42]

Even among oppressive and racist policies and practices, traveling by automobile gave many Black travelers more control over their environment than traveling by railroad car. Sorin notes that "Cars enveloped parents and their children in a protective bubble, providing psychic safety that shielded passengers from insults." Author Jill Nelson adds to this, observing that "driving at night with a car full of sleeping children avoided numerous pitfalls. No whining pleas to stop someplace that we saw from the car window and risk being treated with disrespect or hostility." Sorin continues: "The newfound freedom and adventure of the road seemed particularly sweet for African Americans, a group for whom the full rights of citizenship were denied. Operating a motorcar was a wonderful, liberating experience. Cars offered new opportunities."[43]

National Parks auto route map. National Park Tour Now Possible. *MoTor* magazine, June 1915, 42 (image courtesy of AACA Library & Research Center, Hershey, PA).

Black travelers found segregated accommodations and White hostility awaiting them on automobile trips, just as on railroad trips. Before the publication of travel guides such as *The Negro Motorist Green Book* in the 1930s, it was more difficult for Black motorists to determine where they would be welcome and safe when they stopped for food, accommodation, and to see the sights along the way. Muriel Snowden

remembered her family planning cross-country trips using charts printed in Black newspapers that "...showed you how you got across country without running into discrimination." Snowden also said her parents planned their travel routes to enable them to stay overnight with friends along the way to ensure safe, comfortable places to stay.[44]

Automobile travel, preferable though it could be to the guaranteed insults of train travel for Black travelers, was—as has been shown—not as carefree as it was for White motorists. Jessie Abbott remembered having to drive all day and through the night because they were not able to find a desirable place to spend the night. Black-owned boarding and guest houses could not always accommodate a large party. Gas station restrooms were segregated or for Whites only, so they "would have to drive through the country and find a spot in the woods where the children could go." Because they could only eat in restaurants which served Black customers and those restaurants were difficult to find, Black travelers bought food at grocery stores and ate cold meals in the car. Abbott said she would buy canned beans, heat them by putting them on the hot car radiator so they would have something hot to eat.[45]

Packing for the Long-Distance Drive

As automobilists, particularly White automobilists, began venturing out of town into the American countryside in the early 1900s, they stopped by the side of the road for picnics and overnight stays. These excursions fostered new forms of technology to provide food storage and comfort while venturing into the countryside and away from the established rail road lines and city hotels. How much, and what, to pack varied amongst the automobile excursionists. The common denominator was the need to factor in weight and fitting items into the compact space automobiles afforded. Marie Hjelle Torgrim and her party of three young Iowa women arrived in Marshalltown, Iowa, to meet up with the second party expecting to get underway promptly. Instead, they found "tents, cots, bedrolls, dishes, food staples, fishing gear (including worms), chains, tire pump, folding luggage carriers, and everyone's luggage strewn across the yard, with the Model T in the middle." In addition, the morning had been spent giving the less experienced women driving lessons.[46]

Fitting four people and the gear into and onto the compact space offered by the Model T was a puzzle. As the Model T had no driver's side door, they attached flexible luggage racks the length of the driver's-side running board to hold suitcases, chairs and a car bed. Food and cooking utensils went into special cupboards that doubled as tables. The stove

was left behind when a leak was discovered. A very important canvas bag filled with water for the radiator hung on the side. The Iowa party was ready to start by the middle of the afternoon—they decided to drive the 40 miles from Marshalltown, Iowa, to Ames, Iowa, where they knew of a good campground to spend the first night. That enabled them to test their gear close enough to home to return for any forgotten items.[47]

A common theme in the published travelogues of the early transcontinental automobile tourists was the need to pack the automobiles carefully. Emily Post's party overpacked—and with clothes for the wrong climate. Warren James Belasco writes in *Americans on the Road: From Autocamp to Motel, 1910–1945* of the transition period between hotels catering to train travelers and the realities of automobile travel, particularly in open vehicles. Even the rather shabby hotels with mediocre meals established to cater to the traveling salesmen of the pre–mail order catalog era required customers to meet a dress code; for men that included a jacket and tie. The hotels catering to train passengers traveling for pleasure and those hotels at summer resort areas had higher dress code standards. These dress codes were hard to meet when traveling the dusty, muddy roads. These concerns would be addressed in the years to come by the development of tourist cabins and motels.[48]

Beatrice Larned Massey in her 1920 travel account *It Might Have Been Worse* wrote about the overpacked vehicles they encountered, calling them "houses on wheels." In addition to tents, poles, bedding, cooking utensils, she wrote of seeing stoves, sewing machines, crates of tinned foods and "trunks full of every conceivable incumbrance they could buy, strapped to the back and sides and even on the top of the car." Then there was the personal luggage jammed into corners of the interior and tucked between the exterior mud-guards and hood of the engine. On top of the luggage were perched the passengers, whom Massey described as "the picture of woe and discomfort." Making her preference clear, she continues, "Have you ever seen a party of this description unpack and strike camp after a hot, broiling, dusty day of hard travel? You will do as we did—drive right ahead until you come to a clean hotel and a bath."[49]

Zelda, one of the young women in the two automobile, eight-women autocamping party from Iowa, described their initial packing as similar to others who "start on a camping trip with everything but the kitchen sink. The gross weight was never considered, [or] that we ourselves weighed anything." To the early motorists, although they were accustomed to considering the limits of what a horse could haul, the capability of a machine with a 20-horsepower engine seemed limitless. Zelda wrote of passing cars packed with folding chairs and mattresses to the extent that the passengers rode with their feet hanging out the windows.[50]

After a rainy night early in the trip Marie Hjelle Torgrim mandated that the other six women follow the example she and Laura had set, of having one suitcase between them to reduce the weight and volume of things the Model T Fords had to carry. They were able to go from seven suitcases to four, two per car, by "packing one dress each along with seldom-used garments in one. In the other were towels, PJs (flannel for cold nights) and other things used daily." The remainder they shipped home. They stayed dry that rainy night by having two women sleeping in each car and the other four on cots under the auto tent attached to the vehicle. Side curtains were used for privacy and to try to keep out the rain.[51]

Warren James Belasco notes the two components of autocamping— touring by day and camping at day's end. The number of public campgrounds in municipal parks was between 3,000 and 6,000 in the early and mid–1920s. As noted above, left to their own devices, early motorists who stopped by the side of the road, in school yards, municipal parks, and alongside farmers' fields soon wore out the welcome of their tourist dollars used to purchase local produce. After moving on, the motorists and autocampers were prone to leave a trail of damaged property, garbage and tin cans in their wake, despite the pleas of motoring publications and organizations to clean up after themselves and behave in a respectful and ethical manner.[52]

As F.E. Brimmer warned his readers in the chapter "Ethics in Autocamping," bad behavior could lead to restrictive laws as lawmakers gauged the effect of autocamping on their municipalities. "It will be like the early days of the automobile. First people were amused, then interested, then tolerant, then angry, and then hedged motor vehicles about with iron-clad laws. The same may be true of autocamping. We are just getting through the amused stage with flying colors and people are fired with interest. This enthusiasm must not run amuck!"

The inclination to throw things out of automobile windows while motoring along seems to date back to this early era as Brimmer warns his readers not to throw lighted cigars, cigarettes, matches from the moving automobile. His warnings include securing tent openings so they don't flap and scare passing horses. Careful selection of safe fire pits and management of the flames and sparks are also addressed. In addition to picking up all litter and taking it with you—an early predecessor of the present day "pack it in, pack it out" model for trail use—Brimmer urges the purchase and use of toilet tents or at the very least burying waste and trash that can't be burned. His plea brings a series of unpleasant images to mind.[53]

As a precursor to municipal camping areas, schoolyards were recommended. An advantage to schoolyards, Brimmer writes, are the school

toilet facilities. He tells of finding school buildings unlocked with indoor toilet facilities. In smaller towns he suggests asking at a nearby farmhouse if they know where the school trustee lives to ask permission, but he points out, schoolyards are public land as are state and national parks.

Municipal parks for camping began in the Western United States and spread East. In 1920, the City of Denver, Colorado, set aside 160 acres of land along the Platte River. A similar early motor camping park was established in Spokane, Washington. These parks offered electric lights, a grocery store, separate showers and comfort stations (toilets) for men and women, laundry rooms, a billiard room, barbershop, cafes and vendors selling camping equipment. The practical needs and entertainment options included a gasoline filling station, auto repair shop, garage building and a motion picture theater. Smaller municipal motor camping parks might not offer bathing and laundry facilities but many provided water, cooking facilities and fuel. Fireplaces and stoves were available at municipal and roadside areas.[54]

Marie Hjelle Torgrim described a large tourist camp in Council Bluffs, Iowa, with a view across the Missouri River to Omaha, Nebraska, as being worth the charge of 50 cents per automobile as the camp provided free stoves heated for cooking, water, and fine showers. They waited for the rain to stop and the roads to dry, then took advantage of the 50 miles of paved road out of Omaha—an example of "seedling miles," or paved stretches intended as "seeds" from which longer paved roads would grow. The young Iowa women adjusted their travel plans as they spoke with other autocampers in the tourist camp deciding to avoid Great Salt Lake in favor of a more northern route thru Idaho and Oregon. The Lincoln Highway trek across the deserts between Salt Lake City, Utah, and Reno, Nevada, required specialized preparation against the isolation, heat, sand and deeply rutted roads and was considered the most dangerous section of the Lincoln Highway.[55]

The 50 miles of concrete paved road leading west out of Omaha, Nebraska, were the last bit of good road before the women encountered the legendary gumbo mud of the Iowa and Nebraska stretches of the Lincoln Highway—the mud that clung to the canvas side curtains, clothes, and supplies and filled the tire wheels. Like other cross country motorists, the Iowa women used chains on the tires in valiant attempts to gain traction to move through the thick, sticky mud and got out to push the cars through the mud-filled ruts. For Laura, crossing into Nebraska was her first time leaving her home state of Iowa. Crossing the Platte River brought them out of the mud and onto the welcome gravel roads crossing the prairie across western Nebraska, into Colorado and their first glimpse of the Rocky Mountains.[56]

As young women traveling alone they were cautious about picking up

hitch-hikers. Marie Hjelle Torgrim was alarmed when the women in the second car gave a ride to two hitch-hikers. While that worked out without incident, and the men showed them how to clean and dry the timer at the bottom of the motor after fording streams, it was decided not to do that again. Later in the trip, while looking for a tourist camp near Pikes Peak, Colorado, they had an incident involving a car filled with men who offered to lead the way to a tourist camp. The Iowa women soon realized that they had best turn around and head back the way they came and hope the men didn't follow them. "We just shook them," Torgrim recalled. "I'll never forget [that] sensation, because that was dangerous. Young girls out there had to be careful."[57]

Winifred and Toby found themselves stranded in a stream that rose to a flood at Nambe, New Mexico, and submerged the automobile. Toby had forgotten to get out and check the depth of the water. After multiple failed attempts to get it out by a variety of people they rode eight miles on horses borrowed from some of the onlookers, to the nearest telephone to contact the kindly and skilled mechanic, Bill, in Santa Fe to come out to assist. Thanks to a system of stakes, pulleys and muscle power the automobile was hauled out of the water and gotten back to Bill's garage in Santa Fe. He was able to dry out and refurbish or replace the damaged parts and Winifred, Toby and the "old lady," as they called the car, were on their way again.[58]

In addition to the municipal tourist camps there were the state and national parks, located, as F.E. Brimmer notes, in magnificently beautiful natural settings with a variety of facilities provided for camping. For the White motor tourist, all of these options were available without question or concern. As we see throughout this book, Indigenous communities were forcibly removed from many of the natural wonders that had been their homelands for centuries, and legal barriers and social dangers barred Blacks from the carefree travel White motorists accepted as their natural right.

Two sets of White autocampers, Mary Crehore Bedell with her husband and a group of eight young Iowa women, each described their 1924 autocamping trips. As they got underway for their trek from Iowa to California, Marie Hjelle Torgrim and her party of eight young Iowa women made use of the campgrounds described as being on the edge of every town. Accommodations varied from town to town, some had showers or gas stoves, some did not. But they noted wood was ready for making a campfire at the campground sites. The eight Iowa women made use of side tents that were lashed to the tops of the cars and secured to the ground with stakes, and they set up two cots inside each tent. The remaining two sleeping quarters were inside the respective cars: "Ophelia Bumps" had a

specialized car bed that fit over the front and back seats, whereas the front seats of "Jenny Pep" were cut and hinged to fold back. However, it did not lie flat despite the efforts of the young women to even it out with newspapers, coats, and pillows. Mary Crehore Bedell writes that during their weeklong stay in a hotel in El Paso, Texas, they hired a mechanic to cut down the hinges of the front seat of their automobile and put on hinges to fold back into a bed. The Bedells found that to be a comfortable arrangement and spared the need to set up a sleeping tent in the windy, dusty conditions of the desert roads of the Southwest.[59]

The 1926 handbook *Motor Camping* devotes a chapter to "Camping with a Ford" and describes a variety of accessories available for purchase to convert the Ford four-passenger touring car or sedan interior into comfortable, water-proof sleeping quarters. The two-passenger Ford roadster and coupe models also had accessories for the smaller car size that promised "sagless tension" among other comforts. The Auto Bed Manufacturing Company and the American Camp Equipment Company both made car beds that were advertised as comfortable, lightweight and easy to set up and take down. Also available were tent-bed combinations that either attached to the car or could stand independently. Autocamping outfits could also be home made with the aid of a machine shop or a blacksmith shop. *Motor Camping* describes a nine week, 8,000 mile trip taken by a couple from Brooklyn, New York, with a home made camping outfit that enabled them to stay in reliable comfort by the side of the road. They had found that the municipal camp sites often filled up by late afternoon and liked the independence of carrying everything they needed with them.[60]

The open sided Model Ts, like "Ophelia Bumps" and "Jenny Pep" driven by the young women from Iowa, came with oiled canvas side curtains put up as needed to try to fend off wind, rain and cold. The curtains were held in place with rods that fit into the doors and twisting button snaps to secure them, but the curtains frequently flapped and blew loose despite securing them. Peepholes covered with thin sheets of crackled mica called Isinglass allowed limited visibility. Windshields were split into top and bottom and a canvas top covered the car. Sometimes the top portion of the windshield was folded up to allow the driver to see, a measure that let the rain in but was occasionally necessary.[61]

For many, the recognition of the appeal of wilderness destinations and desire to connect with the so-called "pioneer spirit" and "prove individual strength" led the Bangor & Aroostook Railroad to offer wilderness vacations into the Maine woods for camping expeditions. Railroad companies encouraged destination tourism to Western nature sites; the Northern Pacific Railroad to Yellowstone National Park; the Great Northern Railway to Glacier National Park; the Atchison, Topeka & Santa Fe

Railway to the Grand Canyon. The railroads owned hotels and restaurants at the destinations and provided a range of tourist experiences. Peter Schmitt, in the 1969 book *Back to Nature*, identifies three types of nature tourists: those who like nature but not wilderness, those who want nature and entertainment, and the self-sufficient wilderness camper. The railroads designed their destinations to fit the first two categories with the goal of creating profitable Western vacation spots.[62]

During the years immediately before the 1917 United States entry into World War I, automobile travel became more accepted, available, and popular. Improved road conditions, promotional cross-continent automobile trips by both men and women, the limited ability to travel in Europe following the 1914 outbreak of World War I in Europe, along with the "See America First" tourism campaign, made automobile travel more accessible and appealing. The early attempts to drive across the contiguous United States by automobile were sponsored by automobile manufacturers to publicize the reliability and practicality of their particular model and of the superiority of automobiles over horses.

In the 1920s, municipalities and parks created camping areas for auto tourists. The free camps had fewer facilities than the pay camps, which could include showers. Showers were a welcome sight after hours on the dusty roads, even though "the only satisfactory thing about camping was that one could be as dirty as possible."[63]

Traveling together with a second autocamping party was advised by *Autocamping* author F.E. Brimmer, particularly through the desert stretches of the journey. Brimmer emphasized the importance of bringing along an adequate amount of water for the desert crossings. "The water container, little considered in the East, is here found to be more important than the food basket in the land of sun, sand, and solitude." Railroad watering stations, water holes, wells, and springs were recommended for replenishing the daily water supply—two gallons per day per person. And a "proportionate amount for the car" as the dry heat would cause evaporation of not only the engine coolant, but also the lubricating moisture of the automobile springs, which caused the cars to "roll along sounding like a whole bevy of squeaking mice or singing birds." Brimmer also wrote of desert flora that provided water in emergencies—the barrel cactus could yield a gallon of sweetish water and tules and bullrushes grew near water sources.

Extra gasoline and oil was also advised, as well as a compass and accurate information from a competent organization. Mary Crehore Bedell wrote in her 1924 travelogue *Modern Gypsies: The Story of a Twelve Thousand Mile Motor Camping Trip Encircling the United States* of meeting up with two women from Oregon traveling in a Model T from Florida

to Oregon. The two parties decided to travel together across the 250-mile stretch of desert road between Fort Stockton, Texas, and El Paso, Texas. As F.E. Brimmer had warned, drinkable water was a scarce commodity and the sandstorms made for formidable driving. Formidable camping as well, the wind was blowing so hard when they reached El Paso, Texas, that they chose to sleep in their car rather than risk having the tent blow over. As did all transcontinental motorists, Mary Crehore Bedell realized how large the distances are across the United States. She wrote "I never quite realized when I studied geography that it is as far across Texas as it is from Chicago to Florida."[64]

The thick volumes of the travel guides including the American Automobile Association Blue Book were in the care of the navigator who read off the turn-by-turn directions to the driver. The advertisement for "A Celluloid Cover for your Blue Book Holder" gives an indication of the conditions for the navigator as it is "A great convenience adding greatly to the pleasure of using the Book. You can laugh at the stiffest wind with the Book lying loose in your lap. Relieves that all-day 'death-grip.' The pages can be turned without removing the Book." Emily Post wrote of losing her place in the Blue Book. "Nothing that I could find any longer tallied with the road we were on, and it took us at least half an hour to find ourselves again."[65]

Autocamping Accessories

The 1923 book *Autocamping* by F.E. Brimmer discussed the pros and cons of both gasoline and wood-burning camp cooking stoves. The Kamp-Kook two-burner gas stove was a popular model. It burned the same gasoline as was used to fuel the automobile. It had the advantage of setting up quickly and producing a quick, hot fire for instant cooking. It stayed lit even in rainy and windy conditions. Brimmer wrote, "When carried, this particular gasoline stove looks like a metal suitcase of very small capacity. [...]The gasoline tank for this stove detaches and packs inside the body of the fire-machine when carrying.[...] It is a matter of ten seconds to lift the tank from the interior of the stove and set it in place at the end, no screws or bolts or anything having to be turned." KampKook Ovens were also available. The oven included a 9 × 15–inch bread pan and a 9 × 15–inch combination roasting and frying pan with a folding handle. Mary Crehore Bedell wrote, "These small gasoline stoves are very convenient cooking devices. We used ours a great deal, for in some places we were not allowed to build a fire. Besides, the gasoline stove never blackened the kettles and that was a great comfort."[66]

Refrigerator baskets were used to store food. Milk, cream, and butter were particularly difficult to keep fresh, until the arrival of the refrigerator basket. Ice was kept in the cooling compartment. Brimmer devoted a chapter in *Autocamping* to food preservation. He recommended Hawkeye-brand refrigerator baskets, which could be strapped on the automobile footboard. To avoid the unpleasantness of soured milk, Brimmer advises: "The milk supply for the day is obtained from the farm or the small town milk station [...] anywhere convenient, but early in the day. The ice will keep in the refrigerator basket a little more than twenty-four hours."[67]

The fisherman takes his lunch out and brings his fish home in it "fresh and firm." *Autocamping* recommended the use of a separate refrigerator basket for fish, to keep the fishy smell away from the food basket. Another 1920s food storage item was the Tourists' Kitchenette which advertised "The Comforts of Home on the Open Road." When closed up, it attached to the running board. Features included an Ice Box which held between 20 and 25 pounds of ice and was "built so that ice rides with constant spring. In extreme heat, for additional insulation fold heavy newspaper over top and side of ice." An "Ice Water" compartment that contained a separate piece of ice even came with an outside faucet. An "Ice Drip" compartment aided in the cooling and prevented ice-melt water from leaving a trail behind the automobile. Brimmer wrote that when he used a homemade ice box, his friends told him he "simply had to be good on my trips because that dripping ice box left a tell-tale track wherever I went."

Advertisements proclaimed:

The Hawkeye is a lunch basket and a refrigerator. Just a little ice will keep its contents cool and fresh for twenty-four hours. The basket is made of smooth, tough rattan—woven and bound so it will stand the roughest kind of usage. The inside is lined with nickel-plated or white enameled metal—perfectly clean and rust-proof. Between the lining and the outside basket is a packing of asbestos and mineral wool. The heat cannot get in, the cold cannot get out. All those delightful things that you have wanted to have for your out-of-door lunches, but couldn't because they would spoil, can now go in a Hawkeye and keep cool and fresh for twenty-four hours. Firm butter, cool salads, sweet, fresh milk, iced drinks—everything keeps just as perfectly as if it was in the ice-box at home. Every family in America can get a whole lot of enjoyment out of a Hawkeye Refrigerator Basket. The autoist can strap it on the foot-board of his machine. The fisherman takes his lunch out and brings his fish home in it— fresh and firm.[68]

The water-tight Kool Pak stored bottles of milk as well as meat, fruit, vegetables. "Being just below the ice box it is refrigerated without air circulation from the cold air coming down; metal wall contact with the 'Ice

Drip' compartment on right aids refrigeration." "The Egg-Butter com-
partment is made for the exact height of eggs. Capacity is 1½ dozen eggs
and space for 1½ pounds of butter." Additional drawers in the Kitchen-
ette held non-refrigerated food items. A towel rod, a dish pan which also
stored dishes and cooking utensils as well as a compartment for dish soap
and towels. Thermos provided both round and square utensil carriers. The
round containers fit inside the spare tire. Wearever made an aluminum
cooking and eating outfit for four, including a bottle and can opener. The
1912 Thermos bottle on its own was advertised to keep liquids piping hot
for 24 hours or ice-cold for 72 hours. The 1916 car running board picnic
trunk suitcase came with porcelain enamel cups and plates, and a food
storage container and pan, probably aluminum. The suitcase closed up,
ready to be secured to the running board.[69]

Mary Crehore Bedell described the 400–500 pounds of camping
equipment loaded on their "sturdy little Hupmobile," which included a
"tent, dufflebags, gasoline stove, Adirondack grate and a kit of aluminum
kettles that nested, with coffee pot and enamel cups and saucers." Auto-
tents that attached to the car provided a bit more security and stability
than freestanding tents.[70]

Pleasure travel was sharply curtailed with the entry of the United
States into World War I in 1917. Beatrice Massey wrote of postponing her
plans for a coast-to-coast motor trip: "the United States went into war, and
self-respecting citizens were not spending months amusing themselves."
Automobile magazines featured stories of participation in the war effort,
including a piece in *Automobile Dealer and Repairer* about the male chauf-
feurs of the Automobile Club of America who set up knitting machines
in the weeks following America's entry into the war in their New York
City workroom and were turning out socks and sweaters by the hundreds
during their "odd moments between calls." The same issue carried an arti-
cle calling for "Any man of fifty years who is in good physical condition,"
and willing to take their own automobiles to France to volunteer for the
Young Men's Christian Association (YMCA). The article noted that they
would not be required to do repair work on their vehicles, except in battle
area emergencies.[71]

Thus far, each succeeding chapter has shown how women were able
to expand their travel experiences and incorporate the automobile in their
daily lives. The next chapter addresses what can be considered an ultimate
American road trip, traveling between the East and West Coasts, and set-
ting foot in the Atlantic and Pacific Oceans.

CHAPTER 6

Early Trans-Continental
Driving Attempts

An early attempt to drive from New York City to San Francisco was made by John D. and Louise Hitchcock Davis from July to October 1899 in a two-cylinder, 1899 National Duryea. They drove over one thousand miles from New York City to Chicago before calling a halt to the trip. The trip was co-sponsored by the *New York Herald* and the *San Francisco Call*. Both Louise and John Davis were newspaper reporters. Louise, age 24 at the time of the trip and an established journalist, submitted daily accounts of their journey. The goal of the trip was to prove the superior quality of American-made automobiles over European models, and also to establish the automobile as a viable mode of transportation, not just a toy. Trans-continental treks were considered to be the true test of a new "motive agency" according to *Leslie's Weekly*.[1]

John and Louise Davis' attempt to drive from New York City to San Francisco was fraught with daily mechanical breakdowns, sometimes caused by the crowds pressing in on them at each city and town they passed, but most often by the effect of the very rough roads on the light-weight automobile. It took four days to travel from New York City to Albany, New York, and John Davis developed a painful case of "automobile arm." Their car was equipped with a steering tiller that was more difficult to hold than a steering wheel. The effort of holding the steering tiller over rough road conditions caused the driver's arm to be repeatedly wrenched back and forth, and the steering wheel was not yet in common use.[2]

While the start of the trip was highly publicized, the daily reports of breakdowns and delays and the ridicule that came from the European press caused the trip to fade into obscurity. Both the *New York Herald* and the *San Francisco Call* stopped reporting on the trip, which had become an embarrassment, and the Davises' car was last heard from in Chicago. Without the newspapers' financial sponsorship, the couple could not continue

their cross-country journey. Curt McConnell writes that John and Louise Davis' attempt emphasized the need for more reliable vehicles and well-maintained roads, but it also introduced the idea that the automobile was a vehicle ordinary people could use to travel long distances.[3]

Motorists Alexander Winton and Charles Shanks made a West to East cross-country attempt from San Francisco, California, in May 1901, but stopped 530 miles into the trip just east of Mill City, Nevada. Alexander Winton had driven a car of his own make from Cleveland to New York City in ten days in 1897, one of the earliest distance runs. In 1903, Dr. H. Nelson Jackson and Sewell Crocker, along with Bud, the dog they picked up along the way, made a successful drive from San Francisco to New York City between May 23 and July 26, 1903. They averaged 3.61 miles per hour with a running time of 46 calendar days and an elapsed time of 63 days in their 1903 Winton touring car.[4]

The Jackson–Crocker car arrived in New York City a month ahead of the 1903 Packard driven by E. Thomas Fetch, who, traveling with an observer and a mechanic for the western part of the trip, left San Francisco on June 20 and arrived in New York City on August 21, 1903, averaging 2.2 miles per hour. A third San Francisco-to-New York City run was made by Lester Whiteman and Eugene Hammond between July 6 and September 17, 1903, in a 1903 Oldsmobile averaging 2.4 miles per hour. Curt McConnell writes about three more California to New York City cross-country drives between 1904 by individuals, a relay team, and a 1908 trip by a family of five who traveled with a mechanic in a seven-passenger Packard touring car.[5]

Alice Ramsey

The early attempts to drive across the contiguous United States by automobile were sponsored by automobile manufacturers to publicize the reliability and practicality of their particular model and of the superiority of automobiles over horses. Alice Ramsey was the first woman to drive from coast-to-coast, driving a 1909 Maxwell DA. The party left New York City on June 9, 1909, and arrived in San Francisco on August 7, 1909. The 22-year-old Alice Ramsey made the trip with her 19-year-old friend Hermine Jahns and Alice's two sisters-in-law, Margaret Atwood and Nettie Powell. Atwood and Powell were in their forties at the time of the trip. Alice Ramsey had begun driving automobiles in 1908 after the horse she was driving was spooked by an automobile and ran. She was able to bring him back under control, but her husband decided that automobiles were safer and bought her a 1908 Maxwell. Alice Ramsey had a

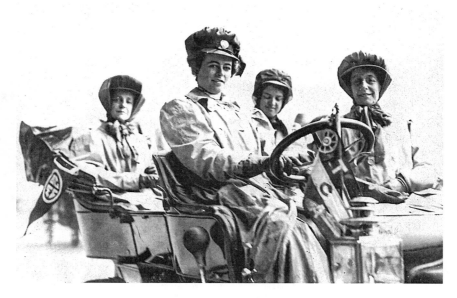

Alice Ramsey and passengers in Maxwell automobile, 1909 Alice H. Ramsey Tour (Lazamick Collection, Detroit Public Library, Resource ID: na032240).

talent for mechanical repairs and soon learned to drive and repair her new automobile.[6]

The first summer with her new automobile, Alice Ramsey logged 6,000 miles of "pleasure-driving" with her friends around the roads of New Jersey. She became president of two women's motoring clubs and entered two endurance contests. At the 150-mile Montauk Point Run, Ramsey's skillful driving, particularly on the tricky sand dunes, won her the bronze medal for achieving a perfect score and caught the attention of Maxwell–Briscoe's publicity man, Sales Manager Carl Kelsey. Kelsey proposed that Ramsey be "...the first woman ever to drive an automobile across the United States of America, from Hell Gate on the Atlantic to the Golden Gate on the Pacific [...] and in a Maxwell!"[7]

In *Veil, Duster and Tire Iron,* her account of the 1909 coast-to-coast trip written in 1961, Alice Ramsey wrote that she and her two sisters-in-law—who were with her on the Montauk Run—discussed the possibilities of the cross-country trek on their way back to New York City. At first, Alice did not think Margaret (Maggie) Atwood and Nettie Powell would be interested in the trip, as they were "well-groomed and dressed in the daintiest of French-heel footgear, were conservative and reserved to the nth degree." Also "I had often heard them say they would not go to Europe...." It turned out that it wasn't the long trek but fear of the water

that prevented even the germ of a desire for ocean travel. "The sisters were interested in going on the cross-country drive." After asking a few more questions about the trip, Maggie Atwood, the "more submissive and sensitive," settled the question by asking Alice Ramsey, "We won't be able to carry much luggage will we? And how will we dress for it?"[8]

Alice Ramsey's husband, John Rathbone Ramsey, gave his consent to the expedition. John Ramsey was more than twenty years older than Alice, he was an established New Jersey lawyer and politician who never learned to drive an automobile and preferred horses all his life. Alice Ramsey, writing of their relationship 52 years after the trip and 27 years after her husband's death, said "he kept an open mind, allowed me to hold an independent opinion, and never 'fenced me in.' […] I am sure he never understood *why* we wanted to go on this long trek but the fact that we did was reason enough for him. He had implicit confidence in us even if he didn't understand or share the desire."

Hermine Jahns, the third passenger, was a friend who accompanied Alice Ramsey on her second reliability run, which was for women drivers only from New York to Philadelphia. Ramsey received a trophy for a perfect score and, with race driver Joan Cuneo, was one of the featured drivers on that tour. Ramsey wrote of the drivers' response to press ridicule about the all-women reliability run that "This criticism, of course, merely whetted the appetites of those of us who were convinced that we could drive as well as most men."[9]

The Maxwell–Briscoe company supplied the 1909 Maxwell DA, paid all expenses, and instructed their agents to have supplies on hand to assist Ramsey with repairs along the trip. The Maxwell agents along the route also supplied accommodations in towns without hotels, provided pilot cars for stretches of road not yet mapped and helped haul the car out of the legendarily thick, deep, and sticky "gumbo" mud of Iowa and Nebraska. Carl Kelsey traveled ahead of the Ramsey party to arrange accommodations. Alice Ramsey did all the driving and made all the repairs along the way. The car was outfitted with a larger fuel tank, a rack for extra tires and repair equipment, and a picnic hamper with supplies to tide them over if they were not able to reach a scheduled accommodation and had to sleep in the car.[10]

The travelers needed what Alice Ramsey called "city duds" for the many photographs and celebratory dinners the Maxwell publicity team arranged along the way, in addition to their traveling clothes. As Alice Ramsey pointed out in her 1961 account, "One suitcase is a small allowance for a woman in days when there was no such thing as nylon—(bless its little traveling heart!)." Since the early automobiles had no storage space for luggage they strapped the four suitcases, one apiece, to a special carrying

rack in the back of the car and wrapped the suitcases with rubber sheets to protect them from the dirt while driving. Nettie Powell and Maggie Atwood brought along their "beautiful traveling luggage, fitted with cut-glass containers with silver tops for toilet articles."[11]

These elegant containers proved to be very useful when the radiator boiled over and ran dry under the strain of pulling through the deep, sticky Iowa mud. Due to both the limited storage space and infrequency of farmhouses to get water, they were not carrying a water container when they were stranded in the mud next to ditches filled with water. Nettie Powell suggested they empty the cut glass containers to carry the water. In her description of "Operation Cut-Glass" Ramsey wrote,

> Can you picture those two sedate and dignified women in this performance? Without hesitation, they opened their treasured cases, removed the silver lids and contents of the beautiful cut-glass jars. Then, gathering up their ankle-length skirts, they stooped over to catch small amounts of water at a time and carried them repeatedly to the thirsty, yawning radiator! Back and forth, back and forth, they made countless trips before the height of the water was even visible as one peered into the opening. When at last they could see it, their efforts were spurred on. They never uttered a complaint about the job. They were contributing to the success of the journey in a very real way and were content. I don't know what we would have done without those little containers, not to mention the willing water-bearers who had the happy thought of putting them to use. We were not blocking the road and no auto but ours was in sight. We had ample time to complete the operation. Of course, the water was not clean and clear, but it was water, and it was wet and cool. The engine was glad to have its new refreshment and purred at its former efficiency.[12]

After they pulled through the worst of the Iowa mud and were nearing the Nebraska border, Ramsey was given a jug that she suspected had previously held corn whiskey. The jug met their radiator refilling needs for the remainder of the trip. Later that day, they were met by a woman who had driven her team of horses six miles to meet them. The encounter bolstered their spirits as they continued the difficult drive through the mud, and then had to sleep in the automobile that night while they waited for a swollen stream to subside so they could drive through it the next day. Ramsey waded out to check the water depth.[13]

Ramsey's account of the trip emphasizes the fun and adventure of driving cross-country: bad roads, thick mud, deep gullies, breakdowns, new experiences, beautiful scenery and all. Ramsey was well aware of her responsibility to provide good publicity for the Maxwell–Briscoe company as she writes of waiting until daylight to drive into San Francisco: "Even as far back as 1909, the advertising profession would not have looked with approval on our entrance to the Golden Gate in the hours of

darkness, so we spent the eve of our arrival in Hayward after a perilous snack of hot tamales and cheese omelettes!"

At this time motorists took their automobiles on a ferry to cross San Francisco Bay and enter with city. After the successful arrival in San Francisco, the Maxwell DA was put on display at a local showroom and then taken on tour to Maxwell agencies around the country. Alice Ramsey was given a new Maxwell and returned home to her husband and young son by train. Her three companions stayed longer to explore California. Ramsey's love of driving continued all her life, and she made cross-country treks annually as well as driving mountain passes in Switzerland.[14]

The year following Alice Ramsey's trip, Blanche Stuart Scott drove a Willys–Overland from New York City to San Francisco. The Willys–Overland company, based in Toledo, Ohio, was hoping the highly publicized trip billed by them as the first coast-to-coast drive by a woman—ignoring Alice Ramsey's drive the year before—would increase their East Coast automobile sales. Harking back to Isabella Bird Bishop's trip to the United States in the 1850s for her health, Scott was said to be traveling to recuperate from a nervous condition and expected to be in perfect health at the end of the trip. Scott also wrote that she enjoyed the publicity that accompanied the trip. Her traveling companions were journalist Amy Phillips from New York City to Toledo, and then Amy's sister Gertrude, also a journalist, who was the passenger from Indianapolis to San Francisco. Scott encountered less rain and fewer muddy roads than Ramsey had driving through Iowa. Thus, Scott's trip over Iowa roads was much smoother than Ramsey's had been the year before.[15]

By the 1916 publication of Amanda Preuss's *A Girl, a Record, and an Oldsmobile*, the emphasis was on the quality of the car and roads that allowed for speed and distance driving. Preuss's volume, published by the Olds Motor Works as a promotional piece, emphasized the quality of the Lincoln Highway and the Oldsmobile Model 44 eight-cylinder that she drove from Sacramento, California, to New York City in 11 days, 5 hours, and 45 minutes. Such promotional pieces were useful tools for automobile manufacturers to reassure potential clients of the safety of their vehicles. The use of the word "girl" and Preuss's statement that her record-breaking cross-country trip started out as the vacation idea of an out-of-doors girl placed the operation of an automobile well within the reach of anyone—male or female—interested in the new technology. Preuss's reaction to the 43-day cross-country trip of silent film star Anita King the previous year is revealing: "'Gracious,' I said. 'I can beat that and never half try.'" She places automobile driving well within the reach of the average working person, moving such feats out of the previous

realm of the adventurous and famous. Employed as a stenographer in a law office in Sacramento, Preuss had the support of her employer and credits her law office experience with aiding her in enlisting the sponsorship of an automobile manufacturer interested in demonstrating the worth and merit of his product.[16]

Preuss was traveling along the newly organized Lincoln Highway, the first transcontinental highway. Her comment about the dangers of falling asleep at the wheel showed the vast improvement in the roadways in the seven years since Alice Ramsey's cross-country drive. The Lincoln Highway, targeted for completion by May 1, 1913, in time for the Panama–Pacific International Exposition in San Francisco, was a system that linked existing and newly constructed roads on a clear route from New York City to San Francisco through the Midwest states. It was created by and under the care of the Lincoln Highway Association (LHA), a private organization that accepted memberships and corporate donations used to plan the route and educate the public. Major funding for construction was the responsibility of the government.[17]

To encourage local municipalities to participate in the Lincoln Highway, the LHA provided "seedling miles," described by author Beverly Rae Kimes as: "...sited in areas where the contrast between a concrete road and unadulterated mud would be the most graphic and at least six miles from the nearest city, to coerce the community to fill in the connecting stretch." The LHA published a road guide, and the highway was marked "with a capital 'L' set against red, white, and blue stripes stenciled on telephone poles and whatever else would not move." This was an improvement over the landmarks used in other roadway guidebooks, including the well-known "Blue Book" published annually by the American Automobile Association (AAA).

The instructions offered to drivers often entailed such details as "Turn right around white cottage crossing single RR and go up grade, passing monument in middle of street," or "turn left around blacksmith's shop upgrade, coming on macadam at trolley" that might have changed since the book's publication. Likely not to change much in the early years was this road description, "Just beyond is an almost impassable mud hole which should be inspected before attempting it."[18] These landmarks changed for Alice Ramsey, too, as she discovered when looking for a yellow house; the homeowner, who was "against auto*mo*biles," had painted the house green specifically to "have some fun with them auto*mo*bile drivers." The neighbor who explained the situation to Alice Ramsey said, "He'll be all right when he gets one himself."[19]

The big "L" against a white background was easier to read with the dim headlights of the time than the homemade signs. Carl Fisher, one of

the founders of the Lincoln Highway system, had personal experience with the importance of easily readable road signs. In 1912, he and a group of friends in an open-top car got lost on a rainy night, just nine miles outside the Indianapolis city limits. Upon coming to a three-way intersection, the friends sent Fisher to the task of shimmying up the pole to read the sign that was dimly visible from the ground. Multiple rain-extinguished matches later, Fisher read the sign: "Chew Battle-Ax Plug." A lot of miserable effort to read a chewing tobacco advertisement that was not helpful in finding their way home.[20]

Auto Travelers That Followed

MoToR magazine published the article "National Park Tour Now Possible: Grand Circuit of Uncle Sam's Playgrounds Within Motorist's Reach Because of the Opening of Yellowstone National Park to Motor Traffic on August 1" and included a map outlining a circuit from Chicago. The establishment of good roads, increasingly reliable automobiles, and the "See America First" campaign promoted by Western state leaders to bring tourism money to Western states combined with the closure of travel to Europe following the 1914 outbreak of World War I to make national tourism a desirable goal. The promotion of the newly completed Lincoln Highway as a means to attend the 1915 Panama-Pacific International Exposition in San Francisco, California, was a turning point in promoting national, and Western States, tourism.[21]

The original route of the Lincoln Highway passed through New York, New Jersey, Pennsylvania, Ohio, Indiana, Illinois, Iowa, Nebraska, Colorado, Wyoming, Utah, Nevada, and California. Later realignments added the northern tip of West Virginia. The success of the Lincoln Highway in bringing automobile tourists, with their tourism dollars, to businesses and municipalities led to the creation of other named long-distance routes collectively known as the National Auto Trails. In 1926 these routes provided the basis of the United States Numbered Highways system.[22]

It is important to keep in mind, however, that this description of the "Friends of the Open Road" did not apply to Black motorists, who planned routes with great care to avoid encounters with hostile Whites. It also did not apply to the Indigenous residents of the land over which the "Open Road" crossed.[23] Even finding a suitable picnic spot was much more difficult for Black travelers. In 1912, the "Vacation Days" article in *The Crisis* magazine gave recommendations of summer resorts for those who had the time and money for a vacation getaway, since due to discrimination "if you are colored, will knock in vain at the farmhouse door for board and lodging."

Dr. Ruth Flowers of Boulder, Colorado, remembers picnicking with her friends along the trails of the Rocky Mountains as an escape from segregation. Dr. Flowers said the 50 Black families living in her Boulder, Colorado, neighborhood made their own entertainment in the spaces they were allowed to be in, singing in the choirs of the Black churches; attending dances, ice cream socials and singing parties in private homes, and hiking and picnicking along the trails of the Rocky Mountains. As work was a major part of their daily schedules, they left for their hikes in the early evening, stopped for dinner and singing after a few hours' hike, then returned home by 2:00 a.m. They took firewood, matches, a coffee pot, and a cast-iron skillet with them and stopped by a stream to cook dinner. They brought ukuleles or banjos to accompany the songs. "So in the summertime," Dr. Flowers said, "we were in the mountains all of the time. The mountains were free and we loved them."[24]

The dress code at hotels and restaurants accustomed to catering to railroad passengers proved to be a difficulty for the early automobile parties. The need to pack efficiently to fit the small spaces in the automobiles and the mud and dust that infiltrated every corner of the automobile, luggage and passengers made it difficult to carry an extra suitcase for fancy dress outfits. Warren James Belasco writes in *Americans on the Road, From Autocamp to Motel, 1910–1945* that even for those automobile tourists who did bring an acceptable change of clothes, arriving at the hotel covered in road dust and grime proved socially awkward. The rarity of automobile parties made for a notable entrance at hotels. He writes of the arrival of the Melville Ferguson party seeking refuge from bad weather at a Harvey House in New Mexico. The grimy, dust covered Melville Ferguson was embarrassed as "the bellhop held open the door and eight grimy intruders marched in, single file. Had we been clean, we should still have been objects of hostile suspicion, owing to our bizarre camping togs."

Hotels were categorized into three major types, summer resorts for long term stays, big city commercial hotels with dress codes and fine dining, and small-town drummers' hotels catering to the traveling salesmen with food and accommodations of variable quality. These hotels, established to accommodate railroad travelers began to receive motorists—with accompanying dust and grim—as the motor age expanded to include long-distance road trips and cross-country travel. Winifred Hawkridge Dixon described the Harvey House in Deming, New Mexico, in her 1921 travelogue *Westward Hoboes* as "...the Mecca of all Western voyages, a clean room, a hot bath, and a Harvey eating house."[25]

Marguerite Shaffer writes in "See America First" about the Great Northern Railway, begun in 1889 and eventually running from Saint Paul, Minnesota, to Seattle Washington. The Great Northern Railway provided

access to Glacier National Park, created in 1910, in northern Montana. "Just as the Santa Fe highlighted the Hopi and Navajo at the Grand Canyon, so the Great Northern linked Glacier with the Blackfeet Indians, making them a central component of the frontier wilderness imagery. Not only were the cultural artifacts of the tribe appropriated to decorate the hotels and chalets, but the Indians and their culture were employed as a decorative presence throughout the park. Although the federal government, in collusion with the railroad, usurped the traditional territory of the Piegan, the Blood, and the Northern Blackfeet tribes (the three branches of the Blackfeet confederacy), forcing them onto an adjacent reservation, the Great Northern sanitized that history and adopted the Blackfeet as the official mascots of the park."[26]

The Park-to-Park Highway system formed in 1916 intersected the railroad routes that previously provided tourist access to National Parks. The railroads provided travel guides describing the sights to be seen along the routes. The hotels and chalets at Glacier National Park were constructed under the supervision of the Great Northern Railway beginning in the early nineteen-teens. Members of the Blackfeet community were paid to set up and camp in a large tepee near the Glacier Park Hotel and perform weekly powwows. Other Blackfeet members were employed to escort tourists from the Great Northern Railway station at East Glacier Station to the Glacier Park Hotel. In addition to the hotels and chalets, the Great Northern Railway offered tourists the opportunity to rent cots for 50 cents a night in tepees built by the Railway to further promote the Western experience. Schaffer writes: "The presence of 'friendly' Blackfeet—nonthreatening but nonetheless 'real' Indians, as represented by their authentic dress and ceremonies—became a central component of the Great Northern's constructed western wilderness." Beatrice Larned Massey wrote of their travels through the region and seeing Indigenous women selling garden vegetables from roadside stands to passing travelers.[27]

The American West as a tourist destination was popularized by the travel authors who chose it as the tamer but still fascinating setting for their writings. The southwest of Arizona, New Mexico, and southern Colorado were no longer just areas to traverse enroute to sunny and balmy California destinations, but places to stop and explore for their own appeal. Architect and designer Mary Elizabeth Jane Colter developed the distinctive style for which the more luxurious Harvey hotels such as El Tovar and Bright Angel Lodge at Grand Canyon and the Alvarado, La Fonda and La Posada in New Mexico became known in the first quarter of the 1900s. The luxurious Harvey Hotels provided a safe, comfortable place to stay while experiencing the American West.[28]

To aid in the sense of adventure for the primarily White tourists,

the Fred Harvey Indian Department was formed in 1902. There were 23 Harvey hotels established between 1878 and 1929. At the 1893 World's Columbian Exposition in Chicago, a display of items taken from the cliff dwellings at Mesa Verde in southwestern Colorado generated interest in southwest Indigenous arts and crafts. The southwestern Harvey Houses were decorated with Navajo and Hopi designs and their art and crafts were sold to the passing tourists. Pima and Papagos baskets as well as Zuni and Navajo silverwork were sold to the tourist trade.[29]

As had the Ho-Chunk communities in the Wisconsin Dells, and Indigenous communities throughout the Americas, Southwest Indigenous communities worked to manage the tourists and control the way their culture and crafts were portrayed. Dr. Margaret Bruchac (Nulhegan Abenaki) writes, "Indigenous gatekeepers and informants observed the actions and motivations of the 'other-than-Indian' persons who came into their worlds, and attempted to mediate contacts with these strangers in ways that might prove the most beneficial and least harmful." She continues, noting that brief encounters as with tourists were easier to manage due to the short duration and focus of the visits: "...they came and went quickly and bought what was offered."

The lengthier interactions with archeology teams from universities and museum in the Eastern United States, of which Bruchac writes in *Savage Kin: Indigenous Informants and American Anthropologists*, required different strategies. The philosophy of Gladys Tantaquidgeon (Mohegan) summarizes a goal in Indigenous—non–Indigenous interactions: "Remember to take the best of what the white man has to offer and use it to still be an Indian." This goal continues in steadfast opposition to the unrelenting efforts of the enforced acculturation and genocide of United States federal policy.[30]

The management of tourists as the railroads shifted their focus from shipping to tourism in the 1890s was the latest in the long experience of Indigenous trading. Dr. Erika Marie Bsumek outlines the evolution of trading between European and Indigenous communities. Trading encounters expanded from Indigenous communities trading with each other to trade with European colonists as the Europeans acquired what they needed to survive. Once Europeans were able to feed themselves securely, the desire for trade goods changed to what Europeans could sell for profit in Europe. The newly formed United States government established trading posts to be the supervisory agencies controlling trade and financial interactions between Indigenous and non–Indigenous people. The personality of the White traders and employees varied widely. Winifred Hawkridge Dixon described a White employee at a Hopi reservation as follows: "I felt sorry for the Indians who had to deal with him. Indian

reservations as we saw them, always seemed to harbor a certain proportion of White vultures ... and some of them, unhappily, were in government employ."[31]

By 1822, rather than trying to control trade from Washington, D.C., the Federal government began licensing individuals who wanted to trade with Indigenous communities. The arrival of the first White federally licensed trader in Navajo country coincided with the Treaty of Bosque Redondo in 1868, which ended the Navajo Wars and allowed for the return of the Navajo and Apache to their homeland. Those who had survived the forced march of 350 miles removal from their homeland in Arizona to the internment camp in New Mexico, and subsequent four years of deprivation and starvation, returned. The 15,000 head of sheep and goats supplied by the Federal government in the late 1860s grew to more than 500,000 by the 1880s.

More White traders arrived to take advantage of the increasing Navajo population and the decreasing role of the Federal government in supplying staples by selling directly to Indigenous families. Add to this the influx of White tourism to the American Southwest that began with railroads and expanded to automobile tourists and there were more opportunities to sell Indigenous crafts and handiwork. As Dr. Erika Marie Bsumek writes, this participation in the American change to a consumption-oriented economy enabled Navajo communities to control their crafts that presented a White-advertised romantic view of peaceful Indigenous life that White tourists found appealing and were willing to purchase.[32]

Dr. Gretchen Sullivan Sorin's description of the advice given by Black magazines and newspapers shows the clear difference between the way Whites packed for long-distance automobile travel and what Black motorists needed to pack to get to their destinations safely. "Safely" meant having a reliable car large enough to hold provisions and bedding as well as the usual clothing and toiletries, and stopping as infrequently as possible—gasoline stops were a necessity. "Baskets overflowed with sandwiches and jugs of water and iced tea. What would happen if you needed a bathroom along the road and the gas stations barred you from their restrooms because of the color of your skin? A large old coffee can became a 'pee can,' a makeshift toilet in an emergency."[33]

Alvin Hall writes in *Driving the Green Book: A Road Trip Through the Living History of Black Resistance* of other strategies Black families utilized to avoid using the filthy "Colored Only" bathrooms at service stations and roadside rest stops. Hall and his colleagues interviewed Black men and women who remembered driving the segregated American roadways before and after the passage of the 1965 Civil Rights Act that made segregated public spaces illegal. These stories would apply to

the early decades of automobile travel. Limiting the amount of fluid con-
sumed on the automobile ride was one strategy. Some families carried
portable urinals, such as used for medical purposes, for boys to use with-
out having to stop the car. Carrying sheets to hold up or tie to trees and
bushes to create privacy walls when utilizing the woods or bushes as an
outdoor toilet was another strategy. Service stations that did not demar-
cate between "White" and "Colored" toilets were included on the travel
route whenever possible.[34]

White motorists did not have to carry an emergency toilet, as clean,
convenient bathrooms were always available to them. Even if they were not
near a public toilet while camping as F.E. Brimmer writes in *Autocamping*,
toilet tents were made especially for the autocamper.[35]

Driving from Monroe, Louisiana, to Los Angeles, California, in the
1950s, Dr. Robert Foster drove on two-lane roads for 15 hours covering
the 766 miles between Laredo, Texas, and Lordsburg, New Mexico, with-
out finding a place to sleep. On the route from New Orleans, Louisiana, to
Los Angeles, California, there was a safe place to stay in El Paso, Texas, the
motel La Luz. Driving throughout the night increased the stress and dan-
ger of travel. And that was with a faster, more reliable vehicle than in the
earlier decades. Isabel Wilkerson writes of a code of the road for Blacks
driving across the country;

> When you got sleepy, there were places you stopped and places you didn't.
> You stopped at a filling station and asked if the owner minded if you parked
> there. If you saw a car or two stopped on the side of the road, you might pull
> up. Somebody else might pull up behind you and do the same. You tried to stay
> awake until you found such a place. Before stopping, you ran your eyes over
> the resting car's bumper and rear windshield, checked for a Confederate flag.
> You would be crazy to pull up behind one of those. If you saw a pack of cars,
> you were wary. If you had to stop, you wanted to stop behind one car resting,
> someone tired and alone like yourself. The next morning, not having been able
> to check into a motel, you might stop at a gas station and slap water on your
> face in the restroom or gargle with ginger ale or fountain water under a "col-
> ored only" sign.[36]

Sundown towns around the United States as described by James Lowen
posted signs warning Blacks to be outside the city limits before sun-
down. White cross-country motorists wrote of meeting a Bismarck, North
Dakota, police chief who spoke proudly of keeping Black families from
moving into Bismarck. Traveling west along the southern route, El Paso,
Texas, was considered to be the western border of segregation. But that
border varied based on the attitudes of the White business owners, and
Black travelers could not be certain of what welcome they would receive.
In Tucumcari, New Mexico; Santa Rosa, New Mexico; and Albuquerque,

New Mexico, there were lodgings available for Black travelers. But along the 800 miles of road between Albuquerque, New Mexico, and Los Angeles, California, there were no places for Blacks to stay. The weariness of driving through without rest was dangerous, as illustrated by Dr. Robert Foster's experience in the previous paragraphs.[37]

Some of the strategies Black motorists used to determine safe places to stop included asking friends which towns to avoid that were noted for violence or discrimination. In Arizona, Kingman was a sundown town that did not allow Blacks within the town limits after sunset, and discrimination was known to be the norm in Winslow and Flagstaff. In towns and cities that were large enough to have a Black neighborhood or a Black part of town there were more likely to be places providing a welcome. Black motorists also sometimes went to the downtown train station and asked a train porter for information—this would be a safer option if the train porter was also Black. Other Black motorists would drive down the main street looking for a Black resident to ask for recommendations or reading the faces of the people they drove past to get a sense of a possible welcome.

In some cases, Black motorists would ask Whites for advice for where they could find a room or a meal. Social networks could provide contacts even in unfamiliar towns. Membership in fraternal organizations, such as the Masons, as well as Elks, Shriners and others that had segregated Black divisions or lodges, could provide access to helpful information. Other networks included that of teachers, alumni of universities and high schools, ministers, choir members that could provide leads to help Black travelers. Black-owned funeral homes were also sources of a safe place to stay in an emergency. Frank Norris writes that one black journalist recalled, "I found myself picking out places to stop, or rather, letting them pick me out ... the eye drifts over this motel or that, seeking some instinctive assurance that you will not have to put your life on the line by asking for a single for the night."[38]

Cross-Country Pleasure Road Trips

For automobilists and autocampers starting their journeys from the East Coast or the Midwest, California—The Golden State—was frequently the goal. Marie Hjelle Torgrim had set Yosemite National Park in California as her goal for the trip the eight young women embarked on from Iowa.

The young Iowa women with a "yen to see some things" drove across the West to California in two Model T's that they named "Ophelia Bumps" and "Jenny Pep." The women met as students while attending Iowa Teachers College (currently the University of Northern Iowa) in

Cedar Falls, Iowa. Marie Hjelle Torgrim's six older brothers left the Iowa farm to go West working as laborers building roads, bridges, railroads, on timber crews, mining camps and oil fields. "Marie saw her brothers come home changed, as if by looking out across the grand vistas of the West they realized they could see beyond their noses. She wanted that for herself."[39] The young women from Iowa were able to purchase food supplies at trading posts and crossroads stores in the mountains of Colorado. They carried a two-day supply to reduce the weight of the already overloaded cars. Driving through the Rocky Mountains required a different technique, the young women backed their cars up the steep hills to keep the gas and oil near the front of the engine to keep it lubricated and avoid burn-out.[40]

While Marie Hjelle Torgrim might have been interested in being a Harvey Girl had she had the opportunity, at the time, in her area of Iowa, the two professions available to a young woman who wanted an independent wage without being tied to farm, husband and children were nursing and teaching. Torgrim chose teaching after high school graduation—in a time when stopping after 8th grade graduation was common. While the high school diploma was adequate to teach in rural schools, a certificate from a teachers' college would lead to higher paying teaching opportunities. Following graduation from Iowa Teachers College she earned her master's degree from a summer program at Columbia University in New York City. The years of saving money and frugal living resulted in savings from better paying jobs, and the ability to make the long-held dream of driving to Yosemite National Park in California a reality.[41]

Torgrim began planning. A group of four women and camping gear would fill a Model T and divide the expenses. For just over $500 Marie could purchase a Model T on payments of $32 a month and get a driver's license. Figuring up to $50 for gear and two months of car payments for the nine-week trip divided among four people seemed manageable. One option would be to drive west from Iowa visiting Estes Park and Pike's Peak, Colorado, and Great Salt Lake, Utah, on the way to Yosemite National Park. Once in California the car could be sold at a profit to pay for a train ride home. The other option was a 9,000-mile loop returning to Iowa with the automobile to include visiting Crater Lake, Oregon; Mount Rainier, Washington; and Yellowstone National Park in Wyoming, and Montana and Idaho. In addition, four of Torgrim's brothers were living in North Dakota and Montana and she could include a family visit. She settled on the 9,000 mile loop plan.[42]

Author Joanne Wilke writes of Torgrim and her friends, "Perhaps her personal life did not encompass the extravagance of new morality, bootlegging, and all the stereotypes, but the essence of the Roaring

Twenties trickled down everywhere, even to Iowa. People took to the new sense of freedom and took to their cars." Of the Model T, Torgrim's vehicle of choice, Joanne Wilke continues: "The Model T, part durable wagon and part modern technology, was a breakthrough allowing hordes to venture out, to venture west, whether roads were available or not."[43]

Marie Hjelle Torgrim invited two friends, Agnes and Grace, who immediately agreed to join the trip. Torgrim, 26 at the time, invited her 19-year-old sister Laura to take the fourth spot in her Model T. It was important to travel with competent companions who would get along well in tight quarters for the nine week sojourn. Next was getting permission from their parents who were very concerned for the girls' safety. Joanne Wilke writes that Torgrim reminded her parents that local young people were getting into trouble without leaving home while Marie and Laura were living decent lives and looking to go on an educational adventure. Eventually their parents agreed. Grace took a different approach by announcing to her parents that she was driving to Yosemite. The second party was made up of four girls, Christy, Bess, Zelma and Martha. Zelma bought the second Model T. It had been decided that traveling with two vehicles was safer than one "...because then one could always rescue the other."[44]

Four of those women learned to drive the day the trip began. Zelma, the new owner of the second car, was shown by the automobile salesman at the time of purchase and she taught the other three young women. That launched their 9,000-mile trip where they honed their driving skills on open roads of many different terrains.[45]

Just as the "gumbo" mud across Iowa and Nebraska was a known challenge for the cross-country automobilists, particularly along the Lincoln Highway, so too was the hot, dusty, dry desert automobilists encountered as they left the Rocky Mountains of Colorado. For the automobile party of the young Iowa women, the dust came before the desert as they encountered a constant wind in western Wyoming that infiltrated their clothes, belongings and the automobile engine. They had to stop to clear sand from the engine coils and drain and refill the radiator. The young Iowa women suffered from windburn despite buttoning up their sweaters, wearing goggles, and tying handkerchiefs over their faces for protection.[46]

The young Iowa women had a pleasant surprise when they reached Green River, Wyoming. When inquiring for the tourist camp, they met a former Iowan who was running the Tomahawk Hotel. He invited the eight Iowa women to spend the night at the hotel as his guests, free of charge. They were given a two-bedroom suite with an adjoining bath. Marie Hjelle Torgrim wrote home that "Our suitcases had sand in 'em last nite, so you

see the idea of a bath sounded good." Between Salt Lake City, Utah, and Ely, Nevada, was 300 miles of uninhabited salt desert. From Ely, Nevada, to Reno, Nevada, was 350 miles of regular desert. After spending some time in Salt Lake City, Utah, the eight young Iowa women decided to take the Oregon Trail route along the Columbia River Highway and down into California. Among the many advantages White motorists had was the knowledge that they would be welcome anywhere, and were thus able to change their travel plans at will.[47]

The roads along this route (although the rough, sharp stones were sometimes hard on the tires and caused blowouts that needed to be changed) were excellent, especially compared with the gumbo mud they had left behind. As the eight young Iowa women drove across southern Idaho, they appreciated the swimming pool at the Buhl, Idaho, tourist camp as even though this was the cooler northern route, it was still hot. Crossing into Oregon they had to stop at the Oregon state line border and unload their gear to "shake out our bedding to get rid of any alfalfa weevils that may have come into it." Once in Oregon, Torgrim wrote, "The Oregon roads are smooth as a floor." They left the dry, sandy scenery for the pine forests and fruit orchards along the edge of the Columbia River. The young Iowa women commented on the registration stickers they purchased when they drove into Oregon: "We have six stickers on our windshield now and feel pretty smart. We are beginning to realize we are a long ways from home. I realized it yesterday, and some of the kids said they did the day before."[48]

The scenery and lush landscape of Oregon and northern California as they made their way to Torgrim's goal of Yosemite was a welcome change from the hot, dry, dusty roads they had left behind. Once they got to Yosemite, they learned they had arrived in the dry season when the waterfalls were a thin trickle. The mountain scenery, however, remained magnificent. While the mountain roads were dusty, they were able to attempt to control the amount of dust that got into the carburetors, spark plugs and coils by driving slowly. Some of the dust they encountered along the way was brick red and covered everything. The showers at the autocamping stop were particularly welcome after long dusty drives. The young Iowa women noted that California had a two-cent tax on gasoline and Oregon had a three-cent tax; they attributed the tax difference to the higher quality roads in Oregon.[49]

The drive to Yosemite over the Sierra Nevada mountains was hard on the Iowa Model T's. The steep, narrow roads with constant twists and turns led to trouble with the brake bands and tires. The camaraderie of the road that White long distance automobilists benefited from served the young Iowa women well as they accepted rides from travelers with more powerful

automobiles to get to the Yosemite waterfalls while their Model T's were being repaired. They wrote of meeting fellow Iowans living in California that the common bond of Iowa, as we saw earlier, provided a platform for a friendship. The etiquette of the White long-distance motorist had similarities to the etiquette advice seen earlier in advice to White train travelers. The advice that "The friendship which has subsisted between travelers terminates with the journey" was followed by the young Iowa women as they parted ways with the three young men from the Netherlands. The two groups of travelers had been traveling along the same stretches together for a few days, helping each other with automobile maintenance and sharing suppers at the automobile tourist camps. The young Iowa women wrote that even with the camaraderie of the road they never learned the names of the young men. When the two parties accidentally met up at an organ concert in Salt Lake City, "After two days in a strange city, it was like finding family."

This familiarity and expectation of welcome was not available to Black travelers. The occasional encounters between individual Indigenous residents and White motorists was different. Beatrice Larned Massey wrote of driving through Idaho Falls and the Blackfeet Reservation on their 1920 trip and being stopped by a "real honest-to-gosh Indian" man who was standing in the middle of the road. They gave him a ride to his home as he requested.[50] For the Massey party, Beatrice Larned Massey considered their destination reached once they "stood on the sands of the Pacific." Prior to the opening of the San Francisco-Oakland Bay Bridge in 1936, motorists crossed San Francisco Bay by ferry.

For the eight young women from Iowa, as with other transcontinental motorists, reaching the Pacific Ocean was the western-most point of their drive. The young Iowa women explored San Francisco before turning north into Oregon to see Crater Lake. Crossing into Oregon, their car was inspected by border patrol agents, and they drove through a solution to disinfect the tires from carrying "hoof and mouth" disease into Oregon.

Establishment of cross-country road connections labeled highways with continuous road signs to aid the motorist, including the Lincoln Highway from New York, New York, to San Francisco, California, previously encountered. F.E. Brimmer provides contact information for other highway associations. The Yellowstone Trail ran from Plymouth Rock, Massachusetts, across the northern United States to Puget Sound, Washington State. The National Park-to-Park Highway was established in the 1910s as a large Western loop passing through 11 states and connecting 12 National Parks. Rocky Mountain and Mesa Verde in Colorado; Yellowstone in Wyoming and parts of Montana and Idaho; Glacier in Montana; Mount Rainier in Washington State; Crater Lake in Oregon; Lassen

Volcanic, Yosemite, General Grant (now part of Kings Canyon), Sequoia, all in California; Zion in Utah; and Grand Canyon in Arizona.

The National Old Trails Road stretched from Baltimore, Maryland, crossing southern Pennsylvania, West Virginia, Ohio, Indiana, Illinois, Missouri, Kansas, southern Colorado, New Mexico, Arizona, and ending in Los Angeles, California. Incorporating the historic National Road and Santa Fe Trail wagon roads, the western portion of the National Old Trails Road, in turn became Route 66. These highway associations provided maps and booklets that began to take the place of the 13-volume American Automobile Association Blue Book series. The highway association guidebooks took up less room and were more pertinent to those following a specific route across country. Mary Crehore Bedell found the guidebook for their ten-hour drive between El Paso, Texas, to Lordsburg, New Mexico, very helpful along the unmarked sandy roads as the guidebook provided a picture of the road and marked the fence-corners of the occasional ranch to help them stay on course.[51]

While these guidebooks and maps were all a White motorist needed for a safe trip, before the publication of travel guides such as *The Negro Motorist Green Book* in the 1930s, it was more difficult, as shown above, for Black motorists to determine where they would be welcome and safe when they stopped for food, accommodation, and to see the sights along the way. One more example of this situation shows a particularly vivid way in which motoring was a complex experience for non–White travelers, with moments of pleasure and danger always ahead. Jessie Abbott, a Black woman, remembered traveling with the Tuskegee Institute women's track team to athletic competitions around the country. They were driving through Carlsbad, New Mexico, on the way to California when she decided to stop to show the girls Carlsbad Caverns. At first, her husband, the track team coach, and driver "did not take kindly to the idea of stopping, because he was afraid they would tell us 'no,' because we were Negroes, and refuse accommodations." Jessie Abbott told him to drive "right up in front of the main office, so they can look out and see us. I'll go in and ask them if they can give us accommodations for the night and meals. They can't do any more than say 'no,' and they will have to tell me 'no,' because I am going to ask point blank." That time they were welcomed and given clean, pleasant accommodations.[52]

Published travelogues chronicled the authors' journeys and encouraged their readers to take trips of their own. Vernon McGill reassured his readers in 1922 that "Anyone who can drive a car can make the trip. Women have made the journey alone. Only a little care is required." Automobile pleasure travel became accessible to more people as automobile production increased, the price of automobiles lowered, and the roads

improved. *Motor Car* magazine wrote about motor camping in 1912 that "Time and space are at your beck and call; your freedom is complete." Beatrice Larned Massey wrote about her 1919 trip from New York City to San Francisco. She noted that "to interest the would-be or near motorists who take dream trips to the Pacific.... It sounds like a rather large order, to motor across this vast continent, but in reality it is simple, and the most interesting trip I have ever taken in our own country or abroad."[53]

Once the pioneering cross-country automobilists had proven it could be done, adventurous pleasure tourists followed. Muddy roads across Nebraska and Iowa, the risks of crossing the desert region of the American Southwest, camping versus staying in hotels and the friends of the open road were recurrent themes in the travelogues. Effie Price Gladding wrote of a 1914 trip "This is part of the charm of the open road, these salutations and this jolly passing exchange of sympathy, not between two ships that pass in the night, but between two parties who enjoy the air and the open, and who are one in gypsy spirit. It all belongs in the happy day."

Gladding and her husband were financially comfortable enough to be winding up three years of touring Europe, Asia, Australia, New Zealand and Honolulu with their west to east cross-country road trip. After landing in San Francisco, they drove around California. Effie noted, "Northern California has not yet been developed or exploited for tourists as has the southern part of the State, but there is beautiful scenery in all the counties north of San Francisco." They took meals and stayed the night at ranch houses, following the signs that indicated accommodations were available.[54]

Southern California's "unfailing stock of sunshine" made Los Angeles and San Diego appealing for motor tourists and newcomers moving into the state. Gladding noted that 80 percent of the population of Los Angeles was from Iowa. After visiting Yosemite by horse and stage they picked up the Lincoln Highway at Stockton and continued east. The Lincoln Highway signs were "sometimes painted on telephone poles, sometimes put up by way of advertisement over garage doors or swinging on hotel signboards; sometimes painted on little stakes, like croquet goals, scattered along over the great spaces of the desert. We learned to love the red, white, and blue, and the familiar big L which told us that we were on the right road." They encouraged a hotel to put out a Lincoln Highway sign to attract more motor tourists. Before connecting with the Lincoln Highway, the Gladdings also needed to check a sign by the light of a match to get back on the right road.[55]

On the way to connect with the Lincoln Highway in Stockton, California, the Gladdings, as White motorists, were able to stop at ranch houses and ask to pay for a meal and place to stay for the night. "These

ranch houses are very hospitable and are willing to take the place of a hotel so far as they are able." At the Lebec ranch house in California, the cook had departed that morning, leaving "the (male) head of the house in some confusion and anxiety." Eating with the ranchmen was part of the adventure. Gladding references the eight-hour law whereby "servants cannot be kept over time. In large hotels they have different shifts; but in country places the landlord must let his cook go at the appointed time." This meant travelers arriving after that time were on their own to find dinner. Gladding recommended that travelers stop for the evening meal where they were, even if they planned to drive further that day, to ensure that they didn't miss the meal. Driving west to east, the Gladdings had the setting sun behind them, lighting their way without being in their eyes.[56]

The Gladdings followed local guide leaflets provided by garages along the route. Another example of the unplanned travel Whites indulged in is this recommendation: "When we do not know the address of a boarding house, we are accustomed, upon entering a town, to make inquiry at the best-looking drug store. We have found this plan admirable, and are indebted for some very kindly and practical advice." White travelers were assured of a welcome wherever they stopped.

Gladding wrote that while the Lincoln Highway was a boon to those who owned hotels, inns, and restaurants along the highway, good quality food and hospitality was important, as "There is an unwritten rule of the open road which reads that the traveler shall tell his fellow traveler of places at which to halt and of places to avoid." Furthermore, she noted that "The biggest bid for a motor tourist is a clean bed-chamber, a comfortable bed, and a well-cooked though simple dinner." Gladding did recommend that simple cooking equipment be brought along for luncheons and afternoon tea in areas between towns. These seasoned world travelers, accustomed to fine accommodations, summarized their drive, writing that "The Lincoln Highway is not as yet a road for those motorists who wish only luxurious hotels, frequent stops, and all the cushioned comfort of the much-traveled main roads of the favorite tourist parts of Europe. It is, however, perfectly practicable in its entire length of 3,200 miles, and rich in interest and charm for those who care for what it has to give."[57]

The following year, in 1915, author and socialite Emily Post, accustomed to first class European travel, traveled the Lincoln Highway with her son as driver and cousin as companion. Her editor directed her to travel west by car for a long as it was pleasurable and write about the experience. They traveled in a heavy, low-slung, open car and were covered in dust that made its way past their goggles and swaths of veils. Post noted that a lighter car, ideally a Ford, which rode higher off the ground, was more convenient for finding replacement parts, passing over rough roads

and easier to push out the mud. Post's party started their trip before the publication of the annual Blue Book automobile guide for 1915. After asking travel bureaus in New York and receiving discouraging answers about the feasibility of crossing via the Lincoln Highway ("The Union Pacific" railroad was one suggestion she received when asking for the best road to California), they started off heading for Chicago and other points to the West.[58]

Winifred Hawkridge Dixon's motoring party in 1920, which included her friend Toby, who learned to drive specifically for the motor trip, had a more helpful experience than Emily Post had six years earlier, when planning their trip with the aid of the map prepared to their interests and provided by American Automobile Association. Winifred and Toby planned to explore New Mexico and Arizona, covering 13,000 miles by automobile, utilizing steamboat and horseback travel for the remainder. The two women started west from Boston along the Yellowstone Trail and turned south to New York City where they made the acquaintance of the American Automobile Association map. "It was love at first sight—our map and us." Winifred and Toby's interests focused on the American Southwest of Indigenous communities and the beauty of the canyons and geologic formations. "...Our itinerary widened until it included vaguely everything there was to see," Dixon wrote.[59]

The mud across the Midwest portion of the Lincoln Highway greeted the Post party as it did every motorist. The thick, sticky, black ooze that clung to tires was notorious throughout the books and articles written about the early roads. For Post, the West began at Omaha, Nebraska. As they drove further into the Southwest, the Post party stayed at Harvey Houses where she described the Navajo and Hopi dancers and craftspeople selling their wares to the train passengers and the passing motorists.

Later in the trip, Winifred Hawkridge Dixon described the Harvey lunchroom at Gallup, New Mexico: "Old settlers from all four states (Colorado, Arizona, New Mexico, Utah) rattle in over the dusty trails, no longer on horses, but in the row-boat of the desert, a Ford. They gather at the Harvey lunch-room and see the latest movies." For Black motorists the Harvey Houses in New Mexico, Arizona, and California could be trusted to provide hot meals and warm beds. Frank Norris writes: "The Harvey Houses in these states, they knew, did not discriminate against Blacks or other minorities by denying service, and they also refused to maintain 'separate but equal' dining facilities."[60]

Emily Post also wrote of arriving at hotels while covered in grime and developed a system to arrive at the front desk as tidy as possible. "As we come into the outskirts of the city where we are to spend the night, I take off, in the car, my goggles and the swathing of veils that I wear touring,

and put on the lace one. The transformation from blown-about hair and dusty face to a tidy disguise of all blemishes is quite miraculous." Once the duster covering her clothes was removed she writes, "I can walk up to the desk and register without being taken for a vagrant." She continues, "The lady who was traveling with us is one of those aggravating women who stay tidy. She keeps her gloves on and her hands dustless." Post found the hotels to be lenient when addressing grimy travelers, though the expensive car the Post party arrived in may have helped with that response. Her son, who did all the driving, was always the grimiest of the three and presented a difference appearance when cleaned up. Emily Post writes of the transformation: "In one hotel, though, a grimy working mechanic having gone up in the elevator and a strange, perfectly well-turned-out person having come down, the confused clerk asked where the chauffeur went and did the new gentleman want a room?"[61]

There were hotels as well as restaurants in the Harvey chain such as the one where Emily Post and her automobile party stayed and as the national park system developed, so did the Harvey hotels. Grand Canyon National Park and Petrified Forest National Park in Arizona, and the Indigenous pueblos in New Mexico and Arizona were attractive layovers for rail travelers who wanted to see more of the American West than could be seen through the railroad car window. The increasing number of automobile travelers were also attracted to the Harvey hotels, though as seen above, bringing with them a different tone in wardrobe. The concern about being grimy and underdressed upon arrival at a hotel applied to White auto tourists as Blacks would not have been likely to be served no matter how they were dressed. As seen earlier, Black railroad passengers made it a point to be meticulously dressed and still received inferior service, while White automobile tourists received a welcome despite the dust and dirt of road travel.[62]

In addition to the Atchison, Topeka & Santa Fe Railway, two other rail lines came to New Mexico and the American Southwest in the 1880s. The Denver & Rio Grande Western Railway that connected Colorado, New Mexico, and Utah was begun to transport coal and mineral traffic from the Rocky Mountains. Passenger service followed as the population increased. The Southern Pacific Railroad covered the American South across 15 states from Illinois west across Texas to the Pacific coast of California. This rail access and the active Southwest-themed advertising campaign conducted by the Atchison, Topeka & Santa Fe Railway and Harvey House décor brought thousands of tourists looking for authentic Indigenous souvenirs to bring home. The opening of the National Parks to automobile access and the influence of the railroad campaigns inspired long-distance automobile road trips.[63]

Within the space of a decade after the major armed conflicts between the Federal government and Indigenous nations in the late 1800s, the White portrayal of Indigenous communities changed from warriors to peaceful primitive artists. The trope of the "vanishing" Indian, as discussed earlier, also gained popularity in the White community in the early 1900s. As Dr. Margaret Bruchac (Nulhegan Abenaki) writes, "...by 1900, few Indigenous communities in North America were as socially isolated or Primitive as collectors might imagine. In some locales, Native individuals and tribal communities were fully fluent in English, French, or Spanish, after having interacted with Europeans for centuries."[64]

The Basket: The Organ of the Basket Fraternity. A Society of Lovers of Indian Baskets and Other Good Things was published quarterly at Pasadena, California. The issues for 1903 and 1904 carried articles about Indigenous basket making and collecting as well as patterns for use by Whites making baskets and members of "Primitive Arts Societies." The tone of the description of "the little brown man and woman whom we know as North American Indians" is extremely insulting and patronizing. *The Basket* articles credit Indigenous people, including the basket makers, with having "set the ball of progress rolling; indeed, they first made the ball, then started it and indicated its general direction." And makes it clear that White civilization has moved past Indigenous cultures.

Written a few years after armed conflict with Indigenous nations ended, the author writes: "During the last few years a great wave of righteous sentiment has been aroused in favor of the North American Indian. As never before in our history, we are seeking to do justice to the peoples we have dispossessed." What is meant by "justice" is unclear. Even the phrases presumably meant to be favorable make it plain that White society is superior: "We too often think of our primitive tribes as dull, stolid, unthinking, unimaginative. Nothing can be farther from the facts. They are quick-witted, observant, thinking, imaginative, poetic."[65]

The attitude displayed in *The Basket*, that Indigenous communities, while able to create fine crafts, were not to be trusted with caring for their own items, was used as justification for the removal of cultural materials by White collectors and archeologists. It continues to the present time as Indigenous communities seek to have those cultural materials returned.

The White traders benefited from the automobile tourist trade during seasons of the year when trade with Indigenous communities slowed. Dr. Erika Marie Bsumek writes that the Hubbell family trading posts in Arizona hosted thousands of automobile tourists. The Navajo blankets the tourists slept on served as souvenirs when purchased to take home. The display of blankets, rugs and other items in a modern domestic setting at the trading posts where overnight accommodations to tourists were

provided made it easier to picture those items in the tourists' own homes. As described in *The Basket* articles, portraying Indigenous craftsmen and women as being part of a primitive lifestyle enhanced the appeal to buyers.[66]

Navajo weavers, well aware of the popularity of their goods, insisted that White traders purchase more stock than the market demanded, thus enabling the Navajo to find the best prices. Between 1900 and 1930 there was a flourishing market for Navajo-made goods. Silver earrings, bracelets, necklaces were popular with White women in the 1920s. Dr. Erika Marie Bsumek writes: "As a result, Navajos began to rely on the income generated by their industries to buy the manufactured goods they both desired and needed to survive. By the early 1930s, nearly one-third or more of Navajo family income came from craft industries."[67]

Emily Post describes the Indian Exhibit Room and the dance performances at the Albuquerque, New Mexico, Harvey House and recognizes a headband popular in New York society as being "that of the Navajo Indians." Post also described the Indigenous women who gathered ten minutes before the arrival of the California Limited train, in two rows to form an aisle between the train, with displays of baskets and pottery in front of them. She writes: "...they are silent until the first passenger alights, and then unendingly they chorus two words: 'Tain cent!' 'Tain cent!'" Her comments are similar to Bsumek's description of the proprietor of the Hubbell trading post: "Even while asserting that Navajo rugs had a place in modern American homes or cars, Hubbell never let on to the public that Navajos might be as market savvy and accustomed to driving automobiles as his customers." No matter the sales situation, Indigenous craftswomen and men were aware of their power in trade negotiations and used it to their advantage whenever possible. Negotiating with automobile and railroad tourists were among the instances of Indigenous survivance in the ever-changing times of the early 1900s.[68]

Post describes another advantage of the railroad and automobile connection when she writes that they decided they had had enough of the rough roads in their heavy, low-slung automobile, loaded it onto the train and traveled by rail via the Grand Canyon and on to Los Angeles. From the 1920s until the early 1930s, automobile and cross-country rail tourists could travel via the Harvey Indian Detours on one, two or three-day trips from the rail stops of Albuquerque, Santa Fe, and Winslow, Arizona, to the natural scenic sites and visit Indigenous villages. The roads to remote sites including the Grand Canyon were unmarked and precarious, and best left to experienced drivers who could also repair broken down automobiles when necessary. The drivers of the Harvey cars were young men.[69]

The Harvey Indian Detours brought tourists and customers to the Indigenous and Spanish communities, remote art colonies and into the new National Parks. This enabled Indigenous artisans to benefit from sales without having to travel far from home. Or indeed, not leaving home at all, which would have another set of privacy issues. Emily Post goes on to describe her embarrassment at entering the hogans of Navajo families at the Grand Canyon in Arizona, considering it an invasion of privacy. As with the Ho-Chunk in the Wisconsin River Dells, White tourists paid to take photographs of Indigenous families and individuals—in Post's case, twenty-five cents for a photograph of a Navajo baby on a cradleboard being held by the father. Not all Indigenous people were willing to have their photographs taken, as Emily Post learned at the Pueblo communities at Acoma, New Mexico.[70]

Winifred Hawkridge Dixon wrote of the Pueblo town of San Ildefonso, New Mexico, as being easy to look into without invading the families' privacy, as the doors were wide open and visitors were not excluded. Winifred described the homes as being around a central plaza that allowed for regular communication. Winifred and Toby found that, with the appropriate payment, they were allowed to take photographs. In addition, a village leader requested that they take him and others for a ride around the plaza in their automobile. Which they did.[71]

Indigenous houses were described by other White automobilists on their trips across the American West and Southwest. Mary Crehore Bedell wrote of traditional Apache homes side-by-side with the Bureau of Indian Affairs mandated style wooden frame houses. In the case of the Apache man Mary Crehore Bedell spoke with, he and his family lived in the traditional home, and he stored his tools and farm implements in the wooden frame house. The "Surveys of Indian Industry" conducted by the Bureau of Indian Affairs of the Meskwaki Nation, Sac and Fox Tribe of the Mississippi in Iowa in Tama, Iowa, reported a mixture of traditional housing and government mandated frame houses. In Tama, Iowa, the two styles of houses were used for a variety of purposes. Traditional Indigenous homes were much better suited to provide shelter and comfort in the environment. There is an irony of Whites utilizing tents for their camping trips while criticizing the traditional Indigenous homes the tents were modeled on.[72]

The Indian Detour Couriers were young women in their mid-twenties. Selected with the customary Harvey care and standards, by Erna Fergusson, a New Mexican writer and operator of her own tour guide service in Santa Fe, they were college graduates and given training in southwestern art, geology, sociology, architecture and history. Despite the hard work of serving a crush of passengers in a short time frame multiple times a day,

Harvey House employment offered women a unique opportunity, whether they were White women serving the tourists or women of color working in the cleaning and maintenance areas, to travel and gain new experiences throughout the United States.[73]

Inspired by Emily Post's account but delayed by the United States' entry into World War I, Beatrice Larned Massey wrote *It Might Have Been Worse* of the cross-country motor trip from New York City to San Francisco in 1919. In contrast to Post's account of overpacking, Beatrice Massey was pleased that the luggage of the two couples fit in the tonneau without needing to be strapped on the back or tied to the running-boards. Post, whose party stayed in hotels each night, wrote of overpacking the automobile for the party of three, herself, her son who did the driving and "the lady who is traveling with us." She miscalculated the weather they would encounter and packed heavy clothes for anticipated cold weather only to find warm weather along the way. Even after they had "gradually eliminated everything we could" they still had "just enough for three hallboys on our arrival and three porters on our departure to stagger under." The Massey party took the overnight steamboat from Cleveland to Detroit on which they were able to ship their automobile and "were most fortunate in getting staterooms, with brass beds (not bunks), running water, and a bathroom."[74]

On a lighter note, while in Albion, Michigan, the Massey party encountered their first ice cream cones. For the rest of the journey, they made a point to make an afternoon teatime stop at soda-water fountains for ice cream. "Even in the tiny hamlets on the plains of Montana we found good-rich ice cream." Post wrote that they even acquired a travel container for ice cream. The ice cream cone is credited with making an early appearance at the 1904 St. Louis World's Fair in Missouri. From there vendors across Missouri and the Midwest expanded sales of the ice cream cone. Having gotten its start in the Midwest, the ice cream cone was a pleasant surprise for automobilists driving through from the East and West Coasts.[75] The Masseys followed the Yellowstone Trail, a highway stretching across the upper Midwest from Plymouth, Massachusetts, to Seattle, Washington. While the road conditions did not meet the description of "A good road from Plymouth Rock to Puget Sound," the motorists appreciated the clear, round, yellow roadside signs marking the turns.[76]

White motorists would continue to write of the enjoyment of meeting fellow travelers, comparing travel stories, and seeing life as lived in different parts of the United States as the century ticked forward. Beatrice Massey wrote of Western women that "They think for themselves on the public questions of the hour, and voice their opinions in no uncertain terms." She prefaced this comment to clarify that the people she wrote of

were "in the same walk of life as your friends at home." Class status was an important factor for her while traveling, as well as at home. The west-bound Masseys exchanged travel information with an east-bound family from Fargo, North Dakota, as they both waited in Stevens Point, Michigan, for the skies to clear before starting off for the day. The encounter was most fortunate for the Massey party as Mr. L.B. Hanna was the 1913–1917 former governor of North Dakota. He gave them a list of towns and hotels with "the kindly remark, 'If you will show the hotel clerks this list with my name, I am sure you will be well taken care of.' We certainly were—and more!—from there to Yellowstone Park."[77]

As noted throughout this study, this is in sharp contrast to the experiences of Black travelers during a period of segregation and violence. Due to the dangers of travel from hostile Whites, Black motorists focused on getting safely from one destination to another, relaxing once they were in a safe place. The simple act of driving a car roused the jealousy and violence of Whites who saw Black success as a threat to their station in life. The divide-and-conquer strategy of the segregation-era political elite was built on having any White person feel superior to any Black person. Black travelers packed their own food for long-distance trips on public and private transportation to ensure they had something to eat along the way. Segregated service, if Blacks were served at all, took various forms and was not known to be either prompt or courteous.[78]

The road that became a legendary symbol for the American cross-country road trip, U.S. Route 66, was established in late 1926. U.S. Route 66, nicknamed "The Mother Road" by *The Grapes of Wrath* author John Steinbeck, ran 2,448 miles from Chicago through Missouri, Kansas, Oklahoma, Texas, New Mexico, and Arizona, ending in Santa Monica, California. U.S. Route 66 is a major feature in Steinbeck's 1939 novel of western migration from the impoverished farmlands of the 1930s Dust Bowl droughts. U.S. Route 66 came to represent westward travel in popular culture as the subject of songs, movies, and television shows. Ironically, the highly popular song "Get Your Kicks on Route 66" was originally sung and recorded by Nat King Cole and the King Cole trio who, as Black men, were not welcome along many stretches of U.S. Route 66. Frank Norris writes: "However, not everyone enjoyed the same degree of freedom while traveling long distances along Route 66 or other highways. [Singer Nat "King"] Cole and other American blacks, for example, yearned to take the wheel and experience adventure out on the open road, but the prevalent racial attitudes of mid-twentieth-century American forced them to adapt, to be inventive, and at times to simply endure."[79]

White travelers wrote of the difficulties of the southwest desert crossings in the 1910s and 1920s; some decided to ship their cars and themselves

by train to California. When Beatrice Larned Massey inquired about shipping their automobile to Reno to avoid the rough desert conditions, she was told sternly that a train strike was on and "The clerk pointed out a dried-up little woman of seventy, and said, with a withering glance at me: 'see that old lady? She has driven her own car across the desert twice this summer!" Despite this reprimand, the Massey party found a way to ship their car by train the 400 miles from Montello, Nevada, to Reno, Nevada.

The advice given by Effie Price Gladding did not apply to Black travelers. "We did not travel by night. We found it very delightful to travel in the late afternoon, when the lights were particularly fine, but we avoided as much as possible traveling late into the evening. In this way one does not miss the scenery of the country, and one is not over-fatigued." She concludes, "In all the distance traversed we were not conscious of braving any dangers or of taking any particular risks." For Black motorists, venturing out onto the road meant braving dangers and having an experience very different from White motorists. The White freedom of the open road to wander at will contrasted sharply with the need for Black motorists to remain vigilant. Mechanical breakdowns, an inconvenience for White travelers, could prove deadly for Blacks.[80]

While Winifred Hawkridge Dixon and Toby's itinerary "included vaguely everything there was to see" it did not include California. Winifred Hawkridge Dixon described California as "...the West, dehorned; it possessed climate, boulevard and conveniences; but it also possessed sand fleas and native sons." As two women driving without a man in the party, Winifred and Toby encountered repeated offers by men to act as their chauffeur, offers which they firmly refused. They also learned to respond to the "Going to California" question with the response "Just left" as that was easier than listening to the arguments of the native son boosters as to why they should include California in their itinerary. Winifred and Toby decided to avoid both the legendary "gumbo" mud roads between them and their Southwest destination, and the long wait shipping their car by rail would likely entail. They chose a third option of shipping their automobile by freight steamboat from New York City to Galveston, Texas, and taking themselves to New Orleans by passenger steamboat and after a brief stay in New Orleans, taking a train to the Port of Galveston to pick up their automobile and start their trip across the Southwest.[81]

Like the other automobile tourists, Winifred and Toby sought advice on camping equipment to use in cases where hotel accommodations were not available. They also settled on practical, dark-colored—to hide the dust—clothing with the necessary outfit for dress occasions. Winifred and Toby struggled with an impractical set of bulky suitcases in which, in time-honored fashion, "Whatever we needed always reposed

in the bottom-most suitcases, and rather than dig down, we did without."
While they did their best to pack light, as most travelers find, in hindsight,
it is always possible to have packed lighter.[82]

While the steamboat travel enabled Winifred and Toby to bypass
many miles of mud bogged roads, they still encountered some on their way
through Texas. As Winifred described the mud holes, there were both nat-
ural mud holes and what she called "professional" mud holes, presumably
set up as a business opportunity for the local people who would be paid
to pull the cars through by mule teams. Winifred and Toby learned that
"...to a Texan, any road twenty miles away is a 'splendid road,' ten miles
away is 'pretty fair,' but at five, 'you'll sure bog.'" Driving through sand
also required skills learned along the way.

Oyster shell hard packed roads were easier to drive on, but the paved
seedling miles into and out of cities were the most welcome—except when
Winifred got a speeding ticket driving along the oyster shell road leading
into Houston and they found themselves paying a ticket at the higher out-
of-towner rate. Winifred also wrote of the excitement of crossing a state
line as they crossed from Texas into New Mexico, a sense of being nearer
the frontier with a layer of Old Spain in the surroundings. Despite those
surroundings being a continuation of the sand and sage brush they had
encountered while motoring through Texas.[83]

The trip through Arizona and New Mexico that Winifred and Toby
asked the American Automobile Association office in New York City to
map out for them included "...an index specially prepared for us of every
Indian reservation, natural marvel, scenic and historical spot along the
ridgepole of the Rockies, from Mexico, to Canada." As they left the flat
lands and entered the steep and narrow mountain roads, Winifred and
Toby learned new ways to handle their automobile, with its wide turning
base not well suited to the sharp, hairpin turns. As Winifred described it:
"...the road rose or fell so steeply in rounding corners that the car's hood
completely concealed which way the road twisted. If we went left while the
road turned right we should collide with a cliff; if the road turned left and
we right, we should be plunged through space, so it behooved us to get our
bearings quickly."

All of those sharp turns were hard on the brakes. Winifred and Toby's
confidence in their ability to face the unfamiliar roads ahead increased
when they were able to figure out how to tighten the foot brakes while on a
precarious stretch of road. "We tried the foot brakes. They held! Never had
we known a prouder moment." They later learned the technique of con-
trolling the automobile's speed by turning off the ignition, shifting into
first gear and using the emergency brake at intervals, with the additional
pumping of the foot brake as needed.[84]

Winifred and Toby traveled by mule and horse in addition to automobile in their tour of the West. They described encountering "sage-brush" tourists, families traveling in overloaded Model T Fords and staying in municipal camps. Winifred Hawkridge Dixon wrote: "As these municipal camps were a bit too noisy for people who loved sleep as did Toby and I, we usually sought the open country, but we loved to walk through the grounds, and enjoy their sociability." Throughout their six month journey, Winifred and Toby regularly encountered the question: "Where's the Mister?" "There is no Mister," answered Toby, to whom that question was a red rag. "We are alone. But that we dared go so far from home Misterless raised his opinion of us to dizzy heights...."[85]

Conclusion

An article by Benjamin F. Thomas, titled "The Automobile and What It Has Done for the Negro," in the Black newspaper *New York Amsterdam News* summarized 25 years of automobile history in the United States. He outlined the ability of Black families to move from the servant class where they earned $5 a week to the mechanical class with drivers earning $25 and chauffeurs and mechanics earning from $30 to $60 per week. Again, where they were allowed to work, the color line (even where not codified by law such as New York City) prevented Blacks from working as chauffeurs by forbidding them to park in the neighborhood garages. Despite this, Benjamin Thomas wrote, in New York City more than one-third of the automobile mechanical work was done by Blacks. He wrote also of the great demand for Black chauffeurs where they were allowed to work.

The article ends: "Thus the Negro has made and is making more money in the automobile business than in any other in the world. And his future is very bright, for the gasoline motor is fast taking first place in all the means of transportation." That bright future was to be short-lived, as the article was dated December 18, 1929, just as the effects of the Great Depression were about to hit and change the economic and political landscape devastatingly for all and particularly for Black and Indigenous families.[1]

A November 11, 1927, article in the Black newspaper *The New Journal and Guide* (Norfolk, VA) described the work of the Federal Automobile Association (FAA) established in 1925 and headquartered in Washington, D.C., as part of its work to serve Black motorists in a similar manner to the way the American Automobile Association served White motorists. It aimed to provide Black motorists with the "benefits of a national organization to promote good will and to provide facilities and accommodation from touring. It being realized that it is seldom that Negro motorist are seen on the magnificent highways that were built to induce taxpayers generally to enjoy some of the wonders of native scenery." The Federal Automobile Association was working to establish tourist camps for its membership throughout the country.[2]

Beatrice Hamilton Sword (Mohegan) out for a Sunday drive, circa 1930s (photograph courtesy Faith Damon Davison, Archivist, The Mohegan Tribe).

Greater ability to achieve independent mobility provided women with tools, of which automobiles were one, to take more control over their lives and future. As they made their way through the White, male-dominated socioeconomic and political environment of the United States in the late 19th-century and moved into the 20th century, by and large the automobile contributed to developing greater mobility and individual freedom. As Amy Bridges wrote on reaching San Diego [by train in 1882], "We are here in San Diego at last and it seems a long way from home. I can see so plainly in my mind the map of the United States as I looked at it at home and saw a little dot way down in the southwest corner on the Pacific and such a big country in between. And now I am really in that second little dot and the first one—Boston—is fully three thousand miles away."[3]

As Dr. Gretchen Sullivan Sorin points out,

For white Americans, freedom of movement has always been a fundamental right. The Articles of Confederation, the original agreement among the 13 states establishing the United States, reads in part: *"[T]he people of each State shall have free ingress and regress to and from any other State, and shall enjoy therein all the privileges of trade and commerce."* The right was considered so fundamental as not to be required for inclusion in the Constitution. Indeed, at the time of the writing of the Constitution, the government had little ability to control the mobility of most of its citizens if they chose to

cross colonial borders or to board a ship to another country. It was simply assumed that they could move about as they wished.[4]

But as we have seen throughout this study, the "they" of that simple assumption was White men.

By charting this journey from restricted travel on public transportation to the independent mobility offered by the automobile, we have explored the path to the common aim of living a rich, full life, and ways automobiles aided that journey for Black, Indigenous, and White women. This study is limited in its choice of subject matter, for the American motoring landscape involves a far more expansive demographic than these three groups. But these examples aspire to serve as a launching pad for readers' and scholars' further interest and industry. This book aimed to reveal the benefits that the automotive life could bring to whomever took the wheel, as well as the harms of inequities to access, safety, good lodging and fuel, and reliable equipment, and fuel.

The promise of any new, groundbreaking, "life-altering" technology is always limited by the social conditions in which its users find themselves. Even the topic of the use of today's cars—examined at the intersection of race, class, and gender—has great potential for further study as we push for an era of cleaner fuel, cleaner travel, and new fuel technologies. We might hope that with a greater and more just social conscience, we will steer this next course toward more equitable and beneficial mobility.

Chapter Notes

Preface

1. The Best Quotes About Travel, https://matadornetwork.com/read/50-most-inspiring-travel-quotes-of-all-time/, accessed October 17, 2022.

2. Robert Sloss, "What a Woman Can Do with an Auto" [orig. pub. 1910 *Outing*] in Frank Oppel, ed., *Motoring in America: The Early Years* (Secaucus: Castle, 1989), 270.

Chapter 1

1. Mary Russell, *The Blessings of a Good Thick Skirt: Women Travellers and Their World* (London: William Collins, 1986), 23.

2. Dorothy Middleton, *Victorian Lady Travellers* (London: Routledge & Kegan Paul, 1965), 7; Dea Birkett, *Spinsters Abroad: Victorian Lady Explorers* (Oxford: B. Blackwell, 1989), 31.

3. Birkett, *Spinsters Abroad*, 110.

4. Birkett, *Spinsters Abroad*, 54; Middleton, *Victorian Lady Travellers*, 172.

5. Nancy Prince, *A Black Woman's Odyssey through Russia and Jamaica* (1850; repr., Princeton: Markus Wiener, 1995), 77–78.

6. Prince, *A Black Woman's Odyssey through Russia and Jamaica*, 82.

7. Prince, *A Black Woman's Odyssey through Russia and Jamaica*, 81.

8. David Lear Buckman, *Old Steamboat Days on the Hudson River* (New York: The Grafton Press, 1909), 16.

9. Ruth Schwartz Cowan, *More Work for Mother* (New York: Basic Books, 1983), 18; Mary Church Terrell, *A Colored Woman in a White World* (1940; repr., North Stratford, NH: Ayer, 1998), 16; Sarah L. Delany and A. Elizabeth Delany with Amy Hill Hearth, *Having Our Say: The Delany Sisters' First 100 Years* (New York: Dell, 1993), 62.

10. Tera W. Hunter, *To 'Joy My Freedom: Southern Black Women's Lives and Labors After the Civil War* (Cambridge: Harvard University Press, 1997), 2; Dorothy Sterling, ed., *We Are Your Sisters. Black Women in the Nineteenth Century* (New York: W.W. Norton, 1984), 311; Evelyn Brooks Higginbotham, *Righteous Discontent: The Women's Movement in the Black Baptist Church, 1880–1920* (Cambridge: Harvard University Press, 1993), 164–166.

11. *Baltimore Afro-American*, September 2, 1899; September 9, 1901.

12. Amy G. Richter, *Home on the Rails* (Chapel Hill: University of North Carolina Press, 2005), 21, 83.

13. https://www.britannica.com/event/Plessy-v-Ferguson-1896, accessed March 18, 2023.

14. Richter, *Home on the Rails*, 21, 83.

15. Richard A. Wells, *Manners, Culture and Dress of the Best American Society* (Springfield, MA: King, Richardson & Son, 1891), 150, 154.

16. Mrs. M.F. Armstrong, *Habits and Manners: Written originally for the students of Hampton N[ormal] and A[gricultural] Institute* (Hampton, VA: Normal School Press, 1888), 76; Mrs. M.W. Baines, *Good Manners* (Springfield, OH: Farm and Fireside Library, 1882), 108–109; Wells, *Manners, Culture and Dress of the Best American Society*, 150.

17. Armstrong, *Habits and Manners*, 80; David Goldfield, ed., *The American*

Journey: A History of the United States, 5th ed. combined volume (Upper Saddle River, NJ: Pearson, 2009), 481; John Hope Franklin and Alfred A. Moss, Jr., *From Slavery to Freedom: A History of African Americans*, 8th ed. (New York: Alfred A. Knopf, 2005), 290.

18. Anna Julia Cooper, *A Voice from the South* (1892; repr.; New York: Oxford University Press, 1988), 89–90.

19. T. Thomas Fortune, "Southern Chivalry," *Baltimore Afro-American*, August 31, 1895.

20. "The Proposed Separate Car Law," *Baltimore Afro-American*, January 11, 1902.

21. John Kasson, *Rudeness and Civility: Manners in Nineteenth Century Urban America* (New York: Hill and Wang, 1990), 128–129.

22. "A Word to Our Women," *Baltimore Afro-American*, January 23, 1904.

23. *Baltimore Afro-American*, June 25, 1904.

24. *Baltimore Afro-American*, June 25, 1904.

25. Delany and Delany with Hearth, *Having Our Say*, 130–131.

26. Terrell, *A Colored Woman in a White World*, 296.

27. Terrell, *A Colored Woman in a White World*, 297–299.

28. Linda O. McMurry, *To Keep the Waters Troubled: The Life of Ida B. Wells* (New York: Oxford University Press, 1998), 26–27.

29. *Baltimore Afro-American*, August 20, 1904.

30. *Baltimore Afro-American*, October 26, 1895.

31. *Baltimore Afro-American*, July 3, 1907.

32. *Baltimore Afro-American*, June 3, 1899.

33. Roxanne Dunbar-Ortiz, *An Indigenous People's History of the United States* (Boston: Beacon Press, 2014), 1.

34. https://globalsocialtheory.org/concepts/settler-colonialism/, accessed October 29, 2022.

35. John A. Strong, *The Unkechaug Indians of Eastern Long Island: A History* (Norman: University of Oklahoma Press, 2011), 17; Catherine C. Robbins, *All Indians Do Not Live in Teepees (Or Casinos)* (Lincoln: University of Nebraska, 2011), 161–162.

36. Dunbar-Ortiz, *An Indigenous People's History of the United States*, 2, 6; Robin Wall Kimmerer, *Braiding Sweetgrass* (Minneapolis: Milkweed Editions, 2013), 17.

37. Dunbar-Ortiz, *An Indigenous People's History of the United States*, 2, 6; Kimmerer, *Braiding Sweetgrass*, 17.

38. Dunbar-Oritz, *An Indigenous People's History of the United States*, 151; Albert White Hat, Sr., *Zuya Life's Journey: Oral Teachings from Rosebud* (Salt Lake City: University of Utah Press, 2012), 19.

39. Philip Deloria, *Indians in Unexpected Places* (Lawrence: University Press of Kansas, 2004), 150; Marilyn Irwin Holt, *Linoleum, Better Babies and the Modern Farm Woman, 1890–1930* (Albuquerque: University of New Mexico Press, 1995), 23.

40. Dunbar-Ortiz, *An Indigenous Peoples' History of the United States*, 1; Heather Cox Richardson, *Wounded Knee* (New York: Basic Books, 2011), Kindle edition, 80.

41. Richardson, *Wounded Knee*, Kindle edition, 111, 114; Heather Bruegl, "A History of Native American Boarding Schools," lecture, https://www.heatherbruegl.com/.

42. Richardson, *Wounded Knee*, Kindle edition, 295.

43. Theda Perdue, ed., *Sifters: Native American Women's Lives* (New York: Oxford University Press, 2001), 6–7; Nancy Shoemaker, ed., *Negotiators of Change: Historical Perspectives on Native American Women* (New York: Routledge, 1995), 2.

44. Paula Mitchell Marks, *In a Barren Land: The American Indian Quest for Cultural Survival, 1607 to the Present* (New York: HarperCollins, 1998), 169.

45. Shoemaker, ed., *Negotiators of Change*, 2; Joel W. Martin, *The Land Looks After Us: A History of Native American Religion* (New York: Oxford University Press, 1999), ix, 8.

46. Zitkala-Sa, *American Indian Stories* (1921; repr., Glorieta, NM: The Rio Grande Press, 1976), 44–45.

47. Zitkala-Sa, *American Indian Stories*, 47–48.

48. Zitkala-Sa, *American Indian Stories*, 54–55.

49. Ruth Edmonds Hill, ed., *The Black Women Oral History Project* (Westport, CT: Meckler, 1991), 5:330.

50. Hill, *The Black Women Oral History Project*, 5:330.

51. Hudson River Day Line online exhibit, https://omeka2.hrvh.org/exhibits/show/hudson-river-day-line/introduction, accessed October 29, 2022-.

52. *Baltimore Afro-American*, July 23, 1904; August 13, 1904.

53. Clay McShane, *The Automobile: A Chronology of Its Antecendents, Development, and Impact* (Westport, CT: Greenwood Press, 1997), 26; Bill Strickland, ed., *The Quotable Cyclist* (New York: Breakaway Books, 1997), 325.

54. Harvey Green, *Fit for America* (New York: Pantheon Books, 1986), 225.

55. Strickland, *The Quotable Cyclist*, 324; Maria E. Ward, *Bicycling for Ladies* (New York: Brentano's, 1896), 110.

56. McShane, *The Automobile*, 26; Strickland, *The Quotable Cyclist*, 325.

57. Frances E. Willard, *A Wheel Within a Wheel* (1895; repr., Bedford, MA: Applewood Books, 1997), 11.

58. John Woodforde, *The Story of the Bicycle* (New York: Universe Books, 1971), 47, 67, 71, 81, 126; *The Girl's Own Paper*, June 27, 1891, 619.

59. Roland C. Geist, *Bicycle People* (Washington, D.C.: Acropolis Books, 1978), 73.

60. Robert Smith, *A Social History of the Bicycle* (New York: American Heritage Press, 1972), 66–67; *The Wheelwoman & Society Cycling News*, August 1, 1896, 2.

61. Willard, *A Wheel Within a Wheel*, 74.

62. Smith, *A Social History of the Bicycle*, 27; Judith Crown and Glenn Coleman, *No Hands* (New York: Henry Holt, 1996), 21.

63. *The Girl's Own Paper*, June 6, 1896, 562–563.

64. Willard, *A Wheel Within a Wheel*, 10, 73.

65. Ward, *Bicycling for Ladies*, 156–157.

66. Ward, *Bicycling for Ladies*, June 6, 1896, 562–563.

67. *Wheelwoman*, July 4, 1896; July 11, 1896.

68. Peter Zheutlin, *Around the World on Two Wheels: Annie Londonderry's Extraordinary Ride* (New York: Citadel Press, 2007), 43.

69. Zheutlin, *Around the World on Two Wheels*, 41, 133, 147.

70. Smith, *A Social History of the Bicycle*, 26–27.

71. Smith, *A Social History of the Bicycle*, 19, 29, 35.

72. Marvin Dunn, *Black Miami in the Twentieth Century* (Gainesville: University Press of Florida, 1997), 43, 60, 61.

73. *Wheelwoman*, July 4, 1896, 1.

74. *Wheelwoman*, July 4, 1896, 1; Marion Nicholl Rawson, *From Here to Yender: Early Trails and Highway Life* (New York: E.P. Dutton, 1932), 120; Smith, *A Social History of the Bicycle*, 2, 57; Willard, *A Wheel Within A Wheel*, 13; *Wheelwoman*, August 1, 1896, 9; John D. Long and J.C. Long, *Motor Camping* (New York: Dodd, Mead, 1926), 30.

75. David M. Wrobel, "Introduction: Tourists, Tourism, and the Toured Upon," in *Seeing and Being Seen: Tourism in the American West*, David M. Wrobel and Patrick T. Long, eds. (Lawrence: University Press of Kansas, 2001), 18; John Sears, *Sacred Places: American Tourist Attractions in the Nineteenth Century* (New York: Oxford University Press, 1989), x, 4, 6, 50, 144; Marguerite S. Shaffer, *See America First: Tourism and National Identity, 1880–1940* (Washington, D.C.: Smithsonian Institution Press, 2001), 4–5, 8, 16–17.

76. Nancy Martha West, *Kodak and the Lens of Nostalgia* (Charlottesville: University Press of Virginia, 2000), 58; Cooper, *A Voice from the South*, 93.

Chapter 2

1. Lesley Poling-Kempes *The Harvey Girls: Women Who Opened the West* (New York: Marlowe & Company, 1991), 34.

2. Poling-Kempes, *The Harvey Girls*, 59.

3. Poling-Kempes, *The Harvey Girls*, xiv, xi, 40, 42, 44.

4. Poling-Kempes, *The Harvey Girls*, xi, 42, 44, 55, 59.

5. Poling-Kempes, *The Harvey Girls*, 44, 71.

6. Poling-Kempes, *The Harvey Girls*, 37, 41.

7. Poling-Kempes, *The Harvey Girls*, 41.

8. *The Automobile Magazine*, October 1899, 133.

9. *The Automobile Magazine*, October 1899, 133–137.

10. Mindy Bingham, *Berta Benz and*

the Motorwagen (Santa Barbara: Advocacy Press, 1989), 14, 17, 22, 24, 27, 30, 34.

11. McShane, *The Automobile*, 16, 19; Georgine Clarsen, *Eat My Dust: Early Women Motorists* (Baltimore: The Johns Hopkins University Press, 2008), 1; W. Robert Nitske in Bingham, *Berta Benz and the Motorwagen*, 43, 46.

12. John B. Rae, *The Road and the Car in American Life* (Cambridge: MIT Press, 1971), 41; McShane, *The Automobile*, 20–21.

13. https://www.wikiart.org/en/julius-leblanc-stewart/end-of-summertime-the-ride-form-the-cover-of-soleil-du-dimanche-sunday-20th-of-october-1901-1901, accessed October 22, 2022.

14. Beverly Rae Kimes, *Pioneers, Engineers, and Scoundrels: The Dawn of the Automobile in America* (Warrendale, PA: SAE International, 2005), 48–49; James J. Flink, *America Adopts the Automobile, 1895–1910* (Cambridge: MIT Press, 1970), 19; McShane, *The Automobile*, 20–21; https://www.britannica.com/science/horsepower, accessed October 29, 2022.

15. McShane, *The Automobile*, 21; conversation with Kay Frazer, curator, Elwood Haynes Museum, Kokomo, Indiana, September 26, 2009.

16. Flink, *The Automobile Age*, 17, 22.

17. Kimes, *Pioneers, Engineers and Scoundrels*, 49–50.

18. Flink, *The Automobile Age*, 22–23; Kimes, *Pioneers, Engineers and Scoundrels*, 54–59; "Notes and Comments," *Baltimore Afro-American* August 17, 1901.

19. Henry A. May, *First Black Autos: The Charles Richard "C.R." Patterson & Sons Company* (Mount Vernon, NY: Stalwart, 2006), 13–18, 25.

20. "The New Car Built by Patterson & Sons," *Chicago Defender*, October 2, 1915; May, *First Black Autos*, 45.

21. Clay McShane and Joel A. Tarr, *The Horse in the City* (Baltimore: The Johns Hopkins University Press, 2007), ix; "The Horse in Cities," *New York Times*, July 24, 1881, http://query.nytimes.com/gst/abstract.html?res=9906EFDC133EE433A25757C2A9619C94609FD7CF&scp=152&sq=July+24%2C+1881&st=p, accessed October 22, 2022.

22. "The Horse in Cities," *New York Times*, July 24, 1881, http://query.nytimes.com/gst/abstract.html?res=9906EFDC
133EE433A25757C2A9619C94609FD7CF&scp=152&sq=July+24%2C+1881&st=p, accessed October 22, 2022.

23. "The Horse in Cities," *New York Times*, July 24, 1881, http://query.nytimes.com/gst/abstract.html?res=9906EFDC133EE433A25757C2A9619C94609FD7CF&scp=152&sq=July+24%2C+1881&st=p, accessed October 22, 2022; "Editorial Comment: The Transition," *The Automobile Magazine*, November 1899, 207; *Report of the Commissioner of Agriculture for the Year 1873* (Washington, D.C.: Government Printing Office, 1874), 34–35; *Report of the Commissioner of Agriculture for the Year 1872* (Washington, D.C.: Government Printing Office, 1874), 206–209; https://archive.org/details/CAT30951786010, accessed October 22, 2022.

24. James J. Walsh, Ph.D., M.D., "The Automobile and Public Health," *The Automobile Magazine*, December 1899, 283–287; McShane and Tarr, *The Horse in the City*, 103.

25. McShane and Tarr, *The Horse in the City*, 18, 29 47, 48, caption between pages 56 and 57.

26. "The Sentimental Plea for the Horse," *The Automobile Magazine*, October 1899, 87–88.

27. "The Horse in Cities," *New York Times*, July 24, 1881, http://query.nytimes.com/gst/abstract.html?res=9906EFDC133EE433A25757C2A9619C94609FD7CF&scp=152&sq=July+24%2C+1881&st=p, accessed October 22, 2022.

28. Chas. E. Duryea, "Comicalities of the Horse," *The Horseless Age*, May 10, 1899, 14; J.B. Hoecker, "Brainless Drivers and Ownerless Horses," *The Horseless Age*, June 28, 1899, 15; Hiram Percy Maxim, "The Intelligent Horse!" *The Horseless Age*, April 26, 1899, 18–19.

29. "How to Meet a Frightened Horse," *The Horseless Age*, April 26, 1899, 6; "The Automobile vs. the Horse" *Country Life in America*, November 1905, 96.

30. *The Horseless Age*, March 7, 1900, 11; March 14, 1900, 10; January 21, 1900, 10–11; Sylvester Baxter, "Why Not Send the Horse to School?" *The Automobile Magazine*, October 1899, 153–157; Sylvester Baxter, "How the Horse Runs Amuck" *The Automobile Magazine*, October 1899, 41–48.

31. "Daring Rescue by Woman in an

Auto," *Chicago Defender*, November 9, 1909.

32. "Brave Motorists Deserves Carnegie Hero Award. Heroism of an Unknown Chauffeur," *Chicago Defender*, May 25, 1912.

33. *The Automobile Magazine*, October 1899, 138; http://www.merriam-webster.com/dictionary/hansom, accessed October 22, 2022.

34. *The Automobile Magazine*, October 1899, 138.

35. *The Automobile Magazine*, October 1899, 138.

36. "Near Ninety: Rides Auto First Time," *Chicago Defender*, January 27, 1923.

37. *The Automobile Magazine*, October 1899, 96.

38. *The Automobile Magazine*, April 1896, 8.

39. Eleanor Arnold, ed., *Buggies and Bad Times* (Bloomington: Indiana University Press, 1994), 32.

40. Hill, *The Black Women Oral History Project*, 8:348–350.

41. Hill, *The Black Women Oral History Project*, 8:348–350.

42. Gretchen Sullivan Sorin, *Driving While Black: African American Travel and the Road to Civil Rights* (New York: Liveright, 2020), xiv; *Afro American Citizen* (Charleston, SC), January 17, 1900; Harry Belafonte with Michael Shnayerson, *My Song: A Memoir* (New York: Alfred A. Knopf, 2011), 520.

43. Arnold, *Buggies and Bad Times*, 16.

44. Arnold, *Buggies and Bad Times*, 30–31.

45. Robert M. Lienert, "Moving Backward," in *The Automobile and American Culture*, David L. Lewis and Laurence Goldstein, eds. (Ann Arbor: University of Michigan Press, 1983), 159.

46. Kate Campbell Mead, M.D., "Should a Woman Doctor Use an Automobile or a Horse?" *The Horseless Age*, November 1, 1905, 507–508.

47. *The Ford High Grade on any Grade*, 1903, Benson Ford Research Center, The Henry Ford, Dearborn, MI; *The Horseless Age*, December 1895; May 1896.

48. *The Horseless Age*, March 28, 1900, 16; Julie Wosk, *Women and the Machine* (Baltimore: The Johns Hopkins University Press, 2001), 116; Edwin C. Chamberlin, M.D., "The Automobile for the Physician,"

The Automobile Magazine, February 1901, 1; *Baltimore Race Messenger*, January 2, 1897.

49. *Baltimore Afro-American*, October 31, 1903; November 5, 1910; January 21, 1911; *Chicago Defender*, June 24, 1911; April 27, 1912; June 24, 1911; April 27, 1912; July 6, 1912; November 16, 1912; *Baltimore Afro-American*, November 5, 1910; January 21, 1911.

50. *Baltimore Afro-American*, May 20, 1911.

51. "What the Motor Car Means to the Doctor," Benson Ford Research Center, The Henry Ford, Dearborn, MI.

52. I.B. Holley, Jr., *The Highway Revolution 1895–1925: How the United States Got Out of the Mud* (Durham: Carolina Academic Press, 2008), 4–5.

53. *Good Roads*, November 1899, 230.

54. George Rogers Taylor, *The Transportation Revolution, 1815–1860* (New York: Holt, Rinehart & Winston, 1951), 15–21.

55. W. Turrentine Jackson, *Wagon Roads West: A Study of Federal Road Surveys and Construction in the Trans-Mississippi West, 1846–1869* (New Haven: Yale University Press, 1965), 319.

56. Jackson, *Wagon Roads West*, 7, 326.

57. Jackson, *Wagon Roads West*, 36–37.

58. Heather Cox Richardson, *How the South Won the Civil War* (New York: Oxford University Press 2020), Kindle edition, locations 1752–1753.

59. Jackson, *Wagon Roads West*, 36–37.

60. *Good Roads*, June 2, 1899, 783; Holley, *The Highway Revolution 1895–1925*, 16–17.

61. *Good Roads*, June 2, 1899, 783.

62. https://constitution.congress.gov/constitution/, accessed October 29, 2022.

63. Tammy Ingram, *Dixie Highway: Road Building and the Making of the Modern South, 1900–1930* (Chapel Hill: University of North Carolina Press, 2014), Kindle edition, 8.

64. Daina Ramey Berry and Kali Nicole Gross, *A Black Women's History of the United States* (Boston: Beacon Press, 2020), 105–106. "Slave Workers Still Aid South. Imprison Men for Forced State Work. Build Highways with Conscript Labor," *Chicago Defender*, June 1, 1929.

65. Cleveland Moffett, "Automobiles for the Average Man," *The American*

Monthly Illustrated Review of Reviews, June 1900, 707, 709.

66. Moffett, "Automobiles for the Average Man," *The American Monthly Illustrated Review of Reviews,* 708–709.

67. *The Horseless Age,* June 7, 1899, 14.

68. *The Horseless Age,* December 19, 1900, 32; *Good Roads,* September 1899, 133.

69. Gijs Mom, *The Electric Vehicle* (Baltimore: The Johns Hopkins University Press, 2004), 59; *The Horseless Age,* November 22, 1899, 8.

70. *The Horseless Age,* April 5, 1899, 7.

71. *The Horseless Age,* November 8, 1899, 1; *The Automobile Magazine,* December 1900, 329; Roy Rosenzweig and Elizabeth Blackmar, *The Park and the People: A History of Central Park* (Ithaca: Cornell University Press, 1992), 400; Mom, *The Electric Vehicle,* 62.

72. *The Horseless Age,* August 22, 1900, 24.

73. *The Horseless Age,* April 1898, 8.

74. *The Horseless Age,* April 1898, 8.

75. *The Horseless Age,* April 1898, 8.

76. *The Horseless Age,* April 1898, 8.

77. Mom, *The Electric Vehicle,* 17; "Hiram Percy Maxim," *Encyclopedia Britannica,* 2009, Encyclopedia Britannica Online, accessed October 26, 2022, http://www.britannica.com/EBchecked/topic/370418/Hiram-Percy-Maxim.

78. Joanne Wilke, *Eight Women, Two Model Ts, and the American West* (Lincoln: University of Nebraska Press, 2007), 56.

79. Wilke, *Eight Women, Two Model Ts, and the American West,* Kindle edition, locations 223, 597.

80. Fosterfields Transportation Exhibit script, courtesy the Morris County Park Commission, Fosterfields, Foster Archival Collection.

81. D. Enville, "The Confessions of an Anti-Motorist," *Country Life in America,* November 1907, 39.

82. Steven M. Gelber, *Horse Trading in the Age of Cars* (Baltimore: The Johns Hopkins University Press, 2008), 2, 29, 64.

83. Gelber, *Horse Trading in the Age of Cars,* 19, 67.

84. Lougheed, *How to Drive an Automobile,* 8.

85. McShane, *The Automobile,* 44; Levitt, *The Woman and the Car,* 42.

86. Lougheed, *How to Drive an Auto-* *mobile,* 17; Waldon Fawcett, "Teaching a Woman How to Operate an Automobile," *Toot-Toot,* October 1906, 27.

87. Enville, "The Confessions of an Anti-Motorist," 40.

88. Enville, "The Confessions of an Anti-Motorist," 40; Arnold, *Buggies and Bad Times,* 30.

Chapter 3

1. Enville, "The Confessions of an Anti-Motorist," 39; *Life,* October 1906, 25–28; Fawcett, "Teaching a Woman How to Operate an Automobile," 25.

2. Fawcett, "Teaching a Woman How to Operate an Automobile," 25; Dorothy Levitt, *The Woman and the Car* (London: Hugh Evelyn, 1909), 15–16.

3. Fawcett, "Teaching a Woman How to Operate an Automobile," 26; Levitt, *The Woman and the Car,* 17.

4. Alfred C. Harmsworth, *Motors and Motor-Driving* (Boston: Little, Brown, 1902), 329.

5. Found in the files of the Antique Automobile Club of America, Hershey, Pennsylvania, with the explanatory note: "February 15, 1961 Fred: The following poem was composed by my Aunt Carol M. Lewerenz after indexing for my library files THE HORSELESS AGE Vol One. No. One, for November 1895."

6. Mom, *The Electric Vehicle,* 119; John B. Rae, *The American Automobile Industry* (Boston: Twayne, 1984), 15; *The Horseless Age,* July 18, 1900, 23.

7. *The Horseless Age,* October 10, 1900, 14; July 18, 1900, 23; September 12, 1900, 24.

8. *The Horseless Age,* November 8, 1899, 1; Flink, *America Adopts the Automobile, 1895–1910,* 235–236.

9. *The Horseless Age,* November 8, 1899, 1; Flink, *America Adopts the Automobile, 1895–1910,* 235–236; *The Horseless Age,* November 22, 1899, 8.

10. *Baltimore Afro-American,* December 11, 1909; *Chicago Defender,* October 29, 1910.

11. *Pittsburgh Courier,* March 25, 1911; "Cincinnati automobile school," *Chicago Defender,* August 26, 1911.

12. *Chicago Defender,* September 9, 1911.

13. *Chicago Defender,* November 24, 1917.

14. *Chicago Defender,* July 27, 1918; July 6, 1918.

15. Frances S. Carlin, "An Artist's Appeal," *The Automobile Magazine,* January 1899, 384–386.

16. Sherrie A. Inness, "On the Road and in the Air: Gender and Technology in Girls' Automobile and Airplane Serials, 1909–1932," *Journal of Popular Culture* 30, no. 2 (1996), 50; Marjorie N. Allen, *One Hundred Years of Children's Books in America Decade by Decade* (New York: Facts on File, 1996), xx, xxii; Carol Billman, *The Secret of the Stratemeyer Syndicate: Nancy Drew, the Hardy Boys and the Million Dollar Fiction Factory* (New York: Ungar, 1986), 57.

17. Nell Irvin Painter, *The History of White People* (New York: W.W. Norton, 2010), 201–211; Anne Scott MacLeod, *American Childhood Essays on Children's Literature of the Nineteenth and Twentieth Centuries* (Athens: University of Georgia Press, 1994), 36.

18. Kevin Borg, *Auto Mechanics: Technology and Expertise in Twentieth Century America* (Baltimore: The Johns Hopkins University Press, 2007), 51; Clarence Young, *The Motor Boys in Mexico* (New York: Cupples & Leon, 1906), v; Emily Post, *Etiquette in Society, in Business, in Politics and at Home* (New York: Funk & Wagnalls, 1922), 290.

19. Katherine Stokes, *The Motor Maids at Sunrise Camp* (New York: Hurst & Company, 1914); Laura Dent Crane, *The Automobile Girls in the Berkshires* (Philadelphia: Henry Altemus, 1910), 245; Laura Dent Crane, *The Automobile Girls Along the Hudson* (Philadelphia: Henry Altemus, 1910), 9; Peter J. Schmitt, *Back to Nature: The Arcadian Myth in Urban America* (New York: Oxford University Press, 1969), 118, 123; Deborah Clarke, *Driving Women: Fiction and Automobile Culture in Twentieth-Century America* (Baltimore: The Johns Hopkins University Press, 2007), 27, 29; Inness, "On the Road and in the Air," 53; *Girls Series Books: A Check List of Titles Published 1840–1991* (Minneapolis: Children's Literature Research Collections, University of Minnesota Libraries, 1992).

20. Beth Bailey, *From Front Porch to Back Seat: Courtship in Twentieth-Century America* (Baltimore: Johns Hopkins University Press, 1988), 19; Florence Howe Hall, *Good Form for All Occasions* (New York: Harper & Brothers1914), 183; Post, *Etiquette in Society,* 292–293; Hill, *The Black Women Oral History Project,* 7:388; *Portland New Age,* June 30, 1906.

21. *Baltimore Afro-American,* September 19, 1903.

22. *Baltimore Afro-American,* July 4, 1903, and October 2, 1909; *Chicago Defender,* February 4, 1911.

23. *Baltimore Afro-American,* August 8, 1908; May 20, 1911; and July 15, 1911.

24. *Chicago Defender,* May 27, 1911, and June 3, 1911.

25. *Pittsburgh Courier,* September 23, 1911; *Chicago Defender* June 17, 1911, and June 24, 1911.

26. *Baltimore Afro-American,* July 10, 1915.

27. *Baltimore Afro-American,* August 29, 1893.

28. *Baltimore Afro-American,* November 30, 1895, and May 30, 1896.

29. "Automobile News of Albany Motorists," *The Albany Argus,* September 2, 1906.

30. "News of the Automobilists," *The Albany Argus,* September 16, 1906.

31. Higginbotham, *Righteous Discontent,* 7, 186.

32. *Baltimore Afro-American,* May 9, 1896.

33. Higginbotham, *Righteous Discontent,* 223.

34. Higginbotham, *Righteous Discontent,* 223; http://www.archives.gov/research/guide-fed-records/groups/134.html, accessed October 22, 2022; Franklin and Moss, *From Slavery to Freedom,* 809.

35. Hill, *The Black Women Oral History Project,* 8:299; 6:329; 9:290–291.

36. Hill, *The Black Women Oral History Project,* 6:329.

37. https://www.archives.gov/milestone-documents/interstate-commerce-act, accessed October 29, 2022.

38. "Sues the B&O Railroad," *Baltimore Afro-American,* January 19, 1907.

39. *Chicago Defender,* January 29, 1916.

40. Terrell, *A Colored Woman in a White World,* 306.

41. Alvin Hall, *Driving the Green Book: A Road Trip Thru the Living History of Black Resistance* (New York: HarperOne, 2023), 126, 127.

42. "Blind Business Men," *Chicago Defender,* September 6, 1913.

43. Dunn, *Black Miami in the Twentieth Century*, 94–95; Deloria, *Indians in Unexpected Places*, 168–169.

44. https://www.meskwaki.org/history/, accessed October 29, 2022.

45. https://meskwakipowwow.com/powwow-origins, accessed October 29, 2022.

46. https://meskwakipowwow.com/powwow-origins, accessed October 29, 2022.

47. https://meskwakipowwow.com/powwow-origins, accessed October 29, 2022.

48. https://meskwakipowwow.com/powwow-origins, accessed October 29, 2022; "Indians Tour in Cars" *Ackley* (Iowa) *World Journal*, August 23, 1917; "Indians Tour in Cars," *Esterville* (Iowa) *Democrat*, August 29, 1917; "Indians in Autos," *Milford* (Iowa) *Mail*, November 22, 1917.

49. "Indians Tour in Cars," *Ackley* (Iowa) *World Journal*, August 23, 1917; "Indians Tour in Cars," *Esterville* (Iowa) *Democrat*, August 29, 1917; "Indians in Autos," *Milford* (Iowa) *Mail*, November 22, 1917.

50. Circular 640, Annual Report 1916, Sorrento, Idaho, July 1, 1916, M.D. Colgrove, Superintendent, Annual Narrative and Statistical Reports from Field Jurisdictions of the Bureau of Indian Affairs, 1907–1935, Coeur d'Alene, 1910–28 (National Archives Microfilm Publication M1011, roll 21); The Osage Indian Agency, Pawhuska, Oklahoma, Annual Report (National Archives Microfilm Publication M1011, roll 95); Seminoles of Florida, 1913–35, Annual Report 1913 (National Archives Microfilm Publication M1011, roll 131); Records of the Bureau of Indian Affairs, Record Group 75, National Archives Building, Washington, D.C.

51. http://www.britannica.com/EBchecked/topic/643434/wickiup, accessed October 29, 2022; Surveys of Indian Industry_1921–1926_Tama Agency Folders 1 thru 4, Record Group 75: Records of the Bureau of Indian Affairs, National Archives at Chicago, NAID:4636245.

52. Deloria, *Indians in Unexpected Places*, 149; Russell G. Handsman, *Being Indian in Providence* (Mashantucket, CT: Mashantucket Pequot Museum and Research Center, 2009), 1–2; exhibit label, *Pequot Lives* exhibit, Mashantucket Pequot Museum and Research Center, September 2009.

53. Deloria, *Indians in Unexpected Places*, 153.

54. Letter from Lucian Spencer, Special Commissioner and S.D.A. to the Commissioner of Indian Affairs, Washington, D.C., March 29, 1921, Box 7 PI-163-121 HM 1997, Subgroup 75.19.102, Records of the Bureau of Indian Affairs, Record Group 75, National Archives Building, Washington, D.C.; Tara Browner, *Heartbeat of the People: Music and Dance of the Northern Pow-Wow* (Urbana: University of Illinois Press, 2002), 1; Clyde Ellis, *A Dancing People: Powwow Culture on the Southern Plains* (Lawrence: University Press of Kansas, 2003), 5, 7; Deloria, *Indians in Unexpected Places*, 154.

55. Albert White Hat, Sr., "Zuya Life's Journey Oral Teachings from Rosebud," 77; Adolf Hungry Wolf, *Pow-Wow Dancer's and Craftworker's Handbook* (Summertown, TN: Native Voices, 1999), 6; Gary Robinson, *Son Who Returns* (Summertown, TN: 7th Generation, 2014), 70.

56. Deloria, *Indians in Unexpected Places*, 62, 63.

57. Hungry Wolf, *Pow-Wow Dancer's and Craftworker's Handbook*, 9.

58. Clifford E. Trafzer, "Horses and Cattle, Buggies and Hacks: Purchases by Yakima Indian Women, 1909–1912," in *Negotiators of Change: Historical Perspectives on Native American Women*, Nancy Shoemaker, ed. (New York: Routledge, 1995), 176–177.

59. Shoemaker, *Negotiators of Change*, 178.

60. Bureau of Indian Affairs Yakima Indian Agency Individual Indian Accounts, 1908–1922 (E36) Box 170. Bills of Sale Personal Property, 1909–1912, Yakima Indian Agency, Records of the Bureau of Indian Affairs, Record Group 75, National Archives, Pacific Alaska Region, Seattle.

61. Bureau of Indian Affairs Yakima Indian Agency Individual Indian Accounts, 1908–1922 (E36) Box 170. Bills of Sale Personal Property, 1909–1912, Yakima Indian Agency, Records of the Bureau of Indian Affairs, Record Group 75, National Archives, Pacific Alaska Region, Seattle; Trafzer, "Horses and Cattle, Buggies and Hacks," 178.

62. Deloria, *Indians in Unexpected Places*, 149; *The Oglala Light*, October 1911, 28; March 1912, 32; December 1912, 24; June 1915, 35.

63. Deloria, *Indians in Unexpected Places*, 149, Figure 35; October 31, 2009, conversation at National Anthropological Archives, Suitland, Maryland, and e-mail correspondence from Jim Yellowhawk to author dated November 20, 2009; October 12, 2009, conversation with Reverend Duncan Burns, Kingston, New York, and e-mail correspondence to author dated July 12, 2010.

64. "Vacation Days," *The Crisis*, August 1912, 186–188.

65. Terrell, *A Colored Woman in a White World*, 86–87.

66. Mark S. Foster, "In the Face of 'Jim Crow': Prosperous Black and Vacations, Travel and Outdoor Leisure, 1890–1945," *The Journal of Negro History* 84, no. 2 (Spring 1999), 132, 133.

67. Susan Armitage, "'The Mountains Were Free and We Loved Them': Dr. Ruth Flowers of Boulder, Colorado," in *African American Women Confront the West, 1600–2000*, Quintard Taylor and Shirley Ann Wilson Moore, eds. (Norman: University of Oklahoma Press, 2003), 170.

Chapter 4

1. Mrs. J.C.C., "Incidents in a Lady Operator's Experience," *The Horseless Age*, June 7, 1905, 631–633.

2. Michael L. Berger, *The Devil Wagon in God's Country: The Automobile and Social Change in Rural America, 1893–1929* (Hamden, CT: Archon Books, 1979), 19, 31; Mrs. J.C.C., "Incidents in a Lady Operator's Experience," 631–633.

3. Berger, *The Devil Wagon in God's Country*, 29.

4. Berger, *The Devil Wagon in God's Country*, 24; Long and Long, *Motor Camping*, 30.

5. Berger, *The Devil Wagon in God's Country*, 24.

6. Joel Smith, "A Good Section for Automobiles," *The Automobile Magazine*, May 1901, 40–41.

7. Rosalyn Baxandall and Elizabeth Ewen, *Picture Windows: How the Suburbs Happened* (New York: Basic Books, 2000), 6–10; Kenneth Jackson, *Crabgrass Frontier* (New York: Oxford University Press, 1985), 142–143.

8. Baxandall and Ewen, *Picture Windows*, 9.

9. *Baltimore Afro-American*, August 22, 1903.

10. Baxandall and Ewen, *Picture Windows*, 11; Bellamy Partridge, *Fill 'er Up!* (New York: McGraw-Hill, 1952), 140; Kimes, *Pioneers, Engineers, and Scoundrels*, 284–285.

11. John Heitmann, *The Automobile and American Life* (Jefferson, NC: McFarland, 2009), 31–32.

12. Eustace Clavering, "The Twentieth Century Runabout," *Munsey's Magazine*, December 1902, 390–392.

13. Partridge, *Fill 'er Up!*, 96–97; Berger, *The Devil Wagon in God's Country*, 26.

14. Partridge, *Fill 'er Up!*, 100; *The Horseless Age*, March 7, 1900, 19; July 26, 1905, 154–155; Virginia Scharff, *Taking the Wheel: Women and the Coming of the Motor Age* (Albuquerque: University of New Mexico Press, 1999), 70.

15. Elsa A. Nystrom, *Mad for Speed: The Racing Life of Joan Newton Cuneo* (Jefferson, NC: McFarland, 2013), 26–27.

16. Nystrom, *Mad for Speed*, 28–29.

17. Nystrom, *Mad for Speed*, 35.

18. Nystrom, *Mad for Speed*, 49.

19. "The Start of the Glidden Tour," *The Horseless Age*, July 12, 1905, 107; "The Glidden Tour," *The Horseless Age*, July 19, 1905, 127; Kimes, *Pioneers, Engineers, and Scoundrels*, 374; Partridge, *Fill 'er Up!*, 102.

20. "The Start of the Glidden Tour," *The Horseless Age*, July 12, 1905, 107; "The Glidden Tour," *The Horseless Age*, July 19, 1905, 127; Robert Sloss, "What a Woman Can Do with an Auto," in *Motoring in America: The Early Years*, Frank Oppel, ED. (Secaucus: Castle, 1989), 265.

21. Partridge, *Fill 'er Up!*, 102; "The Evolution of the Automobile Joke," *The Horseless Age*, August 20, 1902, 184–185.

22. Partridge, *Fill 'er Up!*, 103; "Woman Gliddenite," *The Antique Automobile*, Fall 1955, 16.

23. "Woman Gliddenite," *The Antique Automobile*, Fall 1955, 16.

24. "Woman Gliddenite," *The Antique Automobile*, 16; Kimes, *Pioneers, Engineers, and Scoundrels*, 374.

25. Nystrom, *Mad for Speed*, 63.

26. Nystrom, *Mad for Speed*, 48.

27. Nystrom, *Mad for Speed*, 122.

28. Heitmann, *The Automobile and American Life*, 31–32.

29. "Johnson to Race Barney Oldfield," *Baltimore Afro-American*, October 22, 1910; "About Chicago," *Chicago Defender*, May 22, 1915.

30. Nystrom, *Mad for Speed*, 121–129.

31. Nystrom, *Mad for Speed*, 122.

32. *Baltimore Afro-American*, July 11, 1919; *Pittsburgh Courier*, October 25, 1924, and June 4, 1927.

33. "Nation's Boldest Dirt Track Drivers in Arden Downs Derby," *Pittsburgh Courier*, August 11, 1928, and "Daredevils Prepare for 100-Mile Classic: Brilliant Galaxy of Auto Drivers to Compete at Arden. Speedsters Out to Set New Record," *Pittsburgh Courier*, August 25, 1928.

34. "Daredevils Set for Columbus Gas Classic. Powerful Machines Entered. Governor to Attend," *Pittsburgh Courier*, September 21, 1929; "Fast Automobile Drivers Invade Milwaukee Fair Grounds for Sunday Race," *Chicago Defender*, August 3, 1929; "Speed Demons Vie on Akron Speedway," *Philadelphia Tribune*, July 11, 1929.

35. Melissa Otis, *Rural Indigenousness: A History of Iroquoian and Algonquian Peoples of the Adirondacks* (Syracuse: Syracuse University Press, 2018), 244.

36. Steven D. Hoelscher, *Picturing Indians* (Madison: University of Wisconsin Press, 2008), 25–27.

37. Hoelscher, *Picturing Indians*, 23, 29, 48.

38. Hoelscher, *Picturing Indians*, 14, 68, 79, 136.

39. Strong, *The Unkechaug Indians of Eastern Long Island*, 276, 279; John A. Strong, *We Are Still Here! The Algonquian Peoples of Long Island Today* (Interlaken, NY: Empire State Books, 1998), 27–32.

40. https://shinnecockindianpowwow.com/, accessed October 29, 2022.

41. https://www.ponca-nsn.gov/our-annual-celebration.html, accessed October 29, 2022; Hungry Wolf, *Pow-Wow Dancer's and Craftworker's Handbook*, 6, 10–11.

42. Otis, *Rural Indigenousness*, 117, 120, 121, 219.

43. https://www.gallupintertribalceremonial.com/, accessed October 29, 2022; Nicholas G. Rosenthal, *Reimagining Indian Country, Native American Migration and Identity in Twentieth-Century Los Angeles* (Chapel Hill: University of North Carolina Press, 2012), Kindle edition, 12, 13, 16, 43.

44. David Grann, *Killers of the Flower Moon: The Osage Murders and the Birth of the FBI* (New York: Knopf Doubleday, 2017), Kindle edition, 6–7, 46.

45. Grann, *Killers of the Flower Moon*, 52–53.

46. Alexandra Harmon, *Rich Indians: Native People and the Problem of Wealth in American History* (Chapel Hill: University of North Carolina Press, 2010), 24–25; Deloria, *Indians in Unexpected Places*, 146.

47. Deloria, *Indians in Unexpected Places*, 177; RG 75 M1011 Roll 95, the Osage Indian Agency, Pawhuska, Oklahoma, 1911 Annual Report, Library of Congress.

48. RG 75 M1011 Roll 95, the Osage Indian Agency, Pawhuska, Oklahoma, 1912 Annual Report, Library of Congress.

49. Baxandall and Ewen, *Picture Windows*, 10.

50. Grann, *Killers of the Flower Moon*, 53, 58.

51. Grann, *Killers of the Flower Moon*, 156, 223, 251.

52. Sorin, *Driving While Black*, 147; *Philadelphia Tribune*, May 25, 1912.

53. Alexandra Harmon, *Rich Indians: Native People and the Problem of Wealth in American History* (Chapel Hill: University of North Carolina Press, 2010), 24–25.

54. "Colored Chauffeurs Discriminated Against. Whites Practice Mean and Dirty Methods Trying to Make Colored Men Lose Jobs," *Baltimore Afro-American*, November 3, 1911.

55. "Chicago auto ownership capital," *Chicago Defender*, November 16, 1912.

56. "Automobile News of Albany Motorists," *The Albany Argus*, September 2, 1906.

57. "Automobile News of Albany Motorists," *The Albany Argus*, September 2, 1906.

58. Bunny McBride and Harald E.L. Prins, *Indians in Eden: Wabanakis and Rusticators on Maine's Mount Desert Island, 1840s–1920s* (Camden, ME: Down East, 2009), 2, 11.

59. Margaret M. Bruchac, "Historical Erasure and Cultural Recovery: Indigenous People in the Connecticut River Valley" (PhD diss., University of Massachusetts Amherst, 2007), 19, 77; Jean M.

O'Brien, *Firsting and Lasting: Writing Indians out of Existence in New England* (Minneapolis: University of Minnesota Press, 2010).

60. Bruchac, "Historical Erasure and Cultural Recovery," 84, 87; Exhibit Panel 1 and 2, "Pequot Lives in the Lost Century," Mashantucket Pequot Museum and Research Center, Mashantucket, Connecticut, October 2009; Shoemaker, *Negotiators of Change*, 5.

61. McBride and Prins, *Indians in Eden*, 15, 26.

62. McBride and Prins, *Indians in Eden*, 12; Peter J. Schmidt, *Back to Nature: The Arcadian Myth in Urban America* (Baltimore: The Johns Hopkins University Press, 1969), 3.

63. McBride and Prins, *Indians in Eden*, 40, 45, 88, 100.

64. William A. Haviland, *At the Place of the Lobsters and Crabs: Indian People and Deer Isle Maine 1605–2005* (Solon, ME: Polar Bear & Company in cooperation with the Deer Isle-Stonington Historical Society, 2009), 46, 66, 88.

65. McBride and Prins, *Indians in Eden*, 84.

66. Clay McShane, *The Automobile: A Chronology of Its Antecedents, Development, and Impact* (Westport, CT: Greenwood Press, 1997), 44; Christopher W. Wells, "The Road to the Model T: Culture, Road Conditions, and Innovation at the Dawn of the American Motor Age," *Technology and Culture* 48, no. 3 (July 2007), 522–523.

67. Wells, "The Road to the Model T," 497; Claude H. Miller, "How to Keep Going," *Country Life in America*, November 1907, 45.

68. Borg, *Auto Mechanics*, 17.

69. Borg, *Auto Mechanics*, 24, 59; *The Crisis*, December 1910, 35.

70. *Chicago Defender*, December 8, 1923, and December 22, 1923.

71. Borg, *Auto Mechanics*, 29, 31; Dunn, *Black Miami in the Twentieth Century*, 94, 95, 131.

72. Borg, *Auto Mechanics*, 29, 31.

73. *Chicago Defender*, December 22, 1923.

74. Levitt, *The Woman and the Car*, 20, 32.

75. Clarsen, *Eat My Dust*, 15; Hilda Ward, *The Girl and the Motor* (1908; repr. Whitefish, MT: Kessinger, 2010), 3–4, 10–11, 18–19, 94.

76. Ward, *The Girl and the Motor*, 30, 32, 41, 56, 73, 103–104, 111.

77. Winifred Hawkridge Dixon, *Westward Hoboes: Ups and Downs of Frontier Motoring* (New York: Charles Scribner's Sons, 1921) 2, 3.

78. *Motor*, August 1905, 1; *Pacific Motoring*, October 27, 1906, 10, and March 16, 1907, 5.

79. Hall, *Driving the Green Book*, 210, 211; Ronald J. Stephens, *Idlewild: The Rise, Decline and Rebirth of a Unique African American Resort Town* (Ann Arbor: University of Michigan Press, 2013), 4.

80. "Vacation Days," *The Crisis*, August 1912, 186–188.

81. Hill, *The Black Women Oral History Project*, 2:93; 6:58–59.

82. Hill, *The Black Women Oral History Project*, 8:354; Jill Nelson, *Finding Martha's Vineyard: African Americans at Home on an Island* (New York: Doubleday, 2005), 23, 57.

83. Hill, *The Black Women Oral History Project*, 9:250; Nelson, *Finding Martha's Vineyard*, 22–23, 46–47, 57.

84. Marsha Dean Phelts, *An American Beach for African Americans* (Gainesville: University Press of Florida, 1997), 1.

85. Phelts, *An American Beach for African Americans*, 3, 4.

86. Phelts, *An American Beach for African Americans*, 5, 7, 9.

87. Phelts, *An American Beach for African Americans*, 9, 10.

88. Phelts, *An American Beach for African Americans*, 12, 13, 19, 20.

89. Phelts, *An American Beach for African Americans*, 37, 43.

90. Stephens, *Idlewild*, 15, 16.

91. Stephens, *Idlewild*, 16, 17.

92. Stephens, *Idlewild*, 23, 24.

93. Hall, *Driving the Green Book*, 202, 203; Stephens, *Idlewild*, 24, 25, 36, 40.

94. Hall, *Driving the Green Book*, 198, 199.

95. Gretchen Sullivan Sorin, "'Keep Going': African Americans on the Road in the Era of Jim Crow" (PhD dissertation, University at Albany, State University of New York, 2009), 80, 128.

96. Jan Whitaker, *Tea at the Blue Lantern Inn: A Social History of the Tea Room Craze in America* (New York: St. Martin's

Press, 2002), Kindle edition, locations 60, 88–90, 274–276.

97. Whitaker, *Tea at the Blue Lantern Inn*, locations 196, 360, 406.

Chapter 5

1. Lillian Eichler, *Book of Etiquette*, Vol. II (Garden City, NY: Nelson Doubleday, 1923), 225.

2. Flink, *America Adopts the Automobile*, 45–46; *The San Francisco Call*, April 22–28, 1906; April 23, 1906, http://chroniclingamerica.loc.gov, accessed October 22, 2022.

3. Oppel, *Motoring in America*, 265; Editorial, *Toot Toot*, October 1906, 29.

4. *Pacific Motoring*, January 26, 1907.

5. McShane, *The Automobile*, 44; Christopher W. Wells, "The Road to the Model T: Culture, Road Conditions, and Innovation at the Dawn of the American Motor Age," *Technology and Culture* 48, no. 3 (July 2007), 522–523.

6. Scharff, *Taking the Wheel*, 94, 100.

7. Brooks, *The Khaki Girls Behind the Lines*, i.

8. Virginia Scharff, *Taking the Wheel*, 104, 108–109; Laura Newland Hill, "Montgomery Motor Corps Contributes to War Efforts," Encyclopedia of Alabama, April 11, 2017.

9. Hill, *The Black Women Oral History Project*, 8:118.

10. Eleanor Flexner with Ellen Fitzpatrick, *Century of Struggle: The Woman's Rights Movement in the United States* (Cambridge: Belknap Press of Harvard University Press, 1959, 1975), 71.

11. Flexner, *Century of Struggle*, 80, 81.

12. Margaret R. Burlingame, "The Motor Car Pays Its Debt to Woman—How the Motor Vehicle Has Aided in the Long Fight for Suffrage Now Happily Ending," *Motor*, July 1919, 38, 108; Clarsen, *Eat My Dust*, 82, 87; Karen Manners Smith, "New Paths to Power," in *No Small Courage: A History of Women in the United States*, Nancy F. Cott, ed. (New York: Oxford University Press, 2000), 411–412; Franklin and Moss, *From Slavery to Freedom*, 367, 693, 701; Duane Champagne, ed., *The Native North American Almanac*, 2nd ed. (Detroit: Gale Group, 2001), 48.

13. Flexner, *Century of Struggle*, 269.

14. "Suffragists on Auto Tour," *New York Times*, July 7, 1915.

15. "Saxon Enrolled in Cause of Suffrage," *Detroit Free Press*, April 16, 1916.

16. "Off for 10,000 Miles in a Little Yellow Votes for Women Car," *Fort Wayne Journal Gazette*, April 9, 1916.

17. Margot McMillen, *The Golden Lane: How Missouri Women Gained the Vote and Changed History* (Charleston, SC: Arcadia 2011), Kindle edition, 13.

18. McMillen, *The Golden Lane*, 82.

19. McMillen, *The Golden Lane*, 84.

20. "Suffrage Flier Speeds on Way," *New York Tribune*, April 7, 1916.

21. "Philadelphia Cheers Suffrage Pilgrims," *New York Tribune*, April 8, 1916; "Flier Survives Dixie Highways," *New York Tribune*, May 14, 1916.

22. "Being a Day-by-Day Account of Transcontinental Tour of Mrs. Alice S. Burke and Miss Nell Richardson Under Auspices of the National Woman Suffrage Association—From Augusta, Ga., to Selma, Ala. By Mrs. Alice Snitjer Burke," *Boston Daily Globe*, May 2, 1916.

23. Martha S. Jones, *Vanguard: How Black Women Broke Barriers, Won the Vote, and Insisted on Equality for All* (New York: Basic Books, 2020), Kindle edition, 152, 161, 179–180.

24. Valerie Boyd, *Wrapped in Rainbows: The Life of Zora Neale Hurston* (New York: Scribner, 2003), Kindle edition, locations 95, 100; Zora Neale Hurston, *Dust Tracks on a Road* (New York: HarperCollins, 1995), Kindle edition, 9.

25. Boyd, *Wrapped in Rainbows*, locations 376, 995; *Zora Neale Hurston: Claiming a Space*, directed and written by Tracy Heather Strain, *American Experience*, PBS, 2023, https://www.pbs.org/wgbh/americanexperience/films/zora-neale-hurston-claiming-space/#part01.

26. Boyd, *Wrapped in Rainbows*, locations 1376, 1405.

27. Boyd, *Wrapped in Rainbows*, locations 1795, 1855, 2257.

28. Boyd, *Wrapped in Rainbows*, location 2808.

29. Boyd, *Wrapped in Rainbows*, location 2810.

30. *Zora Neale Hurston: Claiming a Space*; Boyd, *Wrapped in Rainbows*, location 4473.

31. Boyd, *Wrapped in Rainbows*, locations 2936, 2947, 3046.

32. Boyd, *Wrapped in Rainbows*, location 3207.

33. *Zora Neale Hurston: Claiming a Space*; Boyd, *Wrapped in Rainbows*, location 3270.

34. Boyd, *Wrapped in Rainbows*, location 334.

35. Boyd, *Wrapped in Rainbows*, location 3357.

36. Boyd, *Wrapped in Rainbows*, location 3657.

37. Beatrice Larned Massey, *It Might Have Been Worse: A Motor Trip from Coast to Coast* (San Francisco: Harr Wagner, 1920), 143.

38. Florence Howe Hall, *Good Form for all Occasions* (New York: Harper & Brothers, 1914), 182–183.

39. Warren James Belasco, *Americans on the Road, From Autocamp to Motel, 1910–1945* (Cambridge: MIT Press, 1981), 4.

40. F.E. Brimmer, *Autocamping* (Cincinnati: Stewart Kidd Company, 1923), 240–247.

41. Candacy Taylor, *Overground Railroad: The Green Book and the Roots of Black Travel in America* (New York: Abrams Press, 2020) 167.

42. Frank Norris, "Courageous Motorists: African American Pioneers on Route 66," *New Mexico Historical Review* 90, no. 3 (Summer 2015), 300; Sorin, *Driving While Black*, 215–216.

43. Sorin, "Keep Going," 20, 23; Nelson, *Finding Martha's Vineyard*, 74.

44. AUTHOR: SOURCE MISSING.

45. Hill, *The Black Women Oral History Project*, 1:15, 33.

46. Wilke, *Eight Women, Two Model Ts, and the American West*, location 230.

47. Wilke, *Eight Women, Two Model Ts, and the American West*, locations 230, 244.

48. Belasco, *Americans on the Road*, 48.

49. Massey, *It Might Have Been Worse*, 11, 12.

50. Wilke, *Eight Women, Two Model Ts, and the American West*, location 258.

51. Wilke, *Eight Women, Two Model Ts, and the American West*, location 318.

52. Belasco, *Americans on the Road*, 74, 75.

53. Brimmer, *Autocamping*, 242, 243.

54. Brimmer, *Autocamping*, 241–247.

55. Wilke, *Eight Women, Two Model Ts, and the American West*, locations 322, 771.

56. Wilke, *Eight Women, Two Model Ts, and the American West*, locations 329, 335, 384, 504.

57. Wilke, *Eight Women, Two Model Ts, and the American West*, locations 296, 604.

58. Dixon, *Westward Hoboes*, 196.

59. Mary Crehore Bedell, *Modern Gypsies: The Story of a Twelve Thousand Mile Motor Camping Trip Encircling the United States* (Baltimore: Waverly Press, 1924), 83; Wilke, *Eight Women, Two Model Ts, and the American West*, location 249.

60. Brimmer, *Autocamping*, 62, 65; Long and Long, *Motor Camping*, 31–39.

61. Wilke, *Eight Women, Two Model Ts, and the American West*, location 279.

62. Roderick Nash, *Wilderness and the American Mind* (New Haven: Yale University Press, 1967), 143–150, 155; Peter J. Schmitt, *Back to Nature: The Arcadian Myth in Urban America* (New York: Oxford University Press, 1969), 166.

63. Bedell. *Modern Gypsies*, 69; Wilke, *Eight Women, Two Model Ts, and the American West*, location 810–811.

64. Bedell, *Modern Gypsies*, 73, 74, 78; Brimmer *Autocamping*, 252, 253.

65. *The Official Automobile AAA Blue Book 1915* (Chicago: The Automobile Blue Book Publishing Company, 1915), 713; Post, *By Motor to the Golden Gate*, 42.

66. Bedell, *Modern Gypsies*, 69; Brimmer. *Autocamping*, 88–89.

67. Brimmer, *Autocamping*, 109.

68. *Motor*, April 1916.

69. Brimmer, *Autocamping*, 106.

70. Bedell, *Modern Gypsies*, 13.

71. Massey, *It Might Have Been Worse*, 1; *Automobile Dealer and Repairer*, April 1918, 48.

Chapter 6

1. Curt McConnell, *Coast to Coast by Automobile: The Pioneering Trips 1899–1908* (Stanford: Stanford University Press, 2000), 1; Curt McConnell, *"A Reliable Car and a Woman Who Knows It": The First Coast-to-Coast Auto Trips by Women 1899–1916* (Jefferson, NC: McFarland, 2000), 4, 6, 155.

2. McConnell, *Coast to Coast by Automobile*, 309–310.

3. McConnell, "*A Reliable Car and a Woman Who Knows It,*" 6, 7, 18, 21.

4. McConnell, *Coast to Coast by Automobile*, 309–310.

5. McConnell, *Coast to Coast by Automobile*, 310–313.

6. McConnell, *Coast to Coast by Automobile*, 309–313.

7. McConnell, *Coast to Coast by Automobile*, 309–313.

8. Gregory M. Franzwa (annotation and "Chasing Alice"), *Alice's Drive, Alice Ramsey: Republishing Veil, Duster and Tire Iron* (Tucson: The Patrice Press, 2005), 10–12.

9. Franzwa, *Alice's Drive, Alice Ramsey,* 12–13.

10. Franzwa, *Alice's Drive, Alice Ramsey,* 12–13.

11. Franzwa, *Alice's Drive, Alice Ramsey,* 14.

12. Franzwa, *Alice's Drive, Alice Ramsey,* 60.

13. Franzwa, *Alice's Drive, Alice Ramsey,* 60–61, 78.

14. Franzwa, *Alice's Drive, Alice Ramsey,* 131; McConnell,"*A Reliable Car and a Woman Who Knows It,*" 55, 59.

15. McConnell, "*A Reliable Car and a Woman Who Knows It,*" 62, 78, 155–156.

16. Amanda Preuss, *A Girl, a Record and an Oldsmobile* (Lansing: Olds Motor Works, 1916), 2, 4–5.

17. Kimes, *Pioneers, Engineers, and Scoundrels*, 379.

18. *The Official Automobile AAA Blue Book 1915*, 998, 369, 1012.

19. Kimes, *Pioneers, Engineers, and Scoundrels*, 385; Franzwa, *Alice's Drive, Alice Ramse*, 37.

20. Dennis E. and Terri Horvath, *Hoosier Tour: A 1913 Indiana to Pacific Journey* (Indianapolis: Publishing Resources and AGG Publications, 2013), 5.

21. C.G. Sinsabaugh, "National Park Tour Now Possible," *Motor*, June 1915, 41; Shaffer, *See America First*, 26, 29, 35.

22. Heitmann, *The Automobile and American Life*, 77–78.

23. Gladding, *Across the Continent by the Lincoln Highway*, 38.

24. Taylor and Moore, eds., *African American Women Confront the West, 1600–2000*, 170.

25. Belasco, 41, 48; Dixon, *Westward Hoboes*, 65.

26. Schaffer, *See America First*, 68.

27. Schaffer, *See America First*, 69; Massey, *It Might Have Been Worse*, 105.

28. Poling-Kempes, *The Harvey Girls*, 146–148.

29. Poling-Kempes, *The Harvey Girls*, 148, 149, 233, 234.

30. Margaret M. Bruchac, *Savage Kin: Indigenous Informants and American Anthropologists* (Tucson: University of Arizona Press, 2018), 175, 176.

31. Erika Marie Bsumek, *Indian-Made: Navajo Culture in the Marketplace, 1868–1940* (Lawrence: University of Kansas Press, 2008), 53; Dixon, *Westward Hoboes*, 244.

32. Bsumek, *Indian-Made*, 6, 7, 53, 54.

33. Sorin, *Driving While Black*, 61, 63.

34. Hall, *Driving the Green Book*, 127–128.

35. Brimmer, *Autocamping*, 44.

36. Hall, *Driving the Green Book*, 154; Isabel Wilkerson, *The Warmth of Other Suns* (New York: Random House, 2010), 195.

37. James W. Loewen, *Sundown Towns: A Hidden Dimension of American Racism* (New York: Touchstone, 2005), 232–233; Norris, "Courageous Motorists," 303.

38. Hall, *Driving the Green Book*, 140, 141; Norris, "Courageous Motorists," 300, 301, 307.

39. Wilke, *Eight Women, Two Model Ts, and the American West*, location 118.

40. Wilke, *Eight Women, Two Model Ts, and the American West*, locations 611, 642.

41. Wilke, *Eight Women, Two Model Ts, and the American West*, location 126.

42. Wilke, *Eight Women, Two Model Ts, and the American West*, location 134.

43. Wilke, *Eight Women, Two Model Ts, and the American West*, location 138.

44. Wilke, *Eight Women, Two Model Ts, and the American West*, locations 145–156.

45. Wilke, *Eight Women, Two Model Ts, and the American West*, location 221.

46. Wilke, *Eight Women, Two Model Ts, and the American West*, locations 682, 689.

47. Wilke, *Eight Women, Two Model Ts, and the American West*, locations 689, 768.

48. Wilke, *Eight Women, Two Model Ts, and the American West*, locations 812, 818, 834.

49. Wilke, *Eight Women, Two Model Ts, and the American West*, locations 859, 938, 941, 952.

50. Wilke, *Eight Women, Two Model Ts, and the American West*, locations 750, 759; Massey, *It Might Have Been Worse*, 105, 107.

51. http://theplaygroundtrail.com/Playground/Home.html and https://www.fhwa.dot.gov/infrastructure/numbers.cfm, accessed January 29, 2023; Bedell, *Modern Gypsies*, 83; Brimmer, *Autocamping*, 250, 251.

52. Hill, *The Black Women Oral History Project*, 1:34, 9:10; Sorin, "Keep Going," 180.

53. McShane, *The Automobile*, 44; Massey, *It Might Have Been Worse*, ix; Vernon McGill, *Diary of a Motor Journey from Chicago to Los Angeles* (Los Angeles: Grafton, 1922), v.

54. Gladding, *Across the Continent by the Lincoln Highway*, 18, 42.

55. Gladding, *Across the Continent by the Lincoln Highway*, 70, 111, 192.

56. Gladding, *Across the Continent by the Lincoln Highway*, 84, 107, 154, 260.

57. Gladding, *Across the Continent by the Lincoln Highway*, 261.

58. Emily Post, *By Motor to the Golden Gate* (New York: D. Appleton, 1916), 6.

59. Dixon, *Westward Hoboes*, 3, 4.

60. Dixon, *Westward Hoboes*, 260; Norris, "Courageous Motorists," 303.

61. Post, *By Motor to the Golden Gate*, 39, 40.

62. Poling-Kempes, *The Harvey Girls*, 147.

63. Bsumek, *Indian-Made*, 31.

64. Bruchac, *Savage Kin*, 18.

65. *The Basket: The Journal of the Basket Fraternity or Lovers of Indian Baskets and Other Good Things* (Pasadena: The Basket Fraternity, January 1904), 5. Accessed via http://books.google.com.

66. Bsumek, *Indian-Made*, 50, 57, 89.

67. Bsumek, *Indian-Made*, 141.

68. Post, *By Motor to the Golden Gate*, 183; Bsumek, *Indian-Made*, 107, 112.

69. Poling-Kempes, *The Harvey Girls*, 150.

70. Post, *By Motor to the Golden Gate*, 179, 184; Poling-Kempes, *The Harvey Girls*, 150, 151.

71. Dixon, *Westward Hoboes*, 173, 179.

72. Bedell, *Modern Gypsies*, 88.

73. Post, *By Motor to the Golden Gate*, 183; Poling-Kempes, *The Harvey Girls*, 151.

74. Massey, *It Might Have Been Worse*, 3, 24; Post, *By Motor to the Golden Gate*, 37.

75. Massey, *It Might Have Been Worse*, 33–34; Post, *By Motor to the Golden Gate*, 145; https://www.idfa.org/news-views/media-kits/ice-cream/the-history-of-the-ice-cream-cone, accessed January 8, 2023.

76. Massey, *It Might Have Been Worse*, 39.

77. Massey, *It Might Have Been Worse*, 41.

78. Psyche A. Williams-Forson, *Building Houses Out of Chicken Legs: Black Women, Food and Power* (Chapel Hill: University of North Carolina Press, 2006), Kindle edition, 118–119.

79. Norris, "Courageous Motorists," 293.

80. Gladding, *Across the Continent by the Lincoln Highway*, 261, 262; Massey, *It Might Have Been Worse*, 117.

81. Dixon, *Westward Hoboes*, 7, 57.

82. Dixon, *Westward Hoboes*, 7, 8.

83. Dixon, *Westward Hoboes*, 18, 57, 61.

84. Dixon, *Westward Hoboes*, 87, 88.

85. Dixon, *Westward Hoboes*, 234, 358.

Conclusion

1. Thomas, "What the Automobile has done for the Negro," *New York Amsterdam News,* December 18, 1929.

2. "Tourist Camp for Race Motorists," *New Journal and Guide* (Norfolk, VA), November 19, 1927.

3. Schaffer, *See America First*, 272.

4. Sorin, *Driving While Black*, 4.

Bibliography

Archival Collections

Coeur d'Alene Agency, Osage Indian Agency, Seminole Agency, Records of the Bureau of Indian Affairs, Record Group 75, National Archives I, Washington, D.C.

Elwood Haynes Collection, Elwood Haynes Museum, Kokomo, Indiana.

Foster Archival Collection, Fosterfields, Morris County Park Commission, Morristown, New Jersey.

Madam C.J. Walker Papers, African American Personal Papers, African American History Materials, Manuscript and Visual Collections, Indiana Historical Society, Indianapolis, Indiana.

Miriam Snow Mathes Historical Children's Literature Collection, Books and Printed Material Collection, M.E. Grenander Department of Special Collections and Archives, University at Albany, State University of New York, Albany, New York.

Native Americans in Popular Culture Collection, Visual Resources Collection, Printed Materials Collection, Archives and Special Collections, Mashantucket Pequot Museum and Research Center, Mashantucket, Connecticut.

Pequot Lives exhibit, Mashantucket Pequot Museum and Research Center, Mashantucket, Connecticut, September 2009.

Periodical Collection, Antique Automobile Club of America Library and Research Center, Hershey, Pennsylvania.

Prints and Photographs Collection, Library of Congress, Washington, D.C., and www.loc.gov.

Yakima Indian Agency, Records of the Bureau of Indian Affairs, Record Group 75, National Archives, Pacific Alaska Region, Seattle, Washington.

Automobile Registrations

Automobile Register and Road Book for Maryland, District of Columbia and Adjacent Territory. Baltimore: Automobile Register Co., 1906.

Automobile Registrations Received Since February 29, 1908: Supplementary List No. 2. Boston: Auto List Publishing Co., 1908.

Automobile Registrations to April 6, 1906, New Hampshire. Concord: The State, 1906.

Automobile Registrations to July 1, 1913, New Hampshire. Concord: The State, 1913.

New England Auto List Year Book. Boston: Auto List Publishing Co., 1905.

New England Auto List Year Book. Boston: Auto List Publishing Co., 1912.

New York Official Automobile Register and Tourists' Guide. New York: Hall, 1905.

Official Automobile Directory of the State of New York. New York: J.R. Burton, 1914.

Official Automobile Road Book of Western Washington 1910, Automobile Club of Seattle. Seattle: Lowman & Hanford, 1910.

Rhode Island Automobile Directory "Who It Is." Providence: B.S. Clark, 1904.

State of Oregon, List of Motor Vehicles and Chauffeurs Registered in the Office of the Secretary of State June and July 1911. Salem: Willis S. Duniway, State Printers, 1911.

State of Vermont, List of Registered Motor Vehicles. Montpelier: Capital City Press, 1912.

Unpublished Dissertations

Bruchac, Margaret M. "Historical Erasure and Cultural Recovery: Indigenous People in the Connecticut River Valley." PhD dissertation, University of Massachusetts Amherst, 2007.

Sorin, Gretchen Sullivan. "'Keep Going': African Americans on the Road in the Era of Jim Crow." PhD dissertation, University at Albany, State University of New York, 2009.

Magazines and Atlas

American Illustrated Magazine, 1906.
American Magazine, 1907–1908.
American Monthly Illustrated Review of Reviews, 1900–1907.
Antique Automobile, 1955.
Automobile Dealer and Repairer, 1909–1919.
Automobile Magazine, 1899–1905.
Basket, 1904.
Colored American, 1908–1909.
Country Life in America, 1902–1912.
Frank Leslie's Popular Monthly, 1901.
Girl's Own Paper, 1891–1896.
Good Roads, 1899.
Harper's Monthly, 1902.
Harper's Weekly, 1909–1913.
Horseless Age, 1895–1902.
Hub, 1902.
Journal of the American Medical Association, 1906–1911.
Life, the Comic Magazine, 1895–1910.
Lippincott's Magazine, 1904.
Literary Digest, 1911–1912.
Living Age, 1900–1910.
Motor, 1910–1919.
Motor Age, 1899–1906.
Motor Review, 1901.
Motor Vehicle Review, 1899–1900.
Motor Way, 1905.
Motoring and Boating, 1904.
Munsey's Magazine, 1902–1903.
National Geographic, 1917.
Pacific Automobiling, 1904.
Pacific Motoring, 1906–1910.
Popular Monthly, 1901, 1906.

Quarterly Journal Society of American Indians, 1915.
Rand McNally, Auto Road Atlas of the United States, 1926, Facsimile Edition. New York: Rand McNally, 1974.
San Francisco Newsletter and California Advertisor, 1906.
Table Talk, 1913.
Toot-Toot, 1906.
Vogue, 1918.
Wheelwoman & Society Cycling News, 1896.
World's Work, 1902.

Newspapers

Ackley (Iowa) *World Journal.*
Albany (New York) *Argus.*
Baltimore Afro-American.
Baltimore Race Messenger.
Chicago Defender.
Crisis (New York).
Esterville (Iowa) *Democrat.*
Milford (Iowa) *Mail.*
New York Amsterdam News.
New York Sun.
New York Times.
Norfolk (Virginia) *New Journal and Guide.*
Oglala Light (South Dakota).
Philadelphia Tribune.
Pittsburgh Courier.
Portland (Oregon) *New Age.*
San Francisco Call.

Internet Databases

Advertising Ephemera Collection—Database #A0160, Emergence of Advertising On-Line Project, John W. Hartman Center for Sales, Advertising & Marketing History. Duke University Rare Book, Manuscript, and Special Collections Library. http://scriptorium.lib.duke.edu/eaa/.
http://books.google.com.
http://images.indianahistory.org.
http://matadornetwork.com/bnt/2008/03/07/50-most-inspiring-travel-quotes-of-all-time.
http://www.britannica.com.
http://www.merriam-webster.com/dictionary.
http://www.loc.gov.
http://www.photo.nmr.com.

Documentary Film

Strain, Tracy Heather, dir. *Zora Neale Hurston: Claiming a Space*. PBS *American Experience*, 2023. https://www.pbs.org/wgbh/americanexperience/films/zora-neale-hurston-claiming-space/#part01.

Books

Allen, Marjorie N. *100 Years of Children's Books in America. Decade by Decade*. New York: Facts on File, 1996.

Allen, Theodore W. *The Invention of the White Race: Racial Oppression and Social Control (Volume 1)*. New York: Verso, 1994.

_____. *The Invention of the White Race: The Origin of Racial Oppression in Anglo-America (Volume 2)*. New York: Verso, 1997.

Armstead, Myra B. Young. *Lord, Please Don't Take Me in August: African Americans in Newport and Saratoga Springs, 1870–1930*. Urbana: University of Illinois Press, 1999.

Armstrong, Mrs. M.F. *Habits and Manners: Written Originally for the Students of Hampton N[ormal] and A[gricultural] Institute*. Hampton, VA: Normal School Press, 1888.

Arnold, Eleanor, ed. *Buggies and Bad Times*. Bloomington: Indiana University Press, 1994.

Aron, Cindy S. *Working at Play: A History of Vacations in the United States*. New York: Oxford University Press, 1999.

Automobile Blue Book Volume 1, New York and Canada. New York: The Automobile Blue Book Publishing Co., 1915.

Automobile Blue Book Volume 2, New England. New York: The Automobile Blue Book Publishing Co., 1910.

Avery, Gillian. *Behold the Child, American Children and Their Books, 1621–1922*. Baltimore: The Johns Hopkins University Press, 1994.

Bailey, Beth. *From Front Porch to Back Seat: Courtship in Twentieth-Century America*. Baltimore: The Johns Hopkins University Press, 1988.

Baines, Mrs. M.W. *Good Manners*. Springfield, OH: Farm and Fireside Library, 1882.

Barber, H.L. *Story of the Automobile Its History and Development from 1760 to 1917*. Chicago: A.J. Munson, 1917.

Barr, Pat. *A Curious Life for a Lady, The Story of Isabella Bird, A Remarkable Victorian Traveller*. Garden City, NY: Doubleday, 1970.

Bataille, Gretchen, David Mayer Gradwohl, and Charles L.P. Silet, eds. *The World Between Two Rivers: Perspectives on American Indians in Iowa. An Expanded Edition*. Iowa City: University of Iowa Press, 2000.

Bauer, William J., Jr. *California Through Native Eyes*. Seattle: University of Washington Press, 2016.

Baxandall, Rosalyn, and Elizabeth Ewan. *Picture Windows: How the Suburbs Happened*. New York: HarperCollins, 2001.

Bedell, Mary Crehore. *Modern Gypsies: The Story of a Twelve Thousand Mile Motor Camping Trip Encircling the United States*. Baltimore: Waverly Press, 1924.

Belafonte, Harry, with Michael Shnayerson. *My Song: A Memoir*. New York: Alfred A. Knopf, 2011.

Belasco, Warren James. *Americans on the Road: From Autocamp to Motel, 1910–1945*. Cambridge: MIT Press, 1981.

Berger, Michael L. *The Automobile in American History and Culture: A Reference Guide*. Westport, CT: Greenwood Press, 2001.

_____. *The Devil Wagon in God's Country: The Automobile and Social Change in Rural America, 1893–1929*. Hamden, CT: Archon Books, 1979.

Berry, Daina Ramey, and Kali Nicole Gross. *A Black Women's History of the United States*. Boston: Beacon Press, 2020.

Billman, Carol. *The Secret of the Stratemeyer Syndicate: Nancy Drew, the Hardy Boys, and the Million Dollar Fiction Factory*. New York: Ungar, 1986.

Bingham, Mindy. *Berta Benz and the Motorwagen*. Santa Barbara: Advocacy Press, 1989.

Birkett, Dea. *Spinsters Abroad: Victorian Lady Explorers*. New York: Basil Blackwell, 1989.

Bittinger, Cynthia D. *Vermont Women, Native Americans & African Americans: Out of the Shadows of History*. Charleston, SC: The History Press, 2012.

Bold, Christine. *The WPA Guides: Mapping*

America. Jackson: University Press of Mississippi, 1999.

Borg, Kevin L. *Auto Mechanics: Technology and Expertise in Twentieth-Century America*. Baltimore: The Johns Hopkins University Press, 2007.

Boyd, Valerie. *Wrapped in Rainbows: The Life of Zora Neale Hurston*. New York: Scribner's, 2003.

Brimmer, Frank Everett. *Autocamping*. Cincinnati: Stewart Kidd Company, 1923.

Brooks, Edna. *The Khaki Girls at Windsor Barracks; or "Standing To" with the Trusty Twenty*. New York: Cupples & Leon, 1919.

————. *The Khaki Girls Behind the Lines; or Driving with the Ambulance Corps*. New York: Cupples & Leon, 1918.

————. *The Khaki Girls in Victory; or Home with the Heroes*. New York: Cupples & Leon, 1920.

————. *The Khaki Girls of the Motor Corps; or Finding Their Place in the Big War*. New York: Cupples & Leon, 1918.

Brown, Dona. *Inventing New England: Regional Tourism in the Nineteenth Century*. Washington, D.C.: Smithsonian Institution Press, 1995.

Browner, Tara. *Heartbeat of the People: Music and Dance of the Northern Pow-Wow*. Urbana: University of Illinois Press, 2002.

Bruchac, Joseph. *Bowman's Store: A Journey to Myself*. New York: Lee & Low, 1997.

Bruchac, Margaret M. *Savage Kin: Indigenous Informants and American Anthropologists*. Tucson: University of Arizona Press, 2018.

Bsumek, Erika Marie. *Indian-Made: Navajo Culture in the Marketplace, 1868–1940*. Lawrence: University of Kansas Press, 2008.

Buckman, David Lear. *Old Steamboat Days on the Hudson River*. New York: The Grafton Press, 1909.

Bundles, A'Lelia. *On Her Own Ground. The Life and Times of Madam C.J. Walker*. New York: Scribner's, 2001.

Caines, Jeannette. *Just Us Women*. New York: Scholastic, 1982.

Carter, Alison. *Underwear*. New York: Drama Book Publishers, 1992.

Champagne, Duane, ed. *The Native North American Almanac*, 2nd ed. Detroit: Gale Group, 2001.

Clarke, Deborah. *Driving Woman: Fiction and Automobile Culture in Twentieth-Century America*. Baltimore: The Johns Hopkins University Press, 2007.

Clarsen, Georgine. *Eat My Dust: Early Women Motorists*. Baltimore: The Johns Hopkins University Press, 2008.

Cleaveland, Agnes Morley. *No Life for a Lady*. Lincoln: University of Nebraska Press, 1977.

Clymer, Floyd. *Treasury of Early American Automobiles, 1877–1925*. New York: McGraw-Hill, 1950.

Cooper, Anna Julia. *A Voice From the South*. 1892. Reprint, New York: Oxford University Press, 1988.

Cott, Nancy F., ed. *No Small Courage: A History of Women in the United States*. New York: Oxford University Press, 2000.

Cowan, Ruth Schwartz. *More Work for Mother*. New York: Basic Books, 1983.

————. *A Social History of American Technology*. New York: Oxford University Press, 1997.

Crane, Laura Dent. *The Automobile Girls Along the Hudson; or Fighting Fire in Sleepy Hollow*. Philadelphia: Henry Altemus, 1910.

————. *The Automobile Girls at Chicago; or Winning Out against Heavy Odds*. Philadelphia: Henry Altemus, 1912.

————. *The Automobile Girls at Newport; or Watching the Summer Parade*. Philadelphia: Henry Altemus, 1910.

————. *The Automobile Girls at Palm Beach; or Proving Their Mettle Under Southern Skies*. Philadelphia: Henry Altemus, 1913.

————. *The Automobile Girls at Washington: or Checkmating the Plots of Foreign Spies*. Philadelphia: Henry Altemus, 1913.

————. *The Automobile Girls in the Berkshires; or the Ghost of Lost Man's Trail*. Philadelphia: Henry Altemus, 1910.

Crown, Judith, and Glenn Coleman. *No Hands*. New York: Henry Holt, 1996.

Daniel, Walter C. *Black Journals of the United States. Historical Guides to the World's Periodicals and Newspapers*. Westport, CT: Greenwood Press, 1982.

Davis, Mary B., ed. *Native America in the Twentieth Century An Encyclopedia*. New York: Garland, 1996.

Delany, Sarah L., and A. Elizabeth Delany, with Amy Hill Hearth. *Having Our Say:*

The Delany Sisters' First 100 Years. New York: Dell, 1993.

Deloria, Philip. *Indians in Unexpected Places.* Lawrence: University Press of Kansas, 2004.

Dixon, Winifred Hawkridge. *Westward Hoboes: Ups and Downs of Frontier Motoring.* New York: Charles Scribner's Sons, 1921.

Dizer, John T., Jr. *Tom Swift, the Bobbsey Twins, and Other Heroes of American Juvenile Literature.* Lewiston, NY: Edwin Mellen Press, 1971.

Dunbar-Ortiz, Roxanne. *An Indigenous Peoples' History of the United States.* Boston: Beacon Press, 2014.

Dunn, Marvin. *Black Miami in the Twentieth Century.* Gainesville: University Press of Florida, 1997.

Edwards, Laura F. *Gendered Strife and Confusion: The Political Culture of Reconstruction.* Urbana: University of Illinois Press, 1997.

Eichler, Lillian. *Book of Etiquette, Vol. II.* Garden City, NY: Nelson Doubleday, 1923.

Elgersman Lee, Maureen. *Black Bangor: African Americans in a Maine Community, 1880–1950.* Durham: University of New Hampshire Press, 2005.

Ellis, Clyde. *A Dancing People: Powwow Culture on the Southern Plains.* Lawrence: University Press of Kansas, 2003.

Farrar, Hayward. *The Baltimore Afro-American 1892–1950.* Contributions in Afro-American and African Studies, Number 185. Westport, CT: Greenwood Press, 1998.

Flexner, Eleaner, and Ellen Fitzpatrick. *Century of Struggle: The Women's Rights Movement in the United States.* 1959. Revised edition, Cambridge: Belknap Press of Harvard University Press, 1975.

Flink, James J. *America Adopts the Automobile, 1895–1910.* Cambridge: MIT Press, 1970.

———. *The Automobile Age.* Cambridge: MIT Press, 1988.

———. *The Car Culture.* Cambridge: MIT Press, 1975.

Flinn, John J. *Official Guide to the World's Columbian Exposition.* Chicago: The Columbian Guide Company, 1893.

Frankel, Noralee, and Nancy Schrom Dye. *Gender, Class, Race and Reform in the Progressive Era.* Lexington: University Press of Kentucky, 1991.

Franklin, John Hope, and Alfred A. Moss, Jr. *From Slavery to Freedom: A History of African Americans,* 8th ed. New York: Alfred A. Knopf, 2005.

Franz, Kathleen. *Tinkering: Consumers Reinvent the Early Automobile.* Philadelphia: University of Pennsylvania Press, 2005.

Franzwa, Gregory M. (annotation and "Chasing Alice"). *Alice's Drive, Alice Ramsey: Republishing Veil, Duster and Tire Iron.* Tucson: The Patrice Press, 2005.

Garrett, Howard. *The Poster Book of Antique Auto Ads 1898–1920.* Secaucus: The Citadel Press, 1974.

Geist, Roland C. *Bicycle People.* Washington, D.C.: Acropolis Books, 1978.

Gelber, Steven M. *Horse Trading in the Age of Cars.* Baltimore: The Johns Hopkins University Press, 2008.

Gibson, Daniel. *Pueblos of the Rio Grande: A Visitor's Guide.* Tucson: Rio Nuevo, 2001.

Giddings, Paula. *When and Where I Enter: The Impact of Black Women on Race and Sex in America.* New York: Bantam, 1984.

Gilmore, Glenda Elizabeth. *Gender & Jim Crow: Women and the Politics of White Supremacy in North Carolina, 1896–1920.* Chapel Hill: University of North Carolina Press, 1996.

Girls Series Books: A Check List of Titles Published 1840–1991. Children's Literature Research Collections, University of Minnesota Libraries, Minneapolis, Minnesota, 1992.

Gladding, Effie Price. *Across the Continent by the Lincoln Highway.* New York: Brentano's, 1915.

Goldfield, David, ed. *The American Journey: A History of the United States,* 5th ed. combined volume. Upper Saddle River, NJ: Pearson, 2009.

Grann, David. *Killers of the Flower Moon: The Osage Murders and the Birth of the FBI.* New York: Knopf Doubleday, 2017. Kindle edition.

Green, Harvey. *Fit for America.* New York: Pantheon Books, 1986.

Greene, Jacqueline Dembar. *Powwow: A Good Day to Dance.* New York: Franklin Watts, 1998.

Hall, Alvin. *Driving the Green Book, A*

Road Trip Through the Living History of Black Resistance. New York: Harper-One, 2023.

Hall, Florence Howe. *Good Form for All Occasions.* New York: Harper & Brothers, 1914.

Hall, Kermit L., ed. *The Oxford Companion to the Supreme Court of the United States.* New York: Oxford University Press, 2005.

Handsman, Russell G. *Being Indian In Providence.* Mashantucket, CT: Mashantucket Pequot Museum and Research Center, 2009.

Harjo, Joy, and Gloria Bird, eds. *Reinventing the Enemy's Language: Contemporary Native Women's Writings of North America.* New York: W.W. Norton, 1997.

Harmon, Alexandra. *Rich Indians: Native People and the Problem of Wealth in American History.* Chapel Hill: University of North Carolina Press, 2010.

Harmsworth, Alfred C. *Motors and Motor-Driving.* Boston: Little, Brown, 1902.

Haviland, William A. *At the Place of the Lobsters and Crabs: Indian People and Deer Isle Maine1605–2005.* Solon, ME: Polar Bear & Company in cooperation with the Deer Isle Stonington Historical Society, 2009.

Heitmann, John. *The Automobile and American Life.* Jefferson, NC: McFarland, 2009.

Higginbotham, Evelyn Brooks. *Righteous Discontent: The Women's Movement in the Black Baptist Church, 1880–1920.* Cambridge: Harvard University Press, 1993.

Hill, Ruth Edmonds, ed. *The Black Women Oral History Project,* 10 vols. Westport, CT: Meckler, 1991.

Hoelscher, Steven D. *Picturing Indians.* Madison: University of Wisconsin Press, 2008.

Holley, I.B., Jr. *The Highway Revolution 1895–1925: How the United States Got Out of the Mud.* Durham: Carolina Academic Press, 2008.

Holm, Tom. *The Great Confusion in Indian Affairs: Native Americas & Whites in the Progressive Era.* Austin: University of Texas Press, 2005.

Holt, Marilyn Irvin. *Linoleum, Better Babies and the Modern Farm Woman, 1890–1930.* Albuquerque: University of New Mexico Press, 1995.

Horvath, Dennis E., and Terri. *Hoosier Tour: A 1913 Indiana to Pacific Journey.* Indianapolis: Publishing Resources and AGG Publications, 2013.

Hungry Wolf, Adolf. *Pow-Wow Dancer's and Craftworker's Handbook.* Summertown, TN: Native Voices, 1999.

Hunter, Tera W. *To 'Joy My Freedom: Southern Black Women's Lives and Labors After the Civil War.* Cambridge: Harvard University Press, 1997.

Hurston, Zora Neale. *Dust Tracks On a Road.* New York: HarperCollins, 1995.

Hutton, T.R. *Hutton's Highways of the Longhouse showing Principal modern main traveled Motor Roads of New York State that follow the Great Western and Southern War Trails of the League of the Iroquois With the ancient Indian Villages as they existed in 1720 together with the Indian & English names of streams, cities and villages.* Compiled by T.R. Hutton. Map drawn by O. Messerly, 1917.

Ikuta, Yasutoshi. *The American Automobile. Advertising from the Antique and Classic Eras.* San Francisco: Chronicle Books, 1988.

Ingram, Harry M. *The Automobile and the Law.* Albany: J.B. Lyon Company, Printers, 1911.

Ingram, Tammy. *Dixie Highway: Road Building and the Making of the Modern South, 1900–1930.* Chapel Hill: University of North Carolina Press, 2014. Kindle edition.

Jackson, Kenneth T. *Crabgrass Frontier: The Suburbanization of the United States.* New York: Oxford University Press, 1985.

Jackson, W. Turrentine. *Wagon Roads West: A Study of Federal Road Surveys and Construction in the Trans-Mississippi West, 1846–1869.* New Haven: Yale University Press, 1952.

Jakle, John. *City Lights: Illuminating the American Night.* Baltimore: Johns Hopkins University Press, 2001.

_____. *Tourist: Travel in Twentieth-Century North America.* Lincoln: University of Nebraska Press, 1985.

Jepson, Thomas C. *My Sisters Telegraphic.* Athens: Ohio University Press, 2000.

Johnson, Deidre, ed. *Stratemeyer Pseudonyms and Series Books.* Westport, CT: Greenwood Press, 1982.

Jones, Martha S. *Vanguard: How Black*

Women Broke Barriers, Won the Vote, and Insisted on Equality for All. New York: Basic Books, 2020. Kindle edition.

Jordan, Teresa. *Cowgirls Women of the American West An Oral History.* Garden City, NY: Anchor Press Doubleday, 1982.

Kasson, John. *Rudeness and Civility: Manners in Nineteenth Century Urban America.* New York: Hill and Wang, 1990.

Katz, William Loren. *Black Indians: A Hidden Heritage.* New York: Atheneum Books, 1986.

Kessler-Harris, Alice. *Out to Work: A History of Wage-Earning Women in the United States.* New York: Oxford University Press, 1982.

Kimes, Beverly Rae. *Pioneers, Engineers, and Scoundrels: The Dawn of the Automobile in America.* Warrendale, PA: SAE International, 2005.

Kimes, Beverly Rae, and Henry Austin Clark, Jr. *Standard Catalog of American Cars, 1805–1942.* Iola, WI: Krause, 1996.

Kimmerer, Robin Wall. *Braiding Sweetgrass.* Minneapolis: Milkweed Editions, 2013.

Kirsch, David A. *The Electric Vehicle and the Burden of History.* New Brunswick: Rutgers University Press, 2000.

Kline, Ronald R. *Consumers in the Country: Technology and Social Change in Rural America.* Baltimore: The Johns Hopkins University Press, 2000.

Kunzle, David. *Fashion and Fetishism.* Totowa, NJ: Rowman & Littlefield, 1982.

Levine, Lawrence W. *Black Culture and Black Consciousness: Afro-American Folk Thought From Slavery to Freedom.* New York: Oxford University Press, 1978.

Levitt, Dorothy. *The Woman and the Car.* London: Hugh Evelyn, 1909.

Lewis, David L., and Laurence Goldstein, eds. *The Automobile and American Culture.* Ann Arbor: University of Michigan Press, 1980.

Lewis, Sinclair. *Free Air.* New York: Grosset & Dunlap, 1919.

Littlefield, Daniel F., Jr., and James W. Parins. *American Indian and Alaska Native Newspapers and Periodicals, 1826–1924. Vol. 1.* Westport, CT: Greenwood Press, 1984.

Loewen, James W. *Sundown Towns: A Hidden Dimension of American Racism.* New York: Touchstone, 2005.

Long, John D., and J.C. Long. *Motor Camping.* New York: Dodd, Mead, 1926.

Lougheed, Victor. *How to Drive an Automobile.* New York: Motor, 1908.

Lynd, Robert S., and Helen Merrill Lynd. *Middletown: A Study in American Culture.* New York: Harcourt, Brace, 1929.

MacLeod, Anne Scott. *American Childhood: Essays on Children's Literature of the Nineteenth and Twentieth Centuries.* Athens: University of Georgia Press, 1994.

Marks, Paula Mitchell. *In a Barren Land: The American Indian Quest for Cultural Survival, 1607 to the Present.* New York: Perennial HarperCollins, 1998.

Marriott, Alice. *Hell on Horses and Women.* Norman: University of Oklahoma Press, 1953.

Marriott, Alice, and Carol K. Rachlin. *Dance Around the Sun: The Life of Mary Little Bear Inkanish: Cheyenne.* New York: Thomas Y. Crowell, 1977.

Martin, Joel W. *The Land Looks After Us: A History of Native American Religion.* New York: Oxford University Press, 1999.

Massey, Beatrice Larned. *It Might Have Been Worse: A Motor Trip from Coast to Coast.* San Francisco: Harr Wagner, 1920.

May, Henry A. *First Black Autos: The Charles Richard "C.R." Patterson & Sons Company.* Mount Vernon, NY: Stalwart, 2006.

McBride, Bunny, and Harald E.L. Prins. *Indians in Eden: Wabanakis and Rusticators on Maine's Mount Desert Island, 1840s–1920s.* Camden, ME: Down East, 2009.

McConnell, Curt. *Coast to Coast by Automobile: The Pioneering Trips, 1899–1908.* Stanford: Stanford University Press, 2000.

_____. *"A Reliable Car and a Woman Who Knows It": The First Coast-to-Coast Auto Trips by Women, 1899–1916.* Jefferson, NC: McFarland, 2000.

McDonnell, Janet, and Barry Mackintosh. *The National Parks: Shaping the System.* Washington, D.C.: United States Department of the Interior, 2005.

McGill, Vernon. *Diary of a Motor Journey from Chicago to Los Angeles.* Los Angeles: Grafton, 1922.

McMillen, Margot. *The Golden Lane: How Missouri Women Gained the Vote and*

Changed History. Charleston, SC: Arcadia, 2011. Kindle edition.

McMurry, Linda O. *To Keep the Waters Troubled: The Life of Ida B. Wells.* New York: Oxford University Press, 1998.

McShane, Clay. *The Automobile: A Chronology of Its Antecedents, Development, and Impact.* Westport, CT: Greenwood Press, 1997.

McShane, Clay, and Joel A. Tarr. *The Horse in the City.* Baltimore,: The Johns Hopkins University Press, 2007.

Middleton, Dorothy. *Victorian Lady Travellers.* London: Routledge & Kegan Paul, 1965.

Mom, Gijs. *The Electric Vehicle.* Baltimore: The Johns Hopkins University Press, 2004.

Motor Vehicle Manufacturers Association of the United States, Inc. *Automobiles of America Milestones, Pioneers, Roll Call, Highlights.* Detroit: Savoyard Book, Wayne State University Press, 1974.

Mott, Frank Luther. *A History of American Magazines. Vol. IV: 1885–1905.* Cambridge: The Belknap Press of Harvard University Press, 1957.

_____. *A History of American Magazines. Vol. V: Sketches of 21 Magazines 1905–1930.* Cambridge: The Belknap Press of Harvard University Press, 1957.

Muncy, Robyn. *Creating a Female Dominion in American Reform, 1890–1935.* New York: Oxford University Press, 1991.

Murphy, James E., and Sharon M. Murphy. *Let My People Know American Indian Journalism, 1828–1978.* Norman: University of Oklahoma Press, 1981.

Nabokov, Peter. *How the World Moves: The Odyssey of an American Indian Family.* New York: Viking, 1995.

Nash, Roderick. *Wilderness and the American Mind.* New Haven: Yale University Press, 1967.

Nelson, Jill. *Finding Martha's Vineyard African Americans at Home on an Island.* New York: Doubleday, 2005.

Neverdon-Morton, Cynthia. *Afro-American Women of the South and the Advancement of the Race, 1895–1925.* Knoxville: University of Tennessee Press, 1989.

Newman, Harvey. *Southern Hospitality, Tourism and the Growth of Atlanta.* Tuscaloosa: University of Alabama Press, 1997.

Norris, Frank. "Courageous Motorists: African American Pioneers on Route 66." *New Mexico Historical Review* 90, no. 3 (Summer 2015).

Nystrom, Elsa A. *Mad for Speed: The Racing Life of Joan Newton Cuneo.* Jefferson, NC: McFarland, 2013.

O'Brien, Jean M. *Firsting and Lasting: Writing Indians Out of Existence in New England.* Minneapolis: University of Minnesota Press, 2010.

Oppel, Frank, ed. *Motoring in America: The Early Years.* Secaucus: Castle, 1989.

Otis, Melissa. *Rural Indigenousness: A History of Iroquoian and Algonquian Peoples of the Adirondacks.* Syracuse: Syracuse University Press, 2018.

Painter, Nell Irvin. *The History of White People.* New York: Norton, 2010.

Partridge, Bellamy. *Fill'er Up!* New York: McGraw-Hill, 1952.

Peiss, Kathy Lee. *Hope in a Jar: The Making of America's Beauty Culture.* New York: Metropolitan Books, 1998.

Penrose, Margaret. *The Motor Girls at Camp Surprise; or The Cave in the Mountains.* New York: Cupples & Leon, 1916.

_____. *The Motor Girls at Lookout Beach; or In Quest of the Runaways.* New York: Cupples & Leon, 1911.

_____. *The Motor Girls in the Mountains; or The Gypsy Girl's Secret.* New York: Cupples & Leon, 1917.

_____. *The Motor Girls on a Tour; or Keeping a Strange Promise.* New York: Cupples & Leon, 1910.

_____. *The Motor Girls on Cedar Lake; or The Hermit of Fern Island.* New York: Cupples & Leon, 1912.

_____. *The Motor Girls on Crystal Bay; or The Secret of the Red Car.* New York: Cupples & Leon, 1914.

_____. *The Motor Girls on the Coast; or The Waif from the Sea.* New York: Cupples & Leon, 1913.

_____. *The Motor Girls on Waters Blue; or The Strange Cruise of the Tartar.* New York: Cupples & Leon, 1915.

_____. *The Motor Girls; or A Mystery of the Road.* New York: Cupples & Leon Company, 1910.

_____. *The Motor Girls through New England; or Held by the Gypsies.* New York: Cupples & Leon, 1911.

Perdue, Theda. *Sifters: Native American*

Women's Lives. New York: Oxford University Press, 2001.

Phelts, Marsha Dean. *An American Beach for African Americans.* Gainesville: University Press of Florida, 1997.

Poling-Kempes, Lesley. *The Harvey Girls: Women Who Opened the West.* New York: Marlowe & Company, 1989.

Post, Emily. *By Motor to the Golden Gate.* New York: D. Appleton, 1916.

———. *Etiquette in Society, in Business, in Politics and at Home.* New York: Funk & Wagnalls, 1922.

Potter, Vilma Raskin. *A Reference Guide to Afro-American Publications and Editors 1827–1946.* Ames: Iowa State University Press, 1993.

Preuss, Amanda. *A Girl, a Record and an Oldsmobile.* Lansing: Olds Motor Works, 1916.

Prince, Nancy. *A Black Woman's Odyssey through Russia and Jamaica.* 1850. Reprint, Princeton: Markus Wiener, 1995.

Rae, John Bell. *The American Automobile: A Brief History.* Chicago: University of Chicago Press, 1965.

———. *The American Automobile Industry.* Boston: Twayne, 1984.

———. *The Road and the Car in American Life.* Cambridge: MIT Press, 1971.

Rawson, Marion Nicholl. *From Here to Yender, Early Trails and Highway Life.* New York: E.P. Dutton, 1932.

Report of the Commissioner of Agriculture for the Year 1872. Washington, D.C.: Government Printing Office, 1874.

Report of the Commissioner of Agriculture for the Year 1873. Washington, D.C.: Government Printing Office, 1874.

Richardson, Heather Cox. *How the South Won the Civil War.* New York: Oxford University Press, 2020. Kindle edition.

———. *Wounded Knee.* New York: Basic Books, 2011. Kindle edition.

Richter, Amy G. *Home on the Rails.* Chapel Hill: University of North Carolina Press, 2005.

Robbins, Catherine C. *All Indians Do Not Live in Teepees (Or Casinos).* Lincoln: University of Nebraska, 2011.

Robinson, Gary. *Son Who Returns.* Summertown, TN: 7th Generation, 2014.

Rockwood, Roy. *The Speedwell Boys and Their Racing Auto.* New York: Cupples & Leon, 1913.

Rosenthal, Nicholas G. *Reimagining Indian Country, Native American Migration and Identity in Twentieth-Century Los Angeles.* Chapel Hill: University of North Carolina Press, 2012. Kindle edition.

Rosenzweig, Roy, and Elizabeth Blackmar. *The Park and the People: A History of Central Park.* Ithaca: Cornell University Press, 1992.

Russell, Mary. *The Blessings of a Good Thick Skirt: Women Travellers and Their World.* London: William Collins Sons, 1986.

Rydell, Robert. *All the World's a Fair.* Chicago: University of Chicago Press, 1984.

Sandler, Martin W. *This Was America.* Boston: Little, Brown, 1980.

Scharff, Virginia. *Taking the Wheel: Women and the Coming of the Motor Age.* New York: Free Press, 1991.

Schmitt, Peter J. *Back to Nature: The Arcadian Myth in Urban America.* New York: Oxford University Press, 1969.

Schneider, Dorothy, and Carl J. *American Women in the Progressive Era, 1900–1920.* New York: Anchor Books, 1993.

Schriber, Mary Suzanne, ed. *Telling Travels: Selected Writings by Nineteenth-Century American Women Abroad.* DeKalb: Northern Illinois University Press, 1995.

Schroeder, Joseph J., Jr., ed. *The Wonderful World of Automobiles, 1895–1930.* Northfield, IL: DBI Books, 1971.

Schultz, James R. *The Romance of Small-Town Chautauquas.* Columbia: University of Missouri Press, 2002.

Sears, John. *Sacred Places: American Tourist Attractions in the Nineteenth Century.* New York: Oxford University Press, 1989.

Shaffer, Marguerite S. *See America First: Tourism and National Identity, 1880–1940.* Washington, D.C.: Smithsonian Institution Press, 2001.

Shoemaker, Nancy. *Negotiators of Change: Historical Perspectives on Native American Women.* New York: Routledge, 1995.

Sive, Mary Robinson, ed. *When the Trains Ran: Jennie McKenzie Hewitt Doland Diary.* Delhi, NY: Delaware County Historical Association, 2005.

Smith, Robert A. *A Social History of the Bicycle, Its Early Life and Times in America.* New York: American Heritage Press, 1972.

Sorin, Gretchen. *Driving While Black: African American Travel and the Road to Civil Rights.* New York: Liveright, 2020.

Stephens, Ronald J. *Idlewild: The Rise, Decline and Rebirth of a Unique African American Resort Town.* Ann Arbor: University of Michigan Press, 2013.

Sterling, Dorothy. *We Are Your Sisters: Black Women in the Nineteenth Century.* New York: W.W. Norton, 1984.

Stokes, Katherine. *The Motor Maids Across the Continent.* New York: Hurst, 1911.

_____. *The Motor Maids at Sunrise Camp.* New York: Hurst, 1914.

_____. *The Motor Maids by Palm and Pine.* New York: Hurst, 1911.

_____. *The Motor Maids by Rose, Shamrock and Thistle.* New York: Hurst, 1912.

_____. *The Motor Maids in Fair Japan.* New York: Hurst, 1913.

_____. *The Motor Maids' School Days.* New York: Hurst, 1911.

Strickland, Bill. *The Quotable Cyclist.* New York: Breakaway Books, 1997.

Strong, John A. *The Unkechaug Indians of Eastern Long Island: A History.* Norman: University of Oklahoma Press, 2011.

_____ *"We Are Still Here!" The Algonquian Peoples of Long Island Today,* 2d ed. Interlaken, NY: Empire State Books, 1998.

Suggs, Henry Lewis, ed. *The Black Press in the South, 1865–1979.* Westport, CT: Greenwood Press, 1983.

Taylor, Candacy. *Overground Railroad: The Green Book and the Roots of Black Travel in America.* New York: Abrams Press, 2020.

Taylor, George Rogers. *The Transportation Revolution, 1815–1860.* New York: Holt, Rinehart & Winston, 1951.

Taylor, Quintard, and Shirley Ann Wilson Moore, eds. *African American Women Confront the West, 1600–2000.* Norman: University of Oklahoma Press, 2003.

Taylor, Yuval. *Zora and Langston: A Story of Friendship and Betrayal.* New York: W.W. Norton, 2019. Kindle edition.

Terrell, Mary Church. *A Colored Woman in a White World.* 1940. Reprint, North Stratford, NH: Ayer Company, 1998.

Tinling, Marion, ed. *With Women's Eyes, Visitors to the New World, 1775–1918.* Hamden, CT: Archon Books, 1993.

Turner, Frederick Jackson. *The Frontier in American History.* 1921. Reprint, New York: Dover, 1996.

Van Dyne, Edith (L. Frank Baum). *Aunt Jane's Nieces and Uncle John.* Chicago: The Reilly & Britton Co., 1911.

Ward, Hilda. *The Girl and the Motor.* 1908. Reprint, Whitefish, MT: Kessinger, 2010.

Ward, Maria E. *Bicycling for Ladies.* New York: Brentano's, 1896.

Wells, Richard A. *Manners, Culture and Dress of the Best American Society.* Springfield, MA: King, Richardson & Son, 1891.

West, Nancy Martha. *Kodak and the Lens of Nostalgia.* Charlottesville: University Press of Virginia, 2000.

Whitaker, Jan. *Tea at the Blue Lantern Inn: A Social History of the Tea Room Craze in America.* New York: St. Martin's Press, 2002. Kindle edition.

White, Deborah G. *Ar'n't I a Woman?: Female Slaves in the Plantation South.* New York: W.W. Norton, 1985.

White, Roger. *Home on the Road: The Motor Home in America.* Washington, D.C.: Smithsonian Institution Press, 2000.

White Hat, Albert, Sr. *Zuya Life's Journey: Oral Teachings from Rosebud.* Salt Lake City: University of Utah Press, 2012.

Wilke, Joanne. *Eight Women, Two Model Ts, and the American West.* Lincoln: University of Nebraska Press, 2007.

Wilkerson, Isabel. *The Warmth of Other Suns.* New York: Random House, 2010.

Willard, Frances E. *A Wheel Within A Wheel: How I Learned to Ride the Bicycle.* 1895. Reprint, Bedford, MA: Applewood Books, 1997.

Williams, Lillian Serece. *Strangers in the Land of Paradise: The Creation of an African-American Community, Buffalo, NY, 1900–1940.* Bloomington: Indiana University Press, 1999.

Williams-Forson, Psyche A. *Building Houses Out of Chicken Legs: Black Women, Food & Power.* Chapel Hill: University of North Carolina Press, 2006. Kindle edition.

Wilson, Mabel O. *Negro Building: Black Americans in the World of Fairs and Museums.* Berkeley: University of California Press, 2012.

Woodforde, John. *The Story of the Bicycle.* New York: Universe Books, 1971.

Wosk, Julie. *Women and the Machine: Representations from the Spinning Wheel*

to the Electronic Age. Baltimore: Johns Hopkins University Press, 2001.

Wrobel, David M., and Patrick T. Long, eds. *Seeing and Being Seen: Tourism in the American West*. Lawrence: University Press of Kansas, 2001.

Young, Clarence. *The Motor Boys*. New York: Cupples & Leon, 1906.

———. *The Motor Boys Across the Plains*. New York: Cupples & Leon, 1907.

———. *The Motor Boys After a Fortune*. New York: Cupples & Leon, 1912.

———. *The Motor Boys in Mexico*. New York: Cupples & Leon, 1906.

———. *The Motor Boys on the Border*. New York: Cupples & Leon, 1913.

———. *The Motor Boys Overland*. New York: Cupples & Leon, 1906.

Zheutlin, Peter. *Around the World on Two Wheels. Annie Londonderry's Extraordinary Ride*. New York: Citadel Press, 2007.

Zitkala-Sa. *American Indian Stories*. 1921. Reprint, Glorieta, NM: The Rio Grande Press, 1976.

Zuckerman, Mary Ellen. *A History of Popular Women's Magazines in the United States, 1792–1995*. Contributions in Women's Studies, Number 165. Westport, CT: Greenwood Press, 1998.

Journal Articles

Foster, Mark S. "In the Face of 'Jim Crow': Prosperous Black and Vacations, Travel and Outdoor Leisure, 1890–1945." *Journal of Negro History* 84, no. 2 (Spring 1999): 130–149.

Garvey, Ellen Gruber. "Reframing the Bicycle: Advertising-Support Magazines and Scorching Women." *American Quarterly* 47, no. 1 (1995): 66–101.

Hewitt, Nancy A. "Beyond the Search for Sisterhood: American Women's History in the 1980s." *Social History* 10, no. 3 (1985): 299–321.

Higginbotham, Evelyn Brooks. "African-American Women's History and the Metalanguage of Race." *Signs* 17 (Winter 1992): 251–274.

Inness, Sherrie A. "On the Road and in the Air: Gender and Technology in Girls' Automobile and Airplane Serials, 1909–1932." *Journal of Popular Culture* 30, no. 2 (1995): 47–60.

Kerber, Linda. "Separate Spheres, Female Worlds, Women's Place: The Rhetoric of Women's History." *Journal of American History* 75, no. 1 (June 1988): 9–29.

Kline, Ronald, and Trevor Punch. "Users as Agents of Technological Change: The Social Construction of the Automobile in the Rural United States." *Technology and Culture* 37, no. 4 (1996): 763–795.

Norton, Peter D. "Street Rivals: Jaywalking and the Invention of the Motor Age Street." *Technology and Culture* 48, no. 2 (April 2007): 331–359.

Scott, Joan W. "Gender: A Useful Category of Historical Analysis," *American Historical Review* 91, no. 5 (December 1986): 1053–1075.

Tyler, Lyon G. "Review of 'From the Virginia Plantation to the National Capitol,' by John Mercer Langston." *William and Mary Quarterly*, no. 4 (April 1895): 282.

Wells, Christopher W. "The Road to the Model T: Culture, Road Conditions, and Innovation at the Dawn of the American Motor Age." *Technology and Culture* 48, no. 3 (July 2007): 497–523.

White, Deborah G. "Mining the Forgotten: Manuscript Sources for Black Women's History." *Journal of American History* 74, no. 1 (Jun. 1987): 237–242.

Index

Numbers in **bold italics** indicate pages with illustrations

219